ŞEHRENGIZ, URBAN RITUALS AND DEVIANT SUFI MYSTICISM IN OTTOMAN ISTANBUL

Şehrengiz is an Ottoman genre of poetry written in honor of various cities and provincial towns of the Ottoman Empire from the early sixteenth century to the early eighteenth century. This book examines the urban culture of Ottoman Istanbul through *Şehrengiz*, as the Ottoman space culture and traditions have been shaped by a constant struggle between conflicting groups practicing political and religious attitudes at odds. By examining real and imaginary gardens, landscapes and urban spaces and associated ritualized traditions, the book questions the formation of Ottoman space culture in relation to practices of orthodox and heterodox Islamic practices and imperial politics.

The study proposes that *Şehrengiz* was a subtext for secret rituals, performed in city spaces, carrying dissident ideals of *Melâmî* mysticism; following after the ideals of the thirteenth-century Sufi philosopher Ibn al-'Arabî who proposed a theory of "creative imagination" and a three-tiered definition of space, the ideal, the real and the intermediary (*barzakh*). In these rituals, marginal groups of guilds emphasized the autonomy of individual self, and suggested a novel proposition that the city shall become an intermediary space for reconciling the orthodox and heterodox worlds.

In the early eighteenth century, liminal expressions of these marginal groups gave rise to new urban rituals, this time adopted by the Ottoman court society and by affluent city dwellers and expressed in the poetry of Nedîm. The author traces how a tradition that had its roots in the early sixteenth century as a marginal protest movement evolved until the early eighteenth century as a movement of urban space reform.

B. Deniz Çalış-Kural is an architect and historian of Ottoman landscape and urban culture. She was awarded a BArch. by METU, Ankara, Turkey; a MArch. by Pratt Institute, Brooklyn, NY and a PhD degree from METU. For her graduate studies, Çalış was granted fellowship from TUBITAK—The Scientific and Technological Council of Turkey (1996–1998). She was a junior fellow at Dumbarton Oaks Garden and Landscape Studies, Washington, DC (2003–2004). Her work has been published in TOPOS and Dumbarton Oaks Publications, among others. She has taught at Yeditepe and Bahçeşehir Universities of Istanbul. In 2010–2011, she was a visiting scholar at the University of Virginia, School of Architecture. Çalış teaches in the Istanbul Bilgi University Faculty of Architecture.

For Eren and Ali

Şehrengiz, Urban Rituals and Deviant Sufi Mysticism in Ottoman Istanbul

B. Deniz Çalış-Kural

LONDON AND NEW YORK

First published 2014 by Ashgate Publishing

2 Park Square, Milton Park, Abingdon, Oxfordshire OX14 4RN
711 Third Avenue, New York, NY 10017

Routledge is an imprint of the Taylor & Francis Group, an informa business

First issued in paperback 2018

Copyright © B. Deniz Çalış-Kural 2014

B. Deniz Çalış-Kural has asserted her right under the Copyright, Designs and Patents Act, 1988, to be identified as the author of this work.

All rights reserved. No part of this book may be reprinted or reproduced or utilised in any form or by any electronic, mechanical, or other means, now known or hereafter invented, including photocopying and recording, or in any information storage or retrieval system, without permission in writing from the publishers.

Notice:
Product or corporate names may be trademarks or registered trademarks, and are used only for identification and explanation without intent to infringe.

British Library Cataloguing in Publication Data
A catalogue record for this book is available from the British Library

The Library of Congress has cataloged the printed edition as follows:
Çalış-Kural, B. Deniz.
 Şehrengiz, urban rituals and deviant Sufi mysticism in Ottoman Istanbul / by B. Deniz Çalış-Kural.
 pages cm
 Includes bibliographical references and index.
 ISBN 978-1-4724-2709-0 (hardcover : alk. paper)

 1. Istanbul (Turkey)--Social life and customs. 2. Istanbul (Turkey)--Poetry.
 3. Architecture and society--Turkey--Istanbul--History. 4. Literature and society--Turkey--Istanbul--History. 5. Sufism--Turkey--Istanbul--History. I. Title.

DR726.C35 2014
949.61'8--dc23

2013042222

ISBN 13: 978-1-4724-2709-0 (hbk)
ISBN 13: 978-1-138-54830-5 (pbk)

Contents

List of Illustrations	*vii*
Preface	*ix*
Acknowledgements	*xi*
List of Abbreviations	*xiii*

1 "Holy Paradise! Is it Under or Above the City of Istanbul?" 1

2 Gardens, Creative Imagination and the Theory of Intermediary Space in Ibn al-'Arabî's Philosophy and its Reception in the Ottoman World 27

3 *Gazel* Poetry and Garden Rituals (1453–1730): Ideal and Real Gardens of Love 63

4 *Şehrengiz* Poetry and Urban Rituals (1512–1732): Ideal and Real City Spaces of Love, Reconciliation and Liberation 107

5 Nedîm's Poetry and New Rituals of the Tulip Period (1718–1730): The Construction of Gardens at Kağıthane Commons 191

6 The "Storehouse" of Ottoman Landscape Tradition: Gardens and City Spaces as *Barzakh* 229

Appendices 235
 1 *Life of Ibn al-'Arabî* 237
 2 *Disciples of Ibn al-'Arabî in* Bayrami *and* Melâmî-Bayrami *Orders of Sufi Mysticism* 241
 3 Melâmî *Poles* 243
 4 *List of* Şehrengiz *Poems* 245

Bibliography 247
Index 273

Illustrations

3 *Gazel* **Poetry and Garden Rituals (1453–1730): Ideal and Real Gardens of Love**

3.1 "Sultan's garden party" in *Külliyât-ı Kâtibî* (1444–1481). TSMK R.989, 93a.

3.2 "Sultan Süleyman and his son enjoying a garden party" in *Süleymanname* (1520–1566). TSMK H.1517, 477b.

3.3 "Garden party" in *Album of Ahmed I* (1603–1617). TSMK B.408, 16a.

3.4 "Harem enjoying a garden party" in *Album of Ahmed I* (1603–1617). TSMK B.408, 14a.

3.5 "The gnostic has a vision of Angels carrying trays of light to the poet Sa'dî" in Sultan Ibrahim Mirza's *Haft Awrang* (1556–1565) by Jami (d. 1492). Freer Gallery of Art, Smithsonian Institution, Washington, DC. Purchase, F1946.12.147a.

3.6 "Efşancı Garden" in the *Album of Efşancı Mehmed* (1565). IUK F1426, 47a.

3.7 "Complication of vision". Analysis of the visual field in "Efşancı Garden" (1565). IUK F1426, 47a. Analysis by Çalış-Kural.

3.8 "Hierarchy in Ottoman cosmology according to Walter Andrews' analysis of Ottoman *gazel* poetry." Chart by Çalış-Kural.

3.9 "Ideal spaces of Ottoman cosmology according to Walter Andrews' analysis of Ottoman *gazel* poetry." Chart by Çalış-Kural.

3.10 "Real spaces of classical Ottoman cosmology according to Walter Andrews' analysis of Ottoman *gazel* poetry." Chart by Çalış-Kural.

3.11 "Destruction of the garden" in Sultan Ibrahim Mirza's *Haft Awrang* (1556–1565) by Jami (d. 1492). Freer Gallery of Art, Smithsonian Institution, Washington, DC. Purchase, F1946.12.179a.

4 *Şehrengiz* **Poetry and Urban Rituals (1512–1732): Ideal and Real City Spaces of Love, Reconciliation and Liberation**

4.1 "Procession of guilds: Gardeners" in *Surname-i Hümayun* (1582–1584). TSMK H.1344, 349a.

4.2 "Procession of guilds: Sufis of Eyyub-i Ensari" in *Surname-i Hümayun* (1582–1584). TSMK H.1344, 53a.

4.3 "*Şehrengiz* poet Taşlıcalı Yahya (d. 1582)." Portrait from *Meşa'irü'ş-şu'ara* by Aşık Çelebi. AETRH 772, 135a.

4.4 "*Şehrengiz* poet Hayreti (d. 1534)." Portrait from *Meşa'irü'ş-şu'ara* by Aşık Çelebi. AETRH 772, 129a.

4.5 "*Şehrengiz* poet Usuli (d. 1538)." Portrait from *Meşa'irü'ş-şu'ara* by Aşık Çelebi. AETRH 772, 66b.

4.6 "*Şehrengiz* poet Ishak Çelebi (d. 1538)." Portrait from *Meşa'irü'ş-şu'ara* by Aşık Çelebi. AETRH 772, 62a.

4.7 "Istanbul" in *Beyan-ı Menazil-i Sefer-i Irakeyn* (1537) by Matrakçı Nasuh. IUK TY 5964, 8b.

5 Nedîm's Poetry and New Rituals of the Tulip Period (1718–1730): The Construction of Gardens at Kağıthane Commons

5.1 "Nahıls and sugar gardens displayed at the Old Palace before the festival" in the 1720 circumcision festival in *Surname-i Vehbi* (1727–1733). TSMK A.3593, 7a.

5.2 "The display of sugar gardens during the procession" in the 1720 circumcision festival in *Surname-i Vehbi* (1727–1733). TSMK A.3593, folio 163a.

5.3 "Garden types with central kiosks." Plans emulating gardens of the early eighteenth century as reconstructed after the garden models displayed during the procession of the 1720 festival in *Surname-i Vehbi* (1727–1733). TSMK A.3593, 7a. Plans by Çalış-Kural, drawn after Eldem, *Türk Bahçeleri* (1978), 210–211 and TSMK A.3593, 7a.

5.4 "Garden types with central pools." Plans emulating gardens of the early eighteenth century as reconstructed after the garden models displayed during the procession of the 1720 circumcision festival in *Surname-i Vehbi* (1727–1733). TSMK A.3593, 162 b. Plans by Çalış-Kural, drawn after Eldem, *Türk Bahçeleri* (1978), 216–217 and TSMK A.3593, 162 b.

5.5 "Location of Kağıthane at the end of the Golden Horn." Map by Çalış-Kural.

5.6 "Site Plan of Kağıthane during the Tulip Period showing the palace grounds and the public commons." Site plan by Çalış-Kural, drawn after various reconstruction drawings and etchings in Eldem, *Sa'dabad* (1977), 8–9; 16–17; 20–21; 34–35.

5.7 "Young man reading a poem" by Levni. TSMK H.2164, 17a.

5.8 "Young man unwrapping his turban" by Levni. TSMK H.2164, 13a.

5.9 "Site plan for the palace and gardens of Chantilly" from a French book on gardens found in Topkapı Palace Library. TSMK H.2605

5.10 "Site plan of the palace and gardens of Fontainebleau" from a French book on gardens found in Topkapı Palace Library. TSMK H.2605.

5.11 "Plan of Sa'd-âbâd Palace gardens and the neighboring Kağıthane Commons." Plan by Çalış-Kural, reconstructed and drawn after Eldem, *Sa'dabad* (1977), 20–21.

Preface

In Ottoman culture, discourses pertaining to space, urban life and urban culture developed by poetic, metaphoric and intertextual means. In order to study Ottoman space culture, a deeper understanding of Ottoman poetry and practices associated with poetry are fundamental. Ottoman poetry comprised different genres, each reflecting a different attitude towards Ottoman social order, suggesting appropriation of different spaces and fostering ideological world-views which are at odds. Poetic genres gave rise to ritualized practices performed in different kinds of spaces in relation to different interpretations of Islamic cosmology.

Walter Andrews, historian of Ottoman literature and culture, in his seminal book *Poetry's Voice, Society's Song, Ottoman Lyric Poetry* has shown that the *gazel* genre of the Ottoman court poetry constituted subtexts for rituals fostering centralized imperial legitimacy and Islamic Orthodoxy. *Gazel* poetry, performed in gardens, was an expression for the construction and practice of the Orthodox Ottoman society. Following the path that Walter Andrews has paved, this book studies the *Şehrengiz* genre. My research revealed that *şehrengiz* poems were talking about urban rituals performed in city spaces. *Gazel* was performed in private gardens—as a subtext for hosted garden parties, whereas the *şehrengiz* was performed in a variety of city spaces—as a subtext for secret gatherings.

This study proposes that *Şehrengiz* was an expression of groups who were practicing Sufi mysticism influenced by the joy of *Melâmî* ideals, following after the Islamic philosopher Ibn al-'Arabî. 'Arabî proposed a theory of "creative imagination" and a three-tiered definition of space; the ideal, the real and the intermediary (*barzakh*). In *gazel* rituals, Ottoman orthodox society reasserted the primacy of the society over the individual in ideal and real garden spaces. In *şehrengiz* rituals, on the contrary, marginal groups from the early sixteenth century to the early eighteenth century emphasized the autonomy of the individual self and aimed at reconciling orthodox and heterodox worlds and thus their spaces and inhabitants in ideal spaces of Sufi imagination and real spaces of the city. Expressed in simple Turkish, understandable to all city-dwellers, this covert culture shed new perspectives

on urban life. *Şehrengiz* poems illustrated urban rituals. *Şehrengiz* poems—narrated rituals—that took place in a variety of city spaces such as gardens, meadows, friends' houses, the bazaar, or the bath-house. Each one of these places—each a different fragment of urban space—is perceived, experienced and constructed as an intermediary space. Each one of these intermediary spaces is presented as grounds for reconciliation to take shape in between the conflicting, yet complimentary, domains of the Ottoman world.

Ideals of *şehrengiz* rituals did not gain official acceptance until the early eighteenth century, when the high-ranking officials of the Ottoman court came to be adherents of the *Melâmî* philosophy. In addition, the Ottoman sultan was searching for a new regime which shifted its focus from military development through warfare to social development in a peaceful empire. He decided to emulate the leisurely garden life of Paris in the city of Istanbul, while reinventing both its content and its urban settings. This was the spread of a kind of individualism, a form of self-cultivation totally foreign to European endeavor, but deeply rooted in the Turkish subversion of Ottoman culture. It gave rise to new urban rituals adopted by the Ottoman court society and by affluent city dwellers, expressed in the poetry of the early eighteenth century, especially by the poet Nedîm, who also embraced the *Melâmî* joy with other prominent figures of the Tulip Period. However, this cultural revolution came to an end with the events of 1730—through the devastating Patrona Halil Rebellion. 1730 marks a turning point in the modernization of Ottoman culture that had its roots in the early sixteenth century as a marginal protest movement and pursued itself afterwards until the early eighteenth century as a movement of urban space reform.

This book studies Ottoman poetry in three different phases in order to gain a deeper understanding of Ottoman space culture, especially pertaining to gardens, landscape and cities. Yet, looking at space culture, traditions, practices and rituals of space, this book also came to argue that early modernization of the Ottoman society began to take place 200 years prior to the early eighteenth century—the Tulip Period—and it followed from an open development of the cultural attitudes and *Melâmî* ideals illustrated by the *Şehrengiz* rituals since the early sixteenth century. Nevertheless, it talks about urban spaces for the construction of individuality and of free will—each one as a Paradise Garden on earth.

B. Deniz Çalış-Kural
Istanbul

Acknowledgements

This book is published following a very long journey traveling across continents and to different cities and it is dedicated to the multiplicity of the Beloved ones who reside with me in all the gardens of the imagination. Yet, I would sincerely like to acknowledge three scholars and express my gratitude for their academic provision and generosity: Jale N. Erzen of Middle East Technical University, Ankara; Michel Conan, former Director of Garden and Landscape Studies at Dumbarton Oaks, Washington, DC, and Nurhan Atasoy of the Turkish Cultural Foundation. I would also like to thank sincerely Victoria Holbrook and Walter Andrews, whose recommendations, along with their invaluable scholarly works, have been a great influence and shaped the foundation of this study.

I completed a major part of this research during my fellowship at Dumbarton Oaks Research Library. Even after my fellowship, the spirit and joy of working in the library have always accompanied me at different stages of my studies. Through the years my imagination has been enriched by all the seasons and the beloved ones of Dumbarton Oaks gardens. In addition to all the scholars, fellows, directors, librarians and staff of Dumbarton Oaks, I would especially like to recall the garden ladies: Maria Evangelatou, Alicia Simpson, Elizabeth Lebas, Christine Miller, Kathleen Christian Wren and Xin Wu. Margaret Mullet, Director of Byzantine Studies at Dumbarton Oaks, has been my muse over the years.

I would like to express my gratitude to Zeynep Çelik and Esra Müyesseroğlu from Topkapı Museum Library; Hüseyin Kutan, Head of the Department of Manuscript and Rare Book Collection of YEK; Yesemen Akçay of Istanbul University Library Rare Book Collection; Melek Gençboyacı and İlknur Keleş of Millet Library; Betsy Kohut, Rights and Reproductions Coordinator of the Freer Gallery of Art and Arthur M. Sackler Gallery; Sheila Klos, Linda Lott, Bridget Gazzo and Deb Brown of Dumbarton Oaks Library; İbrahim Yılmaz of Simurg, Istanbul, and my fellow scholars and friends—Gül İrepoğlu, İlgi Yüce Aşkun, Namık Erkal and Erik de Jong, who provided me visual images, and primary and secondary sources at different stages of this study. I am also grateful to Erika Gaffney of Ashgate. I wish to acknowledge my colleague

and former student Elif Simge Fettahoğlu for her assistance in the drawing of the plans of Kağıthane gardens. I would also like to express my gratitude to Zuhal Ulusoy of Kadir Has University; İhsan Bilgin and Tansel Korkmaz of Istanbul Bilgi University and Kim Tanzer of the University of Virginia, who showed genuine interest in my studies.

I am indebted to my parents Ayşe Vesile and İhsan Çalış. I have always been lucky to enjoy the delight of residing in gardens of love and intimacy secured by my visionary mother and my father. And I am more than lucky to have been able to work—first, on this research, and later on the book project—in the gardens of joy, pleasure and serenity that we share with my son Eren and my husband Ali.

Abbreviations

AETRH Ali Emîrî Tarih Kolleksiyonu Millet Yazma Eser Kütüphanesi

IUK Istanbul Üniversitesi Kütüphanesi

TSMK Topkapı Sarayı Müzesi Kütüphanesi

1

"Holy Paradise! Is it Under or Above the City of Istanbul?"

The Islamic garden is considered to be the representation of the paradise garden promised in the Koran and further elaborated in religious texts. According to the Islamic tradition, paradise garden is the highest level of cosmography bestowed on human kind in the afterlife. It is the beginning and end of all creation, the abode of the divine being and thus the source of all divine knowledge.

In Orthodox Ottoman tradition, both real and imaginary gardens were representations of the promised paradise garden. Gardens which were manifestations and displays of the supreme divine presence were also the setting where the Ottoman court asserted itself, since the two were integrated in the authority of the Ottoman Sultan as the leader of the Orthodox Muslim community since the early sixteenth century. Thus gardens were reminiscent of religious order and monarchy at the same time. Furthermore, rituals performed in the gardens were tools to control and sustain social order under the rule of the religion and the imperial authority.

Contrary to the Orthodox tradition where the gardens and garden rituals were displays of divine presence and courtly authority, some marginal groups in the Sufi tradition asserted the importance of gardens as a source of inquiry for divine knowledge. Instead of using gardens as a symbol of the religion or the monarchy, they challenged the use of gardens. Contrary to the imperial use of gardens as a tool of social control, these marginal Sufi groups practiced the use of gardens as a tool of individual enlightenment. While the court imposed social control over its subjects by means of gardens and garden rituals, these marginal Sufis practiced the use of gardens and other kinds of open spaces for the liberation of individuals.

Spaces developed, built, planted, and employed by the court represented paradise gardens on earth as the manifestation and display of imperial power. Imperial gardens, gardens of the elite, and all kinds of garden representations in Ottoman court art became displays of power. However, spaces in the city beyond the courtly gardens and their representations became alternative spaces proposing an adventurous journey for individuals to search and to experience new horizons. These spaces of the city were not built

concrete spaces, nor were they walled gardens. But they were parts of city spaces brought together in the minds and rituals of marginal Sufi groups. These spaces can be defined as individual landscapes mapped, shared and experienced by marginal Sufi groups. Thus, while rituals in the gardens supported the solidity of the social order, rituals of marginal Sufi groups in the city challenged the social order and initiated an early modernization of the society by emphasizing individual experience in the perception and construction of space.

This study aims to map the changing rituals in gardens and city spaces of Istanbul from the sixteenth century to the early eighteenth century with respect to the ideals of a marginal Sufi group, whose development and continued existence corresponds to the same period of this 200 years, proposing to understand the changing symbolism of space and spatial practices with respect to the conflicting ideologies of the Orthodox Ottoman court and marginal groups in the heterodox Sufi society.

In 1730 a very significant period in Ottoman history came to an end. In early October 1730, a few days after the execution of the Grand Vizier, a poet died falling from the roof of his house in Beşiktaş, Istanbul. He was in a state of horror, and fearful of getting killed. He was running away from the rebels who had slaughtered almost all of his closest friends, including the Grand Vizier, and who, during this 50-day rebellion, demolished all the gardens where the poet and his beloved friends used to meet. The poet's name was Nedîm. The rebellion that led to his death is known as the Patrona Halil Revolt, which terminated the 12 years of service of the Grand Vizier. Later in the next century, these 12 years came to be called the Tulip Period after the epoch's passion for flowers and gardens. During this period, the craze for flowers and gardens reached such an extent that Nedîm depicted the city as a garden similar to paradise:[1]

> Holy Paradise! Is it under or above the city of Istanbul?
> My Lord, how nice its atmosphere, its water and weather!
> Each of its gardens is a pleasing meadow,
> Each corner is fertile, a blossoming assembly of joy.
> It is not proper to exchange this city for the whole world
> ...
> Or to compare its rose gardens to Paradise!
> Quality of these novel festivities
> Only a book will be able to tell about!

Nedîm's portrayal of the period as a book of novel festivities in a paradise-like city enjoyed in the gardens and meadows was due to the Grand Vizier's reformative projects that instigated the launching of new urban pleasures by taking initiatives in restoring the various spaces of the city and the countryside. His reformative initiatives were not only effective in the domains of culture, but also in imperial self-representation, and international diplomacy.

During the Tulip Period, the Grand Vizier Nevşehirli Damad Ibrahim Pasha aimed at establishing a new imperial rule based on peace. Classical Ottoman rule had been geared towards warfare.[2] Ibrahim Pasha considered the situation, and employed it as a means to ensure peace and stability. Under his supervision, the imperial policy favored the pursuits of a settled life in peace and prosperity. As the frontier culture was replaced with a new culture of immobility, the capital city regained its importance as a space for engaging in cultural and intellectual life. The city was refurbished—its monuments restored, public waterways recovered and improved. The first fire department was initiated. Public use of urban space was emphasized with extensive building of over 200 fountains, each becoming a gathering place. In this period, the first press printing in Ottoman Turkish was established; the first public libraries founded; historical anthologies and philosophical works, originally in Arabic, Persian, and Greek, were translated into Ottoman Turkish; special discussion groups of scholars, intellectuals and poets were organized for exchanging ideas in the arts, philosophy, politics, and public problems.

While restoring Istanbul as the center of the empire, diplomacy was given more importance than before, with the purpose of confirming peace at the periphery. Diplomats were sent to Austria, France and Iran. In 1719, Ibrahim Pasha was sent to Vienna; in 1720, Yirmisekiz Mehmed Çelebi was sent to France, and in 1721, Ahmed Dürri Efendi was sent to Iran. These diplomats documented their journeys in chronicles, comparing the visited countries to the Ottoman land. The Austrian countryside was depicted as neat and very well kept, with all its villages enjoying prosperity. The French palaces and gardens were described as "the paradise of infidels," allowing men and women to enjoy an extraordinary festive life. However, Persia was presented as poor and deprived.[3] It was evident then, that the Ottoman observers found Western civilizations superior to Eastern ones.

As a consequence of these travels, the imperial library was provided with books illustrating European gardens and palaces.[4] Shortly after the Ottoman envoy's return from France, a new imperial palace was built in Kağıthane, accompanied by 40 neighboring mansions of the Ottoman elite, each with splendid gardens. Kağıthane and its gardens became symbols of the period.

The Sultan and his court traveled from one garden to another, from the gardens of Kağıthane to palaces on the Golden Horn and Bosphorus, enjoying themselves in the serene atmosphere of each garden, celebrating marriages, circumcisions, entertaining diplomatic envoys, intellectual assemblies, commemorating religious days, organizing feasts and parties during the daytime and at night. Among these gardens were the "Garden of the Vizier" and the "Promenade of Good Spirits" within the city; the "House of Eternal Happiness" and the "House of Eternal Beauty" at Kağıthane; imperial gardens of Tersane along the Golden Horn; on the banks of Bosphorus on the European side, the "House of Eternal Security" at Fındıklı; the "Palace of Light" and the gardens of the "Vizier's Palace" at Beşiktaş, the "House of

Eternal Gaiety" at Defterdar Burnu, the "Pavilion of Stars" at Kuruçeşme, the "House of Eternal Rule" at Bebek; and on the Anatolian side, the "House of Eternal Honor" at Üsküdar, the "Garden of Pleasure" at Beylerbeyi.[5]

A new elite class emerged engaging in garden activities similar to those of the Imperial court. They oversaw the construction of gardens and numerous public works and became the new patrons of urban space[6] and for the general public, gardens and promenades became more favorable than before. Nedîm's poems illustrated this festive life of the Tulip Period.

However different in architectural form, the gardens of Istanbul became used in a way that obviously resembled the festive life as observed in French gardens[7] As well, representations of European gardens in books might have had an important effect in stimulating the circulation of garden models during this period. Thus, the Tulip Period initiated two major changes in the Ottoman garden tradition. First, private gardens, open to public view, gave way to conspicuous consumption, pomp and festivity in public spaces. Apart from the expenditure for hosting garden parties, consumption of common commodities had reached such an extent that the purchase of luxury materials like silk were forbidden to some social groups. As well, tulip bulbs were sold for a fortune. Second, it gave rise to a display of gardens, and encouraged the dissemination of garden models, similar to the circulation of printed books.

For the celebration of the 1720 circumcision festival, four sugar gardens were constructed. The miniatures in Levni's Surnâme depict these four different gardens.[8] These sugar gardens may have served as garden models displayed either of existing gardens, or of suggested types to be built, though it is evident that they also displayed the scope of the Ottoman imagination flourishing in gardens. Within a short period of time after the display of the sugar gardens, the former meadows of the Kağıthane were developed into a festive site favored by all groups of society by the building of numerous private gardens. An imperial palace and gardens were built accompanied by private gardens of the elite. Both the imperial and the private gardens were surrounded by a promenade open to all citizens of the city. Thus, the private gardens and the gardens of the sultan were displayed to the eyes of the common public.

An Orthodox group of conformists was deeply disturbed by the display of an emerging elite class enjoying a festive garden life under the gaze of the larger Muslim community. In 1730, this Orthodox group engaged in a successful revolution. They demolished most of the gardens and promenades which were the symbols of the epoch, terminated the Tulip Period and destroyed the lives of the prominent figures of its cultural renewal. Most of them were killed or sent into exile, including Nedîm, the poet and Nevşehirli Damad Ibrahim Pasha, the Grand Vizier.

Most scholars would date the efforts at modernizing Ottoman culture to the Tulip Period, and describe reforms of the military, educational and administrative spheres as attempts at Westernization. However, these attempts are known to have failed, resulting in the fall of the Ottoman

Empire. This perspective sees Ottoman culture as unchanging, incapable of any transformation, innovation or internal dynamics. Of course there are exceptions, but any innovation in the arts or sciences is generally evaluated as an instance of individual talent, devoid of any cultural source. It attributes changes prior to the Tulip Period to the imitation of the Persian–Islamic traditions, and after them to Western civilizations.[9]

This view has been challenged by studies that aim to explore the internal dynamics of cultural transformations focusing on the urban practices of the Ottoman elite culture, on public arts and architecture of eighteenth-century Istanbul.[10] These studies considered the entire century as a uniform period of innovation in order to stress the internal dynamics of the Ottoman culture and a certain continuity as well as demonstrating the establishment of new social, cultural and spatial models by studying Ottoman archival documents. Their methods stress the importance of studying Ottoman society from an internal point of view. However, these studies have ignored the significance of the Tulip Period that they took as a starting point. On the contrary, the Tulip Period of the early eighteenth century was the climax of more than two centuries of social and cultural changes. This study argues that modernization as observed in some urban practices of the period—the development of self-consciousness and individuality—can be traced as far back as to the early sixteenth century.

To make clear the cultural changes that the gardens of the Tulip Period revealed to the eyes of orthodox Muslim people, it is necessary to reassess the period by returning to Nedîm's poem. Nedîm depicted the city as a garden similar to Paradise:

> Holy Paradise! Is it under or above the city of Istanbul?

Comparing the city to Paradise may sound very bland and conventional. However, the paradisical qualities attributed to the city, and the delight individuals took in the constant and vivid appraisal of its numerous gardens and promenades were actually intolerable from an Orthodox point of view.

Allusions to paradise in Ottoman classical culture denote a confined space symbolizing the cosmological hierarchy. This cosmological hierarchy was extremely important since it located all aspects of society within a religious ordering, covering the domains of spiritual, ideological, social, cultural, and individual worlds. When in 1517 onwards, the Ottoman sultans became the religious leaders of the Orthodox Muslim community, the empire was reorganized as a centralized authority, as the center of the Orthodox Islamic world. The Ottoman cosmology was mainly based on the Orthodox Islamic Law—the Islamic texts, but it also borrowed from the imperial mythologies of the Near and Middle Eastern cultures. Thus Ottoman cosmology was constructed in order to relate individual existence to the Universal World—that was acknowledged as the world of God—and further, to the imperial

authority. The cosmology was basically composed of different world levels. Each level comprised an interior and an exterior. The interior was always invisible and superior to the visible exterior. The interior of the Universal World embodied the True Reality whose knowledge was invisible and inaccessible to human beings. The exterior of the True Reality was the World, where the visible human world was located.

The World also had an interior and an exterior. The Typal World was its interior, and the Phenomenal World its exterior. The Typal World housed images originated in the Universal World, as images of the True Reality. However, these images were not directly borrowed from the Higher Realm; they were mere reflections of it. These reflections were distorted fractional images of the actual truth. This realm was constructed upon the Islamic texts and upon the imagery of the paradise garden. It also accommodated imperial mythologies borrowed from Persian, Mogul, and Indian cultures, and accommodated the legendary Garden of Iram.

The Phenomenal World, exterior to the Typal World was also divided into an interior and an exterior. Within the interior of the Phenomenal World, there was the House of Islam, and to its exterior there was the House of War. Thus geographically, Muslim states were conceived as within the House of Islam. The House of Islam as an interior embodied a center—the Ottoman state—and more precisely, the city of Istanbul as the Ottoman capital. Thus it empowered all the surrounding land within the rule of Islamic Law. Other cities and peripheral provinces were exterior to this center. The city of Istanbul had the imperial palace as its interior, and the rest of the city as its exterior. The participants of each realm were also precisely defined. In the interior, there were the residents of the palace, the Sultan, his court, and his army. They were the rulers, called *askerî*. Exterior to the palace, there was rest of the public, called *re'âyâ*. The public was made out of the subjects of the ruling class. The main body of the public was made up of guilds. Each guild was delineated with different trades, crafts, or arts. The number of the guilds was fixed; their location within the city was static. They had their own cosmological hierarchy; each modeled after the principal Ottoman cosmology. These cosmologies also had Typal worlds, housing religious–mythical figures as masters of each guild.

The palace of the Sultan also had an interior and an exterior. The interior embodied the private garden, and the exterior the semi-public administrative spaces. The garden of the Sultan was invisible to the eyes of the public, and it housed the private life of the court. Thus gardens in Ottoman cosmology were always private interior spaces, well protected from the exterior world.

Each of the levels of the cosmology was acknowledged as a space, as the world, the house, the city, the palace, and the garden. All interior spaces were symbolically considered as a garden. Whatever the level of the cosmology they evoke, interior spaces could be compared to the Typal World, thus to the paradise garden, or to any of the private gardens. Gardens as private interiors embodied all the blissful qualities. However, exterior spaces were not to

be compared to gardens without compromising the duality of interior and exterior worlds. Public spaces were not to be compared to any of the gardens that made up the interior of the Ottoman cosmology.

The city of Istanbul as the center of the House of Islam was an interior space as opposed to other cities. However, if it was compared to a garden then those characteristics of the city which particularly displayed imperial or religious authority were to be emphasized. Thus, either the mosques as places of religious practice, or the palaces of the Sultan, would be the only appropriate spaces to be compared to the gardens of Paradise. And thus, public city walks, meadows, promenades, bazaars and market places, even of Istanbul, could not be compared to paradise, and urban life could not be compared to life in paradise, or in a garden.

Comparing the whole city to a paradise garden, as Nedîm did, constituted a violation of this classical cosmology. This was a serious offense that could not be imagined by an Orthodox mind. The fact that in the Tulip Period the whole city was publicly compared to a garden implies a large cultural change had taken place. It is likely that the news coming from France and Austria allowed a hidden current of cultural change to break into the open. But this cultural change had little to do with Western practices, and with Western forces of urban or garden space. This development threatened Orthodox Muslim culture by calling into question fundamental aspects of its cosmology. How did this happen? Was this open development a momentary reform in urban life taking place only in elite culture? Or was it a change more deeply embedded in the practices of different groups of society, other than the elite?

Returning to Nedîm's poem:

> Quality of these novel festivities
> Only a book will be able to tell about!

Nedîm portrays the festive life enjoyed in gardens by all ranks of the society as a novelty.[11] Novelty was a quality attributed to all practices developed outside the domain of orthodox traditions. It was a term not only used in the domains of arts and architecture, but also in the domain of spiritual practices, implying Sufi practices. Since the sixteenth century, all the Sufi practices came to be regarded as being novel, as Sufism developed outside the mainstream conventions of orthodox faith and practices. It carried practices of faith outside the holy book, the Koran.

Sufism developed from interpretations of Islam, Christianity, Neo-Platonism, Buddhism, Shamanism, and other esoteric traditions of Near and Middle Eastern cultures. Apart from the orthodox Islamic traditions, Ottoman culture was also under the influence of heterodox beliefs. Where the Orthodox Islamic Law recognized human beings as subjects of God, the heterodox orders perceived human beings as friends of God. There were many Sufi orders established in the Ottoman Empire. In the Ottoman world, Sufism developed under the control of imperial authority within the designated

institutions called *tekke*. These institutions, being private spaces, could well be compared symbolically with other private spaces, with other interior realms of the cosmology, such as the private gardens of the Ottoman cosmology.

Among different schools of Sufism, Ottoman culture was more prone to philosophies with an emphasis on mystic love. Mystic love in Ottoman Sufism was deeply influenced by the ideas of the thirteenth-century Sufi master Ibn al-'Arabî.[12]

Orthodox cosmology ordered all spaces hierarchically, either pertaining to the qualities of the interior or the exterior. However, Ibn al-'Arabî's philosophy gave emphasis to a third kind of space which took shape between the interior and the exterior spaces. This intermediary space brought together the exterior and the interior realms, enabled to question their existence in relation to one another and enabled to question all the qualities that they designate in response to one another. In this intermediary space, all the superior and divine qualities of interior spaces would be questioned in relation to all the worldly qualities of the exterior spaces.

Ibn al-'Arabî's Neo-Platonist philosophy named this intermediary space as the space of "creative imagination" and defined spaces of creative imagination at different levels of the cosmology. His philosophy, largely disseminated in the Ottoman world, proposed a definition of space in consequent levels and scales; the ideal space, the real space, and the space of the human body. All these spaces housed the meeting of divine essence with the worldly form, either in terms of separating the divine element from a worldly element; or in terms of unifying fractions of divine essence to worldly forms. Thus, this intermediary space enabled both deconstruction and construction of all things in the universe; both the analysis of existing things and the synthesis of novel ones.

This intermediary space was also acknowledged as the space where the act of mystic love would take place. Ibn al-'Arabî's followers in the Seljuk and Ottoman courts introduced a well-structured philosophy on mystic love, upon the conviction that a spark of God is present in all things created; allowing a commonality and a base of communication for each human being, enabling their affection and attraction to one another, to the whole universe, and to God. This philosophy was named *Wahdat al-Wujûd* (the Unity of Being). Since God was beyond the grasp of man's understanding, Ibn al-'Arabî proposed that in order to address God, it was necessary to address God's spark in one's individual self, or in every other man. Then 'Arabî reached this paradoxical conclusion of discovering Actual Truth in human self:[13]

> I am the one I love
> And the one I love is I.

In order to address this common phenomenon it was necessary to be able to communicate the divinity that resided in each human being. Thus it was necessary to be able to separate the divine essence from the worldly form.

'Arabî proposed that the process of the separation of divine from worldly took place in the intermediary spaces of imagination. Equating the affection and love for human beings to the love for God was very paradoxical, since Islam was predicated upon God's demand that He be the only object of a believer's love. 'Arabî's emphasis on individuality was a threat to the Ottoman cosmology. Ottoman cosmology denied individuality in favor of community, locating community within the general structure of cosmology, as an exterior space of supremacy. Moreover, suggesting the superiority of an intermediary space was a threat to the ordered structure of the Ottoman cosmology and social order, which assured the supremacy of the interior spaces over the exterior.

In the Ottoman world, two different tendencies developed in the interpretation and practice of Ibn al-'Arabî's doctrines, varying radically from one another. First, the Ottoman rule assimilated 'Arabî's doctrines on mystic love and the concept of intermediary space by disseminating them in garden rituals which were practiced by the whole society within the limits of Islamic Law and within the controlled spaces of the Ottoman cosmology. However, some marginal Sufi groups practiced mystic love in city spaces outside the gardens, proposing these spaces to be spaces of creative imagination.

Sufi traditions were also practiced and assimilated by the Ottoman court and society by rituals in private garden parties. Walter Andrews, who has studied the dissemination of Sufi practices in private gardens, showed that besides many other uses, private gardens were also sites for private parties, enjoyed by a selected group of people who were the members of specific social groups; either members of the court, of one of the guilds, of an elite group, or of scholars.

Garden parties were usually arranged after sunset under moonlight, and lit with candles and lanterns. The host, usually the owner of the garden, invited several guests and poets. The host also provided musicians, wine servers and dancers. Food, fruits and wine were the main items served, and perfumes were used to enrich the atmosphere, with music and dancers in the background. In these private parties, Orthodox members of the community practiced, or pretended to practice, mystic love, indulging in a special genre of poetry called *gazel*, which was originally a Persian genre.

The general theme of *gazel* poetry was the desire of a lover for the Beloved. *Gazel* addressed a beloved, chosen from among the participants of the garden party, who metaphorically represented God. Beginning with the wish for union with the Beloved, *gazels* always ended as the lover is separated from the Beloved, recalling the Orthodox state of mind, where the lover and the Beloved are located in different spheres of the cosmology which were not supposed to unite.

The garden party was a display of the cosmological hierarchy. The music played at the party was defined within the cosmological hierarchy as having twelve modes similar to the twelve constellations of the zodiac; four tones compared to the four elements of fire, air, water, and earth; seven derivative

modes akin to the seven planets, and 24 kinds of compositions as in 24 hours of the day.¹⁴ They evoked sophisticated metaphors about the gardens of the cosmological hierarchy. In *gazel*, all the interior gardens of the cosmology collapsed into the space of the private garden party, allowing comparisons of all these gardens to one another.

Gazel called upon a masterly use of conventions in an artful language, borrowing from Persian and Arabic poetry and languages. Turkish, considered as vernacular, was inappropriate to be used. Each realm of the cosmology was described according to an art of conventions. The poet was expected to use these conventions; he was not permitted to question them, or the levels of cosmological order that they evoked. He was not allowed to introduce any novelty into any of the gardens inhabited or cited, since all novelty had to proceed from God. Thus garden parties were not conducive to cultural innovation.

Different groups of Ottoman society were engaging in private parties restricted to the members of their own communities. The Sultan had his own parties and likewise other groups within the society: various guilds—dervishes, poets, and military corps—had their own private parties within gardens, at designated meadows or within other spaces classified as gardens. These people followed the Orthodox ritual practices in everyday life. During the garden party, however, they broke away momentarily from ascetic principles, and engaged in sensual pursuits and drinking. This was part of a kind of ritual of inversion, in which they pretended to be mystics engaged in the quest for God. Thus they adopted attitudes that were frowned upon in public life, engaging in ritualized deviant behavior as a group. These behaviors allowed each group to experience moments of anti-structure (to borrow a phrase from Victor Turner) as a shared secret that reinforced group members' mutual bonds. Besides, by the recurring clichés of the *gazel*, group identity was further linked to the Ottoman cosmology. So, the garden party reinforced the internal cohesion of each group and linked its existence to Ottoman official doctrine without disturbing any daily public practices of Islam. Thus, the classical garden party contributed to the homeostatic reproduction of the Ottoman state hierarchy, and, anchored the self-representation of its participants in their own community as members of the cosmological hierarchy hinged to the Ottoman rule. These activities made any cultural changes apparently unthinkable since they reproduced the political, religious and social orders of Ottoman society.

In these respects, Nedîm's poetry was surely inventive. By describing real places, recalling the public gardens and promenades as paradise, he challenged the *gazel* tradition. He introduced his real friends as new "beloved" ones living in the city. He carried the theme of mystic love from private gardens into public city-spaces. However, long before Nedîm, back in the early sixteenth century, there had emerged a truly Ottoman genre of poetry, as reformist and challenging as Nedîm's. This genre is called *Şehrengiz*.

Şehrengiz treated the city as Paradise, exactly as *gazel* would treat the gardens. *Şehrengiz*, however, is a neglected genre in Ottoman studies. It is classified as non-metaphysical poetry, artless in form, and morally corrupt in context. It simply accounted for the journey of the poet in the city. The city unfolds in a realistic manner, as the poet wanders about the different neighborhoods; looks around; utters affection for the beautiful young men of the guilds; and broods over urban culture, daily life, architecture, gardens and nature. Traveling, exploration, and visuality were major themes, and the city was a source of joy, pleasure, and wonder. These poems depicted not only Istanbul, but also 13 other provincial cities[15] outside Istanbul as paradises. The first *şehrengiz* is about the city of Edirne, composed by the poet Mesîhî. The poem compares the city of Edirne to paradise and describes several realistic scenes from the city.

The genre developed until the early eighteenth century with poems mapping the poets' experiences in the city of Istanbul, going back and forth to other provinces, especially to Edirne. The genre that originated by narrating rituals of marginal Sufi groups in real spaces of different cities and ideal spaces of the Sufi imagination and was established using Sufi symbolism in the experience and depiction of spaces, further developed narrating rituals practiced in real spaces in the city of Istanbul.

The sources of realism in the *Şehrengiz* genre are diverse. Traveling, documenting, and mapping contributed to the development of realism. Instead of using the conventions of cosmographical hierarchy, realistic accounts of *şehrengiz* called to mind the sense of place as displayed in the Ottoman arts of painting, valued natural and man-made elements, and represented the cities and landscapes in detail. The consciousness and realism of depicting actual places are major characteristics of other discourses developed during the sixteenth century to the late seventeenth century, such as in the arts of painting, geography, and engineering. The 1537 maps of the Iraq military excursion by Matrakçı Nasuh; the Kırkçeşme Waterway Maps dated 1579–1580; the Beylik Waterway Maps dated 1582, along with the miniatures of Surname-i Humayun dated 1582–1584, are examples of growing realism in the Ottoman arts.[16]

In the first *Şehrengiz*, the poet addresses God and apologizes for his addiction to love; he describes parts of Edirne, and continues citing the names of over 40 boys from different guilds. He presents each guild member as a beloved one, describes his beauty as different from the others. The guilds were the largest body of urban subjects of the ruler, maintaining the sustainability of central authority, both practically and metaphorically. The Ottoman regime considered them as one of the major prerequisites in establishing the urban order.[17]

At the same time as the *Şehrengiz* genre was emerging, a secret society was developing among the guilds of Istanbul. This secret society was not an institution. It did not have a specific school, dress code, or any established practices different from the Sufi orders that had become institutionalized.

The participants of this secret society were called *Melâmî-Bayramis*.[18] *Melâmî-Bayramis* adopted a protest philosophy established among the guilds of Anatolia since the fourteenth century, following Ibn al-'Arabî's doctrines of love and of the "Unity of Being". *Melâmîs* advocated Islamic individualism and claimed that individuality embodied true reality. The following verses from the fourteenth-century *Melâmî* poem illustrate the importance given to individuality:[19]

> He found the enlightened in himself
> He found himself

Melâmîs were considered infidels for giving such importance to the individual self that it came to be treated as equal to God. Throughout the sixteenth and seventeenth centuries, some prominent *Melâmî* figures were executed for threatening the cosmological hierarchy as they offered its total destruction, by pointing to the human being as the ultimate Beloved. As members of a secret society, *Melâmîs* however identified themselves by the shape of their tombstones. Thus we can learn from looking at their tombstones that Nedîm, and his close friend, the Grand Vizier of the Tulip Period, as well as most of the *Şehrengiz* poets, were *Melâmîs*.

Melâmîs valued each human being as a beloved reflection of God. They regarded every single citizen as deserving objects of mystic love. As the early sixteenth-century *Melâmî* poet said:[20]

> Lovers desireful to watch the beloved
> Watch carefully every human being you see

Şehrengiz poets emphasized human love as a means to enlightenment, to unify them with God. *Şehrengiz* poets allowed all members of the guilds, thus the inhabitants of the city, to be seen as the Beloved. However, the Beloved was never a single individual, but rather several ones, whose multiplicity represented the richness and the variety of participants of the market place. The poet himself engaged in a personal relationship with these diverse members of the urban community. In their poetry, *Melâmî* poets, *Şehrengiz* poets, and Nedîm, all used simple Turkish, understandable to all ranks of the urban community.

In *şehrengiz* poetry, the city was treated as an interior, a garden, and no longer a space exterior to the House of Islam. Thus the city became the stage for new poetical attitudes towards life, paralleling and displacing the relationship between the garden party, the *gazel*, and the Ottoman order of city life. *Şehrengiz* poems, if not read at the private garden parties, were declaimed in public gardens, and promenades, at the market place, in coffeehouses, wine-houses, or taverns. Thus, urban spaces instead of private gardens were enjoyed by the public engaged in the discovery of this ultimate value of individuals. The privacy of mystic love had been transformed into a public event where pleasure could be pursued and experienced publicly.

There were some other poems written in the late eighteenth century, which were also classified in the genre of *Şehrengiz*. It is worth noting that these poems depicted the lives of social groups different from the guilds and they depicted cities outside the Ottoman dominion. These poems narrated the life of ordinary women and dancers living in the city of Istanbul and in other cities from India to America.

This research proposes that reflections on a mystical innovation of the thirteenth century set into motion religious changes that were successfully marginalized for a long time. Two developments seemed to have played a major role. First, the creation of a secret society that covertly practiced individualism and self-determination, and second the invention of realism that broke away from the conventions of Persian art and language. As a consequence, a new kind of realistic poetry developed which treated the city as a place of pleasure, and its inhabitants as a community of individuals. Expressed in simple Turkish understandable to all city-dwellers, this covert culture shed new perspectives on urban life. It did not gain official acceptance, however, until the early eighteenth century when the Sultan shifted the aim of the Ottoman rule from military development through warfare to social development in a peaceful empire, and decided to emulate the leisurely garden life of the French court in the city of Istanbul, while reinventing both its content and its urban settings. This was the spread of a kind of individualism, a form of self-cultivation totally foreign to European endeavor, but deeply rooted in the Turkish subversion of Ottoman culture. Thus, the modernization of society during the Tulip Period followed from an open development of the cultural attitudes illustrated by the *Şehrengiz* poets since the early sixteenth century. And finally, this cultural revolution enabled the enjoyment of the city as a paradise for all its citizens, where this experience and joy was perceived and represented in popular forms of art, akin to the classical and conventional representation of the city as an exclusive paradise garden of the Sultan in artful Ottoman court poetry.

Methodology and Sources

This study uses Ottoman poetry as source material. It uses different genres of Ottoman poetry; *gazel* as an expression of Ottoman court culture; *şehrengiz* as an expression of a marginal Sufi group; song, *kasides*, and chronograms by Nedîm as an expression of both public and court in the early eighteenth-century Tulip Period.

Though the *gazel* genre and Nedîm's poetry have been examined by many scholars, the *Şehrengiz* genre has never been studied extensively. This study aims to introduce the *Şehrengiz* genre as an important agent in the mutual development of Ottoman modernization and urban culture. It aims to show that their performative representation of landscapes—including cities,

gardens, countryside meadows, open and closed spaces—informs about poets' experience, construction, and transformation of the Ottoman culture.

The Şehrengiz genre has been recognized as non-metaphysical narrations about the beauty of guild boys set in the background of the city, its language simple and artless. Agah Sırrı Levend's 1958 anthology titled *Türk Edebiyatında Şehr-engizler ve Şehr-engizlerde Istanbul* is the only work published on the genre.[21] It is a list of poems, with short entries informing about dates and poets, with archival references. The book also contains transcriptions of parts of the poems, particularly the ones about the city of Istanbul. Apart from Levend's work, there are a few entries on the genre in encyclopedias and anthologies of Ottoman poetry. In the studies of Ottoman art and architectural history, Tanındı, Terzioğlu, Kafadar and Hamadeh roughly refer to the urban content of the genre.

This study aims to focus on the performative qualities of the *Şehrengiz* genre, aiming to examine the pragmatics of the poems. Pragmatics is a subfield of linguistics. It studies performative qualities of texts. The tradition of pragmatics can be traced back to the ancient Greek rhetorics, and to the arts of ekphrasis. Ekphrasis is generally translated as an extensive textual description of an image. Most of the contemporary studies of the tradition of ekphrasis focus on the contrast between image and text, emphasizing that visual imagery is superior to textual narrative. However, the tradition of ekphrasis neither favors text nor image. It aims to create a lively scene where the writer tries to trigger the imagination of the audience / reader to a point where he would be able to experience the text more vividly than its actuality. This performative quality of ekphrasis is explained by *energeia*. The arts of ekphrasis involve pragmatics and imagination. It requires the involvement of an audience. The famous first-century rhetorician Quintilian discusses the importance of imagination in the arts of ekphrasis by explaining the term *energeia* which is "produced when the orator uses his own power of imagination to conjure up a scene in his mind."[22]

The study aims to shed light on the Ottoman experience of space as depicted in different genres of Ottoman poetry. The work may hopefully inspire further literary studies to reconsider the syntax and semantics of *şehrengiz* poems, which have long been considered artless in form and perverted in content.

In order to understand the experience, perception and representation of spaces in *şehrengiz* poems and in other genres of Ottoman poetry, this study will make use of the theories of "experience" developed by Victor Turner within the discourse of post-structural anthropology. Turner defined "experience" by asserting its performative qualities as something lived through. "Experience" is more than an abstract concept. It involves both body and soul. Turner argues that, for a simple experience to be noteworthy and significant, such experience has to be communicated and shared. Thus, such "urge to display" an experience necessitates representation and restructuring of the past experience. This process of communicating the past experience

in a performative way that has a certain structure, resembles that of a ritual to be lived through.[23] Thus, such restructuring and communication of any experience lived through results in the re-experience of the past experience. The performative quality of the restructured and communicated experience then becomes a script to be played and lived through by those who communicate, and those who are communicated to. Thus, reality as perceived by a subject has three phases, where reality is captured in an experience, represented in an expression, and finally developed into a performed text. According to Turner, these texts are used as scripts to perform rituals. Representations, performances, objectifications, poetry theaters, narratives, hunting stories, curing rites, murals, parades, and carnivals are rituals that are shared through the re-experience or performance of past accounts in present time. Turner claims that texts performed into rituals have the power to sustain and transform culture. However, in order to understand the importance of rituals, it is necessary to examine the whole ritual process.

Rituals are used as tools to communicate ideas and ideals between different groups of the social world. Turner examines the social world as a product of culture in constant flux, movement, change, and dynamism. Turner explains the concept of the social world in various ways. He makes use of Kurt Lewin's "field theory," where the social field involves the key concepts of "field," "vectors," "phase-space," "tension," "force," "boundary," and "fluidity." He also makes use of I.A. Richard's "interaction view," which shows the importance of "communication process."[24]

In the experience of rituals, Turner restructures the concept of sociability into two opposing modalities: *society* and *communitas*. In rituals, *society* and *communitas* stand for the different ways in which people relate to one another. According to Turner, the endurance of a culture is sustained by the dynamic interface relating "hierarchical structured" relationships in society and "unstructured, or rudimentarily structured" *communitas*, both of which contribute to a complex order which is called the social order.[25]

The social order of any culture is sustained by the co-existence of structure and anti-structure. Turner, who studied the interface between structure and anti-structure, explains the cyclical dynamic of the two opposing modes of sociability in terms of rituals. Cultures sustain their social order by allowing their members to experience both states of structure and anti-structure. The structure sustained by any society imposes a prevailing order and a dominant culture upon its members. Rebellions and cultural changes can be understood as a result of new ideals developed in *communitas* that deconstruct the structure imposed by society. Diffusion of ideals through different modes of communication such as poetry, mystical circles, and fraternities, may take place within limits posed by the social structure, thus slowing down or preventing culture change. However, rebellions might bring public recognition to the ideals of *communitas*. The same ideals might also become assimilated, interiorized and adapted within the existing social structure; for instance, in the form of rituals of inversion, allowing the

experience of *communitas* to be repeated and re-experienced in a derisive mode under the control of the dominant culture.

In his study of rituals, Victor Turner, examines different kinds of rituals, from tribal ceremonies to social drama, theater, and pilgrimage. Turner describes rituals as experienced in three stages, pre-liminal, liminal and post-liminal.[26] He stresses the analysis of the liminal phase, which is a state of "separation" and "re-aggregation" into society of people who undergo a specific experience of *communitas* outside the control of the larger society. Turner asserts that the liminal experience is observed forms of "myths, symbols, rituals, philosophical systems, and works of art"[27] in different cultures, from primitive tribal societies to industrialized postmodern civilizations.[28] He explains that these forms constitute multiple meanings stirring different psychological experiences:[29]

> Liminality, marginality, and structural inferiority are conditions in which are frequently generated myths, symbols, rituals, philosophical systems, and works of art. These cultural forms provide men with a set of templates or models which are, at one level, periodical reclassifications of reality, and man's relationship to society, nature, and culture. But they are more than classifications, since they incite men to action as well as to thought. Each of these productions has a multivocal character, having many meanings, and each is capable of moving people at many psychological levels simultaneously.

In rituals, the psychological states indicated by the *society* and the *communitas* represent different modes and different ideals carried by different groups of the social order. *Communitas* represent the ideals of a group of people marginal to the centralized order represented by the *society*. Bergson calls such groups "open" which have an "open morality." These groups act as agents to introduce different motivations and ideals beyond the limits of the structured closed *society*. They constitute the evolutionary "life-force" of cultures.[30] *Communitas* have communal ideals and motivations to attain a common good. *Communitas* stand for lower classes of the *society* who, in the rituals, would act with the "fantasy of structural superiority."[31] Rituals communicate ideals in which the social status of higher and lower ranks are altered. Turner explains this switching over of positions as "elevation and reversal of status." Turner describes the liminal experience as transgendered and chaotic, which involves the experience of existence and ecstasy.[32] Rituals employ common themes like universal love and unity of universe in the expression of communal ideas. Turner uses the following poem as a clear example of universal unity as expressed in Hindu rituals:[33]

> Hindu, Muslim—there is no difference,
> Nor are there differences in caste.
> Kabir the bakhta (devotee) was by caste a Jolâ,
> But drunk with prima-bhakti (true love)
> He seized the Black Jewel's feet (i.e. Krishna's feet).
> One moon is lantern to this world,
> And from one seed the whole creation sprung.

Apart from the rituals, Turner acknowledges some other forms of human activities as liminal experiences. According to Turner, social drama is also a liminal experience.[34] Turner introduces the term "social drama" as an aharmonic phase experienced by "conflicting situations" in temporal structures. Social drama portrayed as a liminal stage is a means to experience "creative imagination."[35] Turner compares and contrasts the states of harmonic and aharmonic experiences. Harmonic experience is acknowledged and experienced, built through reason, cohesion, harmony, atemporality, and central authority. However, aharmonic experience, which is a liminal stage in the case of the social drama, is associated with intuition, conflict, discord, temporality, and marginality.[36]

Pilgrimage is another liminal experience, an "expression of the *communitas*." Pilgrimage involves movement through several routes, mapping several sacred nodes, consecutively defining them as cultural symbols. It embodies varying temporal experiences. It embodies and generates legends, mythology, and folklore. Turner defines pilgrimage as an anarchical activity. It can be expressed as a desire to break free from the central static structure of the *society* into an individual journey, which transgresses space and time. Pilgrimage concerns communally shared ideals that are represented by the unity of faith. However, the spiritual development articulated by communally-shared ideals pertains to individual achievement.[37] Thus pilgrimage encourages construction of self and individuality.[38]

This study examines rituals as narrated in different genres of Ottoman poetry in terms of their experience, construction, and the transformation of the culture in terms of rituals.

The Ottoman social order is studied in three different approaches. First, perspective emphasizes the centralized imperial power of the Ottoman Empire, and studies it as a static social and cultural construct. In this prospect Ottoman social order is defined in two opposing static realms: *askerî* as the domain of rulers, and *re'âyâ*, as the domain of subjects. The rulers constituted of members of the palace, military offices, corps of gardeners who served for the maintenance and protection of all land which belonged to the Sultan, thus all palaces and public places in cities; governmental and administrative offices like grand viziers, viziers, participants of the Imperial Council and the Imperial Treasury, supreme court of Shariah (*Sheikh-ul-islam*), clerics (*muftis*), court officials (*kadis*), etc. Most of the scholars of Shariah (*ulemâ*) were employed by the palace, and they were categorized in the ruling class. Outstanding members of the society who served the sultan in a significant way were called notables and they were also exempt from tax paying. The *re'âyâ* constituted all the population who were not rulers. It included guilds, merchants, farmers and herdsmen. Evliya Çelebi draws an outline of the Ottoman social and cultural world in his seventeenth-century chronicle. He informs about 1,100 different types of guilds in 57 categories. In Çelebi's account, the guild of poets are listed along with the guilds of painters, manuscript illuminators, cartographers, carpenters, bread-makers, street cleaners, gardeners, postmen,

doctors, dentists, students, fortune-tellers, pimps, homeless people, immoral young men, Sufis, and masters of Sufi orders. Social mobility between the two social classes was possible. An *ulemâ* would be considered as *re'âyâ* if he was employed by any participants of the *re'âyâ*; likewise a poet would be exempt from tax paying if anyone from the ruling class was his patron.[39]

Stanford Shaw bases this two-poled structure on the economic and military maintenance of the imperial family and the imperial order they imposed. Halil Inalcık discusses the construction of Ottoman social order with respect to cultural and religious concerns, apart from the economic and military motivations. Inalcık explains the Ottoman social order with reference to ancient Near Eastern and Islamic traditions, where the leader of the community was required to sustain justice and ethics by governing their subjects. Franz Babinger asserts the submissive quality of the *re'âyâ* as opposed to the dominance of the *askerî*. *Re'âyâ* is depicted as a passive group of people who did not have any individuality or creative power. İsmail Hakkı Uzunçarşılı examines the social circles of the *askerî* in detail, however he refers to *re'âyâ*, roughly presenting it as a working group of subjects under the control of the monarch.[40] This classical approach also defines the Ottoman arts in two separate and disconnected categories: first as the higher elite arts of the court, and second as the lower arts of the folk culture.

The second perspective carries a nationalistic approach emphasizing a central Turkish–Muslim background, regardless of diverse social and cultural affiliations and motivations that were carried out by numerous groups, which were embodied in Ottoman society. Studies which can be classified in this category examine the construction of Ottoman identity under the influence of three main traditions: nomadic and Islamic–Persian for the formation and classical periods of the thirteenth to seventeenth centuries; and European, for the latter periods of the eighteenth to twentieth centuries. Such nationalistic and modernist approaches to the history, evaluate the arts of the Ottoman Empire formally with respect to the restricted and generic categories of arts of the Central Asian nomadic civilizations, Persian, Islamic, or French.

The third perspective aims to examine the complexity of the Ottoman social and cultural worlds with respect to different ideological and political motivations of different groups, tribes, ethnicities, and associations. This approach does not necessitate grounding itself to any meta-narrative. It portrays a dynamic representation of the Ottoman social and cultural worlds. The works of Cemal Kafadar, Stefanos Yerasimos and Derin Terzioğlu are important in this respect. Kafadar studies the construction of Ottoman state identity in the early fourteenth century by intertextual reading of oral folk literature, epic stories and hagiography, with diverse religious and ethnic references to different heterodox orders like *Baba'îs*, Shi'i Bektaşîs, Mevlevîs, Hamzavîs, and *Melâmîs*. Yerasimos focuses on the construction of Ottoman imperial identity after the conquest of Istanbul in early historical chronicles written by individuals who represent the ideals of imperial or anti-imperial circles with contrasting political ideals. Terzioğlu analyses the changing

dynamics, confrontations and conflicts between the agents of centralized state power associated with Islamic law, and the heretic tendencies of a seventeenth-century *Halveti-Melâmî* poet and scholar in his 1999 doctoral thesis titled "Sufi and Dissident in the Ottoman Empire: Niyazi-i Misri (1618–1694)." These studies examine the dynamics of heterodox orders, and their interface with the orthodox law in specific case studies.

One of the best examples analysing Ottoman society through literary sources is Kafadar's study of a seventeenth-century diary *Sohbetname*, written by Seyyid Hasan. Covering a short period of four years between 1661 and 1665, the diary acknowledges the social life of the writer, informing about the social circle of a Sufi dervish in Ottoman Istanbul. Seyyid Hasan narrates his daily life, making a list of different groups he takes part in, with different participants pursuing various activities:[41]

From Sohbetname, we learn of the intricate web of relationships established, on the basis of family ties as well as order affiliation and mahalle solidarity, between that social world and other sectors of Ottoman society: most notably, the esnaf (shop owner artisans) and mid-level members of the askeri (military administrative) class. Numerous tradesmen (spice sellers, grocers, bakers, book binders, quilt-makers, and others) are recounted at various social gatherings in Seyyid Hasan's diary. We also read of kethüdas, çavuşes, or beşes (titles for various positions in the military administrative class) on those gatherings… Occasions that bring these people together are not limited to dinner parties; our diarist also records post-dinner get-togethers; festivities like weddings and circumcision ceremonies; or sad ones like funerals inevitably followed by the helva-eating and prayer ceremonies; joint visits to graveyards; friendly walks; coffee parties; social calls to other Sufi orders; visits to shops for errands or socializing; and certainly zikr sessions.

In this way, as each one of the mentioned groups performs a different ritual within a different setting, the diary maps urban places of encounter within the city, such as the neighborhood, barber shop, public bath, seashore, graveyard, bazaar, or dervish convent.[42]

Kafadar argues that *Sohbetname*, as a first person narrative, is different from the Western examples in terms of lacking the subject's viewpoint. Studied in relation to the historical background of the Ottoman Empire in the seventeenth century, Kafadar argues that the writer, who was a Sufi dervish at the same time, was not able to acknowledge his position explicitly due to the growing opposition towards the Sufi orders. Instead he accounted for the events, social groups, and places he had attended. The narrative should be considered as a map of the world of a dervish. It constructs the self as an element of the community, not as an individual detached from the community. Self is constructed as its presence is mapped among different social groups.

In his study of the "ecology" of *gazel* genre in Ottoman literature, Walter Andrews also asserts the importance of literature in the understanding of Ottoman society and culture.[43] He argues that the relationship between the "text" of the *gazel* and its "context" requires an intertextual reading of the

society and its culture, whose poetic tradition was based on different layers of meaning: "Poetry is an area of communication which these many voices are free to sing and be heard in all their complexity… They are the products of uniquely talented individuals embedded in a vastly complex socio-cultural context, reflecting numerous and often conflicting motivations and needs."[44]

Andrews claims that Ottoman poetry and Ottoman society mutually constructed one another. Andrews asserts that "one might replace the word 'poet' with the term 'Ottoman subject' and 'poetry' with 'Ottoman life' (or, more particularly, Ottoman urban life) and still have a meaningful and accurate statement."[45]

Both Andrews' and Kafadar's arguments display the association between literary practices and dynamics of the society as expressions of conflicting realms of orthodox or Sufi circles. Following Walter Andrews' line of argument, Shirine Hamadeh makes use of literary sources in the study of space. She mainly uses *kaside*s and chronograms in order to examine the transformation of the city space and urban rituals. She argues that poetry was used as an expression of urban space and its experience. Hamadeh studies the evolution of a new social class as the patrons of new urban inventions, yet she disregards the conflicting spheres of the society.

This study examines different genres of poetry as artifacts of a social order which was in constant transformation. The poets themselves are studied as models of individuals who represent participants of different groups that made up the society in order to understand the dynamics of the Ottoman social order and its spaces with respect to transformations in the performative arts of poetry. It aims to examine the Ottoman social world as a dynamic field of interaction in which different groups conflict and clash with one another in order to communicate their own values, using poetry as a tool of communication. Thus, these poems indicate different uses of different spaces conveying diverse ideals. As Bruner argues, "there are no silent texts" and parallel to Bruner's argument, this study also examines different genres of poetry as "performed text":[46]

It is in the performance of an expression that we re-experience, re-live, re-create, re-tell, re-construct, and re-fashion our culture. The performance does not release a pre-existing meaning that lies dormant in the text… Rather the performance itself is constitutive. Meaning is always in the present, in the here-and-now, not in such past manifestations as historical origins or the author's intentions. Nor are there silent texts, because once we attend to the text, giving voice or expression to it, it becomes a performed text, active and alive.

And as Bruner says, once cited, the "performed text" becomes "active and alive."[47]

In order to understand the conflicting forces within Ottoman society and their spatial expressions, Chapter 2 will begin by examining Sufi philosophies that assert a different understanding of space than that of the orthodox traditions. In this respect, heterodox tradition will be traced back to the

thirteenth-century Sufi philosopher Ibn al-'Arabî (d. 1230). The impact of 'Arabî's doctrines on the Ottoman world will be examined from the thirteenth century to the end of the Tulip Period by the early eighteenth century.

Chapter 3 will study rituals performed in private gardens as expressions of the Ottoman orthodox society and culture. This chapter will use the *gazel* genre and try to understand its performative qualities and discuss how garden rituals were used to interiorize heterodox philosophies within an orthodox structure. This chapter will mainly refer to Walter Andrews' study on the *gazel* genre that has examined 160 *gazels*, composed from 1453 to 1730. Andrews studied *gazels* from the anthologies of four court poets, the last being Nedîm (d. 1730). Chapter 4 will examine the *Şehrengiz* genre as an expression of marginal Sufi groups and will try to understand the concept of space and its transformation as depicted in *Şehrengiz* rituals from 1512 to 1674. In this chapter, 11 *şehrengiz* poems will be examined, translated into English and analysed from Agah Sırrı Levend's transcriptions in his anthology of *şehrengiz* poems. In this chapter, all the translations of the *şehrengiz* poems are by the author.[48] Chapter 5 will discuss the conditions under which *şehrengiz* rituals of marginal Sufi groups were transformed into new urban rituals practiced both by the Ottoman court and elite along with the public during the Tulip Period from 1718 to 1730. This final chapter will analyse Nedîm's poetry as an expression of the epoch's urban rituals, covering 300 poems from his anthology.

Notes

1. Translated from Nedîm in Ahmet Atilla Şentürk, *Osmanlı Şiiri Antolojisi*. (Istanbul: Yapı Kredi Yayınları, 1999), 599–580.

2. After 1683 the army was not as victorious as before. Signing the 1699 Karlofça Treaty, after four unsuccessful attempts to capture Vienna (1683–1699), the Ottoman Empire lost a significant amount of land to the Austrians, Russians and Venetians. Following the defeat at the Austrian border, with the 1718 Pasarofça Treaty, they also lost Eflak, Bogdan, Belgrad, and north Serbia (1715–1718) at the western frontier. On the contrary, the Ottoman Empire was in a superior state at the northern and the eastern frontiers. Russians neighboring the empire in the north and Safavids in the east were in vulnerable positions. The Russians were fighting with the Swedes and the Safavid Dynasty hardly survived for the last years of its power. However, the Ottoman regime preferred not to try taking advantage of circumstances; or simply was not able to do so. Since the Ottoman sultans were not able to sustain the imperial agenda by extending their power over new territories, by the end of the seventeenth century they had also abandoned the city of Istanbul, which was the symbol of imperial tradition. The court preferred to stay out of sight and they retreated back to the Edirne Palace; İsmail Hakkı Uzunçarşılı, *Osmanlı Tarihi* I–IV (Ankara: Türk Tarih Kurumu Basımevi, 1961), vol. 1, 501–518, 1956; Halil İnalcık, *Osmanlı İmparatorluğu Klasik Çağ 1300–1600*, 1973, trans. Ruşen Sezer (Istanbul: YKY, 2003); Donald Quartet, *The Ottoman Empire, 1700–1922* (Cambridge, UK: Cambridge University Press, 2000).

3 For Ottoman diplomacy during the early eighteenth century, see Baki Asıltürk, *Osmanlı Seyyahlarının Gözüyle Avrupa* (Istanbul: Kaknüs Yayınları, 2000); Hadiye and Hüner Tuncer, *Osmanlı Diplomasisi ve Sefaretnameler* (Ankara: Ümit Yayıncılık, 1997); Abdullah Uçman, *Yirmisekiz Çelebi Mehmed Efendi Sefaretnâmesi* (Istanbul: Garanti Matbaacılık ve Neşriyat, 1975); *Yirmisekiz Mehmet Çelebi'nin Fransa Seyahatnamesi*, ed. and transcribed Şevket Rado (Istanbul: Hayat Tarih Mecmuası Yayınları, Doğan Kardeş Yayınları, 1970).

4 I am thankful to Professor Gül İrepoğlu, who referred to European printed books in the Topkapı Palace Archives.

5 For the development of the festive life along Bosphorus and the detailed study of the shore palaces over the course of the eighteenth century, see Tülay Artan, "Architecture as a Theatre of Life: Profile of the Eighteenth-Century Bosphorus." PhD diss. (MIT, Cambridge, MA, 1989).

6 For the study of the transformation of urban space and urban practices in the city of Istanbul during the entire eighteenth century in relation to the emergence of a new elite class who became new patrons of art and architecture, see Shirine Hamadeh, *The City's Pleasures: Istanbul in the Eighteenth Century* (Seattle and London: University of Washington Press, 2008).

7 Istanbul was always planted with numerous gardens which not only the aristocracy, but all ranks of Ottoman society used to enjoy. The gardens were always an important part of the Ottoman culture. For the city of Istanbul, the seventeenth-century traveler Evliya Çelebi mentions 40 imperial gardens, and numerous gardens and open spaces favored by the public, which are even larger in number than the imperial gardens. See Mehmed Zıllîoğlu Evliya Çelebi, *Evliyâ Çelebi Seyâhatnâmesi* 1–15, trans. Zuhuri Danışman (Istanbul: Çetin Basımevi, 1971).

8 Esin Atıl, "Surname-i Vehbi: An Eighteenth-Century Ottoman Book of Festivals." PhD diss. (University of Michigan, Michigan, 1969) and *Levni ve Surname Bir Osmanlı Şenliğinin Öyküsü* (Istanbul: APA Tasarım Yayıncılık ve Baskı, 1999); Nurhan Atasoy, *A Garden for the Sultan: Gardens and Flowers in the Ottoman Culture* (Istanbul: Mas Matbaacılık, 2002).

9 See Gibb quoted by Victoria Holbrook, *The Unreadable Shores of Love: Turkish Modernity and Mystic Romance* (Austin, TX: Texas University Press, 1994), 18.

10 Tülay Artan, "Architecture as a Theatre of Life: Profile of the Eighteenth-Century Bosphorus," PhD diss. (MIT, Cambridge, MA, 1989); Shirine Hamadeh, *The City's Pleasures: Istanbul in the Eighteenth Century.*

11 Hamadeh argues that novelty means originality in terms of form and type. She portrays the Tulip Period as an era of inventions and novel forms; Shirine Hamadeh, "Ottoman Expressions of Early Modernity and the 'Inevitable' Question of Westernization" in *JSAH* 63:1 (2004), 32–51.

12 In 1517, when the Ottoman Sultan Selim I conquered the city of Damascus, he immediately ordered the construction of a mausoleum for a thirteenth-century philosopher called Ibn al-'Arabî (1165–1240). Ibn al-'Arabî was born in Andalusia, traveled in North Africa and Anatolia and died in Damascus. He was also called Şeyh Ekber Muhyiddin-i Arabî in Turkish; the *Ekberiyye* tariqat was founded referring to his name in Turkish. Arabî was invited to the Seljuk court and he lived in Malatya and Konya for a short while. Though later considered as an infidel by some Sunni scholars, he was much respected by many Seljukid and Ottoman intellectuals. Arabî is the author of over 400 works; two of his major

works are *Futuhat* and *Fusus al-Hikam*. Many Seljukid scholars, and later the Ottomans, have composed commentaries about Arabî's works through the thirteenth to the twentieth centuries. For further information on the life of Ibn al-'Arabî, see Appendix 1; for his philosophy see Chapter 2.

13 See William Chittick, *The Self-disclosure of God: Principles of Ibn al-'Arabî's Cosmology* (Albany, NY: State University of New York Press, 1998), 80.

14 Howard Crane, *Risale-i Mimariye: An Early Seventeenth Century Ottoman Treatise on Architecture* (Leiden; NY: E.J. Brill, 1987), 26–27.

15 There are şehrengiz poems dedicated to cities: Istanbul, Edirne, Vize, Bursa, Belgrad, Yenice, Rize, Gelibolu, Amid, Siroz, Manisa, Sinop, Antakya, and Kashan; Agah Sırrı Levend, *Türk Edebiyatında Şehr-engizler ve Şehr-engizlerde Istanbul* (Istanbul: Baha Matbaası, 1958).

16 See Nurhan Atasoy, "Türk Minyatüründe Tarihi Gerçekçilik," in *Sanat Tarihi Yıllığı* I (1965) and *1582 Surname-i Hümayun: An Imperial Celebration* (Istanbul: Koçbank Publications, 1997); Ahmet Karamustafa, "Military, Administrative, and Scholarly Maps and Plans," and J.M. Rogers, "Itineraries and Town Views in Ottoman Histories," in *The History of Cartography Vol. 2 Book 1 Cartography in the Traditional Islamic and South Asian Societies*, ed. J.B. Harley and D. Woodward (Chicago; London: University of Chicago Press, 1992).

17 The body of guilds was the main body of subjects to the imperial authority. They also enabled its economic sustainability. The Ottomans used to transfer guilds in the newly conquered cities and provinces in order to repopulate the land by subjects of the Ottoman order; Halil İnalcık, *Osmanlı İmparatorluğu Klasik Çağ 1300–1600* (1973), trans. Ruşen Sezer (Istanbul: YKY, 2003).

18 Other than being the subjects of any ruler, the *Melâmî* philosophy suggested each individual as the ruler of his own life by stressing religious and economic freedom; Abdülbaki Gölpınarlı, *Melâmîlik ve Melâmîler* (Istanbul: Gri Yayın, 1992, c. 1931); Ahmet Yaşar Ocak, *Osmanlı Toplumunda Zındıklar ve Mülhidler 15.–17. Yüzyıllar* (Istanbul: Tarih Vakfı, 1998) and Cavit Sunar, *Melâmîlik ve Bektaşilik* (Ankara: AÜ İlahiyat Fakültesi, 1975).

19 Hacı Bayram Veli, translated from Turkish in Gölpınarlı, *Melâmîlik ve Melâmîler*, 36–37.

20 Ahmet Sarban, translated from Turkish in Gölpınarlı, *Melâmîlik ve Melâmîler*, 59.

21 Agah Sırrı Levend, *Türk Edebiyatında Şehr-engizler ve Şehr-engizlerde Istanbul* (Istanbul: Baha Matbaası, 1958).

22 Ruth Webb, "Ekphrasis Ancient and Modern: The Invention of a Genre" *Word and Image* 15, no. 1 (1999): 7–18. For further studies on ekphrasis see Andrew S. Becker, *The Shield of Achilles and the Poetics of Ekphrasis* (Lanham, MD: Rowman & Littlefield Publishers, 1995); David Carrier, "Ekphrasis and Interpretation: Two Modes of Art History Writing" *British Journal of Aesthetics* 27, no. 1 (1987): 20–31; Christopher Caudwell, *Illusion and Reality* (New York, NY: International Publishers, 1955); James A. Heffernan, *Museum of Words: The Poetics of Ekphrasis from Homer to Ashbery* (Chicago: University of Chicago Press, 1993); John Hollander, "The Poetics of Ekphrasis" *Word and Image* 4, no. 1 (1988): 209–219; Peter Wagner, ed. *Icons, Texts, Iconotexts: Essays on Ekphrasis and Intermediality* (Berlin; New York: W. de Gruyter, 1996); Murray Krieger, *Ekphrasis: The Illusion of Natural Sign* (Baltimore, MD: Johns Hopkins University Press, 1992); George Kurman, "Ekphrasis in Epic Poetry" *Comparative Literature* 26 (1974): 1–14; Valerie Robillard and Els Jongeneel, ed. *Pictures into Words: Theoretical and*

Descriptive Approaches to Ekphrasis (Amsterdam: VU University Press, 1998); Robert S. Nelson, ed. *Visuality Before and Beyond the Renaissance: Seeing as Others Saw* (Cambridge, UK; New York, NY: Cambridge University Press, 2000);

23 Victor W. Turner, "Dewey, Dilthey, and Drama: An Essay in the Anthropology of Experience" in *The Anthropology of Experience*, ed. Victor W. Turner and Edward M. Bruner (Urbana, IL: University of Illinois Press, 1986), 34–37. Also see Thomas M. Alexander, *John Dewey's Theory of Art, Experience and Nature: The Horizons of Feeling* (Albany, NY: State University of NY Press, 1987).

24 Victor Turner, *Dramas, Fields, and Metaphors: Symbolic Action in Human Society* (Ithaca, NY: Cornell University Press, 1974), 27; 29; 36–37.

25 Victor Witter Turner, *The Ritual Process: Structure and Anti-structure* (Ithaca, NY: Cornell University Press, 1977), 96; 140. Turner classifies *communitas* as three different kinds: existential spontaneous *communitas*—"happening," normative, and utopian models—ideological *communitas*.

26 Turner borrows the term "liminal" from Arnold van Gennep: Turner, *The Ritual Process*, 94–95; 166–167.

27 *Ibid.*, 128–129.

28 *Ibid.*, 113.

29 *Ibid.*, 128–129.

30 *Ibid.*, 110–111; 128; 132.

31 *Ibid.*, 168.

32 *Ibid.*, 188.

33 *Ibid.*, 138; 154–165.

34 Turner explains the experience of the social drama in four consequent stages: breach, crisis, redressive action, and consummation. The social world sustains its survival by the aesthetics and social dramas which make up the "cosmos;" Victor Witter Turner, "Are There Universals of Performance in Myth, Ritual, and Drama?" in *By Means of Performance: Intercultural Studies of Theatre and Ritual*, ed. Richard Schehner and Willa Appel (Cambridge, UK: Cambridge University Press, 1990), 8–18.

35 Victor Witter Turner, *Dramas, Fields, and Metaphors: Symbolic Action in Human Society*, 51–52.

36 *Ibid.*, 32–37; 46–47.

37 Victor Turner and Edith Turner, ed., *Image and Pilgrimage in Christian Culture: Anthropological Perspectives* (New York, NY: Columbia University Press, 1978), 32.

38 *Ibid.*, 34.

39 See Mehmed Zıllîoğlu Evliya Çelebi, *Evliyâ Çelebi Seyâhatnâmesi*, vol. 2, 23; 169–287; Stanford Shaw, *History of the Ottoman Empire and Modern Turkey Volume I: Empire of the Gazis: The Rise and Decline of the Ottoman Empire, 1280–1808* (Cambridge, UK: Cambridge University Press, 1976), 112–168.

40 Stanford Shaw, *History of the Ottoman Empire*, 112–168; Halil Inalcık, *The Ottoman Empire: The Classical Age 1300–1600* (New York, NY: Praeger Publishers, 1973), 65–103; Franz Babinger, *Mehmed the Conqueror and His Time*, trans. R. Manheim (Princeton, NJ: Princeton University Press, 1992, c. 1453); 432–461; İsmail H. Uzunçarşılı, *Osmanlı Tarihi*, vol. 1, 501–518.

41 *Sohbetname* is studied in Cemal Kafadar, "Self and Others: The Diary of a Dervish in the Seventeenth Century Istanbul and First Person Narratives in Ottoman Literature" in *Studia Islamica* 69 (1989), 121–150. Among other first-person narratives, Kafadar lists seventeenth-century traveler Evliya Çelebi's *Seyahatname*, *Vakiat* by Şeyh Mahmud Hüdai (in Arabic, 16th–17th centuries), Sunullah Gaybi's *Sohbetname*, containing his conversations with the *Melâmî* Şeyh İbrahim Efendi (seventeenth century), Niyazi Mısri's diary *Sohbetname* (seventeenth century), Telhisi Mustafa Efendi's diary (1711–1735), müderris Sıdkı Mustafa's diary (1749–1756), Asiye Hatun's autobiographical dream diary (eighteenth century), and Yirmisekiz Mehmed Çelebi's ambassadorial chronicle (1720–1721).

42 Cemal Kafadar, "Self and Others", 121–150.

43 Walter Andrews, *Poetry's Voice, Society's Song: Ottoman Lyric Poetry* (Seattle and London: University of Washington Press, 1985), 143–174.

44 *Ibid.*, 11.

45 *Ibid.*, 65.

46 Edward M. Bruner, "Experience and its Expressions" in *The Anthropology of Experience,* eds. Victor W. Turner and Edward M. Bruner (Urbana, IL: University of Illinois Press, 1986), 6–7; 11–12.

47 *Ibid.*, 6–7; 11–12.

48 About the multivocal quality of Ottoman poetry, see Walter Andrews, "Ottoman Lyrics: Introductory Essay," in *Intersections in Turkish Literature: Essays in Honor of James Stewart-Robinson*, ed. Walter Andrews (Ann Arbor, MI: University of Michigan Press, 2001), 3–25.

Gardens, Creative Imagination and the Theory of Intermediary Space in Ibn al-'Arabî's Philosophy and its Reception in the Ottoman World

By the end of the twelfth century, the meeting of Abu' Walid Ibn Rushd (Averroës) with Ibn 'Arabî was a brief encounter of two contrasting realms of philosophy—the Western Latin school and the Islamic. Ibn Rushd[1] (1126–1198), known as the Commentator of Aristotle (384 BC–322 BC), requested to meet young Ibn 'Arabî[2] (1165 Murcia–1240 Damascus), who later came to be called the son of Plato (429 BC–347 BC).[3] This meeting, that took place in Cordova, demonstrates Ibn 'Arabî's Neo-Platonic influence in the Islamic world, and his position within world philosophy.[4] Ibn Rushd, the commentator and translator of Aristotle's works, had composed numerous books on science, medicine, law, philosophy, and religion. He claimed that philosophy and religion belong to different domains of study. He acknowledged knowledge as the study of visible objects in nature. However, he was challenged by Ibn 'Arabî's confidence in the reception of both physical and metaphysical worlds as sources of knowledge. 'Arabî argued that "vision" was a means to acquire knowledge. Ibn Rushd argued that "reason" was the only means to acquire knowledge. Ibn Rushd discussed the concept of the "creative intellect." 'Arabî introduced the concept of "creative imagination." Ibn 'Arabî is the first Sufi philosopher who had established a well-structured cosmology involving both physical and metaphysical worlds. It connected the phenomenal and the universal worlds. It related the individuality of the subject to the universality of the cosmology.

Ibn Rushd introduced Aristotle to the Latin world of Western Europe. He is deemed to be one of the most important figures whose work had absorbed Aristotelianism, the development of natural sciences, and thus the birth of the Renaissance in Europe. The philosophers of antiquity had been reintroduced to the Western world by Byzantine scholars who had migrated to Italy throughout the fifteenth century. One of these scholars was George Gemistos (d. 1452). Gemistos named himself Plethon after Plato. Gemistos had given lectures in Florence about the differences between the philosophies of Aristotle and

Plato, and argued the superiority of Plato over Aristotle. However, Gemistos observed that the Western world was interested in the studies of Plato only in the domain of arts. He wanted to establish Neo-Platonism in the domains of philosophy and science. Gemistos explained his Neo-Platonic arguments in relation to Islamic and other ancient Near Eastern philosophies. He claimed that in the future, the world would be dominated by a single religion. Scholaris, who was appointed as the Patriarch of the Orthodox Church by Mehmed II after the conquest of Istanbul, accused Gemistos of associating Platonism with paganism. Scholaris claimed that Gemistos' association of Platonism with paganism was a result of his education by a scholar, who was a subject of the Ottoman rule. In the major research conducted on the life and philosophy of Gemistos, Woodhouse argues that Gemistos did not have any knowledge of Arabic or Persian. He adopted the ideas of his teacher directly. Gemistos even became a disciple of this Ottoman subject. Though the identity of this Ottoman scholar still has not been truly identified,[5] Gemistos himself stands as one of the major indications that by the fifteenth century, Neo-Platonism was adopted and practiced in the intellectual circles of the Ottoman rule in Asia Minor.

In this respect, it is noteworthy to summarize briefly the history of Asia Minor through the thirteenth to the fifteenth centuries, between 'Arabî's visit to Konya and the conquest of Istanbul in 1453. Asia Minor was a land of invasions in the thirteenth century. In the northwest, the Byzantine capital was invaded and destroyed by the Latins (1204–1261). The central and eastern peninsula was under the rule of the Seljuk Empire. The Seljuk culture was flourishing when the Mongols defeated them at Kösedağ in 1243. After this date, Asia Minor was not only invaded by Moguls, but also by thousands of migrants who were running away from the impelling force of Moguls. These flows of refugees included Türkmen tribes, and as well many individual immigrants, including prominent Sufi scholars. Due to the intellectual flow, Kalenderi (following *Melâmîs* of Horasan), Vefai, Haydari, Yesevi, Kübrevi, Sühreverdi, Rifai, and *Kadiri* orders established themselves in Asia Minor early in the thirteenth century. Parallel to the establishment of different Sufi orders, Türkmen tribes had begun to establish themselves in small principalities by the end of the century. Türkmen dervishes became spiritual masters of their communities, each possessing political power.[6] Thus, in the thirteenth century, west and central Anatolia had experienced the cultural and political appropriation of Anatolia by Sufis, and Türkmen tribes; whereas, in northwest Anatolia, the Byzantine Empire was fighting against the Latins. Türkmens rebelled against Seljuk power, and were in opposition to one another; Seljuk princes disputed amongst themselves and with the Mongol appointees; Byzantines struggled against their Latin invaders. Meanwhile, some of the Byzantine principalities were separated from the empire.

Ibn al-'Arabî entered this scene in the early thirteenth century while he was traveling from Andalusia to different cultural centers and pilgrimage

sites of the Middle East. Upon Keyhusrev I's invitation to the Seljuk court, he visited Konya, Malatya, and Diyarbakır in 1210. He lived in Konya for a brief period, and then he continued his travels; he finally settled and died in Damascus in 1240. Despite the fact that his stay in Anatolia was quite short, his influence on Ottoman philosophy and culture was significant. Though 'Arabî's reputation and his ideas were already recognized in Andalusia even when he was a teenager, his works were incomprehensible to many. They had a complex structure with diverse references, and multivalent arguments. His stepson Sadreddin Konevi, whom 'Arabî had adopted while he was living in Konya, had restructured his philosophy by following an analytical and comprehensible order. Following Konevi, 'Arabî was reintroduced to the Islamic philosophy through the works of other Ottoman scholars. Thus the Seljuk–Ottoman scholarship restructured 'Arabî's philosophy into a school of thought recognized as the "Unity of Being" (*Wahdat al-Wujûd*). 'Arabî's philosophy has always been a subject of dispute. His doctrines have been recognized in two extreme fashions both by his followers, and his commentators throughout history. Due to his diverse references from conflicting domains of various religions—from Orthodox Islamic tradition, various heterodox orders of Sufism, and other world religions outside the realm of Islam, his work has been associated with either the highest level of religion, or pantheism.

Gardens, Creative Imagination and the Theory of Intermediary Space in Ibn al-'Arabî's Philosophy

The philosophy of Abu Bakr Muhyi al-Din Ibn al-'Arabî is important because it does not only underline some of the most crucial points regarding the cultural and social values of Ottoman society for a deeper consideration of the history of Ottoman architecture and landscape cultures, but because it proposes a significant understanding of space. 'Arabî structured a complete theory on the concept of intermediary space. This intermediary space was called *barzakh*. He discussed this concept in relation to the domains of ontology, epistemology, and hermeneutics; and his commentaries examined it accordingly. Ibn 'Arabî's philosophy develops at an intermediary domain as well. Epistemology encounters ontology at this intermediary domain. Their encounter is experienced and interpreted in terms of hermeneutics.

The concept of *barzakh* as an intermediary space reconciles ontology and epistemology in Islamic philosophy. Among many other Islamic scholars who had dwelled on the problem of explaining the concept of knowledge as of this world, and / or as of God, there had been different perspectives developed, which favored ontology or epistemology with one another. Ibn Rushd argued for studying the two domains disconnected from one another, and his work had been interpreted to separate ontology and the positive sciences. On the

other hand, another Islamic scholar, Ghazali, proposed the superiority of ontology to positive sciences. The lack of any proper explanation with regards to understanding of ontology and epistemology with respect to one another in terms of Islamic philosophy led the Islamic world into confusion. As Henry Corbin acknowledges, this confusion guided most of the intellectual contemplation to an either / or state, which resulted in favoring one or the other until 'Arabî discussed both domains as equivalent: "The magnitude of the loss becomes apparent when we consider that this intermediate world is the realm where the conflict between theology and philosophy, between faith and knowledge, between symbol and history, is resolved."[7]

Ontology covers the study of religious cosmology. Islamic cosmology is born out of one single entity that is God. The domain of God is acknowledged as the realm of existence which houses absolute reality. The realm of existence manifested the creation of all things. Outside the domain of God, there is the realm of non-existence, which designates everything that is not God. Neither existence nor non-existence can be observed. They are invisible (*batînî*). Yet, a third realm is manifested as the realm of relative existence. It is the realm of possible things, which is visible (*zahîrî*).[8]

The realm of existence contains true knowledge. The essence of true knowledge is acknowledged as being, as existence (*wujûd*), since it is recognized that only God exists and there is no reality outside his existence. In the realm of existence, there is no form. There is only pure essence. Outside the realm of existence there are all other things. In the realm of non-existence, there are epiphanic forms. Finally, in the realm of relative existence, there are corporeal bodies.

All things in the realms of non-existence and relative existence are portrayed as spaces where the existence of God is manifested. All things are acknowledged as signs that embody knowledge of God. All things manifested are spaces, which are denoted as a "locus of manifestation."[9] They are manifestations (*zahîrî*) of the hidden essence (*batînî*): "To see God in his Self-disclosure is to see a perpetual and never repeated display of novel forms."[10] All corporeal and epiphanic forms are signs, and all signs embody the knowledge of God. All signs are acknowledged as marks of God. Knowledge is attained by unfolding signs. Accordingly, William Chittick explains, "Arabî's cosmology as a science of signs, an account and a narration of the significance of marks."[11]

In 'Arabî's philosophy, epistemology is associated with the knowledge of God.[12] However, human attainment of the knowledge of God contradicts Orthodox Islam. Orthodox Islam acknowledges that knowledge of the realm of existence, thus the knowledge of God is only accessible to God himself. Orthodox belief asserts that the only knowledge available to the human is attained by learning religious texts (Koran and Hadith) and by repetition of traditional practices (Sunna). On the contrary, Sufi mysticism argues that the knowledge of God is accessible to the friends of God.[13] Thus, the friends of God, who are the mystics, acquire knowledge by special training.

The mystic believes that the knowledge of God is not limited to the religious texts or orthodox practices. Knowledge of God is inherited by every human being. It is recognition, disclosed by special training, which is acknowledged as the path of Sufism. Acquiring knowledge is regarded as "recognition and recollection" of the already inherited knowledge of God. Thus, such learning is considered in line with divine vision or theophanic inspiration.

'Arabî puts emphasis on the importance of the individual self who receives theophanic inspiration. 'Arabî argues that all human beings are entitled to attain true knowledge. However, the attainment of knowledge from one self to another would differ dramatically with regards to the capacities of each individual. The capacity of individual enlightenment is explained in terms of hermeneutics. Though the content and quality of knowledge would change from one individual to another, the essence of the knowledge would not change. In a physical metaphor, it can be explained that even if the shadows of each object differ from one another with regards to their different positions or their mass, the quality of the light source would not change.

'Arabî also argues that all existence is in constant renewal of itself. The universe is considered to be in constant movement. Movement is one of the qualities of creation. It is not things themselves that create movement. Things enter, or in other terms, experience different states of movement:[14] "Know that there is no stillness whatsoever in the cosmos. It fluctuates endlessly and perpetually from state to state." Since all existence, as the source of knowledge, constantly renews itself, the whole of creation and its knowledge are also in constant "transmutation" and renewal.

Hermeneutics, then, can be explained as a compilation of momentary intersections of the two realms—ontology and epistemology—which are simultaneously in constant transmutation. It becomes the experience of an encounter between meaning and form in simultaneous transmutation. Ibn 'Arabî explains each meeting of the manifest and the non-manifest as a representational encounter which takes place at different levels of the cosmology, regardless of the hierarchy of the cosmology.

Since everything is in constant transmutation, then the attainment of knowledge is actually the collection of instants by the individual self. It is the unfolding of the signs by the individual self. It is a constant interpretation, construction, and deconstruction of signs by the individual self. Thus, Ibn 'Arabî's philosophy explains the encounter between God and the individual self. However, since God cannot be encountered directly, everything else becomes proof of His existence, including the individual human itself. Ibn 'Arabî is the principal Islamic philosopher who emphasized the individual self with such assertion, and related the attainment of knowledge to the individual. It is noteworthy to emphasize that 'Arabî considered his own individuality as an important derivative of his philosophy. Among many other Sufi masters with whom 'Arabî has associated himself, there is one legendary figure whose authenticity explains 'Arabî's assertive discussions underlining the concept

of the self. It is the legendary Khidr, whose link to 'Arabî gives insight into 'Arabî's aims to achieve individual enlightenment:[15]

> Khidr is the master of all those who are masterless, because he shows all those whose master he is how to be what he himself is he who has attained the Spring of life, the eternal Youth… he who has attained haqiqa, the mystic esoteric truth which dominates the Law and frees… from the literal religion… He leads each disciple to his own theophany, the theophany of which he personally is the witness, because that theophany corresponds to his "inner heaven" to the form of his own being, to his eternal individuality.

Ibn 'Arabî discusses three types of cognition for the attainment of knowledge. Responding to these three domains, there are three different types of cognitive faculties. These are sensual, intellectual, and imaginative faculties. The organs of sensual cognition are the five senses of the body. Sensual cognition—the most deprived and inferior faculty among the three, is empowered by the five senses of the human body and activated by the soul. The organ of intellectual cognition is the mind and related to the rational thinking. The imaginative faculty is empowered by the organ of the heart. The heart is furnished with both intellectual and spiritual abilities. However, the faculties of the heart should not be understood as being emotional. The faculties of the heart enable the individual to communicate beyond the apparent form. In the words of the scholar of mysticism,

> Its nature is rather intellectual than emotional, but whereas the intellect cannot gain real knowledge of God, the heart is capable of knowing the essence of all things, and when illuminated by faith and knowledge reflects the whole content of the divine mind.[16]

Ibn 'Arabî considered imagination superior to rational thinking. Thus he favored the faculty of imagination superior to the intellectual faculties of the rationale. According to 'Arabî, rationality is only able to discriminate a static truth learned from written reports, and fixed by the tradition of Sunna. However, the faculty of imagination allows an ever-shifting correspondence between form and meaning, allowing dynamism and transmutation. Thus, imagination surpasses both the sensual and intellectual cognitions.

'Arabî considered the imaginative faculty superior to the other two faculties, because it embodies both of them. It is a divine state of inspiration towards the understanding and realization of true knowledge. It is a creative process, which enables the interaction of two different worlds. Faculties of the imagination enable the human being to unfold signs, and to attain knowledge. Corbin describes the practice of the faculty of the imagination through heart. The heart is able to communicate and relate the signified and the signifier, thus questioning the relation between essence and form. Corbin discusses the multiplicity of the variegated powers of the heart (*himma*). He also explains that, through creative imagination, the creative power of the heart enables one to have a direct impact on the outside world:[17]

… *himma* is an extremely complicated notion which cannot perhaps be translated by any one word. Many equivalents have been suggested: mediation, project, intention, desire, force of will; here we shall concentrate on the aspect that encompasses all the others, the "creative power of the art"… The active Imagination serves the *himma* which, by its concentration, is capable of creating objects, of producing changes in the outside world… If the heart is the mirror in which the Divine Being manifests his form according to the capacity of this heart, the Image which the heart projects is in turn the outward form, the "objectivization" of this image.

Creative imagination, or in other words, the imaginative faculty, explores the relationship between form and meaning. The attainment of knowledge is the construction and deconstruction of signs made out of a signifier and a signified. The construction of signs is the meeting of essence with form. Deconstruction, however, is the deciphering of the signs. The imaginative faculty enables to the human being to perceive beyond the apparent form of a sign.[18] Corbin calls the hidden structure of signs idea–images:[19]

Between the universe that can be apprehended by pure intellectual perception, and the universe perceptible to the senses, there is an intermediate world, the world of idea–images, of archetypal figures, of substile substances, of "immaterial matter." This world is as real and objective, as consistent and subsistent as the intelligible and sensible worlds; it is an intermediate universe "where the spiritual takes body and the body becomes spiritual," a world consisting of real matter and real extension, though by comparison to sensible, corruptible matter these are substile and immaterial. The organ of this universe is active Imagination; it is the *place* of theophanic visions, the scene on which visionary events and symbolic histories *appear* in their true reality.

The unfolding and folding, deconstruction and construction of idea–images reveal true knowledge. This process is the attainment of knowledge. Corbin also discusses the contemporary relevance of the study of imagination as a way to attain knowledge in terms of phenomenology:[20]

Today with the help of phenomenology, we are able to examine the way in which man experiences his relationships to the world without reducing the objective data of this experience to data of sense perception or limiting the field of true and meaningful knowledge to the mere operations of the rational understanding. Freed from an old impasse, we have learned to register and to make use of the intentions implicit in all the acts of consciousness or transconsciousness. To say that the Imagination (or love, or sympathy, or any other sentiment) induces knowledge, and knowledge of an object, which is proper to it, no longer smacks of paradox.

'Arabî also discusses the locus of the faculty of imagination. In other words, he emphasizes the importance of the space(s) of this unfolding of signs, and names such space(s) as the realm of imagination. According to 'Arabî, the realm of imagination exists at three different levels. First, it exists between the invisible domains of non-manifest things (realms of existence and non-existence) and the visible domain of manifested things (realm of relative

existence). Second, it exists between the realm of existence and non-existence as the realm of relative existence. Third, it exists between body and spirit. First is the realm of idea–images. Second is the realm of the phenomenal world. Third is the human self.

In the realm of imagination, a part of the divine knowledge descends, where it meets with the ascending form, which has lost its density. The realm of imagination is a place of encounter.[21] The realm of imagination is acknowledged as an ever-changing domain, where the same form (since the form also changes by passing from one state into another over time) will not be able to meet the same meaning again. This dynamic relation between form and meaning[22] that is staged within a space, which has no density, is actually a space of representation, the domain of true knowledge.[23]

'Arabî portrays signs to be read and deciphered like letters. The attainment of knowledge takes place as a process, as an act of questioning, as an act of communication between essence and form by deconstructing the apparent meaning and body. Thus the act of deconstruction is the unfolding of true knowledge, the knowledge of God:[24]

> He is a letter you are the essence of it
> I have no intentions other than Him
> Letter is an essence, it's meaning attached to it
> The eye does not see anything else than this meaning
> The heart will come and go due to its nature
> Once to its body, once to its meaning
> God is magnificent no body can contain him
> Though we can embrace him in our hearts

Corbin argues that in 'Arabî's perspective, the unfolding of knowledge, or in other words, theophanic vision, is activated and communicated by metaphors:[25]

Allegory is a rational operation, implying no transition either to a new plane of being, or to a new depth of consciousness; it is a figuration, at an identical level of consciousness, of what might very well be known in a different way. The symbol announces a plane of consciousness distinct from that of rational evidence; it is the "cipher" of a mystery, the only means of saying something that cannot be apprehended in any other way; a "symbol" is never explained once and for all, but must be deciphered once and for all, but calls for ever new execution.

Communication through metaphors is possible, because beyond the multiplicity of the apparent world, the whole universe is sustained in unity, which speaks a common language. That reality is the knowledge of God bestowed to all the participants of the universe. This common ground enables sympathy and attraction between things, enables their communication. All the elements of the universe are attracted to one another because they are carrying the same essential life substance. 'Arabî names this attraction as love. In 'Arabî's philosophy, all creation is enabled by the act of love.

Love is dynamic and enables the sustainability of life: "If there were no love, the world would be frozen."[26] Love enables communication beyond the sensible and intelligible worlds. 'Arabî defines "love" as a-priori and permanent (*ma'dum*). The imaginative faculty is activated by the act of love. Since the domain of imagination was considered as a space, this space was constructed metaphorically as a domain of exchange and communication, between God and the human being. Ibn 'Arabî illustrates this communication as a ritual of "love".

'Arabî also defines "love" in three categories. First is divine love. It is the love between God and human beings. The second is spiritual love, between the lover and the beloved, where the lover is in full pursuit of the act of loving. The third one is natural love between the lover and the beloved, where the lover is aiming to fulfill his sensual desires.[27] At all levels of the cosmology, human beings carry the act of love with respect to their capacities. Schmimmel describes visuality as an agency of love, "looking becomes, then, one of the central topics of mystical love experience."[28] Divine love arouses through natural bodily love: "Conjunction of spiritual love and the natural love it transmutes is the very definition of mystic love."[29]

Using the metaphor of love, 'Arabî defines the whole cosmology in terms of a lover and a beloved. The beloved symbolizes the essence and the true knowledge. The lover symbolizes the whole universe desperate to unite with this essence, longing to acquire divine knowledge.

Form is defined as an instant image in the mind of the lover. It is the image of the beloved. It is an image of the loved one in the lover's imagination. Forms are dynamic, because they would never stay in a single state. They transform from one state into another. For example, the human form will grow old with the passing of time. As well, all things manifested will be experiencing one state after another, either posed still, in a state of immobility, or moving, in a state of motion. The changing states will leave a trace on the manifested thing, and it is the form that will change with the passing time. There will not be a static definition and depiction of any form as a single image. The state of love also encourages formlessness and transformation of all things manifested from one state to another. For the true lover, the image of the beloved will also change, as the form of the beloved will always be in transformation.

The attainment of knowledge takes place within an intermediary domain called *barzakh*. Ibn 'Arabî reintroduced the concepts of *barzakh* as "imagination," which he borrowed from Sufi terminology, and totally restructured into a new philosophy. The concept of *barzakh* embodies an understanding of "both / and" instead of "either / or." The presence of a *barzakh* enables the coexistence of ontology and epistemology; so far it proposed metaphysical and physical worlds as equally important; and discussed the significance of the individual self as equal to God. Thus, in each case, *barzakh* is portrayed as a space of encounter, as a third space, in which the other two different domains meet. In this respect, the act of imagination takes place at *barzakh*. It is called the realm of imagination.

Barzakh, or the realm of imagination, is portrayed in the form of an ideal or real space. This space is depicted as the only place to attain true knowledge. It exists at all levels and in all scales of the cosmology. It places the individual human self at the center of understanding the whole creation. It is a space created by the act of communication, act of imagination. Thus it is a space created by the attainment of knowledge. 'Arabî explains the concept of *barzakh* and "imagination" as such:[30]

> A barzakh is something that separates (fâsıl) two other things while never going to one side (mutatarrif), as, for example, the line that separates shadow from sunlight. God says, 'He let forth the two seas that meet together, between them a barzakh they do not overpass' (Koran 55:19); in other words, the one sea does not mix with the other. Though sense perception might be incapable of separating the two things, rational faculty judges that there is a barrier (hâjiz) between them, which separates them. The intelligible barrier is the barzakh. If it is perceived by the senses, it is one of the two things, not the barzakh. Any of two adjacent things are in need of a barzakh, which is neither one nor the other but which possesses the power (quwwa) of both. The barzakh is something that separates a known from an unknown, an existent from a non-existent, a negated from an affirmed, an intelligible from an unintelligible. It is called barzakh as a technical term, and in itself intelligible, but it is only imagination... Imagination is neither existent nor non-existent, neither known, nor unknown, neither negated, nor affirmed.

'Arabî basically proposed the application and experience of this understanding of *barzakh* in three different scales; in macrocosmic, cosmic, and microcosmic levels. In microcosmic scale, which is the scale of the individual human being, *barzakh* corresponds to the soul, which operates between body and spirit. In macrocosmic scale, *barzakh* had been discussed as an intermediate world between the existence and non-existence. It is a space between God and everything that is not God. Existence contains the essence of the True knowledge. Non-existence embodies epiphanic forms. Between them lies cosmos as the *barzakh*. In the cosmic scale, *barzakh* is the equivalent of the realm of imagination.

'Arabî's cosmology valued the realm of imagination above all other levels of the hierarchy. However, the Orthodox cosmology had a different structure. It was made up of three main realms where each is structured into different levels. The first and lowest realm of Orthodox cosmology was the phenomenal world of human beings. Second was the domain of planets as observed in the sky. Third was the divine world. Following after the domain of the phenomenal world, the first seven stages in the domain of planets were represented by seven planets—Moon, Mercury, Venus, Sun, Mars, Jupiter, Saturn, and finally the sphere of fixed stars—each level acknowledged as a "celestial" heaven. Each of these levels was believed to embrace one of the holy characters mentioned in the Koran: Adam, Abraham, Khidr, and others.

The "celestial" heavens were followed by the domain of a divine world made out of three "theological" heavens, which were acknowledged as the Paradise Garden. The first of the last heavens had a lotus tree, the second

had the Temple of Jerusalem, and the third the throne of God.[31] Each level of the Orthodox cosmology was associated with a different kind of cognitive faculty.[32] Intellect was associated with the highest level of the cosmology, the divine world. Imagination was associated with the second level. Human perception was associated with the lowest level.[33]

However, different than the Orthodox cosmology, 'Arabî's cosmology altered the order of the cognitive hierarchy of the Orthodox tradition, and emphasized the superiority of the "realm of imagination" to the other two. Meanwhile, 'Arabî's cosmology valued each domain in the hierarchical order of the cosmology as a realm of imagination with varying capacities. 'Arabî discussed these different realms of imagination in all the domains of cosmology with regards to the concept of *barzakh* having spatial qualities; as a garden, pool, meeting place, abode.[34]

Barzakh is illustrated as the paradise garden in the macrocosmic level, an ideal space in the cosmic level, and a real space in the microcosmic. All ideal spaces are gardens and they are representations of the heavenly paradise garden. The real gardens include all the variety of the natural and man-made environments. Both real and ideal gardens have qualities as that of existence.

Yet, there is nothing static about Paradise,[35] and accordingly nature is renewed constantly. In his argument, 'Arabî portrays all ideal and real spaces as parts of a harmonious unity: "The cosmos, all of it, is a heaven and an earth."[36]

The garden is portrayed as a place to see the truth. The paradise garden is the last abode before total illumination. The Koran also cites the paradise garden as a screen between the Divine and human sight. It is this screen that differentiates between divine and human existence. It is depicted as the only place where the vision of God himself is available.[37] Arabî also compares the cosmos to an image on the screen, which stands between God as the creator and the subject as the viewer. This representation is similar to the depiction of the garden as a veil between the Real and the subject.

At this point, the faculty of imagination becomes a virtual space, a virtual garden, an imaginary screen, where the subject as the viewer tries to identify the forms on the screen, or in the garden with respect to his selective will, with regards to his "appetite", which will be discussed in the following pages:[38] "The garden is named 'Garden' because it is a curtain and a veil between you and the Real for it is the locus of the appetites of the souls."[39]

'Arabî illustrates the location of the ideal garden in two different ways. In the first one, the ideal garden occupies a section in the realm of the *barzakh*. So the *barzakh* is not only merely composed of a garden, but the garden is only one part of it. In the second argument, the human world is surrounded by a garden, which can only be perceived during the act of imagination. The garden becomes apparent when the act of imagination is practiced. Form meets essence in a garden. The essence that is going to join the form for a single moment during the act of imagination descends from the heavens in the form of light. So this illumination made possible by traveling light illuminates

a garden, which had already been surrounding the world. This ever-present garden is perceived only by those who are able to imagine and thus who are able to see by their hearts.[40]

'Arabî discusses the concept of garden as such:[41]

Know my brother—may God take charge of you with his mercy—that the Garden that is reached in the last world by those who are its folk is witnessed by you today in respect of its form. Within it you undergo fluctuations in your states, but you do not know that you are within it, because the form within which it discloses itself to you veils you. The folk of unveiling, who perceive that from which the people are absent, see that locus, if it is a Garden, as a green garden plot. If it is a Gehanna, they see it in keeping with the descriptions that are within it—its bitter cold and its burning heat—and what God has prepared within it. Most of the folk unveiling see this at the beginning of the path. The Sharia has called attention to this with the Prophet's words, "Between my grave and my pulpit is one of the garden plots of the Garden (paradise garden)." The folk of unveiling see it as a garden plot as he said. They see the Nile, the Euphrates, the Sarus, and the Pyramus as rivers of honey, water, wine and milk, as they are in the Garden. After all, the Prophet reported that these rivers belong to the Garden. When God has not unveiled someone's eyesight and he remains in the blindness of his veil, he does not perceive this and is like a blind man in a rose garden. He is not absent from it in his essence, but he does not see it. The fact that he does not see it does not necessitate that he is not within it. No, he is within it. The vision of God does not take place through seeking and is not reached through recompense, in contrast to the blessings in the Garden.

In another argument 'Arabî explains real garden(s), originally part(s) of the heavenly paradise garden as bestowed gift(s) to the human world. Then the garden, originally a divine creation, is given as an ornament to decorate the mundane world.[42] In this argument, 'Arabî stresses the symbolic value of the real garden as a reflection of the Heavenly Paradise. The multiplicity of different kinds of gardens on earth, all refer to the original paradise garden:[43]

Hence from the heaven, becomes manifest the earth's ornament. Thus the heaven draped the earth with its reckoning, and the heaven stripped its ornament from it through its reckoning. From the earth's ornament, its names became many, because of the various classes of fruits, trees, and flowers within it. But from its becoming stripped and cleared, its name was made one. Its names disappeared within the disappearance of its ornament. Surely we have appointed whatever is on earth as an ornament for it. In the metaphorical interpretation, the earth is nothing but what is called "creation" and its ornament is what is named "Real." Hence through the Real it is ornamented, and through the Real it is cleared and stripped of the garments of number and it becomes manifest in the attribute of the One.

Thus, contemplation of any garden would reveal knowledge about the paradise garden. Ideal gardens are ideal places where essence meets epiphanic forms. They enable construction of knowledge in idea–images. Real gardens are the repository of signs, which enables the deconstruction of idea–images as embodied beyond the apparent visualization of the sign.

'Arabî refers to those spaces occupied with signs as the "pool of imagination" or the "Market of the Garden."[44] The world of imagination, *barzakh*, is imagined to embody part of the garden known as the "Market."[45] This Market is portrayed as a "pool." It is a pool, storage of signs waiting to be unfolded:[46]

> This then is the turbidity that joins with knowledge. When this becomes manifest for people, they need a divine faculty that will take them from this form to the meaning that has become manifest in this form and has troubled them. The occasion of this is the Presence of imagination and imaginalization and the reflective faculty. Its root is this natural body, which in this way station, is called the "pool". The depth of the pool is everything that imagination and imaginalization remove from its own form.

The faculty of imagination is able to depict the novelty of ever changing forms. These forms are either bodies or places. 'Arabî illustrates the multiplicity of forms and different places as things to be contemplated. He uses the metaphor of traveling between the multiplicity of these ever changing novel forms, bodies and places: "The names are diverse because of the diversity of the loci and the forms."[47] Similarly, 'Arabî explains traveling from one garden to another as a quest for the attainment of knowledge:[48]

> Heaven's wisdom in the earth is its traveling to bring together thereby all its scattered things
> For God built it for us and designated through the traveling its moments

This travel is a kind of pilgrimage, which is the journey of both the heart and the body.[49]

The soul (*nefs*) is also an intermediary space between the form of the body, and the intellect of the spirit. The soul is between spirit and body. The body has sensory organs, which perceive all natural phenomena. All things perceived fall onto the space of the soul. The spirit is the intellectual power, which is supposed to assess this collection gathered by the body. The spirit is associated with reason, and it is an agency for differentiating between good and bad, between light and darkness, between bliss and sin. The spirit is the guide of the soul. The soul is like a vessel where "the light of the spirit" and "the darkness of the body" encounter each other. All the impressions from the outside world are stored within the soul as undifferentiated. It is like an unclassified library, which accumulates information perceived from the outside world, similar to the domain of imagination portrayed as the market of the garden or a pool:[50] "Soul is that dimension of man and other animals which stands between the disengaged spirit and the corporeal body; it is the domain of imagination, which is neither the pure light of spirit nor the darkness known as clay."[51]

The soul is divided into three in itself, as the vegetal (controls nourishing and digestive needs and activities of the body), the animal (performs the "wrathful" inheritance like displaying vulgarity, anger, rage, slaughter),

and the appetitive soul (faculties aimed at pleasure by the senses of taste and desire).[52] The soul is generative of human desires, which are called appetite. Appetite is different than divine desire. It is the aspiration for things phenomenal. It is the "desire for food, sexual gratification, and all forms of pleasure."[53] The human soul has a constructive ability as far as the self is able to perform activities as desired by the soul. This skill of creativity is similar to the creativity of the imagination performed by the heart. The soul is a place where appetite will meet with the "possibility"[54] of its actualization. Since appetite is attached to natural forms in the natural world of the human being, the soul becomes a domain of imagination where natural forms become signs. Thus in this level of imagination, the beauty of the natural forms communicates with the self.[55] With the metaphor of love, the desire to unite with the beautiful, representing the divine love, motivates the soul as in the realm of imagination.

For the soul, its space of operation is the human self and the natural world. It interacts with natural world forms. 'Arabî discusses that appetite is basically the desire for beautiful things, which are representations of the beloved: "As for the appetitive soul its ruling authority in this frame is seeking what is beautiful in its view."[56] Divine beings do not have appetite.[57] They do not possess things. They do not have an interest in forms. However, that does not mean that appetite is a worthless and shameful kind of desire. According to Arabî, appetite is a positive faculty that gives strength to the human being.[58] Appetite is a means to practice a certain intensity of the faculty of imagination in the phenomenal world. The appetitive soul would crave to have pleasure in anything, which he would appreciate as beautiful with respect to its form, its image.[59] Chittick explains the virtue of the appetite necessary to individual enlightenment and mysticism in the following words:[60]

The fact that appetite becomes attached to things in the natural world does not detract from its inherent eminence and worth—if it did, there would be no appetite in paradise. Ibn al-'Arabî repeatedly cites the Koranic verses telling us that the felicitous will be given everything for which they have appetite. After all, appetite is the soul's desire to take pleasure, and pleasure is found on the natural, bodily level.

Mapping the Impact of Ibn al-'Arabî's Philosophy in the Ottoman World

'Arabî's philosophy had deeply influenced different trends in Ottoman mystical thought.[61] With respect to the context of this study in particular, his influence on the Ottoman cultural and intellectual world is to be summarized in two phases historically corresponding to consequent periods. The first phase covers the impact of his philosophy from the thirteenth to fifteenth centuries, which coincides with the rise of the Ottoman state into the establishment and development of an empire. The second phase covers the

period from the sixteenth to early eighteenth centuries, which coincides with the centralization of the Ottoman Empire.

In the first phase, Ibn 'Arabî's influence and interpretations had taken place in the multi-central cultural centers of Anatolia, like the cities of Konya, İznik, Bursa, Ankara, or Edirne. This study will try to acknowledge briefly the multiplicity of individual scholars who were under the influence of 'Arabî's philosophy. Yet in the second phase, the argument will focus on the city of Istanbul, and try to understand how his philosophy had developed into a school of thought within a group of deviant Sufi mystics, who called themselves Melâmîs.

The first phase, spanning the period from the thirteenth to the fifteenth centuries, covers the interpretation and analytical analysis of 'Arabî's work by the Seljuk and Ottoman scholars. This period can simply be called the initial period of the development of first major commentaries on Ibn 'Arabî. Ibn 'Arabî's short visit to Anatolia, in the cities of Malatya, Konya, and Diyarbakır, in c. 1210, had left behind major advocates, who later interpreted 'Arabî's work and established his fame not only among the mystics of Anatolia, but as well in Iran, and other Islamic societies. The second phase spanning the period from the sixteenth to the early eighteenth centuries, covers the practice and conception of Ibn 'Arabî's interpretations by Melâmîs and those who have experienced the "joy" of Melâmîs (in the words of Gölpınarlı) and their reception by the agents of power in the city of Istanbul. These agents of power include the centralized authorities of the Ottoman Empire, thus the political social groups and scholars of religion.

The first phase covers interpretation of Ibn 'Arabî's thoughts by individual scholars and mystics, who had both popular and elite recognition. The first is Davud b. Mahmud el-Rumi el-Kayseri (d. 1350) of İznik Madrasa, who holds the title of the first scholar commissioned by the Ottoman authority. The second is the first Ottoman Şeyhülislam Molla Hamza Fenari (1350–1431). The third is the famous Ottoman scholar Şeyh Bedreddin (1358–1420). And finally the fourth one is the popular mystic Hacı Bayram Veli (1352–1429) of Ankara, who was the founder of the Bayrami order of Islamic mysticism—later followed by Melâmî-Bayramis. These individuals were important characters who constructed the objectives of the Ottoman mystic culture following the line or the philosophy of Ibn 'Arabî among other Islamic philosophers.

The second phase embraces contrasting attitudes towards the philosophy and/or the followers of Ibn 'Arabî in the Ottoman world. In this second phase, 'Arabî's influence is traced mainly by means of studying the development of the Melâmî order in Istanbul and its reception by the agencies of power centralized in the imperial city of Istanbul.

Interpretations of 'Arabî's work and his doctrines on mystic love gave rise to two distinctly different practices in Ottoman culture. The first one was called the Unity of Being (Wahdat al-Wujûd), and the second the Unity of Existent (Wahdat al-Mevcûd). The philosophy of the Unity of Being considered the phenomenal world and all the phenomenal existence as an allegorical

and distorted image of the Universal Truth. It argued that contemplation of the phenomenal world would unfold knowledge of the Universal Truth. However, the Unity of Existent considered the phenomenal world as confined within itself without any further reference to any Universal Truth. Thus, this second perspective insisted on the contemplation of the phenomenal existence as the only Truth itself. These two contrasting perspectives portray the diverse range of 'Arabî's interpretation in Ottoman lands.

The Unity of Being was considered as the highest level of mystic contemplation regarding all existence as evidence of God's existence beyond the phenomenal world. However, the Unity of Existent was considered as a dissident faith neglecting the existence of God beyond this world. By the late thirteenth century, interpretations of the Unity of Being were widely accepted both in the popular public sphere and in the intellectual spheres of Sufism. In the popular sphere, folk literature conveyed the ideals of the philosophy. In the scholarly tradition, two contradicting perspectives developed. The first one practiced the doctrines of love within the limits of Sharia. They were obedient to Orthodox traditions of Islam and the central authority. The second perspective interpreted doctrines of love to the extent of the Unity of Existent that they had become known as infidels and dissidents. This second group consisted of mainly some of the fractions, or individuals from different schools of Sufi mystic groups, such as *Melâmîs*, *Hamzavis*, and *Gülşenis*. The Ottoman rulers were always alert to the activities of these Sufi groups, and often inspected them. This two-phased mapping of Ibn 'Arabî's influence in Ottoman lands in particular also explains the construction, composition and operation of the Ottoman culture and society from the thirteenth to the eighteenth centuries.

In regards to the first phase, which concentrates on the multi-cultural centers of Anatolia, this study tries to map the complex structure of the peripheral folk culture. The second phase that considers the developments in Istanbul, displays both the changing perspectives of the Ottoman central authorities of power and the conflicting intellectual debates among the scholars of religion; for and against the teachings of 'Arabî, and the practices of his advocates, who were considered either as true believers, or as dissidents. Neither the first phase, nor the second phase can present a unified perspective towards the reception of 'Arabî. The Ottoman social order, which seems to be simple at first sight, is actually rather complex when its terms of operation are considered. Thus, it is necessary to map the complex dynamics of the Ottoman social order in order to map the development of Ottoman culture and its reception of Sufi mysticism in this case: how the teachings of 'Arabî were practiced.

Reception of Ibn al-'Arabî's Philosophy in the Ottoman World Before 1453

The Seljuks were advocates of Orthodox Islam; they were Sunnites. Mongols admired Sunni thought, but later adopted Shia belief. Yet, both the Seljuk

and the Mongol courts protected and admired the development of mystic thought, Islamic Sufism. Türkmen tribes interacting with such different gnostic philosophies also gave birth to different mystic orders. Türkmen dervishes were called *bâbâs*, *abdals*, or masters of Khurasan (*Horasan erenleri*). The Baba'î order was founded by Türkmen mystics, which later developed into the Bektashi order. During the thirteenth century, when the Ottoman principality became a growing power, they employed Türkmen groups on the frontier of their expansions. Throughout the fourteenth century and first half of the fifteenth century, the Ottoman powers ruled over two major regions. One was the Balkans and the Thrace, and the other was Anatolia. The dynamics of military and political campaigns in these regions mutually influenced social and cultural developments. At all times of political or military unrest, the major cultural centers of these regions gave birth to new forms of cultural and social expressions, either in the form of rivalries, or the establishment of new mystic orders. Beginning with the first conquest of Gallipoli in 1354, the Ottomans gained significant power in the Balkans and Anatolia—from the Danube to the Euphrates by the end of the fourteenth century. They conquered Edirne in 1361, and turned the city into the capital of military campaigns to the west. On the other side of the Ottoman realm—to the east—Timur defeated Ottoman forces in Ankara in 1402. This resulted in a period of unrest between 1402 and 1413. The Ottoman princes agreed to become vassals of Timur, governing different territories. Upon Timur's death, the Ottoman princes began to conflict with one another. Çelebi Musa, based at Bursa and Amasya, sought after moving towards Edirne. Çelebi Süleyman based at Edirne aimed at moving towards Anatolia. Mehmed I came into power and united both territories under his control. The second period of unrest was in 1416, when Mehmed I's uncle Mustafa rivaled in Thrace, supported by the Byzantine princes. The third period of unrest was between 1421 and 1424, after the death of Mehmed I. The power was divided between Mustafa, Mehmed I's uncle, and Murad II. Mustafa was based in Edirne. He was again supported by the Byzantine principalities. Murad II was based in Bursa, and was supported by the *ulemâ*, scholars of Islamic Orthodoxy. Murad II defeated Mustafa in 1422 and gained control of the Thrace region. However, at the same time, the principalities in Anatolia challenged Murad II's power and began to take back the control of their former states. Murad II re-established his power in Anatolia, the Balkans and Thrace for the rest of his reign. He left a wealthy powerful state to his son Mehmed II in 1444.

Türkmen groups led by *gazî* lords were the major force in the conquest of new territories. Through their conquests, Türkmen tribes also begin to inhabit the Balkans, either settling in existing villages, or establishing new ones. However, the Ottomans began to structure a new army by the end of the fourteenth century. The establishment of the Ottoman army pushed the *gazîs*—thus the Türkmen tribes—to the background in the political and military domination of the growing Ottoman state. Thus, the frontier culture of Türkmen tribes and dervishes, and mystic communities related to the *gazî*

culture, gained unfavorable status in favor of urban developments in the eyes of the growing Ottoman supremacy. However, 'Arabî's philosophy found adherents in both of these conflicting political domains; both among the Türkmens and among the scholars of the rising Ottoman power.

The Türkmen tribes and the surrounding communities under Türkmen rule formed a multicultural mosaic. These communities were composed of Türkmens, Moguls, Greeks and Armenians. They represented the varied mosaic of the local population that had been diversified by migration and flight over centuries. The Türkmen culture is described best in Türkmen literature developed both orally and in written form from the thirteenth to the fifteenth centuries. These stories were both warrior epics and hagiographies at the same time. They document the Türkmen striving for political power and a harmonious life in a multicultural society. Cemal Kafadar, in his study of the construction of the Ottoman state, emphasized the importance of these epic stories in understanding the dynamics of the Ottoman culture and society.[62] These epics were numerous. *Dânişmendnâme* was compiled under the patronship of the Seljuk court, but it was about the legendary stories of Danişmends, who belonged to a frontier culture, and were the rivals of the Seljuks. *Dânişmendnâme* was about the encounter and conflict of the local population composed of Christian communities, Türkmen tribes, and infidel Mongols with authorities who held extreme orthodoxy of Islamic religion. According to Cemal Kafadar, the narrative suggested crossing "religious, ethnic, and gender boundaries." Kafadar makes an explicit list of these epics. He acknowledges *Hamzanâme*, about a holy horse belonging first to Muhammed's uncle then to legendary *gazî* characters Seyyid Battal and Sarı Saltuk. Another epic, *Düsturnâme*, was compiled in 1465. *Battalnâme* was about the life of Seyyid Battal, an Arab warrior who was a friend of the Greeks. The *Story of Dede Korkut* embraced the themes of war and love at the same time. The desire for power accompanied by the desire for a beloved was one of the major themes of *gazî* literature. *Menakıbü'l-Kudsiye* was composed by Elvân Çelebi, the grandson of Baba Ilyas in 1358–1359. The story suggested that both Baba Ilyas, who was the founder of the *Baba'î* order in the early thirteenth century, and his followers were able to unite all communities with different religious backgrounds. *Saltuknâme* depicted the life of the thirteenth-century legendary *gazî* Sarı Saltuk. It was compiled under the patronship of Sultan Cem in 1473–1480. The story of Sarı Saltuk, which was the most popular *gazî* epic story, suggested the city of Edirne as the capital of *gazîs*.[63]

There were many followers of 'Arabî in Anatolia. Sadreddin Konevi (1210–1274) of Konya was the stepson of Arabî. He was a respected scholar who lived during the sultanate of *Aleaddin Keykübad*. He founded the *Ekberriye* Sufi order after the teachings of 'Arabî. The commentaries by Konevi and el-Kayseri are more explicit and analytical works than the original texts of 'Arabî's.[64] Davud b. Mahmud el-Rumi el-Kayseri (d. 1350) was the first scholar and president (*müderris-i 'am*) of the first Ottoman educational institution, İznik Madrasa, that was founded by Orhan Gazi in 1336. He is the author of the *Mukaddimat—*

an analytical explanation of Arabi's *Fususu'l-hikem* in 12 chapters. Persian commentaries on *Fusus* refer to Davud el-Kayseri's work. Molla Hamza Fenari (1350–1431) was the first Şeyhülislam appointed to the Ottoman court in 1424, during the reign of Sultan Murad II (1421–1444). He established the structure of the Ottoman academy of intellectual studies (*madrasa*).[65] Şeyh Bedreddin (1358–1420) was a scientist, saint, and scholar, while at the same time he was considered to be a dissident, infidel and rebel. Hacı Bayram Veli (1352–1429), was the founder of the *Bayrami* order of Sufism.

Adherents of 'Arabî's thoughts were numerous. Among many others was Hızır Bey Çelebi (d. 1459), who was a student of Molla Fenari; he had been the kadı to Istanbul after the conquest. He was known to be the mentor of Hayali and Tacizade, who were *Şehrengiz* poets. Ibrahim Gülşeni was the founder of the *Gülşeni* Sufi order; Şemseddin A. Ibn Kemal Paşazade (1468–1534), who lived in Edirne and Tokat, was a scholar, kadı, and a şeyhülislam. He was the author of many religious works. İsmail Hakkı Bursevi (1653–1726), who lived in Istanbul, Bursa, and Aydos, was also a well-known author of over 100 works on Sufism. He was also the founder of the *Celvettiye* Sufi order.

Among all the followers of 'Arabî', this study focuses mainly on four individuals who were all well recognized and respected Ottoman scholars of Orthodox Law and sciences. The influence of these four prominent figures, affecting different populaces of the Ottoman state in terms of territory and population, represent the composition of Ottoman society and culture. The first couple of scholars are Davud b. Mahmud el-Rumi el-Kayseri (d. 1350), the first appointed Ottoman scholar, and Molla Hamza Fenari (1350–1431), the first Ottoman Şeyhülislam who constructed Ibn al-'Arabî's teachings into an analytical scheme recognized as the Unity of Being. These two scholars represent 'Arabî's interpretation and recognition by the agencies of Ottoman state, authority, and institutions.

The second couple of scholars are Şeyh Bedreddin (1358–1420) and Hacı Bayram Veli (1352–1429/30) and they represent 'Arabî's interpretation and recognition by the population outside the noble sphere of the Ottoman authority, namely in the provincial settlements of west Anatolia, the northwest regions of Thracia, and in central Anatolia. Both Bedreddin and Hacı Bayram Veli were well known scholars of Orthodox Islam in the early years of their lives. They had later become Sufi mystics, and both became eminent characters in the history of heterodox tradition. Şeyh Bedreddin, coming from a wealthy family, who had served in the Seljuk and Ottoman courts, and who had been the leader of a Türkmen tribe, represents the diverse composition of the provincial population made up of former landowners, mystic dervishes, and the general public of mainly Christian and Islamic origins. Hacı Bayram Veli, as a public celebrity, a Sufi mystic, as well as a farmer, represents the values and common interests of the common provincial public.

The works of these four individuals also acknowledge different mediums of representations that were used to convey ideas. Each social group within Ottoman society became aware of the interpretations of 'Arabî through

different channels of knowledge, varying from scholarly treatises to conversations or folk poetry. Both Davud b. Mahmud el-Rumi el-Kayseri and Molla Hamza Fenari had composed scholarly treatises on the Unity of Being and commentaries on 'Arabî's works that were among the curriculum of the Ottoman institutions. Their works were well known and widely read by Ottoman scholars. Şeyh Bedreddin's most recognized ideas on the Unity of Being were a compilation of his conversations. Hacı Bayram Veli communicated his ideas to the public through his poems, which were akin to folk literature. All the four individuals made use of different discourses using different terminology and techniques for explaining their ideas. In his treatises, Davud b. Mahmud el-Rumi el-Kayseri made use of positive sciences, especially physics, in explaining the Unity of Being. Molla Hamza Fenari used allegorical metaphors discussing the related concepts. In his conversations, Şeyh Bedreddin gave demystifying explanations for the conventional metaphors which had been used for spiritual concepts. Davud b. Mahmud el-Rumi el-Kayseri constructed the philosophy of the Unity of Being by giving explicit and analytical explanations. He discussed the concept of unity in terms of "energy" of "atomic particles" common to all "things." He introduced the concept of "thing" referring to all creation, covering everything whether considered as living and non-living.

Molla Hamza Fenari deconstructed the concept of "thing" as made up of two different components: body and essence. He discussed the relationship between the body and essence as a means of gaining knowledge. Following el-Kayseri's discussion of unity with respect to energy common to all things, Fenari introduced the concept of multiplicity. He discussed the multiplicity of things with reference to the multiplicity of bodies, contrary to the unity of essence in all things.

Şeyh Bedreddin introduced the concept of "public" in the discussion about the multiplicity of things. He highlighted the presence of the public as one of the things to contemplate, thus to love. Hacı Bayram Veli presented the concept of the "individual" as another thing to contemplate to gain True Knowledge. Different than the anonymous body of public, Hacı Bayram Veli's presentation of the individual stressed the identity and consciousness of the individual Self.

As a brief summary, these four scholars introduced the following key words in the study and interpretation of the concept of the Unity of Being, which will be discussed in detail in the following pages: journey, text, garden, paradise garden, energy, thing, thingness, experience, encounter of things, body and essence, love as contemplation, unity, multiplicity, city, public, and individual.

Davudu'l-Kayseri structured a cosmology upon the doctrines introduced by the Unity of Being.[66] He explained the harmony and oneness of all the creation in terms of energy. He was not only interested in the metaphysical world, but also studied the physical world, introducing a convincing doctrine about the Unity of Being, covering both the divine and phenomenal worlds.

According to him, all nature was pure energy. He considered all living and non-living things to be made out of atomic particles carrying energy. These particles were organized in different numbers and in a different order in every other thing. Thus this variety of atomic order created the multiplicity of things. Energy was common to all divine and phenomenal existence. Time was an empirical experience exchanged between things.

Davudu'l-Kayseri argued all things to be alive; however, he explained that human intellect considered things whose life was not understandable to him as non-living. Thus according to him, these things considered to be non-living were in fact living things. Things were existent in either spiritual or physical worlds. Things in the spiritual world contained the knowledge of thingness. However, things in the physical world had a reflection of a distorted knowledge of their thingness. Thus, in the physical world, between the thing and its true being—its knowledge which acknowledges its thingness—there was a gap. The things of the physical world did not portray a true vision of what they refer to in the spiritual realm. This gap between the thing and its true essence was considered as a space of contemplation. This space of contemplation provided means for an interaction between the two worlds, and such an interaction enabled that all things in the physical world match with their true knowledge in the spiritual world. Mapping the space between a thing seen and its true knowledge was considered to be a spiritual journey from the physical to the spiritual world. It was a quest to find the true meaning of things.

This spiritual journey was described in stages of spiritual evolution. True knowledge required by the spiritual journey from the physical to the metaphysical world was considered as a quest for Universal Truth. Universal Truth was common to all the creations of God. It was the basic knowledge that underlined the whole being. This basic and universal knowledge was metaphorically explained as "the water of life." Drinking from the water of life was meant to be illuminated by the ultimate knowledge of creation, thus the knowledge of God. However, different from the readings of Ibn al-'Arabî, regarding this spiritual journey, Davudu'l-Kayseri condemned the desireful human soul. Desire was an obstacle which was to be trained and eliminated.

Molla Fenari explained the world as a book made out of divine letters.[67] Divine letters carry the essential truth and knowledge of God. These letters combine to make words, sentences, phrases, and texts, all of which are divine. The human being called *insan-ı kamil* is the most perfect creation of this book. According to Fenari, the essence of God was described according to its qualities (*sıfat*). These qualities were listed as life, science, will, power, audition, sight, speech and creation (*Hayat, İlim, İrâde, Kudret, Semi', Basar, Kelâm, Tekvin*). They were neither static descriptions of the essence of God, nor images reflecting it. Fenari explained these qualities as relative natures with respect to the essence of God. These qualities were then manifested in the names of God. Finally, the names of God were manifested in things. This representation takes place in three stages, evolving from the True Being and

finally completing in things, in the sequence of essence–quality–name–thing, which could not be traced back to the essence of God. Thus the thing would never be considered as equal to the name, the quality, or to the essence of God itself. According to Fenari, qualities were not directly illustrated in names nor were they equal to them. As well, the names once manifested in the presence of things became hidden, and invisible to the eyes of the human being. Though those people who trained themselves, who were illuminated, were able to see the presence of the name of God, and his qualities in things created.

Apart from his scholarly significance, Şeyh Bedreddin was also a political and military figure. He was a *kazasker* to Çelebi Musa in 1405–1412 during the "interregnum" after the Battle of Ankara in 1402.[68] However, when Çelebi Musa was defeated by Mehmed I in 1413, he and his soldiers were perceived as rival forces in opposition to the Ottoman power. In 1416, Şeyh Bedreddin was accused of manipulating the public towards disorder and heresy. In particular, his followers' agenda of dissident abandoned traditional Muslim practices, believing in the unity of religions, and thus, the union of the members of all religions, and also of sharing property on a communal basis. He was accused of heresy, acting against Orthodox Law by announcing his prophecy. A group of Bedreddin's disciples rebelled against the central authority in various regions of Anatolia. When Bedreddin was in Edirne Börklüce Mustafa in Karaburun, İzmir (1415), Torlak Kemal in Aydın and Aygıloğlu Kazova all gathered local populations to rebel against the Ottoman authorities. At the same time as his dissidents were rebelling, Bedreddin fled to Dobruca and announced his prophecy. He rebelled in Dobruca, not only with the support of provincial villagers—as it was the case in first Türkmen revolts in Anatolia—but with the additional provision of land owners, prior Christian feudal landlords and Sufi dervishes, who were all in pursuit of regaining their status.[69] These rebellions for creating anarchy were called one of the Kızılbaş rebellions. Bedreddin was executed in 1416. During the trial before his execution, he was acknowledged as one of the most prominent intellectuals of his time, though he had to be executed for acting against Ottoman authority.[70]

Vâridât is a collection of Bedreddin's mystic conversations compiled in 1407, mainly about the philosophy of the Unity of Being. He tried to explain the creation in a logical method. Bedreddin acknowledged invisible creatures like angels and devils to be things imagined by the human intellect. Thus angels metaphorically represented good will and power; while the devil represented evil desires. Similarly paradise and hell were described as having symbolic existence. The trees, rivers, fruits and houris promised in the paradise garden were explained as being mere metaphors, similar to the symbolic fire of hell. In *Vâridât*, he made five different interpretations of paradise, from the most literal explanation to the least. The most literal was his portrayal of paradise as the garden promised in the afterlife. However, the least literal explanation presented the perspective of a mystic and a heretic at the same time. Bedreddin argued that paradise was meant to be a spiritual station either in the hereafter

or in the phenomenal world. The human being would arrive at these spiritual stations whenever he lost himself within the Unity of Being. Bedreddin's agenda strongly emphasized the importance of the phenomenal world. He stressed the human being as the "caliph" of God, as evidence of God's presence in the phenomenal world. The public also had an important place in his agenda. He acknowledged the public as the multiplicity of human beings, who the real Sufis should take pleasure in as they do in the unity of God. The public were also a part of the being. Thus, Bedreddin argued that there was no contradiction in enjoying the unity of God or the multiplicity of the public. He described a true Sufi as the son of time, who would not worry about his past, or for his future, but would glorify the present time by enjoying the unity of Being in God. In addition to this, he would appreciate the Unity of Being in the multiplicity of the beloved ones—thus in the multiplicity of the common public.[71]

There is a famous commentary composed by Nûreddin-zâde (d. 1573) disapproving the content of *Vâridât*. The following quotation from Nûreddin-zâde disapproves the comparison of Ibn 'Arabî to Bedreddin, whom he considers as a heretic:[72]

Part of the public was become perverted, and influenced some others who had faith in them; part of the public stayed mute due to their lack of knowledge on the basic principles of Islam; moreover these people even considered an eminent man like Şeyh-i Ekber (Ibn 'Arabî) as carrying the same faith as him (Bedreddin). God forbid!

Yet, a reader who called himself Can wrote a long commentary in the margins of the page criticizing Nûreddin-zâde. This reader acknowledges that Nûreddin-zâde was himself an admirer of Ibn 'Arabî so that he used to instruct his students about the works of 'Arabî and especially requested the study of *Fusus al-Hikem*. This reader argues that such a person who understood 'Arabî should have also understood and respected scholars like Bedreddin. Therefore, according to Can, the commentary of Nûreddin-zâde on Bedreddin was not fair, and was probably written for the sake of gaining the attention of a conformist audience.[73]

Hacı Bayram Veli (1352–1429/30) was a poet apart from being a Sufi dervish. He was a scholar of Kara Medrese in Ankara. However, he left his position as a scholar to become a mystic, and he traveled to Mecca and Damascus, and later returned to Ankara. He then founded the *Bayrami* order. His fame for being a former scholar and his mystic ideology which reflected the latter ideals of the *Melâmî* order created a lot of adherents among the public. In order to understand his growing recognition, Murad II (1421–1444) wanted to learn more about him, and invited him to Edirne. The Sultan was overwhelmed by Hacı Bayram Veli's wisdom and his teachings. The Sultan insisted that he stay in Edirne, but he returned to his hometown Ankara after a short stay in Edirne. His ideology united arts and crafts. He advised working and finding pleasure in work. He encouraged the singing of songs while working.[74] The

following poem by Hacı Bayram Veli acknowledges his perspective on the composition of the Ottoman faith as diverse within two worlds; the Orthodox and the heterodox traditions:[75]

> My Lord has created a city
> In between two worlds.
> One sees the beloved if one looks
> At the edge of that city
> I came upon that city
> And saw it being built
> I too was built with it
> Amidst stone and earth

The city metaphor also stood for the esoteric sciences:[76]

> I am the city of science, Ali is its door.

The city metaphor was also used extensively in the mystic folk poetry of Yunus Emre and other poets. The metaphor of pilgrimage was also a common one which accompanied the metaphor of the city. Thus, pilgrimage in the city stood for a spiritual development through esoteric sciences.[77]

Reception of Ibn al-'Arabî's Philosophy in the Ottoman World After the Conquest (1453–1730) and the *Melâmîs*

By the early sixteenth century, when the Ottoman Empire had established its authority as a centralized Sunni order, all traditions outside Islamic orthodoxy were considered as threats to the Ottoman ideology. Among other Sufi orders, the philosophies of Ismaili Gnostics and Shiah made their way into Asia Minor. While most of the Sufi orders of Asia Minor were pursuing mystic practices under the dominant Sunni Law, Ismaili and Shiah influences accelerated the growth of mystic orders under the Shiah principles. Thus, later Ottomans named the adherents of Sufi orders under Shiah influence Kızılbaş because of their red outfits, as explained in the following paragraph. Kızılbaş groups became a revolting population. Thus when the Ottomans adopted Sunni Law as an imperial conviction, they became extremely conscious of the activities of mystic orders, observing and controlling their development, and condemning their associations with any other theological philosophy outside the domain of Sunni Law, especially with Shiah beliefs. Fatih's period of rule (1444–1481) was spent conquering neighbouring countries. This was a tiring period for the army, as well as exhausting the populace, especially the rural population, because of taxes being increased in order to support military campaigns in the East and the West.

During the sultanate of Fatih's son Beyazıd (1481–1512), despite Beyazıd's peaceful attitude compared to his father, the Türkmen tribes who resided on the periphery of Ottoman rule in the rural areas were fighting for their

survival and economic sustainability in defiance of a higher authority asserted by the centralized power of the Sultan. These Türkmens protested against the taxation system and authority by dressing in red outfits, and they were called "Kızılbaş" (Redheads) after the color red. These tribes, supported by Shah Ismail of the Safavids, revolted in East Anatolia in the name of the rebellion "Şahkulu." After Selim (1512–1520) had ascended to the throne, his army won the Çaldıran Victory against Shah Ismail in 1514, and after this victory he was able to sustain order in East Anatolia for a while.

The conflict and confrontation as defined between the drive and wish for a governing centralized Islamic law and inherited heterodox traditions had always been brought up as problematic during times of unstable political and economic periods of the empire.[78] These circumstances forced the development of mystic movements in urban centers under the control and inspection of the central Shariah Law. The aim of the following pages is to study the influence of 'Arabî's philosophy throughout the sixteenth to the eighteenth centuries and they will map 'Arabî's followers in urban centers. This study will also include the development of *Melâmî* philosophy in Istanbul following the *Bayrami* order founded by Hacı Bayram Veli in Ankara.

Islam constituted two different worlds. Orthodox Islamic tradition (Shariah) formed the exoteric teachings of the religion; Islamic mysticism (tariqat) formed the esoteric teachings. Shariah was the teachings of the religious text, tariqat was the teachings of the Gnostic enlightenment. Shariah had been studied in schools of Law (*madrasa*). Tariqat developed by various means: among mystic brotherhoods, practiced in Sufi lodges (*tekkes*, and *zawiyas*) by individual mystics, institutionalized orders, or secret societies.[79] The unconventional Sufi practices had usually been targets of disapproval, criticism and attack. There were three main Sufi practices performed communally; dancing (*devr*), singing (*sema*), and remembrance (*zikr*). At many instances of the Ottoman history, various Orthodox scholars of Shariah condemned different Sufi practices, arguing that they were not known at the time of the Prophet. Thus, they were invented by the Sufis themselves, and they were not acceptable practices in a Muslim community. Sufi practices of "listening to music, singing and chanting" are called *sema*. Sufi dance is called *devr*. *Devr* stands for rotation and dancing in a circle. In *Kadiri, Rufai, Halvati, Gülşeni*, and *Uşşaki* orders dancing was part of the mystic practices. Every Sufi order practiced dancing in a different way. Dancing was a means to stir up the emotional and bodily involvement. It was the movement of both the body and the soul.[80] Though most of the Sufi dance rituals took place in Sufi lodges, some were recorded as being performed in the open air. For example, a European traveler to Samarkand documented Sufis practicing dance in the meadows. At the beginning of the ritual, Sufis were seated around their master. By the end of ritual, they were dancing freely all around the meadow. Though most of the Sufi rituals were open to communal display, the *Mevlevi* dance was the most popular. In the

1582 festival, dancing *Mevlevi* dervishes participated in the parade of the guilds.[81] Another controversial Sufi practice, *zikr*, was the remembrance of God by repeating his names. *Zikr* combined language, bodily movement and breathing into a rhythmic practice.

Gölpınarlı argues that many Sufi orders were influenced by *Bâtınî* (*Bâtınîyya*) concepts, and thus they were associated with Shi'i doctrines,[82] and were influenced by Indian–Persian religions and Greek philosophy. Like Sufi orders, *Bâtınî* orders were multiple and they differed from one another. However, there were two common principles *Bâtınîs* carried out. First, they accepted a human being as a messiah as equal to God. This messiah could be either the prophet himself, or another religious personality of significance. Thus *Bâtınîs* were known to acknowledge the leaders of each different order as prophets themselves. Second, they practiced intentional misinterpretation (*ta'wil*) of the religious text, the Koran. They have argued that the laws of Shariah would not be relevant for those who were able to decipher the true meaning, the essence of Law. During the ninth century, with respect to the anarchist practices of members of the Bâba-î order that had a red flag and wore red attire, *Bâtınîs* came to be called Redheads (*Kızılbaş*).

In addition to the Alevi and Bektashi orders among the Sufis, *Melâmîs*, *Nusayrîs*, *Baba'îs*, *Kalenderîs*, *Haydaris*, and *Celâlis* were also strongly influenced by *Bâtınî* concepts. Thus, in history, members of these orders were also called as Redheads from time to time. As acknowledged by Yaşar Ocak, there are two main groups in Heterodox Islam, who had practiced the doctrines of *wahdat al-wujûd*; *Gülşeni* order and *Melâmî* philosophy. As Derin Terzioğlu points out in her seminal work, there was an increasing interest in the works of Ibn al'Arabî, which reached a climax during the mid-seventeenth century: "'extreme' interpretations, or misinterpretations, of the teachings of *wahdat al-wujûd*, attributed among others to some *Melâmî* sheikhs in the sixteenth and seventeenth centuries."[83] The research of Terzioğlu shows that from the fifteenth to the eighteenth centuries, the relationship between the ruling class, elite *ulama*, and the Sufis illustrate three different periods: appreciation and protection of Sufism, a balance, and finally prohibition. By the first quarter of the sixteenth century, the Ottoman elite culture was beginning to get separated between two opposing tendencies, one following a desire to establish an Orthodox Muslim community associated with the Salafi movement, the other expressing a growing interest in Islamic mysticism. Terzioğlu points out that by the early sixteenth century, higher-ranking scholars like Sarı Kürz (d. 1521/23), *kadı* of Istanbul, and Gürz Seydi, a *müderris*, were the first scholars who opposed the Sufi practices.[84] She shows that the chief muftis of early sixteenth century had conflicting attitudes towards Sufis and Sufi practices. Zenbilli 'Ali Cemali (d. 1525), the chief mufti—a *Halveti* Sufi himself—was defending Sufi practices, while his descendant Kemalpaşazade (d. 1537), had forbidden Sufi dance, and attacked *Melâmî* practices in particular. However as Terzioğlu notes, Kemalpaşazade was a protector of Sufis and a devotee of Ibn 'Arabî. He advised the building of a mosque

complex honoring Ibn 'Arabî when Selim I conquered Damascus.[85] Terzioğlu points out that another chief mufti, Çivizade Mehmed (d. 1547), was against both the Sufi practices and teachings of Ibn 'Arabî, and even Mevlana Celaleddin-i Rumi. The latter chief muftis of the late sixteenth century and early seventeenth century, Ebussud Efendi (1545–1573); Sunullah Efendi (who held the office several times between 1599 and 1606/8); Esad Efendi (who held the office several times between 1615 and 1625); and Zekeriyazade Yahya (who held the office several times between 1622 and 1644), generally tried to establish a "harmony" between mystic practices and Orthodox laws. Thus they were praised as "the unifier of the seas of the Sharia and the Sufi path (*mecma'ü'l-bahreyn-i şeri'at ü tarikat*)."[86]

By the end of the sixteenth century, the hostility between the Sufis and Sunnis was growing. A group of scholars, who aimed to imitate the life of Mohammed and thus practice Orthodoxy in its most original state, conflicted with all Muslim traditions which they argued were not initiated during Mohammed's era. They called Sufi practices novel inventions, contradicting the fundamental traditions of the religion. They claimed that Sufi practices were not performed by Mohammed, and argued for their abandonment. This extremist movement was called the Salafi movement. It was instigated by Kadızade Mehmet Efendi (d. 1635), who was a preacher, and Birgivi Mehmed Efendi (d. 1573), who was a scholar. The advocates of the Salafi movement were called Kadizadelis, and they were numerous amongst the preachers, public lecturers, provincial scholars, and guilds. Thus, Terzioğlu argues that the chief muftis of the late seventeenth century, under the influence and compelling force of the Salafis, were severe with Sufis and Sufi practices compared to their predecessors of earlier periods. Kadızadelis of the mid-seventeenth century and Minkarizade, the chief mufti of the late seventeenth century, were aggressive towards Ibn al-'Arabî's doctrines, whose popularity was expanding in the *ulema* and elite circles by then.

The following quotation from Terzioğlu explains the efforts of the Sufi circles following the doctrines of 'Arabî in their struggle to reconcile Sufism with Shariah. The metaphor of reconciling the two seas was a common one both in the work of 'Arabî and his followers, such as Niyazi-i Mısrı (1618–1694), Ottoman Sufi writer and poet, who explains the metaphor as follows:[87]

In his explication of the Quranic verse "He has set two seas in motion that flow side by side together / with an interstice (barzakh) between them which they cannot cross." (Rahman, 19–20) Mısrı explained that the relationship between the two seas was analogous to the relationship between shari'a (the religious law, the object of the study of the ulama al-zahir) and hakika (divine reality, the object of the quest of the 'ulama al-batin). Just as the two seas were prevented from mixing by the barrier between them, these two groups were prevented by a similar barrier from realizing that they were in fact searching after the same truth, and remained at odds. Only a minority of people from both sides who managed to climb to the top of that barrier could see and verify that exoteric and esoteric knowledge are in fact one, and these were the people to whom Mısrı referred as the "people of the A'raf" and as the meeting-place of the two seas (*majma' al-bahrayn*).

Ibn al-'Arabî's teachings were also quite influential in *Melâmî* society. Sarı Abdullah (d. 1644/45) had written a commentary on the *Fusus-al-Hikam* of Ibn 'Arabî. Despite the growing antagonism towards *Melâmîs*, their philosophy found more adherents among the intellectual groups of the elite due to their secret activities. By the beginning of the seventeenth century, there were *Melâmîs* among high-ranking officials, including the posts of chief mufti and grand vizierate. Among these officials were chief muftis Ebulmeyamin Mustafa Efendi (m. 1603/4–1606) and Paşmakçızade Seyyid Ali Efendi (who held the service several times in 1704–1712); grand vizier Halil Pasha (1617–1619 and 1626–1628).

By the early eighteenth century, Şehid 'Ali Pasha (1713–1716), who was the grand vizier, was also the leader of *Melâmî* society (*Melâmî kutb*). In the early eighteenth century, grand vizier Damad Ibrahim Paşa, court poet Nedim, Habeşizade Mevlevi Abdürrahim Efendi, known as poet Rahimi, La'lizade Abdülbaki, Reisülküttab Mustafa Efendi, Ahmed Arifi Paşa, Defterdar Sarı Mehmed Paşa, historian Mehmed Raşid, Mustafa Sami, and Osmanzade Taib were all *Melâmîs*.[88]

The first phase of *Melâmî* values had been initiated and developed among the guilds and tradesmen in the cities of Horasan, Merv and Belh in the ninth century. By the fourteenth century, as a result of the interaction with *Hurufis*, the philosophy had adopted the tradition of *wahdat al-wujûd*, and entered a second phase called *Melâmî-Bayrami* philosophy. Ocak defines *Melâmîs* as a semi-political mystic philosophy.[89] In Anatolia, *Melâmîs* developed as a separate faction derived from the *Bayrami* order which was founded by Hacı Bayram Veli. (See the related appendixes showing the development of the *Bayrami* order and *Melâmî* philosophy).

Ottoman *Melâmîs*, also acknowledged as *Melâmîs-Bayrami*, formed a secret society.[90] Though they stressed that they were not an institutional society and they abandoned all kinds of institutional affiliations, dress code, or ritualized ceremonials like other Sufi orders, yet they were organized around a central figure called pole (*kutb*) who had assistants called guides (*rehber*), and, a group who look after the heart (*kalbe bakıcılar*).[91]

Melâmîs rejected Sufi practices, especially *zikr*, which was the remembrance of God by continually reiterating the names of God. Despite this, they favored conversing as the principal *Melâmî* practice. The most important *Melâmî* practice was to clean one's heart of pride, desire and lust, in order to let it get filled with the love of God. This activity was called the Cleaning of the Heart. The way to clean one's heart was enabled by conversing about Truth. *Melâmîs* were required to be honest and to live on uncorrupt earnings.[92] Following Hacı Bayram, *Melâmîs* also stressed the presence of God in human beings, and thus the importance of self and self-knowledge. The following poem by Hacı Bayram Veli acknowledges his philosophy on the importance given to self:[93]

> He whoever knows about his own desires
> He knows about his own qualities.
> He recognized himself in His image.
> You should know yourself, you, yourself!
> Bayram learned about his essence
> He found the enlightened in himself,
> He found himself.
> You should know yourself, you, yourself!

Melâmîs earned their own livelihoods, had their own businesses. Some of the prominent *Melâmî* figures belonged to guilds. These included Yakub-i Helvai (from the guild of desert makers); *Melâmî* poles Ahmed-i Sârban (from the guild of camel traders); and Hasan-ı Kabâdûz (from the guild of tailors). In order to hide their association with the *Melâmîs*, they became members of other Sufi orders. They made use of the institutionalized Sufi orders and the established organizations of the guilds both to conceal and to expand *Melâmî* philosophy. It was a common tendency of the heterodox groups to hide their development within the organization of guilds.[94]

Melâmî thought openly entered the city of Istanbul when the Sultan invited the pole İsmail Maşuki (d. 1539) to the city. Maşuki influenced the expansion of *Melâmî* philosophy in Istanbul among the guilds and the army (*Sipahiler Ocağı*). However, he was accused of acting and behaving against the Islamic Law and executed with several of his disciples in 1539 after a court held against him in 1538–1539.[95] Maşuki guided his disciples to be their own masters, not subjects of another master.[96] At the same time, when Maşuki was preaching in Istanbul, another prominent *Melâmî* figure Ahmed Edirnevi (d. 1591) was engaged in *Melâmî* practices in the city of Edirne. After Maşuki's execution, the *Melâmî* order shifted its center out of the city of Istanbul to the provinces. They continued developing and expanding in secret. They established themselves in Edirne and its environs, and further expanded towards the Balkans to Bosna. By the third quarter of the sixteenth century, *Melâmîs* had a significant number of advocates in Thrace and the Balkans. Already by the early fifteenth century, Hacı Bayram Veli's visit to Edirne had been shaped following the *Bayrami* order. And at the same period, the Edirne and Dobruca regions and their vicinity had housed the advocates of Şeyh Bedreddin. As well, since the late thirteenth century, the Balkan states were also the home of Türkmen tribes. In their development in Thrace and the Balkans, *Melâmîs* encountered these local communities and they mutually inspired one another.

By the early seventeenth century, *Melâmî* poles returned to Istanbul, and the development of the community continued until the first half of the eighteenth century. After the end of the Tulip Period until the second half of the nineteenth century, there is a gap in the documentation and history of the community. Thus, when *Melâmî* thought was revised in the nineteenth century, it was established as an institutionalized Sufi order.

Though the *Melâmî* poles were positioned out of the city of Istanbul, the philosophy continued developing in the city of Istanbul, attracting more adherents. The first known *Melâmî* lodge was founded in 1548–1555 in the countryside of Istanbul, within the vicinity of the Bozdoğan Aqueducts. It was called the Helvai Lodge. By the end of the sixteenth and early seventeenth centuries, Saçlı Emir Lodge in Kasımpaşa, and Şah Sultan Mosque in Davutpaşa had become gathering places of the *Melâmîs*. However at the same time, during late sixteenth century, *Melâmîs* were also in favor of meeting at places outside the lodges, or places with religious affiliation. At the time, houses, bazaars and shops at Kapaliçarşı, Beyazıt, Unkapanı, and Eminönü became their meeting places.[97]

Melâmîs believed in the importance of individuality and the human self in the attainment of knowledge. *Melâmî* philosophy developed as a protest culture that was expressed through a new way of life. *Melâmî* society became a marginal group developed in seclusion in spaces peripheral to central authority. However, by the late seventeenth and early eighteenth centuries, it was carried to the center—though in covert practices—when some high-ranking officials in the Ottoman court came to practice the *Melâmî* philosophy.

Notes

1. For an introduction to Ibn Rushd, see Kemal Salim, *The Philosophical Poetics of Alfarabi, Avicenna and Averroës: The Aristotelian Reception* (London; New York: Routledge Curzon, 2003), and Oliver Leaman, *Averroës and his Philosophy* (Oxford: Clarendon Press, 1988). For the contradictory position of Ibn Rushd among Islamic scholars, see Iysa Ade Bello, "Ijma' and Ta'wil in the Conflict between al-Ghazali and Ibn Rushd," unpublished PhD thesis, University of Toronto, Toronto, 1985. For Ibn Rushd's influence on Western philosophy, see Therese-Anne Druart, "Averroës: The Commentator and the Commentators" in *Aristotle in Late Antiquity*, ed. Lawrence P. Schrenk (Washington, DC: Catholic University of America Press, 1994).

2. See Appendix 1 for a brief summary of Ibn 'Arabî's life and bibliography on 'Arabî.

3. Steffen Stelzer, "Ibn Rushd, Ibn 'Arabî, and the Matter of Knowledge," *Alif* 16 (1996), 19–55.

4. The following remark by Nasr explains the importance of these two scholars and their influence on the latter Christian and Islamic societies explicitly: "In an encounter which is full of significance, for in it two personalities meet who symbolize the paths to be followed in the future by the Christian and the Islamic worlds." Seyyed Hossein Nasr, *Three Muslim Sages: Avicenna, Suhrawardi, Ibn Arabi* (Cambridge, MA: Harvard University Press, 1964c, 1969), 93.

5. C.M. Woodhouse, *George Gemistos Plethon: The Last of the Hellenes* (Oxford: Clarendon Press, 1986). I am thankful to Professor John Monfasani, Director of the Renaissance Society of America, for his reference to Gemistos Plethon.

6. Ibrahim Kafesoğlu, *Selçuklu Tarihi* (Istanbul: MEB, 1972), 151–186; Cemal Kafadar, *Between Two Worlds: The Construction of the Ottoman State* (Berkeley,

CA: University of California Press, 1995), 60–151; Stanford Shaw, *History of the Ottoman Empire and Modern Turkey Volume I: Empire of the Gazis: The Rise and Decline of the Ottoman Empire, 1280–1808* (Cambridge; London: Cambridge University Press, 1976), 1–11; Mehmed Fuad Köprülü, *Islam in Anatolia after the Turkish Invasion (Prolegomena)*, trans. Gary Lesier (Salt Lake, UT: University of Utah Press, 1993), 3–31; Speros Vryonis Jr, "Nomadization and Islamization in Asia Minor," *Dumbarton Oaks Papers* 29 (1975), 41–71; Mikail Bayram, *Ahi Evren ve Ahi Teşkilatının Kuruluşu* (Konya: Damla Matbaacılık, 1991), 11–31, 129–160; Abdülbaki Gölpınarlı, "Islam ve Türk İllerinde Fütüvvet Teşkilatı ve Kaynakları," *İktisat Fakültesi Mecmuası* X (1949–1950), 6–354; Cemal Anadol, *Türk-Islam medeniyetinde Ahilik Kültürü ve Fütüvvetnameler* (Ankara: T.C. Kültür Bakanlığı, 2000).

7 Henry Corbin, *Creative Imagination in the Sufism of Ibn' Arabi*, trans. Ralph Manheim (Princeton, NJ: Princeton University Press, 1969), 13.

8 William C. Chittick, *The Self-Disclosure of God: Principles of Ibn al-'Arabî's Cosmology* (Albany, NY: State University of New York Press, 1998), 79.

9 Ibid., 89.

10 Ibid., 57–60.

11 Ibid., 3; 8; 23.

12 Ibid., 91.

13 For a contradictory discussion about Sufi episteme, see Syed Jamaluddin, "Epistemology in the Sufi Discourse," *Islam and the Modern Age,* vol. 26, issue 2/3 (1995), 137–148.

14 Movement can be observed through traces which will be left on things: William C. Chittick, *The Self-Disclosure of God*, 59.

15 Henry Corbin, *Creative Imagination in the Sufism of Ibn 'Arabî*, 60–61.

16 Reynold A. Nicholson, *The Mystics of Islam* (Beirut: Khayats, 1966), 68.

17 Henry Corbin, *Creative Imagination*, 220–224.

18 William C. Chittick, *The Self-Disclosure of God*, 346–349.

19 Henry Corbin, *Creative Imagination*, 3–4.

20 Ibid., 3–4.

21 Ibid., 156.

22 William C. Chittick, *The Self-Disclosure of God*, 260–261.

23 Ibid., 259–262.

24 Ibn 'Arabî, *İlahi Aşk*, trans. Mahmut Kanık (Istanbul: Insan Yayınları, 2002), 21; translated from:

 Varlık bir harftir sen onun anlamısın / Hayatta bir emelim yok ondan başka / Harf bir anlamdır, anlamı kendindedir / Göz görmez o anlamdan başka hiçbir şey / Kalb gider gelir fıtratının bir gereği / Kah şekline o harfin kah anlamına / Tanrı yücedir, Hiç kimse onu içeremez / Ama biz O'nu kalbimize sığdırırız

25 Henry Corbin, *Creative Imagination*, 14.

26 Annemarie Schimmel, *Mystical Dimensions of Islam* (Chapel Hill, NC: University of North Carolina Press, 1975), 293.

27 Ibn 'Arabî, *İlahi Aşk*, 64.

28 Annemarie Schimmel, *Mystical Dimensions of Islam*, 290.

29 Henry Corbin, *Creative Imagination*, 151.

30 William C. Chittick, *The Sufi Path of Knowledge: Ibn al-'Arabî's Metaphysics of Imagination* (Albany, NY: State University of New York Press, 1989), 117–118.

31 Edith Jachimowicz, "Islamic Cosmology," *Ancient Cosmologies*, eds. Carmen Blacker and Michael Loewe (London: George Allen and Unwin, 1975), 143–155.

32 Divine essence (*hadrat al-dhât/ hâhût*—stage of selfhood, or the world of Absolute Mystery), Presence of Divinity (*hadrat al-ulûhiyya / lâhût*—Divine names). This second stage is also associated with the Universal Intellect /*al-akl al-kullîy*). The third stage is called Presence of Masterhood (*hadrat al-rubûbiyya/ djabarût*), followed by the fourth stage of world of imagination (*barzakh*), and finally by the plane of sensible experience (*mushâdada*); Jachimowicz, "Islamic Cosmology," 156–171.

33 All Sufi cosmologies differed from one another. As an example of a Sufi cosmology, Ardalan and Bakhtiar give the following cosmological order. The authors do not give the source of this hierarchy. The seven stages of Being are first, the Divine Essence (*'âlam-i-hâhût/ latîfah haqîqa*, the sphere of Truth), second the Divine Nature (*'âlam-i-lâhût/ latîfah khafiya*, inspiration), third (*'âlam-i-jabarût/ latîfah rûhiyya*, spirit), fourth, the world of imagination (*'âlam-i-malakût/ latîfah sirriya*, superconciousness), fifth, the world of spiritual perception (*'âlam-i-ma'nâ/ latîfah qalbiyya*, the heart), sixth, the world of forms (*'âlam-i-sûrat/ latîfah nafsiyya*, vital senses), and finally, the lowest and the seventh is the world of nature (*'âlam-i-tabî'at/ latîfah qâlibiyya*, body); Nader Ardalan and Laleh Bakhtiar, *The Sense of Unity: The Sufi Tradition in Persian Architecture* (Chicago and London: University of Chicago Press, 1973), 3–10.

34 William C. Chittick, *The Self-Disclosure of God*, 116–117.

35 William C. Chittick, *The Sufi Path of Knowledge*, 151–156.

36 Arabi quoted in Chittick, *The Self-Disclosure of God*, 255.

37 *Ibid.*, 393 n. 16.

38 *Ibid.*, 344. Contrary to Arabi's positive evaluation of the Soul as an agency that can be used to acquire knowledge, the generic Sufi belief is towards accepting the Soul as an organ embodying evil for its inhibition by worldly forms and desire; R.W.J. Austin, *Sufis of Andalucia* (London: Ruskin House, 1971), 53.

39 William C. Chittick, *The Self-Disclosure of God*, 395 n.18.

40 *Ibid.*, 362.

41 *Ibid.*, 57.

42 Chittick interprets Arabi's explanation of the creation of the earth (the witnessed world / the mundane world of the human beings) both as "corruption" (*arada* in Arabic means a woodworm damaging the pages of a book), and as an ornament (*sūs*): William C. Chittick, *The Self-Disclosure of God*, 254–255.

43 *Ibid.*, 255.

44 *Ibid.*, 357.

45 *Ibid.*, 358

46 *Ibid.*, 348.

47 *Ibid.*, 60.

48 *Ibid.*, 256.

49 Reynold A. Nicholson, *The Mystics of Islam* 90–91.

50 William C. Chittick, *The Self-Disclosure of God*, 339.

51 *Ibid.*, 162.

52 *Ibid.*, 393–395.

53 *Ibid.*, 339.

54 *Ibid.*, 345.

55 *Ibid.*, 346.

56 *Ibid.*, 340–343.

57 *Ibid.*, 339.

58 *Ibid.*, 341–342.

59 *Ibid.*, 344.

60 *Ibid.*, 344.

61 For basic reading on the followers of 'Arabî in Anatolia see the following works: William C. Chittick, "The Five Divine Presences: From al-Qunawi to al-Qaysari," *The Muslim World* 78 (1998), 51–82 and Ahmet Yaşar Ocak, *Osmanlı Toplumunda Zındıklar ve Mülhidler 15.–17. Yüzyıllar* (Istanbul: Tarih Vakfı, 1998); and the unpublished PhD thesis by Derin Terzioğlu, "Sufi and Dissent in the Ottoman Empire: Niyazi-i Misri (1618–1694)"; Mehmet Bayraktar, *Kayserili Davud* (Ankara: Kültür ve Turizm Bakanlığı, 1998); Mustafa Aşkar, *Molla Fenari ve Vahdet-i Vücud Anlayışı* (Ankara: Muradiye Kültür Vakfı Yayınları, 1993); Michel Balivet, *Şeyh Bedreddin: Tasavvuf ve isyan (Islam mystique et révolution armée dans les Balkans ottomans: vie du Cheikh Bedreddîn le "Hallâj des Turcs" 1358/59–1416)*, trans. Turkish Ela Güntekin (Istanbul: Tarih Vakfı Yurt Yayınları, 2000); and Abdülbaki Gölpınarlı, *Simavna Kadısıoğlu Şeyh Bedreddin* (Istanbul: Eti Yayınevi, 1966).

62 Cemal Kafadar, *Between Two Worlds*, 60–151.

63 *Ibid.*, 60–151.

64 He was a friend of Mevlana Celaleddin Rumi. He later became the student of Evhadüddin-i Kirmani (d. 1238), who was a close friend of Arabi. The famous Sufi mystic Abdülrezzak Kaşani (d. 1329) was a disciple of Konevi. Among his many works, he was the author of *Nüsûs, Hukûk, Mefâtîh-ül-Gayb, Fâtiha Tefsîri, Şerh-i Ehâdîs-i Erbaîn*; William C. Chittick, "The Five Divine Presences: From al-Qunawi to al-Qaysari," 51–82.

65 Author of *Misbahu'l-uns, Aynü'l Ayan, Talikat ala Tefsiri'lKeşşaf, Haşiyetü Hırzi'l-Emani fi'l-Kıraat's-Seb', Tefsiri Sureteyi'l Kadrve'l Feth, Enmüzecü'l ulum*; Mustafa Aşkar *Molla Fenari*.

66 Davudu'l-Kayseri (d. 1350) was one of the first scholars who explained the philosophy of the Unity of Being explicitly. His analytical studies and commentaries made the doctrines of Ibn 'Arabî understandable to a larger audience. Later in the Ottoman, Persian, Indian and Arab worlds, scholars learned the philosophy of Ibn 'Arabî mainly by referring to Davudu'l-Kayseri's

commentaries on his work. Davudu'l-Kayseri was the first Ottoman scholar commissioned by Orhan Gazi, as the first scholar (*müderris*) to the İznik Medresesi. Davudu'l-Kayseri influenced the construction of the Ottoman scholarly tradition which followed from his ideals. He is considered a direct disciple of Ibn 'Arabî, the third caliph of the Ekberriye Sufi order, following 'Arabî and Sadreddin Konevi. Davudu'l-Kayseri's most important works were his commentary on Arabî's *Fusus*, titled *Matla'u Hususi'l-Kelim fi Maani Fususi'l-Hikem*, and a treatise on the concept of unity in multiplicity as explained by the philosophy of the Unity of Being. Among many other works, he also wrote a treatise on time and a treatise on the prophethood of Khidr. See Henry Corbin, *Spiritual Body and Celestial Earth From Mazdean Iran to Shî'ite Iran*, trans. N. Pearson (London: Taurus Publishers, 1990), 144–148.

67 Molla Fenari was the kadı of Bursa (k. 1393, 1415), and the first Ottoman Şeyhülislam (1424). Among his more than 100 works, Molla Fenari had written a commentary titled *Misbahu'l-Üns Beyne'l-Makûl ve'l-Meşhûd fi Şerh-i Miftâhü'l-Gayb el-cem ve'l-Vücûd* on Sadreddin Konevi's *Miftâhü'l-Gayb*. He included both Konevi's work and his commentary within the curriculum. He also wrote a treatise on the Unity of Being called *Risâle fi Beyân-ı Vahdeti'l-Vücûd*; Aşkar, *Molla Fenari*.

68 Şeyh Bedreddin was a famous scholar of Islamic Orthodox law and Islamic mysticism. He composed about 30 books on the interpretations of Shariah, Arabic language and mysticism, with a commentary on Arabi. However, he is most well known through the collection of his conversations compiled in *Vâridât*. He came from a family which had political military and intellectual significance. His grandfather was a high-ranking Seljuk officer. His father was an Ottoman *gazî* and religious officer. His mother was the daughter of a Byzantine commander. Bedreddin's wife and daughter-in-law were also Christian. Bedreddin traveled to Konya, Cairo, Mecca, and Tabriz. He became a distinguished scholar of sciences of astronomy, chemistry, and philosophy. He was a distinguished scholar of Islamic Law, as well as mysticism, including Hurufi philosophy. Bedreddin considered himself as a follower of Abû Madyan-ı Mağrıbî, who was also the master of Ibn 'Arabî. He was educated within the circle of intellectuals who considered themselves as disciples of Ibn 'Arabî (1240) and Hacı Bayram Veli (d. 1429/30). Influenced by Molla Fenari (d. 1430/31), and especially by Fenari's student Abdurrahman ibn 'Ali ibn 'Ahmad il-Bıstâmî, in later centuries Bedreddin was cited and studied along with Ottoman scholars like *Melâmî-Bayrami* Atayi (d. 1634), poet Necâtî (d. 1508), Katip Çelebi, and Niyazi-i Mısrî (d. 1694). The father of Şeyhülislam Ebusuud, Muhyiddin Muhammed (d. 1516), and later *Melâmî-Nûriyye* Sheikh Muhammed Nûr ül-Arabi (d. 1888), Seyyid Kemâleddin (d. 1882) composed commentaries on Bedreddin's *Vâridât*. There were also a number of translations of the *Vâridât* into Turkish, from the 19th to mid-20th centuries; Abdülbaki Gölpınarlı, *Simavna Kadısıoğlu Şeyh Bedreddin*.

69 Ocak, *Osmanlı Toplumunda Zındıklar ve Mülhidler*, 174–180.

70 *Ibid.*, 201–202.

71 Abdülbaki Gölpınarlı, *Simavna Kadısıoğlu Şeyh Bedreddin*, 51–88

72 *Ibid.*, 46.

73 *Ibid.*, 48.

74 Abdülbaki Gölpınarlı, *Melâmîlik ve Melâmîler* (Istanbul: Gri Yayın, 1992), 33–39.

75 Transated from Turkish in Kafadar, *Between Two Worlds,* vii.

76 "*Ben ilim şehriyim, Ali kapısıdır*" (Hadis el-Aclûnî, 2000: I, 235 no:618); Mehmet Yılmaz, *Edebiyatımızda İslâmî Kaynaklı Sözler* (İstanbul: Enderun Yayınları, 1992), 40.

77 Abdülbaki Gölpınarlı, "Alevi Bektaşi Edebiyatı," in *Tekke Siiri: Dini ve tasavvufi siirler antolojisi,* ed. Ahmet Necdet (İstanbul: Inkılap Kitabevi, 1997), 28–36; Abdülbaki Gölpınarlı, *Yunus Emre ve Tasavvuf* (İstanbul: Remzi Kitabevi, 1961); Abdullah Uçman, "Tekke Şiirinin Gelişimi," in *Tekke Siiri,* 37–47.

78 Halil İnalcık, *Osmanlı İmparatorluğu Klasik Çağ, 1300–1600,* 1973, trans. Ruşen Sezer (İstanbul: YKY, 2003), 40.

79 After being institutionalized in the 11th century, Sufi schools (*zaviyes, tekkes*) taught esoteric (*batıni*) knowledge, parallel to the exoteric (*zahiri*) practices taught in Shariah schools (*medrese*). Following the establishment of the first Ottoman *medrese,* a *tekke* was established next to it: Abdülbaki Gölpınarlı, *Melâmîler,* 169.

80 Metin And, *A Pictorial History of Turkish Dancing from Folk Dancing to Whirling Dervishes, Belly Dancing to Ballet* (Ankara: Dost Yayınları, 1976), 32–36; B. Duncan Macdonald, "Emotional Religion in Islam Affected by Music and Singing," *Journal of the Royal Society* (1901); 195–252; 705–748.

81 Metin And, who has studied the Sufi practices in terms of their performative quality, explains the multivocal quality of dancing in circles with respect to various influences and diverse symbolism. He argues that the Sufi dance resembled the movement of the planetary system. The rotation represented seasons of the year. The circle also symbolized the perfection and "harmony of the God's creation;" And, *A Pictorial History of Turkish Dancing,* 37.

82 On discussions about *Bâtınî* practices, see Abdülbaki Gölpınarlı, *Simavna Kadısıoğlu Şeyh Bedreddin,* 12–29; Mehmed Fuad Köprülü, *Islam in Anatolia after the Turkish Invasion (Prolegomena).*

83 Derin Terzioğlu, "Sufi and Dissent in the Ottoman Empire: Niyazi-i Misri (1618–1694)," unpublished PhD thesis (Cambridge, MA: Harvard University, 1999), 242–243.

84 *Ibid.,* 139–166.

85 *Ibid.,* 223.

86 *Ibid.,* 229.

87 *Ibid.,* 270.

88 "Melâmîlik," in *Dünden Bugüne Istanbul Ansiklopedisi,* vol. 5, 380–386.

89 Ahmet Yaşar Ocak, *Osmanlı Toplumunda Zındıklar ve Mülhidler,* 252.

90 See *ibid.* and Abdülbaki Gölpınarlı, *Melâmîlik ve Melâmîler.*

91 *Ibid.*

92 Cavit Sunar, *Melâmîlik ve Bektaşilik* (Ankara: AÜ İlahiyat Fakültesi, 1975), 18–19.

93 Abdülbaki Gölpınarlı, *Melâmîlik ve Melâmîler,* 37; translated from:

 "Kim bildi ef'âlini / Ol bildi sıfâtını / Anda gördü zâtını / Sen seni bil sen seni!" and in the following verses "Bayram özünü bildi / Bileni anda buldu / Bulan ol kendi oldu / sen seni bil sen seni"

94 Idries Shah, *The Sufis* (New York, NY: Anchor Books, 1990, c. 1964), 158.

95 He was persecuted for his beliefs: "The human being is eternal. There is no sin in this world for the human being after he was born as a human. Everything signified as bad and sinful (haram) by the Islamic Law is good and is a blessing (helal). Wine is a joy of lovers and it is not a sin but a blessing (helal). Eating, drinking, sleeping, resting are all regarded as religious practices. Feasting, pilgrimage to Mekke, sharing of the income with the poor has no meaning. A true believer only practices namaz twice a year. Intercourse is not a sin—it is an act of love. Every man is God himself. Soul travels from one body to another. There is no questioning after death. Daughters and sons are created by human beings. Children are creations of human beings, not of God. Those practice for the sake of a Heaven which we would not even leave our donkey in;" Ocak, *Osmanlı Toplumunda Zındıklar ve Mülhidler* 219; 286–287.

96 Ocak and Gölpınarlı argue that İsmail Maşuki directed his disciples to repeat "Allah'ım Allah'ım" (I am God, I am God) as opposed the traditional Sufi practices of remembrance by repeating the name of God as "Allah Allah" (God, God). Ahmet Yaşar Ocak, *Osmanlı Toplumunda Zındıklar ve Mülhidler,* 288; Abdülbaki Gölpınarlı, *Melâmîlik ve Melâmîler,* 49.

97 "Melämîlik," in *Dünden Bugüne Istanbul Ansiklopedisi,* vol. 5, 380–386.

Gazel Poetry and Garden Rituals (1453–1730): Ideal and Real Gardens of Love

Gardens and garden parties constituted an important part of Ottoman arts and culture. Garden parties displayed vivid images of the Ottoman cultural life and anchored Ottoman social order. They asserted divine and imperial cosmography by means of rituals. Garden parties acknowledge how gardens became expressions of divine and imperial orders according to the orthodox laws of the Sharia. Thus, gardens and their representations became expressions of imperial ideology and places of its practice.

In his seminal study *Poetry's Voice, Society's Song: Ottoman Lyric Poetry*, Ottoman literary historian Walter Andrews argued that private gardens were central to the Ottoman poetic tradition. Andrews proposed that a certain genre of poetry—*gazel*—was closely associated with private gardens and private garden parties. And thus, private garden parties actually constituted the "ecology" of this genre.[1] This chapter will first reconsider Walter Andrews' study of private garden parties in the light of Victor Turner's definition of rituals, identifying the temporal structure of these rituals and their participants. Second, it will analyse the ideal and real spaces of the city of Istanbul as suggested by these garden rituals.

Through the fifteenth to the late eighteenth centuries, private garden parties were represented extensively in Ottoman miniature art. Most of these parties take place in gardens. However, during winter time, private parties took place in garden kiosks decorated like gardens themselves. The participants at the party are usually seated in a circle, surrounding offerings. The host of the party has the most privileged position. Sometimes he is seated in a small kiosk or in an elevated pavilion. At the Sultan's parties, there are examples depicting him on his throne. If the party takes place in a countryside garden, the site of the party is usually marked by two cypress trees. The party usually takes place by a river or around an ornamental fountain.

In the late fifteenth-century album *Külliyât-ı Kâtibî* (TSM R.989, folio 93a) prepared at the court of Mehmed II, one of the scenes depicts a

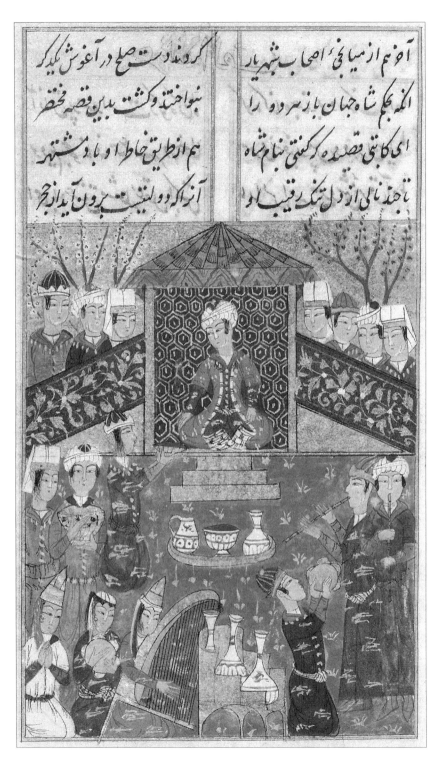

3.1 "Sultân's garden party" in *Külliyât-ı Kâtibî* (1444–1481). TSMK R.989, 93a.

garden party hosted by the Sultan (Figure 3.1).[2] The Sultan is seated at a slightly elevated pavilion listening to a group of musicians playing various instruments. In front of him there are some containers of wine or other drinks and a goblet. One of his servants is offering him a cup or dish. There are other wine containers placed among the musicians. The Sultan's party takes place in a garden, but the activity is bounded by a low partition which seems to be made of a stretched fabric. Beyond the fabric partition, other people watch the garden party under trees in blossom. The *Iskandarmâme of Ahmadî* (İÜ T6044) was also dated to the late fifteenth century. The front page of the album depicts a private party scene that takes place in a garden kiosk. The garden kiosk is a "domed iwan attached to a two storey structure... the iwan has a central window opening onto a garden in the background."[3]

In his sixteenth-century literary chronicle, Aşık Çelebi describes a garden named the Garden of the Paper Cutter (*Efşancı Bahçesi*). It was a private garden renowned for poetry reading during garden parties that was frequently visited by the elite, including Sultan Süleyman I and his Vizier İbrahim Pasha.[4] In the sixteenth-century Album of The Paper Cutter Mehmed (*Album of Efşancı Mehmed*, İÜK F1426, 47a), a little garden is represented (Figure 3.6). It is a garden made out of cut papers of various colors.[5] Verses praising the spring surround the gilded borders of the rectangular garden. This garden representation, that appears disorganized and wild at first sight, is planted with cypresses and fruit trees in blossom. Various flowers in different colors cover the lawn. Rose bushes with flowers of varying colors in bloom climb upwards and encircle trees. Among many other uses for gardens, Nurhan Atasoy portrays numbers of garden parties as illustrated in Ottoman arts. Atasoy argues that the paper-cut representation of the garden might represent the real garden of the Paper Cutter Mehmed.

In an early sixteenth-century album, *Gharâ'ib al-Sighar*, a "young prince is entertained" in a garden party. The party takes place on a hillside. The whole party is organized into a circle around the young prince. The pages are serving drinks and food. All the participants are depicted listening to two persons engaged in a conversation. There are other people beyond the party scene who are peeping at the party.[6]

In the *Süleymanname* (TSMK H.1517, 477b), Süleyman I and his son Mustafa are depicted at a party (Figure 3.2). They are seated on an elevated pavilion looking below at a fountain. Behind the pavilion lie a green meadow and hills, planted with trees and flowers. They are listening to two musicians seated beside the fountain.[7] This party most probably takes place during a hunting campaign of Süleyman since he is holding a bow and arrows. The location of the fountain and the musicians is noteworthy in this picture since they are sited at the same level below the audience. The sound of music, the sound of water and the sound of nature must be expected to blend into one another to be appreciated by the audience.

There are many miniature paintings from different periods that depict poets in gardens where they either contemplate, converse with a

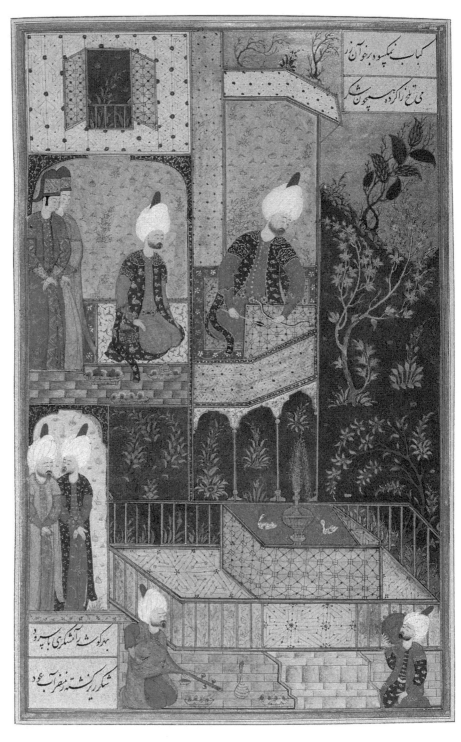

3.2 "Sultan Süleyman and his son enjoying a garden party" in *Süleymanname* (1520–1566). TSMK H.1517, 477b.

companion, read or compose. *Divân of Baki* from the sixteenth century also depicts a garden party scene where the court poet Baki is seated among other poets in a garden kiosk. Eight poets are grouped around a circle. Some poets are holding books. They either read poems from these books to one another, or by themselves. Two of the participants are conversing and two others are writing, probably composing poems.[8] *Divân of Hafiz* is another sixteenth-century album that depicts several garden party scenes (TSMK H.986, folios 11b, 156a and 170b). In one of them (TSMK H.986, folio 11b), a young man is seated in a garden pavilion. The young man who is the host of the party is surrounded by other companions, who are playing music, conversing or reading poetry. The poet who is reading poems from a book is seated between the musicians. The garden is green with flowers and trees. The site is marked by two cypresses, painted in the background.[9]

In the early seventeenth-century album of Ahmed I, there are several miniatures depicting garden parties. One of them (Figure 3.3), which Atasoy portrays as a "drinking party scene," depicts a party on a green

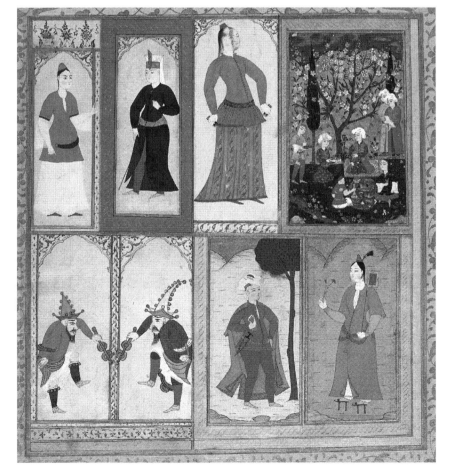

3.3 "Garden party" in *Album of Ahmed I* (1603–1617). TSMK B.408, 16a.

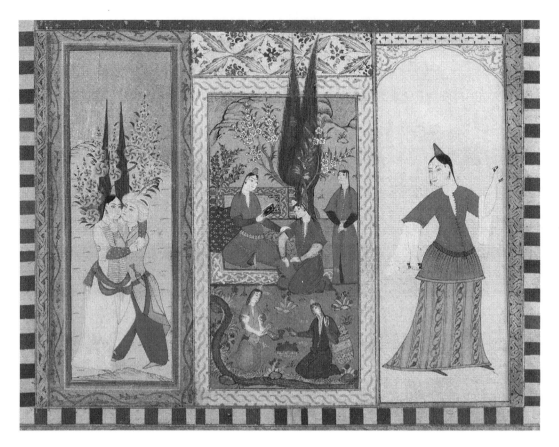

3.4 "Harem enjoying a garden party" in *Album of Ahmed I* (1603–1617). TSMK B.408, 14a.

lawn planted with colorful flowers (TSMK B.408, folio 16a). A tree in blossom stands in between two cypresses. The party is enjoyed by three figures. Inbetween two seated figures, various dishes are placed including chicken, fruits, and wine.[10] The second miniature (Figure 3.4) from the same album—*Album of Ahmed I*—depicts a harem enjoying a garden party, drinking wine and reading poetry (TSMK B.408, 14a).[11] The party is set at the riverside on carpets and cushions. In the background there are a couple of cypresses with a blossoming tree in between. Another miniature depicts a couple listening to a group of musicians and drinking wine (TSM B408, folio 19r).[12] Similar to the spatial arrangement of the garden party at *Süleymanname*, there is a fountain between the musicians and the guests who are listening to the music and enjoying the party. As well, in the background there are birds singing. The setting is enclosed with cypress tress planted in pairs with flowering trees between each pair.

Private garden parties were called *bezm* (party), *'ayş*, *sohbet* (conversing), *meclis* (gathering), or *devr* (passing cup). These assemblies usually took place at night lit by the moonlight, *'şem* (candle) or *çerağ* (lanterns). The parties continued until sunrise. Musicians played music and sang songs.

The musical instruments played were the *çeng* (harp), *ney* (reed-flute), *tabl* (drum) and *saz* (long flute).[13] Perfumes were used to enrich the atmosphere. These intimate parties were enjoyed by close friends.[14]

Fruit and dishes were served with various drinks. A court poet lists various kinds of food served at these parties such as: chestnuts, walnuts, almonds, pistachios, hazelnuts, cherries, plums, figs, strawberries, melons, water melons, apples, peaches, caviar, fish eggs, fish pickles, pastrami, lobsters, mussels, sardines, cheese and kebab varieties.[15]

Wine was one of the major refreshments served at private parties. It comprised different kinds of wine with a variety of names: *âb-ı engür* (grape juice), *arak* (rakı), *bikr* (wine), *bâde* (wine), *mey* (wine), *mül* (wine), *rah* (wine), *bâde-i gülgûn* (red wine), *âteş-i seyyale* (red wine), *dide-i horos* (red wine), *hun-i ketuber* (red wine), *sahbâ* (red wine), *bâde-i sadsâle* (matured wine), *gül'arak* (rose wine), *şerab-ı cül* (rose wine), *kümeyt* (dark red wine), etc.[16] The wine cup was also called with different names such as *ayağ*, *câm*, *câm-ı billûr*, *câm-ı cem*, *câm-ı lebriz*, *câm-ı mey*, *câm-ı musaffâ*, *çanak*, *desti*, *fincan*, *gûze*, *mina*, *kadeh*, *kap*, *kâse*, *peymâne*, *piyâle*, *rıtl*, *sâgar*, etc. Wine containers were called *sürahi*, *abgîne*, *bat*, *sebu*, etc.[17]

Among all the servants, the person who was serving the wine had utmost importance. The wine server was called *sâkî*. *Sâkîs* were one of the central characters of the garden parties because they were the ones who intoxicated the guests by serving wine.[18]

Private parties took place in gardens called *gülşen* or *gülistan* (rose garden), *bağ* or *ravza* (garden), *gülzar* (rose plot), *çemen* (lawn), *cennet* (paradise), *sahn* (yard).[19]

Reading poetry was an important element of these parties. Walter Andrews argues that in these private parties a specific genre of poetry was read or cited. This genre is called *gazel*. *Gazel* poetry both described the garden party and was used as a tool to order its arrangement. To illustrate a vivid image of the party scene, Andrews translates lyric quatrains by the poet Hayreti (d. 1535), who narrates the participants of the party along with the wine served and music played. Hayreti describes the site of the garden similar to the paradise garden, and compares it to the legendary garden of Iram:[20]

> It is a chat with ruddy wine or highest garden of skies?
> Perhaps the garden of Iram or rosy mead of paradise?
> Or gathering of fairy fair, of heaven's maids with coal black eyes?
> Hurrah! And praise a thousand times this party that revivifies?

> Some party-goers like Hüsrev, some of them Ferhat's forlorn,
> Some lovers true and others still beloved of the Houris born,
> The blue stell cup passed round therein is from the domes of heaven torn.
> Hurrah! And praise a thousand times this party that revivifies?

From transitory earth they take their vintage pleasures constantly;
To one another full they raise their cups of healing chemistry,
Yet not a word that's said therein offends against propriety.
Hurrah! And praise a thousand times this party that revivifies?

Musicians catch the fevered mood wherever their tuneful anthems start;
Each like a nightingale to each in unison performs his part
The long-necked lutes play endlessly and sing the language of the heart.
Hurrah! And praise a thousand times this party that revivifies?

Who once observes this revelry is freed from taint of grief and woes,
His soul released, though sad of eye, his heart a joyful fullness knows,
And from the ruins of his breast, a stately, spacious mansion grows.
Hurrah! And praise a thousand times this party that revivifies?

Constrained Order of Garden Rituals

Garden parties can be regarded as rituals in the sense Victor Turner proposes. According to Turner's definition, rituals always follow pre-liminal, liminal and post-liminal phases. Garden parties similarly took place in three tiers. Entering into the secluded space of the private garden corresponds to the pre-liminal phase. The party members' experience of exchanging with other participants, enjoying the offerings of the party, their intoxication and citing poetry constitutes the liminal phase. Leaving the garden space, and returning to the daily life that took place outside the garden space concludes the ritual's post-liminal phase.

The Ottoman poet Aynî describes the order of a private party. He acknowledges that parties took place in every season. With changing seasons and climatic conditions, the location of the parties would change from open spaces to indoors. He states that first the drinking cups would be arranged, and then the participants would arrive. The party would continue with servings of fruit and wine, while at the same time musicians were playing music and singing songs. The participants would converse and cite poems while listening to the music and enjoying the food served. Aynî mentions that all the participants were expected to know how to behave at a party. There were certain manners to be followed. The guests would kneel down, sitting on their heels. They were expected to sit straight. They were not allowed to support their bodies, bend or rest. They were not allowed to bend their heads downwards, cough, sneeze, yawn, or stretch. The guests were not supposed to hold wine cups for a long time.[21] It was not tolerable to display emotional states in the extreme. It was not tolerable to cry, display anger, or discontent.[22]

In order to participate in the party, individuals were required to relinquish their daily routines. Daily life was organized and controlled by the laws of Shariah. The party space was completely disconnected from the spaces of daily life. The party took place either in a garden, a meadow, or a garden

pavilion, which was the representation of an ideal garden. Garden parties lasted until sunrise. Leaving the garden space constituted the final stage of the garden party ritual. As the participants left the garden space, they returned to their daily routine. The liminal phase of the ritual will be discussed in the following pages, as well as the reasons why the experience of the garden party rituals differed from that of the daily routine.

Garden parties stimulated all the cognitive faculties of its participants: the body, the intellect and the imagination. At the garden parties, the body was sited among a group of close friends in a tranquil environment, in a garden, or in a garden kiosk. It was spoilt with endless offerings appealing to all the senses. It was filled with pleasure. The desiring soul was satisfied with delicious foods and fruits, stirred with pleasant perfumes, and intoxicated with wine full of flavor. It was carried away with music and songs. The sound of music blended with the sound of running water, singing birds and the voices of conversing friends. The vision was challenged with handsome young men serving wine and food, dancers moving in harmony, with the beauty of nature, flowers, trees and animals, and with the beauty of architectural edifices, garden pavilions, kiosks, fountains, flower vases, carpets, wine cups and even costumes.

The cognitive faculties of the spirit were challenged by participating in this event according to the pre-established rules of conduct. Each one of the ceremonial practices of the ritual contributed to the building up of a memory shared by all its participants.

Finally, engaged in poetry, the heart, the most superlative faculty of cognition, surpassed all the other faculties and guided the experience of the ritual into a make-believe travel into the realm of imagination. The heart experienced a kind of pilgrimage from one station point of the imagination to another. This pilgrimage was enabled with words uttered and images dreamed. It was guided by the recitation of poetry that was the most elevated experience of the gathering.

The *Gazel* Genre

The special genre of poetry read or cited at garden parties was called g*azel*. It is important to give a brief description of the genre of *gazel* that formed the central focus of the garden parties as the text that describes and orders the ritual at the same time. A *gazel* was a short poem, whose theme was love, beauty and wine; and whose most important characteristic was its artful form and language. It was originally a Persian genre. The *Encyclopedia of Islam* gives information on the pre-Islamic origin of the genre that developed both in the Arabic and Persian languages:[23]

A short poem of more than four but less than fifteen lines. The first two have the same rhyme, which is repeated at the end of the fourth, sixth, etc. lines. The

poet usually mentions his own name in the last line ... The form should be the most perfect possible, especially from the point of view of language; vulgar and cacophonous words are to be most rigidly avoided.

Originally introduced to Anatolia in Persian, Andrews argues that Ottoman poets adapted the genre through the fifteenth to the nineteenth centuries. He argues that almost every poet composed *gazels*, and the genre had became an essential part of the Ottoman poetic culture:[24]

During the more than four hundred years (1453–1860 C.E.), which span the mature life of the Ottoman Turkish classical tradition, virtually every poet of note—and countless poets of lesser acclaim—wrote *gazel*s. It can be said with much conviction that the *gazel* was the heart and soul of classical Ottoman literature, a central focus for a centuries-long expenditure of labor and talent, and a major voice in the song of Turkish culture.

The theme of *gazel* poems was love. Each poem would tell about love experienced in an ideal garden. They narrated the experience of love between a lover and a beloved. The narration of love also gave emphasis to the beauty of the beloved.

Gazel poetry rested upon a set of conventions. Its themes of love; cast of characters that took part in short anecdotes of love; its use of language and vocabulary; its depiction and illustration of spaces; its construction, and its structures were all established according to rules set by the tradition. The beauty of the beloved was narrated by set cannons. The beloved was portrayed having a cypress-like posture and a slender belly:[25]

The beloved has a slender belly, with black hair like the fate of love and the night of sorrow; like the worry of reunion with the beloved, his / her hair is intricate and twisted into curls; neck white and transparent like the balm acquired from the cheery laurel of the far East; with black eyes; has an Indian-style mole on his / her cheek, and a dimple like a dagger, with a well on his / her chin; has a posture like a cypress tree.

The art of the *gazel* demanded the mastery in using these signs in order to compose a poem, harmonious in essence, musical in hymn, and aesthetic in vision. The artist was not permitted to create anything different than the predetermined conventions. The poet was not permitted to question the cosmological order. He was not able to introduce any novelty into any of the gardens. Novelty was a deed of God, so that individuals were not supposed to create, but to imitate and to appreciate the creation. Apart from listening to the meaning of the verses, and the harmonic musical tone achieved by the use of rhyme, poetry almost became an art for watching. It became a theatre of images.

The language of *gazel* was made up of Turkish, Persian, and Arabic words, which used Arabic phrases, with Turkish syntax, making Persian compounds. *Gazel*s were composed for and understood by cultivated, learned, and literate circles, like the people of the court, the elite—simply the *askerî*.

Society and Garden Rituals

According to Islamic mythology, the first group assembly was hosted by God after the creation of the human being. According to the mythology, God invited all his angels to this assembly and asked them to consent to his being the creator. Upon their approval, God created the universe and the world. This archetypal gathering was called *bezm-i ezel* (party of the infinity).[26]

Following the pattern of this archetypal model of *bezm-i ezel*, private parties became gatherings that located the power of its host within the cosmological hierarchy. Different groups within Ottoman society hosted parties and invited guests and poets to their parties. The Sultan hosted his own private parties, inviting the prominent members of his court and court poets. The Sultan's parties used to take place in imperial gardens. Members of the elite used to become patrons of poets, and they hosted their own circle of friends. The elite parties were hosted in private gardens.

Members of the guilds each had their own private parties. Each sub-group of the guilds had a principal, who would also master their gatherings. These principals represented the legendary characters who were acknowledged as creators of each profession and they were acknowledged as disciples of Islamic figures who performed their trade for the first time, in the age of the prophet Mohammed. For example, Adam was acknowledged as the master of bread makers. Amir bin Imran from Medina, who was a baker at the time of the prophet, was acknowledged as the Islamic master of bread bakers.[27] Thus the cosmology of all guilds followed after both the Near Eastern mythology and the collective memory of the Islamic tradition.

The guild gatherings took place in meadows. Guilds would gather in a meadow either once a year or once every ten to 20 years. The guild gatherings would last for two to ten days. During these gatherings, the guilds would amuse themselves in the meadow playing games, enjoying food and drinks. They would also converse and read poetry.[28] At the military gatherings, the Bektashi dervishes supervised the assembly. In tariqat congregations, the leader of the group or the order (*şeyh*, *baba*, or *kutub*, etc.) directed the meeting.[29]

Participants of the Garden Rituals

Participants of the private garden party were called *dostan* (beloved friend), *yaran* (friends), *ehl-i dil* (master of the tongue), *eshab-i dil* (owner of the language), *ehl-i batın* (master of mystery), *eshab-ı kemal* (master of perfection). The participants simply constituted a host and his guests, including one or several poets. Sometimes poets were invited to compete with one another.

Apart from the guests there were the servers. Among them, the most important was the *sâkî* who used to serve wine. Garden parties also included musicians, singers and dancers.

The guests of the private garden parties knew the rules of conduct. It was important that they would be able to pursue the ritual of the garden party by conversing, attending to discussions and citing poetry. People who were neither too serious, boring or gloomy, nor carefree or bad-mannered were invited to the private parties of the elite. The guests were well educated. They were the masters of language since *gazel* poetry cited in these garden parties called upon a difficult language and was exceptionally artful. Since *gazel* poetry included Persian and Arabic words, its language was not understandable to the common public who used vernacular Turkish.

In conclusion, it would be necessary to recognize that private garden parties and the *gazel* genre were enjoyed by the court and the elite groups. However, gatherings of other social groups like the guilds or the mystic orders resembled garden parties in terms of arrangement and purpose of the ritual.

Role-playing in Garden Rituals: *Sufi* and *Rind*

The theme of the *gazel* poetry was love. Each participant of the party reciting *gazel*s would become a lover. He would recite *gazel*s addressing the Beloved. When reciting *gazel*s, the poet would become a lover. The beloved could be God, the Sultan, the host of the gathering, or the *sâkî*, the wine server who was present at the garden party, and who was responsible for the intoxication of the poet with beauty.

Each time the participants of the party cited verses from a poem, they would also become lovers like the poet himself. Playing the part of the lover by citing poetry is the most important part of the garden parties. Andrews calls this role-playing a game. Role-playing gives the flexibility of engaging in an imaginary persona for the predetermined period of the play. In Victor Turner's terms, it can be identified as the reversal of social status and constitutes the climax of the liminal phase.

Playing the role of lover, a participant of the party also played the role of mystic. At the garden party, he would play as if he were a mystic, even if he was a severe ascetic in the real world. Thus, *gazel* poetry would lead the participants of the party to behave as mystic lovers. They acted as if they were friends of God. An ascetic would practice his faith according to the rules of Shariah as codified by religious texts and conventional practices. This implies a deep departure from the rules of everyday life for an orthodox believer or for an ascetic. An ascetic would value the intellectual faculties of recognition above all the others and would turn away from any novel form of practice that was outside the conventions of the orthodox faith. On the contrary, a mystic would practice his faith by means of his imaginative faculties.

Intoxication stimulated the mystic in his quest for the divine. However, intoxication was severely prohibited for an ascetic. So, by a reversal of status,

the participants of the garden party enjoyed being mystic lovers even if they were severe ascetics in their daily life. In the Ottoman poetic tradition, the mystic lover was signified by the character *rind*, and the ascetic by the *zahid* or *sufi*. The *rind* was a protest character, a dissident. The *Zahid* or *sufi* was an ascetic. The *rind* considered himself as a friend of God, as opposed to the *zahid*, who considered himself as a slave of God.[30] By playing the role of *rind*, one engaged in protest attitudes towards the institutionalized worship and public display of faith in order to get admired and recognized. *Rind* was a character criticizing and opposing the *sufi / zahid*.[31] *Rind* refused to adapt the public forms of Heterodox Islamic faith. He disapproved both of the distinguishing apparel of the *sufi / zahid* and the institutionalized ceremonials of worship and their hierarchy. Opposite to *sufi / zahid* wisdom and reasoning, *rind* contemplated love and acknowledged love as a practice of loyalty. In contrast to the *sufi / zahid's* appreciation and expectation of the heavenly paradise, the *rind* admired worldly beauty, and craved worldly pleasures. Intoxicated, disapproved of, and displeased with himself, the *rind* always criticized himself as the opposite of the *sufi / zahid's* display of wisdom and anticipation of public approval.

Corruption in Sufi society was a common concern in all Muslim societies. Schmimmel argues that poets had a critical idea of the Sufis as early as the eleventh century and that poets differentiated between corrupted and true Sufis. The true Sufi was defined as a true lover. Some Sufis preferred not to be called Sufis, in order not to be associated with the degeneration of Sufi society. Schimmel cites the following verses by a sixteenth-century Sufi poet:[32]

> The Sufi is busy with deceiving men and women,
> The ignorant one is busy with building up his own body,
> The wise man is busy with coquetry of words,
> The lover is busy with annihilating himself.

However, the experience of love expressed by Sufi poems never ended in union with the beloved. The union with the beloved was not possible. Since the beloved represented God and union with God was not possible. Thus all poems ended with grief and sorrow.

Garden party, poetry and mystic love are also common themes in Persian culture. In Sultan Ibrahim Mizra's *Haft Awrang* of the sixteenth century, poetry is described as a medium for attaining divine knowledge (Figure 3.5). The poet attains divine knowledge by revelation, through angelic illumination. The painting conveys the idea that poets "have the capacity to create works of great spirituality and assuage the doubts of those seeking enlightenment."[33] The painting depicts the poet as a mystic lover, and his abode as the garden of paradise. On the door of the garden pavilion in which the poet Sa'di is composing a new poem, the following verse from the Koran (Koran 38:50) is written:[34] "Gardens of Eden, whereof the gates are opened for them."

3.5 "The gnostic has a vision of Angels carrying trays of light to the poet Sa'dî" in Sultan Ibrahim Mirza's *Haft Awrang* (1556–1565) by Jami (d. 1492). Freer Gallery of Art, Smithsonian Institution, Washington, DC. Purchase, F1946.12.147a.

Sultan Süleyman I's anthology of his own poems signed by his pen-name *Muhibbî* is also a good example to illustrate the close connection between poetry, mystic love and gardens. The verses below from *Muhibbî Divanı* (İÜK T5476) are an expression of the Sultan's mystic love and quest:[35]

> I am the Sultan of Love, a glass of wine will do for a crown on my head,
> And the brigade of my sighs might well serve as the dragon's fire-breathing troops.
> The bedroom that's best for you, my love, is a bed of roses,
> For me, a bed and a pillow carved out of rock will do.
> My love, take a golden cup in your hand and drink wine in the rose garden;
> As for me, to sip blood from my heart, it is enough to have the goblets of your eyes.
> ...
> The heart can no longer reach the district where you live
> but it yearns for reunion with you,
> Don't think paradise and its rivers can satisfy the lover of the adorable fan.

Muhibbî Divanı as a book combines poetry and gardens. The poems are on pages which represent gardens planted with tulips, violets, poppies, irises, roses, peonies, hyacinths, calendula, and cypress trees.[36]

The nineteenth-century poet Şeyh Galip's work *Beauty and Love*,[37] is another example, illustrating the close connection between garden spaces and poetry. "Poetry" is one of the main characters in Şeyh Galip's work and he resides in a garden called the "Garden of Meaning." Poetry is personified as a "gracious person" and he embodies all the dual qualities, both the good and bad states that are all fashioned by Creation.[38] He becomes lover and beloved at the same time; plays both of the roles of the Sultan and the subject; and as narrated in the poem, once he becomes "the sprite" or "the devil":[39]

> That gaily blooming garden was, in short
> Alike to the talent of a pure poet
> A sage young at heart and sprightly of limb
> Welcomed the guests to that pleasure place in
> Poetry by name, gracious his person
> His life preceded heaven's creation
> He was both the question and the answer
> Prophecy's miracle and messenger
> ...
> He could be a sprite, he could be a devil
> Now aquatic, and then terrestrial
> ...
> He could be a poet, or a scholar
> Now an ascetic, or now sorcerer is with him

Spaces of Garden Rituals

There was a close association between the arts of poetry, garden space and the order of the garden ritual. They carried two contrasting intentions.

3.6 "Efşancı Garden" in the *Album of Efşancı Mehmed* (1565). IUK F1426, 47a.

First, they stimulated the imaginative faculties. Second, they anchored the participants of the garden party in society. Thus, while imaginative faculties supported the development of individuality, the organization of the garden rituals suppressed it.

The organization of the garden, the order of the ritual and the content of *gazel* poetry stimulated the imaginative faculty of individual participants. Gardens in which garden parties took place were designed in such a way that they triggered imagination. They had a complex organization, which did not reveal its order at first sight. Poetry cited in gardens also called for a complex order that involved the whole of Ottoman cosmology. Garden rituals stimulated the imaginative faculties by intoxication and poetry after arousing all senses by perfumes, delicious food and fruits, music and dancers. Simply organized around a circle, participants either surrounded a fountain, or they sat on a riverbank. The circle represented the ideal form and resembled the cosmological order. The water element stood for the fountain of life, the symbol of the source of divine knowledge and the origin of all creation.

The sixteenth-century Garden of the Paper Cutter illustrates the close association of poetry, gardens and garden rituals. The sixteenth-century literary critic Aşık Çelebi describes a certain garden called the Garden of the Paper Cutter. It was a private garden renowned for garden parties for reading poetry, which was frequently visited by the elite, including Sultan Süleyman I and his Vizier İbrahim Pasha.[40] As mentioned at the beginning of this chapter, the illustration in the sixteenth-century Album of The Paper Cutter Mehmed might represent the real garden (Figure 3.6). Despite the fact that the representation of this garden depicted in the Album seems to

follow no order at first sight, it encloses a very complex arrangement of trees. The order is maintained by the type, size, color and location of the trees and flowers. The geometry of the garden is suggested by the decorations on the margins creating a symmetry axis (Figure 3.7). The center is regulated by a small cypress tree. Two of the cypress trees, which seem to govern the composition, at first sight are symmetric with respect to an unseen axis, but this axis is shifted from the axis of the page that is governed by the small cypress tree. The whole composition is a complex organization of games of symmetry and mirror symmetry, with shifting axis, plays of matching colors and shapes. Trees in bloom, rose bushes, and flowers further complicate the simple vertical appearance of the cypress trees. Blooming trees are planted in between pairs of cypresses.

The vision achieves complexity on purpose. In Ottoman optical treatises, the perception of objects is portrayed on three different levels. For example, in the sixteenth-century optic treatise revised from Ibn al-Haytham's *Kitâb al-manâzir*, perception is ordered according to the three levels of "pure sensation," "glancing perception" and "contemplative perception."[41]

"Pure sensation" is described as the sensual cognition of light and color. It involves sensual faculties. "Glancing perception" is cognition by remembrance. It involves the mind and the memory. "Contemplative perception" involves imaginative faculties that enable seeing beyond the apparent form of the object, and contemplating its novel qualities, which the mind or the memory cannot recognize and the eye cannot distinguish. Necipoğlu argues that Islamic decorative arts made use of such optic doctrines and created complicated patterns that

3.7 "Complication of vision." Analysis of the visual field in "Efşancı Garden" (1565). IUK F1426, 47a. Analysis by Çalış-Kural.

required contemplation of the individual and triggered imaginative faculties. "Contemplative perception" required the subject's individual involvement in the process of perception, contemplation and cognition. It valued the individual taste of the subject and defined the beauty of the object contemplated as subjective and contextual. "Complication of vision" in Islamic arts was an affirmative quality accomplished on purpose. In the paragraph below, Necipoğlu, who examined abstract patterns in Islamic art, claims that such "complication of vision" was a willful effort of the artist. Necipoğlu argues that initially, the complexity of patterns was designed so as to attract the eye of the beholder. After the initial attraction, the beholder is taken into the field he / she gazes at. This journey requires a subjective initiation and a personal journey, since the visual field has no singular focal point, but it constitutes a surface with depth, an intricate mesh of Islamic patterns overlaid, without a beginning or an end. Necipoğlu further concludes that this subjective experience stimulates the faculty of imagination among other cognitive faculties:[42]

> Another implication of Ibn al-Haytham's psychological theory of optics is that the willful complication of vision by intricately decorated surfaces was a calculated way of inducing contemplative vision, a "way of seeing" which often is referred to as the "scrutinizing gaze" (*im'ân-i nazar*) in Ottoman texts. Elaborately patterned surfaces, covered by multilayered geometric designs interlaced with geometrized vegetal, calligraphic, and occasionally figural motifs, constituted magnetic fields to attract the gaze with their bewildering vertiginous effects. Their infinitely extendable, non-directional patterns of line and color, with no single focal point or hierarchical progression toward a decorative climax, required the insertion of subjectivity into the optical field; they presupposed a private way of looking. Such surfaces seduced the eye to alight on harmoniously combined colors and abstract patterns that could stir up the imagination, arouse the emotions and create moods.

Similar to the arts and crafts, Islamic tradition also considered poetry as a medium to trigger the imagination. In various treatises, the art of poetry is exemplified with metaphors from arts, crafts, and architecture; such as "patterned brocade," "rhythmic arabesque," "necklace," "wall paintings," "tile work (*kâşîkâr*)," and "pomp (*alayiş*)" of a house, referring to the art of homophony as *tarşî'* (lit. "tarsia," or "to inlay with pearls and precious stones").[43] Al-Gahazali compared the creative powers of a poet to that of God as a miracle.[44]

Likewise, the art of *gazel* poetry suggested that the poetic medium also constituted a visual space. This visual space enabled contemplation, and further triggered imagination. The verses below of the sixteenth-century poet Zati quoted by Andrews illustrates that the choice of vocabulary and choice of letters or words had a very important part in the arts of *gazel* poetry. Andrews argues that Zati's verses are the perfect example showing how the poet mastered the tools of his art:[45]

Kaşı med kaddi elif yāruñ öñinde Zātī
Düşmanuñ kāmetini dāl idüben ad itdüm

translated as:

> Before the beloved, with her eyebrow like a *med* and body like an *elif*
> By bending the enemy's body like a *dal*, I made a name for myself

In Zati's two lines, by using the visual image of the Arabic letters of *med*, *elif*, *dal*, the poet suggested the poem as a visual field to meditate. He described how he handled these images: by bending, twisting, changing their shape, almost like giving form to a sculptural object, he created a name (*ad*) for his fame. Thus, the word name (*ad*) when written in the Arabic alphabet, is made out of the letters *med*, *elif*, and *dal*. Zati's poem invites its reader to imagine every one of the letters and words as images. Letters that made up the words in a poem—by means of their forms and the meanings that these forms suggest, trigger the imagination of the individual who is reading or listening to the poem. Apart from the apparent meaning of the poem itself, these letters themselves also begin to manifest themselves as images upon which the imagination begins to contemplate.

Ideal Spaces

In order to understand *gazel* poems, it is important to understand the structure of the world within which *gazel* poetry was composed. The world was strictly organized into a hierarchical cosmology that ordered every single thing, metaphysical and physical, that is considered to have real or imaginary, real or ideal, this-worldly or after-worldly existence, as a thing, a concept, an idea, a form, or meaning. Everything had a place in the cosmological hierarchy.[46] The earth and the heavens were constructed according to seven levels. There were seven levels under the ground. The levels of the earth above ground level were called *Demga*, *Hulde*, *Arfe*, *Cerba*, *Melsa*, *Siccin*, and *'Acıba 'Acıba*. The seven layers above the earth—the spheres of the Moon (*Berkı'a*), Mercury (*Kaydum*), Venus (*M'un*), Sun (*Erkalut*), Mars (*Retka*), Jupiter (*Retka*) and Saturn (*Gariba*), were each symbolized by a different color.[47]

Following these seven layers of the planets were the eight heavens, also ranked along a hierarchical order: *Darülcelal* as a white pearl, *Darüsselam* as red ruby, *Cennet-ül Mevahir* of green crystal, *Huld* of yellow coral, *Naim* of white silver, *Firdevs* of red gold, *Karar* of musk; and above all there was the highest of all the heavens, which was considered to neighbor all the others—with a huge castle surrounded by walls—the *Cennet-ül Adn* of white sweating pearl. The roots of the *Tuba Tree* were in the *Cennet-ül Adn* and its branches ascended through all the other seven heavens. All these heavens were depicted as paradise gardens one after the other. Beyond the highest garden of paradise *And*, the domain of *Kürsi*, made out of pure light, was located. Above it there was *Arş*, the throne of God, as the origin and beginning of everything.[48]

In order to reach a better comprehension of the cosmology, it would be necessary to construct each one of these terms into a structure. As already discussed in Chapter 2 concerning the theories of Ibn 'Arabî, Ottoman

cosmology considered the origin and beginning, and the Absolute Reality of the God as incomprehensible to human beings. Thus, *Arş*, the throne of God, was beyond human cognition, and it constituted the True Reality. *Kürsi*, however, embodied everything created, thus the whole world. *Kürsi* in the dictionary meant a table or a folded space in which the created world was contained. Thus the folded space of *Kürsi* contained all the explanations concerning the creation of the world, all the layers of cosmology, fixed stars, seven planets, seven layers above and below the earth and human beings, all civilizations, all religions, myths and legends, lives of the prophets, all of history—the past, the phenomenal world as present, and future.

Ottoman cosmology was based on Islamic cosmology, which was constructed in order to relate the individual existence to the Universal World, which was acknowledged as the World of the God. However, it should also be noted that Ottoman cosmology also had to relate the Sultan to his subjects. Thus, it not only expounded Islamic imperatives, but also included imperial accounts for other civilizations; lives of rulers and warriors of Mogul, Persian, Mani, or Indian origin; stories of legendary kings; characters from the Old and the New Testaments. The late sixteenth-century manuscripts of *Zübdetü't-Tevarih* produced under Ottoman rule narrating the Ottoman cosmology clearly illustrates that Ottoman rulers not only linked their kinship to Islam, but also to pre-Islamic and non-Islamic traditions.

Walter Andrews points out the order of the Ottoman cosmology following his deconstructive study of the Ottoman poetic genre of *gazel*. Andrews suggests that Ottoman cosmology was based upon a two-poled structure, which consisted of interior and exterior spaces. Each level of the cosmology was formed of interior and exterior spaces and in each level, the interior space was always superior to the exterior one (Figures 3.8, 3.9 and 3.10).

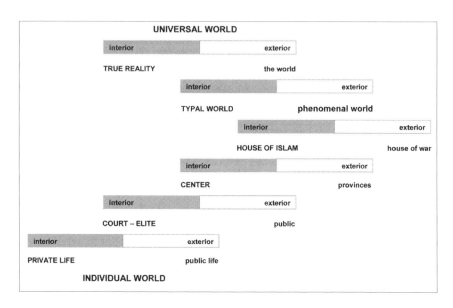

3.8 "Hierarchy in Ottoman cosmology according to Walter Andrews' analysis of Ottoman *gazel* poetry." Chart by Çalış-Kural.

3.9 "Ideal spaces of Ottoman cosmology according to Walter Andrews' analysis of Ottoman *gazel* poetry." Chart by Çalış-Kural.

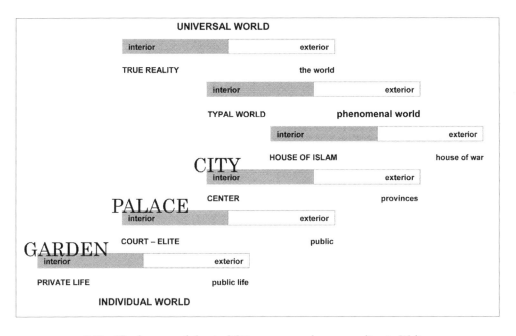

3.10 "Real spaces of classical Ottoman cosmology according to Walter Andrews' analysis of Ottoman *gazel* poetry." Chart by Çalış-Kural.

The interior of the Universal World embodied the True Reality whose knowledge was inaccessible to the human being. Exterior to it, there existed the World within which all creation was located. The World embodied the Typal world within its interior realm, and the Phenomenal world to its exterior. The Typal world housed images that originated in the Universal World. However, these images were not direct depictions of the True reality, but they were distorted reflections of it. So, the accounts of the paradises, the layers above or below the earth, the life of the prophets, legendary characters and ancient rulers resided in this Typal world.

The Typal world housed the main characters of "Persian tradition, Greek legends, in the pursuit of Ptolemy (Batlamyus), or individuals of the Jewish mythology" like "Dârâ, Ferîdun, Nûşîrevân, İskender, Rüstem, Efrâsyâb, Sûhrâb, Siyâvûş, Keykubâd, Behrâm, Kahrâman-ı Kaatil, Süleyman, Âsaf, Hârûnürresîd, Fazl, Hâtem..."[49] These legendary characters were Faridun and Jamshid, kings of Iran; Khusraw and Bahram (Gur), rulers of the Sassanian dynasty; Bahman, known as Artaxerxes Longomanus; Dara, as Darius, the Achaemenid king; Rustam, son of Zal; Yusuf, son of Yakub; Kaykhusraw, the ruler of the Kayanids; Faruk, the Caliph Omer; Karrar and Haydar, as Ali; Mani, the third-century prophet of the Mani religion; the Persian painter Bihzad and Solomon, the legendary king.

The Phenomenal world was exterior to the Typal world, and it also had an exterior and an interior. Within the interior of the Phenomenal world, there was the House of Islam, and outside it was the House of War. The House of Islam had the Ottoman Empire central to it. Peripheral to this center were the other Islamic states. Within the House of Islam, the capital city of the Ottoman Empire was the center, and the other provinces were peripheral. So, there was one ruling center, the capital city, which empowered all the land, within the rule of the Islamic Law. Even the capital city had an exterior and an interior. The palace was the interior, and the rest of the city was the exterior world. The residents of the palace, the ruling elite, the Sultan and his court were within the interior domain of the palace, and were classified as *askerî*. They were spatially differentiated from the public, who were exterior to the palace, and classified as *re'aya*. The palace, the space of the Sultan, also had an interior and an exterior. The interior embodied the private life, and the exterior embodied the public life. The private life was practiced in the gardens, and it displayed the emotional world of the individual. The exterior domain of the space of the palace was associated with the public service activities of the ruling court which housed the public ceremonies and assemblies. The garden of the Sultan also had an interior and an exterior. The interior was the individual Self, and the exterior was the garden itself. And the human breast, which housed the human heart, was the interior realm of the Self, and the whole human body with the exception of the heart, was the exterior.

Thus this cosmology placed society within a religious, imperial, and social ordering, where the hierarchy was precisely defined covering all the

domains of spiritual, ideological, social, cultural, and individual worlds. Each world was interiorized by another expanding domain superior to the former one. Consecutively, each world unfolded into another domain. From the individual heart to God, each and every thing belonging to different levels of Creation was defined.

However unified this construction seems to be, with all its elements ordered in an unchanged strict hierarchy, it embodied diverse worlds. Walter Andrews, reading the genre of Ottoman *gazel* poetry, deconstructs this seemingly unified structure mainly into three different worlds. This deconstructive attitude enables the reading of each different world with reference to different sources that made up Ottoman society and culture, and at times which could lead to contradictory results.

These three worlds, as Andrews suggests, expressed the "mystical–religious voice," the "voice of power and authority" and the "voice of emotion" that matched to the three domains of existence; "the universal," "the earthly" and "the personal."[50] The relationship between these three domains suggests an intertextual study of Ottoman culture and society. In this way *gazel* poetry anchors the individual existence of the single person to the earthly authority, and then to the universal order, thus to religion.

The intertextual experience as a journey between the different realms begins in the heart of the individual. In the following example, the sixteenth-century poet Yahya expresses his individual experience and his emotions. He expresses his pain for the ultimate separation from the beloved. He intoxicates himself with wine. The poet uses the garden space and the garden ritual as a means to express his personal emotions:[51]

> Oh Saki, give me wine for the days of spring are soon gone out of hand
> The time of the seal of the cup of pleasant tasting wine will soon be gone out of hand
> ...
> Oh Yahya, union with the Beloved is the motive of separation
> Do not be heedless, for the skirt of union with the beloved goes from hand

The private garden is located within the dominion of the ruling authority. The poet as an individual and the garden he uses as a medium are anchored to the power of the Sultan within the cosmological hierarchy. As Walter Andrews argues, in many *gazels*, the eminence of the monarch is asserted:[52]

> I am the monarch of love, the smoke and sparks of sighs
> Have become a gold parasol over me in the wilderness of grief
> ...
> Since I came to realize the amazement of the secret of loving you, oh Monarch!
> The wind of annihilation has turned the structure of my body to dust

The garden of the monarch was imagined in the center of the garden of Islam, in which the beloved addressed would be the God in his unparalleled, unimaginable, and inconceivable being, greatness and beauty:[53]

> The people of the world are on one side, this impassioned one on another
> I will not give up being near to you for all the world
>
> If you say never let anything harm perfect beauty
> Oh, ruler of the world, do not withdraw alone by yourself, like the sunset
>
> Though they looked they did not find anything matching your graceful way of walking
> The tree of paradise went one way, the heart-captivating cypress went another

Each one of these levels of Ottoman cosmography was acknowledged as a space, as the world, the house, the city, the palace, and the garden. And each one of the interiorized spaces could be illustrated with gardens as metaphors and explicit examples of the respective category. The security and ideal of the garden analogy was practiced at all levels of hierarchy. The interior of the garden embodied all blissful qualities. The world of the garden was considered as a perfect mimesis of the divine order, and of the Ottoman court, which considered itself as the representative of the Divine order in this world.

The Ottoman *gazel*s each constructed a garden in poetry in accordance to Arabî's discussions about the realm of imagination as a garden. These gardens representing ideal gardens of the cosmology, or the real gardens of the city, became spaces where imagination, the highest of all the cognitive faculties, was practiced. Thus every reference to another different garden in a single *gazel* poem carried the poet, or his listeners to another level of the cosmic hierarchy. In these gardens made out of the words of the *gazel*, the individual Self had to put into practice his cognitive powers of his imagination.

Each garden in the cosmic hierarchy was made out of signs: gardens of eight paradises, the myths of the House of Islam, Sultans of the Palace, friends, music, dance, intoxification, wine-server, and natural elements of the private garden. Each was a sign used together with others in constructing the poetry of the private garden party. A hero from a love story was a sign just like a single Arabic letter. The stature of the beloved could for instance be portrayed by depicting the body as the letter *elif* in the Arabic alphabet; or as the *tuba tree* of the Paradise Garden.

Since the imagery of the *gazel* poetry was an established set of conventions, the poet used elements whose symbolism was fixed by the literary tradition. These sets of fixed images became sets of signs. By the development of the genre of *gazel* in Ottoman poetry, each sign engaged in a static relationship between the signifier, the word and the signified, as its meaning. Thus, in this tradition, signs—chosen from the pre-determined set—were comprehensible to those who read or enjoyed *gazel* poems. The use of signs in such an illustrative manner, which did not allow any representation, prohibited the artist from claiming an interest in the production of knowledge. Each sign was chosen from the interiorized worlds, the gardens of each cosmic level.

Each garden became a representation of the promised paradise garden. Sandys, who traveled to the Ottoman Empire and to Istanbul in the early seventeenth century, illustrated the concept of the Islamic paradise garden.

Sandys argued that the Prophet Mohammed structured the concept of Islamic paradise upon the depictions of the Elysian fields of antiquity, where only the chosen ones were able to enter:[54]

It is to be more than conjectured; that Mahomet grounded his devised Paradise, upon the Poets invention of Elisium. For thus *Tibullus* describeth the one:

> *For that my heart to love still easily yields,*
> *Love shall conduct me to the Elisian fields.*
> *There songs and dances revel: choice birds flie*
> *From tree to tree, warbling sweet melody.*
> *The wild shrubs bring forth Cassia: everywhere*
> *The bounteous soil doth fragrant Roses bear.*
> *Youths intermixt with Maids disport at ease,*
> *Incountering still in loves sweet skirmishes.*

And Mahomet promiseth to the possessors of the other, magnificent Palaces spread all over with Silk Carpets, flowry Fields, and crystalline Rivers; Trees of Gold still flourishing, pleasing the eye with other goodly forms, and the taste with their fruits;

> *Which being pluckt, to others place resign*
> *And still the rich twigs with metal shine.*

Under whole fragrant shades thay shall spend the course of their happy time with amourous virgins, who shall alone regard their particular Lovers: not such as have lived in this world; but created of purpose; with great black eyes, and beautiful as the Hyacinth. They daily shall have their lost Virginities restored; ever young (continuing there, as here at fifteen, and the man as at thirty) and ever free from natural pollutions. Boys of divine shall minister unto them, and let before them all variety of delicate Viands.

There were two different features that enabled the intertextuality of the *gazel* genre. The first one, as discussed above, is the presence of the seemingly unified fusion of the three realms of the religious, political, and the personal worlds. This view suggests an interiorized reference system that made use of the interior spaces of Ottoman cosmology, thus the gardens of all levels. *Gazel* poems enabled the comparison and association of all the interior spaces, especially the gardens of the cosmological hierarchy, to one another. These gardens include the gardens of paradise, gardens of Islam, gardens of the worldly authority, private gardens, and even the breast of the human being in which the heart resides as if in a garden. The private garden became a space where the friends of the assembly met, enjoyed themselves, conversed, and read poems to one another. In the background of this real garden the imagination introduced secondary garden(s) with the *Tuba* tree and the *Kevser* river, populated with legendary characters such as *Iskender, Yusuf, Leyla* or *Noah*. Poetry enabled the juxtaposition of the different layers of the cosmic order. The private garden unfolded into the other imaginary gardens and enabled a journey within all the interiorized spaces of the cosmology.

The best example for illustrating the association of the different orders of the cosmological order is a Persian miniature painting from the sixteenth-century *Divan of Hafiz*. The painting titled "The Allegory of Drunkenness" (private collection, TL 17443-5) illustrates a "ceremonial ritual" of the mystics in a garden.[55] While the intoxicated mystics are dancing, playing music and conversing in the garden below, the angels are enjoying themselves and getting intoxicated on the roof terrace above the garden. Both the mystics and the angels quest for divine knowledge, and both reside within a garden.

This intertextual association and comparison of different interior spaces of different hierarchical levels done by calling attention to similarities is called *tashbîh*. In mysticism, it stands for the act of attaining divine knowledge through studying the similarities of all creation. Ibn 'Arabî explains *tashbîh* as a means to draw similarities between the unity of True Knowledge, and its reflections in the multiplicity of things created.[56]

The second method used is the opposite of the arts of *tashbîh*. It is the exercise of trying to identify the beloved by pointing out the qualities that he does not embody. It is called *tanzîh*. Where *tashbîh* is comparison with respect to similarities, *tanzîh* is comparison with respect to differences. *Tanzîh* is also a common term used in mystic philosophy. *Tashbîh* admits that all things are reflections of the divine being, and thus their qualities can be compared. However, the arts of *tanzîh* practice the differences between things created and the divine being asserting their dissimilarity and incomparability. 'Arabî explains *tanzîh* as a means to attain knowledge by studying its opposites.[57] Thus divine knowledge can be attained both by means of *tashbîh* and *tanzîh*. 'Arabî identifies the intermediary realm of the garden as a curtain that veils divine knowledge. Thus contemplating the images on this veil to understand what it conceals is called *tashbîh*. However, the images reflected on this metaphorical curtain do not actually stand for what is behind it. This consciousness is called *tanzîh*:[58]

His words are correct that there is "what no eye has seen" in the "Garden," that is, in the "curtain"—on the basis of the metaphorical interpretation, not exegesis. Were an eye to see it, it would not be curtained. Were someone to see it, he would speak about it and it would be "heard." Were it heard, it would be limited. Were it limited, it would pass into his heart and be known.

This is an affair that veils us from Him through a veil that is not known, for He is in the curtain called "the Garden." Since his Entity is identical with the curtain, nothing veils us save the fact that we see a curtain, so our aspiration attaches itself to what is behind the curtain, that is, the curtained. This comes to us from us, and nothing makes us do it save *tanzîh*. Hence along with *tanzîh* the prophets brought the attributes of *tashbîh*, so that these might make the affair nearer to the people and call the attention of those who are nearest to God—those who are in nearness itself along with the veil of the actual situation. Thus, in calling attention through *tashbîh* is lifting of the coverings from the eyesight, and the eyesight comes to be qualified as "piercing," just as does the eyesight of the person near death. God says, *We have unveiled from you your covering, so your eyesight today is piercing* (50:22). The person near death sees what those who sit with him do not.

He reports to his sitting companions what he sees and perceives and he reports truthfully, but those present see nothing, just as they do not see the angels and spirituals who are with them in the same session.

The arts of *tanzîh* in poetry suggested the definition of a particular thing, concept or event through contrasting the qualities it stands for to its opposites. Andrews suggests that the following verses from the sixteenth-century poet Zati's *gazel* are a good example to explain the arts of *tanzîh*:⁵⁹

> *Kaşı med kaddi elif yāruñ öñinde Zātī*
> *Düşmanuñ kāmetini dāl idüben ad itdüm*

is translated as:

> Before the beloved, with her eyebrow like a *med* and body like an *elif*
> By bending the enemy's body like a *dal*, I made a name for myself

These verses, as Andrews proposes, suggest that the poet tries to identify the garden space and everything it houses by things that are actually exterior to the garden space. In this particular example, the poet makes use of the body of the enemy from outside the garden. Zati uses the form of the enemy's body and molds it into a new form that stands for his own name.⁶⁰

Andrews suggests that the poet's use of an element outside the protected world of the private garden was a very common tradition. Thus, *gazel* poems, depicting the protected ideal worlds of the Ottoman cosmology, the interior spaces of the ideal gardens, also suggested the presence of other spaces exterior to them. According to Andrews, this way of giving exterior reference to an interior realm had become one of the most important motives of the Ottoman poetic tradition. It also suggested the existence of opposing worlds—the interior and the exterior—to acknowledge and to explain one another.

Returning to Yahya's *gazel* already quoted in previous pages illustrating the wine serving "Sâkî," "pleasant tasting wine" served, wine "cup" and "days of spring," the poem portrays the blessed qualities of the interior space, the garden, and as well, the private garden party:⁶¹

> Oh <u>Saki</u>, give me wine for the <u>days of spring</u> are soon *gone out of hand*
> The time of the <u>seal of the cup</u> of pleasant tasting <u>wine</u> will soon be *gone out of hand*

However, the poet also reminds of their temporality, suggesting their absence in the exterior world. In the next two verses, Yahya uses the word of the "Beloved" and the "union" with the terms of "separation" and "going from hand." He again suggests the ideal concept of the union with the Beloved within the garden as opposed to the absence of this union in the exterior realm.⁶²

> Oh Yahya, <u>union</u> with the <u>Beloved</u> is the motive of *separation*
> Do not be heedless, for the <u>skirt of union</u> with the beloved *goes from hand*

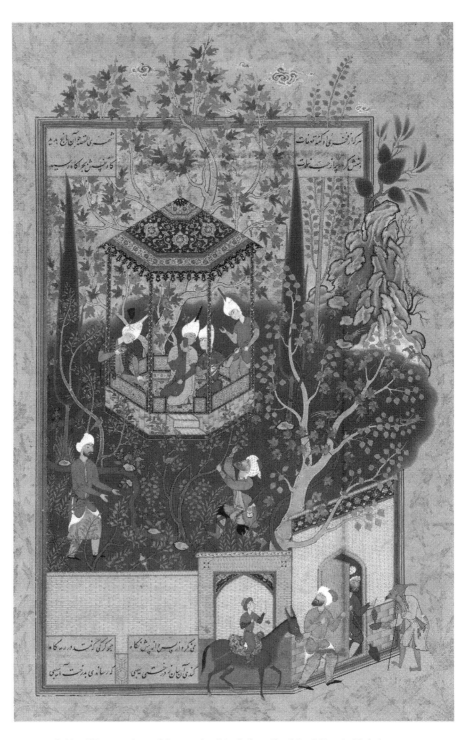

3.11 "Destruction of the garden" in Sultan Ibrahim Mirza's *Haft Awrang* (1556–1565) by Jami (d. 1492). Freer Gallery of Art, Smithsonian Institution, Washington, DC. Purchase, F1946.12.179a.

The best example to illustrate the association of the opposing domains of the cosmological hierarchy is a painting from the sixteenth-century Persian miniatures from Sultan Ibrahim Mizra's *Haft Awrang* (Figure 3.11).[63] This painting portrays the interior–exterior duality explicitly. The painting shows a garden enclosed by high brick walls. Inside the walls there is a blissful garden planted with cypresses, fruit trees and all kinds of flowers. On the exterior, the painting depicts a beggar who represents the misery of the outside world. The owner of the garden invites a "city-dweller" to his garden to attend a garden party. In the background, beautiful young boys enjoy a garden party. The city-dweller, who is surprised by the beauty of the garden, gets jealous. Instead of attending the garden party, he damages the garden. He tries to tear down the trees and breaks their branches. The city-dweller is dressed as a vulgar person, while the owner of the garden is well dressed and elegant. This painting clearly portrays the two opposite domains of the cosmological hierarchy, the interior and the exterior. The interior realm is symbolized by a paradise-like garden and it houses all the blissful and superior qualities. The interior world is prosperous. The ones inside the garden are well mannered and beautiful. The exterior realm is symbolized by the deprived city and it houses all the deprived and inferior qualities. The ones in the exterior realm are bad mannered and hideous.

Real Spaces

The Sultan's palace was a well-protected garden symbolizing his authority. It displayed imperial power in its gardens. All the elements within the imperial garden add up to the representation of the paradise garden on earth, ruled by the Ottoman Sultan. Other places, other imperial gardens and imperial mosques also displayed the power of the Ottoman rule by using garden metaphors. Thus, each one of the spaces commissioned by the Ottoman court became an expression of the imperial power and the Ottoman cosmology that anchored earthly order to the celestial order; subjects of the Sultan to his rule.

Evliya Çelebi narrates that there were 40 imperial gardens, but he only lists about 20 of them as the foremost known gardens: Sarayburnu "has bahçe" with 80,000 gardeners, Fitneköy Garden built during the Beyazıd II (1481–1512); gardens of Siyavuş Paşa, Davud Paşa, Silivri, Harami River, İskender Çelebi, and Halkalı Garden built by Architect Sinan on the European side during the sultanate of Süleyman I (1520–1566); Tokat, Sultaniye, Çubuklu, Kandilli, Haydarpaşa gardens on the Asian side; Istavroz, Üsküdar, Fener gardens built by architect Sinan; Mir-gûne Garden in Kağıthane built by Murad IV (1623–1640); Tersane Garden, Karaağaç Garden, Dolmabahçe, Büyükdere, and Çamlıca gardens. The imperial Tersane Garden was located in Hasköy, and was a favorable site since the Byzantine period. Evliya Çelebi describes the garden with many pavilions, pools, fountains, rooms, and records that 12,000 cypress trees were planted in this imperial garden in a grid pattern.

Fatih Sultan Mehmed had planted seven cypresses himself. The Tokat and Sultaniye gardens of the Sultan were located at Beykoz. Fatih Sultan Mehmed, who heard the news about the capture of Tokat while he was hunting in Beykoz, ordered the building of a garden "similar to the Garden of Iram" to be named the "Garden of Tokat." Evliya Çelebi records that a low pavilion, pool and an ornamental fountain were built at the site, which was surrounded by fenestration similar to the city walls of Tokat. Evliya gives us evidence that the garden was probably located on a hillside that was approached by a road in the valley, with trees planted on both sides. Further down in the valley, there were other promenades: Akbaba Sultan, Âl-i Bahâdır, Alemdağı, Koyun Korusu, and Yûşâ nebi. The Sultaniye Garden, described as a "rose garden similar to the paradise" by Evliya Çelebi, was built by Beyazıd II (1481–1512) on the shoreline of the Bosphorus. During the sultanate of Murad III (1574–1595), a pavilion was constructed with the building materials of a former pavilion that was located in one of the Turcoman provinces close to Tabriz. The new pavilion, which had illustrative paintings of animals, and other "artful" decorations inside, was overlooking the sea, and was surrounded by a garden.[64]

Ogier de Busbecq, who had been to Istanbul several times during the period of 1554–1562, records his excursions in Istanbul and its environs. In 1555, he accounts for lavender fields at Üsküdar[65] and describes imperial "country-houses" and "parks":[66]

I had a delightful excursion, and was allowed to enter several of the Sultan's country-houses, places of pleasure and delight. On the folding doors of one of them I saw a vivid representation of the famous battle of Selim against Ismael, King of Persia. I also saw numerous parks belonging to the Sultan situated in charming valleys. What homes for the Nymphs! What abodes of the Muses! What places for studious retirement!

Salomon Schweigger, who traveled to Istanbul in the late sixteenth century, also recorded the numerous imperial gardens of Istanbul, and the Sultan's travels to these gardens by the imperial boat.[67] Lubenau, who traveled to Istanbul at the end of the sixteenth century, accounts for gardens of the elite along the Bosphorus:[68]

On my tour I saw on both shores of Bosphorus many exquisite and beautiful gardens built in the Turkish manner with palaces (palatio) and pleasure houses (lustheuser), which were planted with extremely beautiful tulips (tulipanis) in a medley of colors and an abundance of Turkish flowers. These gardens and palaces, which lie beneath beautiful mountains and hills, belong to the pashas and grandees…

From a sixteenth-century anonymous European album (A watercolor (1588) from Oxford University, Bodleian Library, ms. Bod. Or. 430, fol. 2r.) Necipoğlu identifies seven gardens along the Bosphorus, both on the European and the Asian sides; the Topkapı Palace gardens planted with cypresses, Üsküdar

Garden surrounding the Kavak Palace built in the 1550s out of independent kiosks and pavilions, Tower Garden at Çengelköy, Kandilli Garden, Karabali Garden at Kabataş, built during the reign of Sultan Selim (1566–1574), gardens of the Palace of the Grand Admiral Hasan Pasha at Beşiktaş, and royal gardens at Rumelihisarı. The Tower Garden (Kule Bahçesi) and the Sultaniye Kiosk were both dated to the time of Süleyman I. The Tower Garden, which was used as a hunting garden mainly, was deconstructed in 1722 and stones from its walls were reused in the construction of the Sadabad Palace at Kağıthane. Antoine Galland, who traveled to Istanbul in 1672–1673, was impressed by the splendor and original plan of the Sultaniye kiosk and described it as "This pavillion has no equal in the world, it owes its beauty to its position at the edge of the sea."[69]

The Topkapı Palace is an example of the garden of worldly authority. From the most private to the most public, the palace is made out of three enclosed courtyards. At the end of the third courtyard, there are two passages to a cascaded garden. The top part of the cascaded garden is a continuation of the Sultan's private lodge, his living quarters, known as the Privy Chamber.[70]

A larger garden surrounds the whole palace complex, including the cascaded private garden of the Sultan, stretching from the central palace complex to the outer periphery defined by the fortified walls of the palace, *Sur-i Sultani*, of 1,400 meters, which forms the boundary between the city (both the built fabric, and the sea, the Golden Horn and the Marmara) and the central palace complex.

The gardens, like the palace, are refurbished with all kinds of macrocosmic references, in an attempt to embody all the gardens of the macrocosmic hierarchy, from the Universal world, to the individual world. Just like the walls surrounding the whole complex had 28 towers resembling the 28 days of the moon calendar, the fourth court, as the most private garden of the Sultan, attached to his bedroom complex, the Privy Chamber, was once surrounded by a perforated wall which had seven belvedere towers, again associating the space with astrological connotations. The private garden of the Sultan embellished with pavilions and belvedere towers, located on the top of a cascaded garden, refers both to the story of the Persian legend Bahram Gur's love stories in seven pavilions within an imperial garden as depicted in the Haft Paykar,[71] and to the hanging gardens of Babylon.[72]

The resemblance of the palace garden to the Paradise Garden, or to the King Solomon's Garden of Iram was repeated many times by Ottoman historians, and poets.[73] The fifteenth-century historian Idris Bidlisi, as referred by Necipoğlu, illustrates the Sultan, his pages, and his harem enjoying the terraced gardens ornamented with all kinds of fountains, vineyards, and pavilions, that the gardens resemble the heavenly Paradise Garden adorned with all kinds of wonders, in which the *houris* and *ghilman* enjoy themselves.[74]

Evliya Çelebi cites this garden as the "Garden of Iram," built and organized surrounding the whole palace complex, in which "twenty thousand cypress, plane, juniper, and pine trees, box plants had been

planted together with hundreds of fruit trees."⁷⁵ Necipoğlu mentions further Tursun Bey, Kemalpaşazade, poets Câfer Çelebi, and Hamidi, who compares the gardens of the palace to paradise, referring to the different elements that made up the garden.⁷⁶ The well-watered garden with its decorated fountains, marble pools, with a variety of flowers, roses, cultivated and wild tulips, hyacinths, jasmine, fragrant herbs, and fruit tress, cypresses, and pines occupying the same garden with floral ornamentations of the lavishly decorated pavilions located freely in the garden resemble the Paradise Garden.⁷⁷

The palace garden was also the garden of Islam itself. The garden displayed, represented and became an agent for the practice of Ottoman imperial power, embracing elements of all the different worlds, as a collection of all the natural and cultural realms, which the Ottoman rule covers. This garden, called "Paradise Garden" by many historian and poets, had different artifacts symbolizing the lands captured. It was recorded that Mehmed II had built three pavilions on the west side of the garden, overlooking the city and the Golden Horn, around a courtyard called Kumlu Meydan. According to Necipoğlu, these three garden pavilions symbolized significant powers and rivals of the Ottoman Empire, with respect to which Ottoman rule defined its own territory. Similarly, Revan Köşk was completed in 1636, after the capture of Erivan. Bagdat Köşk was built after the second capture of Baghdad in 1638. Similarly, when Ottoman culture was under the influence of European cultures, Mecidiye Köşk was designed in European style, built by Abdülmecid, in the late ninteenth century.⁷⁸

Necipoğlu studies the gardens of the Topkapı Palace as a container accommodating an extensive display of the limits and magnificence of Ottoman power and reach. The garden accommodated Byzantine heritage with a display of several artifacts and architecture. The natural world under Ottoman rule was also displayed in the gardens. The three worlds of the natural realm, minerals, animals, and plants were also a part of the garden. There were a variety of animals, wild or tamed, that were kept in different parts of the bigger garden surrounding the palace complex in three dimensions. Domesticated birds, fowls, deer, does, roe deer, foxes, hares, sheep, goats, and Indian cows were among the kind of animals to be found in the palace gardens. In a special marshy pond there were ducks and geese. The horses were kept in the stables.⁷⁹ There were many kinds of plants, including fruit trees and vegetables. Just like the flowers were sold together with baskets of fruits in the market outside the palace, fruit trees occupied the same garden with the various kinds of tulips, roses, hyacinths, and carnations. Various types of these flowers are known to have been imported from other provinces outside Istanbul by order of the Sultan.⁸⁰ Necipoğlu argues that the flowers were also a part of the imperial collection, the treasury.

The palace garden had its own ecology. First, its interior was considered as a depository of all the territory, in terms of nature and culture, under

the Ottoman–Islamic rule. Second, it was a stage for the display of the new character of Ottoman authority, compiled from the Persian, Greek, and Turkish cultures. Third, it accommodated garden spaces, where the Sultan would host parties overlooking the rest of the city, from the belvederes or pavilions built in the new Ottoman heritage. Fourth, it included the Sultan's most private garden, entered from his bedroom—the Privy Chamber—where he enjoyed himself with his household. The Sultan would expel gardeners from the gardens when he wanted to enjoy privacy with his concubines.

The interior of the garden space was a dynamic world in harmony. This harmony was maintained partially by the services of the gardeners of about 200 young men in total. These gardeners were grouped into nine corps, each one identified with a different colored belt. The corps' dormitory was located within the walls surrounding the palace.[81]

Comparable to Zati's poetic artistry discussed in previous pages is the building of a pavilion in the gardens of the palace, whose style is composed as an eclectic composition out of the styles of the imperial friends and enemies, nevertheless the rivals of the Ottoman Empire. It is still debatable whether the kiosk resembling a paradise in the garden refers to this or that culture. The Persian pavilion named the Tiled Pavilion (*Çinili Köşk, Sırça Saray*), completed in 1472, was built in the style of the Timurid palaces with a cruciform plan, inscribed in Persian, and ornamented with the cut-tiles probably by Khurasani tile-cutters, or the masters of Tabriz who were brought from Tabriz. It was a large pavilion and some historians refer to it as a palace. The Tiled Pavilion resembles the Timurid Hast Bihest (Eight Paradises) in Tabriz, built in honor of ruler Uzun Hasan of the Akkoyunlu Dynasty. According to the accounts of travelers, it had narrative murals painted on its walls depicting "reception ceremonies, hunting scenes, military campaigns."[82] It was used for the Sultan's parties.

The gardens of the Topkapı Palace were separated from the city. The palace walls were the literal boundary between the interior and the exterior of the garden space. They were built for reasons of security, for seclusion and privacy.

In *Tezkiretü'l-Bünyan*, Sinan acknowledges the role of architecture in the Muslim tradition. He asserts that like the Kaaba, architecture should guide the human being from the phenomenal world to the gardens of paradise. He stresses the architect's duty to lead society through his architecture like building a bridge between the two worlds, here and hereafter as "the bridge leading from this world to the gardens of paradise."[83] Architecture becomes like a poem where each architectural feature, be it columns, fountains, domes, vaults or other elements, act in a similar way to words in a poem. Each element in space incites imaginative faculties and encourages the individual to pursue his quest for divine knowledge, similar to words in a poem where each one initiates a journey between meaning and form:[84]

> Words are the fruits of the garden of meaning
> Words are a river of exuberance
> Words are meaningful and measured
> Enchant whoever might listen
> These are the words of generous men
> He who is perfect appreciates the worth of the perfect man
> Knowledge is a bottomless sea
> Its accompaniment a bright pearl
> Those who journey by ship find mother of pearl in the depths
> Others gather pots and jars at its edge
> If divers descend to the seabed
> If they fill bags with pearls
> Sometimes pearls of eternal beauty
> Sometimes the flotsam of the sea is revealed

As with each word in a poem, each element of architecture becomes a tool to contemplate for the attainment of eternal knowledge:[85]

> Likewise original poetry is the gift of God
> Can every drop of April rain be a pearl
> No poem is perfect and beyond reproach
> No rose without thorns blooms in the world's garden

Necipoğlu presents architect Sinan with the qualities of a poet in reference to the tectonics of his architecture. Though her argument develops with different paradigms and concerns than this study, where she studies the eclectic style of the architect with his references to historical works of architecture like Hagia Sophia, her claim to consider the architect as a poet who refers to other poems, questions the association of the arts of poetry and the arts of space:[86]

His imperial mosques can therefore be seen as architectural counterparts of emulative poems called *nazîres*, which were composed on the model of admired exemplars in order to invite a competitive comparison. Built during the Golden Age of the Ottoman Empire, they proclaim imperial achievement, the triumph of Islam, and the role of the architect in codifying the canons of a historically conscious architecture expressing a glorious epoch.

Architect Sinan's Şehzade Mosque Complex, "*Zehî â'lî binay-ı Cennet-âsâ,*" completed in 1548, is compared to the "paradise" with its refreshing air and pure water.[87] The mosque is described as having colorful vaults, which the architect compares to the rainbow, and its serene interior is compared to the delightful space of *mesire*. The progress of the construction and the high-rising domes are described as being similar to the waves of the sea.[88] The columns represent cypresses in a garden:[89]

> Do not mistake the marble pillars erected in the garden
> They are cypresses of beloved countenance rising to watch

Süleymaniye Mosque is compared to a book. When the mosque is completed, the architect presents it to the Sultan as a book to guide the ones who are questing for the divine knowledge:[90]

> Thank be my Sultan that God
> Made for you an illustrious mosque
> Take this, the key of the house of God
> It is the guide to enlightened travelers
> Each of its double doors is like a book
> Through which surely a door will open for you

The building of the Süleymaniye Mosque is again depicted with metaphors of paradise garden. The construction of the central space is compared to a cypress tree growing in the garden of Islam. The four columns supporting the main dome represent the four caliphs. The domes are described as similar to the waves decorating the sea, and its central dome similar to a painting drawn on the sky. Further, the interior space of the mosque is illustrated as a beautiful garden of spring, where the colorful and ornamented glass of the windows are similar to the rainbows as they glitter in different colors by the changing sunlight throughout the day.[91] The mosque is described as a paradise garden that would host the meeting of the lovers, thus the mystics, the friends of the divine being:[92]

> The mosque has become a place where lovers of pleasure meet
> A place like paradise that gladdens the spirit

Similarly, Selimiye Mosque in Edirne is also compared to the paradise garden:[93]

> Every corner is a (rose) garden of paradise, with spring adornments
> Its cursive inscriptions like the river of *selsebil*

The praying time is also depicted with reference to a garden. The minarets are depicted as cypresses endowed with birds nests. The prayer's call as if sung by the angels is heard from these nests, like a nightingale's chanting in a rose garden:

> When the beautiful angels of resounding voice gather
> To nest like doves at the summit of the cypress trees
> From all four minarets melodies in the modes of *neva* and *pençgâh*
> Like nightingales invite the world to this rose garden

The tomb of Sultan Süleyman in the garden of Süleymaniye is accounted for as "a dome within the vineyards, fruit gardens, and rose plots, similar to the paradise garden."[94] Similarly, the inscription on the tomb of Murad III, which is located in the garden of Hagia Sophia, also identifies the space as a paradise garden.[95]

There are also allusions to the paradise garden in the seventeenth-century Mosque of Sultan Ahmed I. In *Baharriye Kasidesi*, the Sultan Ahmet Mosque

is cherished for giving more pleasure than a rose garden or a *mesire*.[96] The following poem celebrates the entrance of the Sultan to the mosque, depicting the interior as a paradise garden:[97]

> How can I not call this place of worship the rose garden of paradise?
> When seeing its form, the forlorn heart blossomed open like a rose

The mosque is depicted with allusions to a real garden planted with cypresses, plane and fir trees, fruit trees and palm trees, with colorful flowers of tulips and jasmine, where at one of its corners there is a rose garden. Lamps are compared to the bushes of the Iram Garden with shiny leaves, the sound of water pouring from the fountains to the sound of nightingales, columns to the trunks of various trees—fir, cypress, or palm trees:[98]

> It is like the garden of heaven to the community of worshipers
> Its every joy-filled corner gives pleasure to the heart
> The sacred excursion spot is a charming rose garden
> Oh God, the flowers in the marble are the image of the beloved
> Within are the flames of the lamps not tulips?
> Is not the lamp a bush of Iram, are not the lights the leaf of the jasmine?
> The spouted fountain is a caged nightingale
> For like the nightingale, it continually produces a pleasing sound
> Its columns in their stature are the cypress or the fir
> The throne of the high *mahfil* is the spreading branch of the plane tree
> Each of its columns is a tall palm trunk
> And the appearance of its clusters of lamps is like fruits

In the *Essasiye Kaside* in *Risaletü-l Mimariye*, the architectural features of the mosque are compared to the elements of the Typal world; sun, rainbow, stars, Mount Sinai, nightingale, and the rose garden:[99]

> Lightning struck the golden realm of the sun and the revolving sphere with gold
> And caused the vault of heaven again to manifest a halo of light
> The rainbow assumed the delightful form of the mihrab
> ...
> You might suppose that Mount Sinai became an artfully fashioned *minbar*
> In which illumination from God was made manifest
> The lofty mountains became here and there rare *mahfils*
> The beautiful-voiced *hafız* is the nightingale of the rose garden

The Sultan's breast is depicted as a garden, and his heart as a rose. The individual breast, which symbolizes the most private sphere in the cosmological hierarchy of gardens, is mentioned as a locale in the structure of spheres, where the space of the mosque is also depicted within the Garden of Islam:[100]

> May his heart blossom like an open bud
> So long as the sun traverses the garden of this world

The mosque, the abode of Islam as protected by the Sultan, is presented in the center of the world of Islam:[101]

> The world became like a mosque with its star candles
> The sun and the moon are the two bright candles to the mosque of the world
> ...
> The mosque of the ruler of the World made known his image
> The Shadow of the unique and eternal God, His Majesty Sultan Ahmed

And as located in the city of Istanbul, which is considered as an interiorized space within the cosmological hierarchy:[102]

> This abode became pleasant and airy like paradise
> From time to time the gentle morning breezes visit it
> Its qibla is the sea, it faces the Hippodrome
> In addition on every side is the prosperity of the city and the bazaar
> And beside the mosque there remain many more (fine) places (in the city)
> Where quarters like that might be built and great cities might be

What is left outside the circle of the House of Islam are the non-believers, the rebels, or the heretics of other Islamic orders:[103]

> When, along with your majesty, they saw your success and faith and sword
> Bans, and kings and unbelievers prostrated themselves before you

In *Baharriye Kasidesi*, the space of the Sultan Ahmet Mosque, referring to its decorations, the choice and quality of building materials, its architectural elements, and the underlying geometry, is depicted as being a "symbol" for the garden of paradise:[104]

> The entire artifice is naught but a symbol
> In it are many of these unique sorts of creations

The interior space of the mosque with all its inscriptions is compared to a poem. The space, with the presence of the verse, is transformed into a paradise garden, similar to the perception of the other architectural features, which represent the natural elements of the paradise. The author reminds us the legendary poems that were written in gold and hung from the door of Ka'ba, that were called the Suspended Odes:[105]

> Now those who see this pure verse (the mosque) would think it to be a garden plot
> Purple violets became letters and the lily a scroll
> This is not a garden plot but the Suspended Seven Odes

The verses inscribed within the dome within a circle represent the borders of the mosque and its perfected symbolism:[106]

> None (but the Aga) can give such splendor to the flowers of the rose garden
> He who seized the pen drew the border as though a compass were in hand

Private gardens and private garden parties anchored imperial authority and social hierarchy in order to sustain the social order. In this understanding,

gardens were described as enclosed private spaces, which stimulated imagination that would only serve to sustain a static cosmological order. Gardens and representations of gardens in different mediums, in the decoration of mosques, tombstones, and even clothing, became symbols of imperial ideology, asserting imperial authority associated with divine power as asserted by the Shariah Law and practiced by the Ottoman monarchy.

Istanbul as the capital of the Ottoman Empire, planted with numerous gardens and decorated with representations of gardens and floral ornamentation, turned into a space of this ideological manifestation. It suggested the imperial and religious spaces of the city as a paradise, as interior and blessed spaces of the cosmological hierarchy.

Garden rituals enabled real gardens to accommodate ideal gardens. *Gazel* poems read in garden rituals depicted imaginary gardens of other Near Eastern imperial traditions, as depicted in storybooks, Ottoman genealogies, and in different kinds of art form and as well-brought ideal gardens of paradise as narrated in religious texts. Garden parties constantly referred to the real world as an exterior space. They created a duality between interior spaces and exterior spaces. Though garden rituals were considered to be activities in order to practice the faculty of imagination, their static order hindered novelty and innovation, and failed to support the development of individuality.

Notes

1 For the associations between Ottoman gardens, garden parties and Ottoman poetry, see Walter Andrews, *Poetry's Voice, Society's Song: Ottoman Lyric Poetry* (Seattle and London: University of Washington Press, 1985), and Harun Tolasa, *Sehi, Latifi, Aşık Çelebi tezkirelerine göre 16. y.y.'da edebiyat araştırmaları* (Izmir: Ege Üniversitesi Matbaası, 1983); Halil İnalcık, *Şair ve Patron Patrimonyal Devlet ve Sanat Üzerine Sosyolojik Bir İnceleme* (Ankara: Doğu Batı Yayınları, 2003), 23–35, 43–44; Nurhan Atasoy, *A Garden for the Sultan: Gardens and Flowers in the Ottoman Culture* (Istanbul: Mas Matbaacılık A.Ş., 2002), 50–53, 70–73, 146–147, 154–160, 126–127, 170, 231–232.

2 Zeren Tanındı, *Türk Minyatür Sanatı* (Istanbul: Türkiye İş Bankası Kültür Yayınları, 1996), 9–10; Ernst Grube, *Studies in Islamic Painting* (London: The Pindar Press, 1995), 446.

3 Esin Atıl, "Mamluk Painting in the Late Fifteenth Century," *Muqarnas* 2 (1984), 159–171, 161.

4 Shirine Hamadeh, "The City's Pleasures: Architectural Sensibility in 18th Century Istanbul," PhD diss., MIT, Cambridge, MA, 187; from Aşık Çelebi, *Meşa'ir üş Şu'ara*, 160b–161a.

5 Nurhan Atasoy, *A Garden for the Sultan*, 73–89.

6 Norah Titley, *Persian Miniature Painting and its Influence on the Art of Turkey and India: The British Library Collections* (London: The British Library, 1983), 143.

7 Nurhan Atasoy, *A Garden for the Sultan*, 156.

8 Norah Titley, *Persian Miniature Painting*, 139.

9 Filiz Çağman and Zeren Tanındı, "Remarks on Some Manuscripts from the Topkapı Palace Treasury in the Context of Ottoman–Safavid Relations," in *Muqarnas* 13 (1996), 132–148.

10 Nurhan Atasoy, *A Garden for the Sultan*, 50–51.

11 *Ibid.*, 157–158.

12 *Ibid.*, 157.

13 Andrews, *Poetry's Voice*, 48.

14 *Ibid.*, 143–174.

15 Agah S. Levend, *Divan edebiyati: kelimeler ve remizler, mazmunlar ve mefhumlar* (Istanbul: Inkilap Kitapevi, 1943), 319–320.

16 *Ibid.*, 323–335.

17 *Ibid.*, 336–342.

18 *Ibid.*, 320–321.

19 Andrews, *Poetry's Voice*, 46.

20 Walter G. Andrews, "Literary Art of the Golden Age: The Age of Süleyman," in *Süleyman the Second and His Time*, ed. Halil İnalcık and Cemal Kafadar (Istanbul: Isis Press, 1993), 353–368.

21 Agah S. Levend, *Divan edebiyati*, 309–310.

22 *Ibid.*, 311.

23 Walter G. Andrews, *Poetry's Voice, Society's Song*, 3–18; *Encylopedia of Islam*, vol. II (1927), 146; *Islam Ansiklopedisi*, vol. 4 (1945), 730–732; E.J. Gibb, *Osmanlı Şiir Tarihi* (Istanbul: Akcag), vol. I, 1–70.

24 Though it had been recognized as a form of high art practiced by the elite circles due to its artful language which comprised a high percentage of foreign words, it was also adapted to the understanding and enjoyment of the Turkish-speaking common public by the efforts of Turkish-speaking dervishes; Walter G. Andrews, *Poetry's Voice, Society's Song*, 4–5.

25 Translated from Abdülbaki Gölpınarlı, *Nedim Divanı*, XVIII.

26 Şemsettin Kutlu, *Divan Edebiyatı Antolojisi* (Istanbul: Remzi Kitabevi, 1983), 501.

27 Reşad Ekrem Koçu, *Tarihte Istanbul Esnafı* (Istanbul: Doğan Yayınları, 2002, c. 1970), 11–14.

28 "Esnaf Gelenekleri" in *Dünden Bugüne Istanbul Ansiklopedisi*, vol. 3, 218.

29 Halil İnalcık, *Osmanlı İmparatorluğu Klasik Çağ 1300–1600*, 1973, trans. Ruşen Sezer (Istanbul: YKY, 2003).

30 Metin And, *A History of Theatre and Popular Entertainment in Turkey* (Ankara: Forum Yayınları, 1963).

31 For detailed information on the opposition between the *rind* and the *sufi*, see Ahmet A. Şentürk, *Klasik Osmanlı Edebiyatı Tiplerinden Sufi yahut Zahit Hakkında* (Istanbul: Enderun Kitabevi, 1996), and Mine Mengi, *Divan Şiirinde*

Rindlik (Ankara: Bizim Büro Basımevi, 1985); Harun Tolasa, *Sehi, Latifi, Aşık Çelebi tezkirelerine göre 16. y.y.'da edebiyat araştırmaları* (Izmir: Ege Üniversitesi Matbaası, 1983).

32　Annemarie Schmimmel, *Mystical Dimensions of Islam* (Chapel Hill, NC: University of North Carolina Press, 1975), 20–21.

33　Mariana Shreve Simpson, *Persian Poetry, Painting and Patronage Illustrations in a Sixteenth Century Masterpiece* (New Haven, CT: Yale University Press / Freer Gallery of Art, Smithsonian Institution, Washington, DC, 1998), 44–45.

34　*Ibid.*, 45.

35　Talat S. Halman, *Süleyman the Magnificent Poet* (Istanbul: Dost Yayınları, 1987), 32–33.

36　Nurhan Atasoy, *A Garden for the Sultan*, 134; 140–142; 135–139; Yıldız Demiriz, *Osmanlı Kitap Sanatında Natüralist Üslupta Çiçekler* (Istanbul: Acar Matbaacılık Tesisleri, 1986), 278–280; 281–303.

37　For a detailed study of Şeyh Galip's work, see Victoria Holbrook, *The Unreadable Shores of Love: Turkish Modernity and Mystic Romance* (Austin, TX: Texas University Press, 1994).

38　*Ibid.*, 83–84.

39　*Ibid.*

40　Shirine Hamadeh, "The City's Pleasures: Architectural Sensibility in 18th-Century Istanbul," 187; from Aşık Çelebi, *Meşa'ir üş Şu'ara*, 160b–161a.

41　Gülru Necipoğlu, *The Topkapı Scroll*, 197–216.

42　*Ibid.*, 203.

43　*Ibid.*, 185; from thirteenth-century Shams-i Qays and sixteenth-century Muslih al-Din Mustafa Sururi.

44　*Ibid.*, 185.

45　Andrews, *Poetry's Voice, Society's Song*, 173.

46　On Islamic cosmography see Seyyed Hossein Nasr, *An Introduction to Islamic Cosmological Doctrines* (Cambridge, MA: Harvard University Press, 1964); R.C. Foltz, F.M. Denny, and A. Baharuddin, eds., *Islamic Ecology* (Cambridge, MA: Harvard University Press, 2003); M.A. Angelis and T.W. Lentz, *Architecture in Islamic Painting: Permanent and Impermanent Worlds* (Cambridge, MA: Acme Printing, Fogg Art Museum / The Aga Khan Program for Islamic Architecture, 1982); Nader Ardalan and Laleh Bakhtiar, *The Sense of Unity: The Sufi Tradition in Persian Architecture* (Chicago; London: University of Chicago Press, 1973). Even the music played followed conventions similar to the layering of cosmology. In music, there were 12 modes (makam): *Rast, 'Irak, Isfahan, Zirefkend, Büzürg, Şernegule, Revahi, Hüseyni, Hicaz, Buselik, Neva*, and *Uşşak*, similar to the 12 constellations of the zodiac of the eight heavens: *Aries, Taurus, Gemini, Cancer, Leo, Virgo, Libra, Scorpio, Sagittarius, Capricorn, Aquarius, and Pisces*. And the four tones of music: *Yegah, Dügah, Sergah*, and *Çargah* were compared to the four elements of creation which were known to be fire, air, water, and earth. There were seven derivative modes akin to the seven planets, and 24 kinds of compositions as there are 24 hours of the day; Howard Crane, *Risale-i Mimariye: An Early Seventeenth-Century Ottoman Treatise on Architecture* (Leiden; NY: E.J. Brill, 1987), 26–27.

47 Howard Crane, *Risale-i Mimariye*, 19.

48 E.J.W. Gibb, *Osmanlı Şiir Tarihi*, vol. 1, 44–47; E.J.W. Gibb, *Osmanlı Şiiri Tarihine Giriş* (Istanbul: Köksal, 1999), 41–79.

49 Abdülbaki Gölpınarlı, *Nedim Divanı*, XXIII.

50 Walter G. Andrews, *Poetry's Voice, Society's Song*, 62–142; 152.

51 *Ibid.*, 123.

52 *Ibid.*, 102.

53 *Ibid.*, 75.

54 George Sandys (1578–1644) *Sandys travels: containing an history of the original and present state of the Turkish Empire, their laws, government, policy, military force, courts of justice, and commerce, the Mahometan religion and ceremonies, a description of Constantinople, the Grand Signior's seraglio, and his manner of living. A Relation of a Journey begun An Dom: 1610 Fovre Books the sixt edition London: Printed for Philip Chetwin, 1610,* 7th ed. (London: Printed for J. Williams Junior, 1673), 46.

55 M.A. Angelis and T.W. Lentz, *Architecture in Islamic Painting*, 20–21; Sheila S. Blair and Jonathan M. Bloom, eds., *Images of Paradise in Islamic Art* (New Haven, CT: Trustees of Dartmouth College, 1991).

56 William C. Chittick, *The Self-Disclosure of God: Principles of Ibn al-'Arabî's Cosmology* (Albany, NY: State University of New York Press, 1998), 12; 16; 91; 149; 169; *The Sufi Path: Ibn al-'Arabi's Metaphysics of Imagination* (Albany, NY: State University of New York Press, 1989), 68–76.

57 William C. Chittick, *The Self-Disclosure of God*, 8; 13; 53; 106–107; *The Sufi Path*, 68–76.

58 William C. Chittick, *The Self-Disclosure of God*, 106–107.

59 Walter G. Andrews, *Poetry's Voice, Society's Song*, 173.

60 *Ibid.*, 173.

61 *Ibid.*, 123.

62 *Ibid.*, 123.

63 Mariana Shreve Simpson, *Persian Poetry, Painting and Patronage*, 52–53.

64 Mehmed Zıllîoğlu Evliya Çelebi, *Evliyâ Çelebi Seyâhatnâmesi*, vol. 1.

65 Edward Seymour Forster, trans., *The Turkish Letters of Ogier de Busbecq Imperial Ambassador at Constantinople 1554–1562*, translated from the Latin Elzevier edition of 1633 (Oxford, UK: Clarendon Press, 1968, c. 1927), 43.

66 *Ibid.*, 39–40.

67 Gülru Necipoğlu, "The Suburban Landscape of Sixteenth-Century Istanbul as a Mirror of Classical Ottoman Garden Culture," in *Gardens in the Time of Great Muslim Empires*, ed. Attilio Petruccioli (Leiden, New York; Cologne: E.J. Brill, 1997), 32–33.

68 *Ibid.*, 33.

69 *Ibid.*, 37.

70 For an extensive study of the gardens of the Topkapı Palace, see Gülru Necipoğlu, *Architecture, Ceremonial and Power: The Topkapı Palace in the Fifteenth and Sixteenth Centuries* (Cambridge, MA: The MIT Press, 1991).

71 In the legendary story of Haft Paykar, in which the main character, the emperor Bahram Gur, travels in his imperial gardens visiting his seven lovers each day of the week. The lovers are living in seven different pavilions of seven different colors of black, yellow, silvery-green, red, turquoise blue, sandalwood colored, white pavilions. The weekly journey of Bahram Gur symbolizes the Sufi idea regarding the "progress of soul" through seven stages. So each pavilion visited one after another on consecutive days of the week addresses the seven planets (Saturn, Sun, Moon, Mars, Mercury, Jupiter, Venus), establishing a macrocosmic order within which the soul progresses from darkness to purification. Grace Guest, *Shiraz Painting in the Sixteenth Century* (Washington, DC: Lord Baltimore Press), 43–44.

72 Gülru Necipoğlu, *Architecture, Ceremonial and Power*, 184–200.

73 *Ibid.*, 201.

74 *Ibid.*, 201.

75 Mehmed Zıllîoğlu Evliya Çelebi, *Evliya Çelebi Seyahatnamesi*, vol. 1, 113–114.

76 *Ibid.*, 201.

77 Gülru Necipoğlu, *Architecture, Ceremonial and Power*, 201.

78 *Ibid.*, 201.

79 *Ibid.*, 201.

80 Ahmet Refik cites two imperial orders in the late 17th century requesting the import of 50,000 white and 50,000 sky-colored hycanith (gök sünbül soğanı) bulbs from the plains and mountains of Maraş, 400 kantar red roses (kırmızı gül) and 300 kantar white roses (sakız gülü) to the gardens of the palace: Ahmet Refik, *Hicri Onbirinci Asırda İstanbul Hayatı (1000–1100)* (İstanbul: Devlet Matbassı, 1931), 3, 9. Earlier accounts from the era of Süleyman I record for orders to bring in tulip bulbs from Caffa (1527–1528), and pomegranate trees from Aleppo and Diyarbakır. Another financial record of 1579 cites importing hyacinth bulbs from Uzeyr; Gülru Necipoğlu, *Architecture, Ceremonial and Power*, 202.

81 Each corp had a separate kitchen and a bath; Gülru Necipoğlu, *ibid.*, 207.

82 *Ibid.*, 217.

83 Sâî Mustafa Çelebi, *Book of Buildings: Tezkiretü'l-Bünyan and Tezkiretü'l-Ebniye Memoirs of Sinan the Architect*, trans. Hayati Develi (İstanbul: MAS Matbaacılık A.Ş., 2002), 29.

84 *Ibid.*, 33–34.

85 *Ibid.*, 33–34.

86 Gülru Necipoğlu-Kafadar, "The Emulation of Past in Sinan's Imperial Mosques," *Uluslararası Mimar Sinan Sempozyumu Bildirileri Ankara Ekim 1988* (Ankara: TTK, 1996), 177–189.

87 Metin Sözen and S. Saatçi, *Mimar Sinan ve Tezkiret-ül Bünyan* (İstanbul: Emlak Bankası, 1989), 63.

88 Metin Sözen and S. Saatçi, *Mimar Sinan*, 40–41; 60–62.

89 Sâî Mustafa Çelebi, *Book of Buildings*, 43; Metin Sözen and S. Saatçi, *Mimar Sinan*, 62.

90 Sâî Mustafa Çelebi, *Book of Buildings*, 75.

91 Metin Sözen and S. Saatçi, *Mimar Sinan*, 50–51.

92 Sâî Mustafa Çelebi, *Book of Buildings*, 71.

93 *Ibid.*, 96.

94 Mehmed Zıllîoğlu Evliya Çelebi, *Evliyâ Çelebi Seyâhatnâmesi*, 43.

95 *Ibid.*, 46.

96 Howard Crane, *Risale-i Mimariye*, 73.

97 *Ibid.*, 74.

98 *Ibid.*, 73–76.

99 *Ibid.*, 65.

100 *Ibid.*, 76.

101 *Ibid.*, 65.

102 *Ibid.*, 66.

103 *Ibid.*, 67.

104 *Ibid.*, 74.

105 *Ibid.*, 75.

106 *Ibid.*, 75.

4

Şehrengiz Poetry and Urban Rituals (1512–1732): Ideal and Real City Spaces of Love, Reconciliation and Liberation

The *Şehrengiz* genre offers poems depicting cities and their beautiful young guild boys. They are written in the *mesnevi* form. In a study of the genre, Agah Sırrı Levend lists 49 *mesnevis* classified as *şehrengiz* poems. The first *mesnevi* composed in 1493 and the last four *mesnevis* composed at the late eighteenth century do not actually belong to the genre. They are only similar to *şehrengiz* poems. In this perspective, there are 44 *şehrengiz* poems as recorded by Levend, narrating 17 different cities and provinces. The first *şehrengiz* was composed in 1512 and the last one was composed before 1732. Out of 44 poems, eleven poems depict the city of Istanbul. One of the eleven poems about Istanbul is in Persian, and two others are lost. Thirteen poems depict cities and provinces of Thracia and the Balkans, including Edirne, Siroz, Yenişehir, Yenice, Vize, Çorlu, Gelibolu and Belgrad. Fifteen poems depict cities and provinces of Anatolia and further east, including Bursa, Antakya, Manisa, Rize, Sinop, Beray-ı Taşköprü, Kashan and Diyarbakır. Five poems depict unidentified cities.

The first and the last *şehrengiz* depict two cities to the west of Istanbul. The first one depicts the city of Edirne. The last one that is known as of depicts the city of Yenişehir. In the last *şehrengiz*, which was written before 1732, the poet Vahid Mahtumî Mehmed describes his discontent concerning the period and explains that he was forced to move to Yenişehir from Istanbul. Though this study aims to focus on *şehrengiz* poems about the city of Istanbul, it will also investigate the reasons why the genre was practised outside the city of Istanbul (see Table 4.1).

Edirne was the major city among the provinces to the west of Istanbul and it was the city of the *gazîs*. Throughout history, Edirne represented heterodox groups of the *gazî* tradition. It embodied anti-imperial tendencies and housed anti-imperial groups that were hostile towards the growing imperial power associated with the city of Istanbul. Istanbul, which became the capital city after Edirne, constituted a central position in the Ottoman cosmology as the

Table 4.1 List of *şehrengiz* poems examined in this study

DATE	POET OF THE ŞEHRENGİZ	RELATED CITY OR CITIES
1512	Mesîhî	Edirne
1513	Katib	Istanbul, Vize, Çorlu
1520s	Taşlıcalı Yahya	Edirne
1520s	Taşlıcalı Yahya	Istanbul
1534	Fakiri, Kalkandelenli	Istanbul
1540s	Taşlıcalı Yahya	Istanbul
Before 1562	Tab'î Ismail	Istanbul
Before 1566	Anonymous	Istanbul
1564	Cemali	Istanbul
Before 1585	Azizi	Istanbul
Before 1674	Neşati Ahmed Dede	Edirne

house of the Ottoman authority. It was an imperial city. It represented the orthodox community and Shariah. This chapter will analyse eleven poems written about the cities of Istanbul, Edirne and the provinces of Edirne in order to understand how the two cities in conflict shaped the experience and perception of the city of Istanbul from 1512 to 1732.

Şehrengiz of Edirne by Mesîhî (1512)

Mesîhî's *Şehrengiz* is about the city of Edirne. The poem is composed in five main parts;[1] prayer (*münacat*), depictions of the day and night, depictions of young men, *tetimme*, and the final part as the *ihtitam* that is made up of two *gazels*.[2] Most of the *şehrengiz* poems, follow the same order. They begin with a prayer, continue by recalling general themes of Islamic legends, depict city space, make a long list of young men who were supposedly the beautiful members of the guilds and conclude with one or more *gazels*. Mesîhî's *Şehrengiz* begins with a prayer and ends with a *gazel* about Hacı Bayram Veli.

Acknowledging that he faces the mihrab wall at the beginning of the poem, and his reference to Hacı Bayram Veli in the last part, it is probable that Mesîhî is telling this story at a Sufi lodge, among those people who are prone to *Melâmî-Bayrami* philosophy. The whole story is an account of Mesîhî's former experience in the city of Edirne, his travels in the city, at the bazaar, about the guild shops, at the gardens and meadows, by the riverside.

In the first part of the poem, Mesîhî presents himself as an individual within the larger cosmology and portrays a poet confronting God. This first part is important since it paints the picture of an individual. It visualizes an individual alone by himself. Thus, it suggests the study of self according to the mystic tradition. It directs the reader to contemplate the constituents of the self. It enables one to contemplate the material and spiritual constituents of self, his cognitive organs and faculties.

The second part of the poem about night and day, each in ten verses, depicts the transformation of the skies from sunset until sunrise. This part symbolizes the invisible divine world at night-time and the visible human world of manifested bodies in day time. Though there is a third instant in between day and night, the transition from the day to the night or from the night to the day. This transitory period corresponds to the concept of *barzakh*. It is an intermediary time period and it symbolizes the realm of the imagination.

The third part of the poem illustrates the city of Edirne and describes the Tunca River passing through the city. The fourth part is the longest. The beautiful young men of the various guilds are evoked, appreciated and acknowledged with respect to their names and associations. The third and the fourth parts will be studied in order to understand the perception of the microcosm, the world of manifested bodies. These bodies comprise both the architectural edifice that makes up the space of the microcosm as it is perceived by humans, and the human inhabitants of this space who are considered as natural forms. The discussions concerning these parts refer to the attainment of knowledge as a means to comprehend and interpret the Universal Reality. In the final part, the poet once again presents himself as a viewer upon the scenery he has just narrated.

In the first part, the poet concentrates on his body and his sensual desires. He presents his material body and desiring soul and apologizes for his addiction to love, beauty, and worldly pleasure. The poet converses about himself in this first part, as he does in the final *gazels*. As a poor worshipper, as a *rind*, he admits that he pursues his faith in mystical piety rather than following the orders of the orthodox law. As a sinful worshipper, he admits that he believes in Love. He is enchanted by the beauty of the beloved. He pleads himself sinful for his attraction to the beloved ones that is forbidding him from worshipping, as the image of the beloved ones would always be present in his imagination. His vision is distracted by pleasure and longing, his body is stirred with passion to touch the beloved. He declares that all his attempts to practice worship are transformed into cravings for love:[3]

> If I ever intend to fast for a couple of days
> The image of the beloved will hinder my intention

> If I raise my hands to pray
> I believe, with my arms open, I will embrace the beloved

> If I turn to the direction of prayer in the holy shrine
> The mihrab wall will turn into an image of the beloved

He describes moments of his sensual and sexual arousal out of pleasure, as he is charmed by the image of the beloved.[4] Mesîhî uses the adjectives of "mourning, weak, sinful, wrong, eager, mad, and wild" when he mentions his soul.[5] His manifestation as a craving subject with desires suggests a certain understanding of space, where this body interacts with the surrounding environment.

Portrayed as a human being with a material body, a desiring soul, and a rational spirit, under the skies, in the second part of the poem Mesîhî narrates the arrival of the darkness of the mystic night that will be followed by the illuminating daylight of the morning. Day-time is associated with the witnessed bodily world; and night-time with the absent divine world. Night symbolizes the heterodox practices. Day symbolizes orthodox practices. Instants of transition from one to the other—from day to night, or from night to day, are considered to be the important instants that are associated with the *barzakh*, the higher world of imagination.

In this second part of the poem, Mesîhî elaborates moments of sunset and sunrise, each in ten verses. He narrates the stars and the planets as they change their locations one day after another. As Mercury can be observed either on Sunday night or on Wednesday, the planets change their location day after day, the sky is not the same sky one day after another. As the evening falls, Mesîhî describes the sky by using layers of resemblances. The changing colors of the skies as the sun sets each tell a different story, each color: the gilded yellow, the red, the twilight shade with interfering dark lines, and the blackness of the dark night become metaphors referring to various allegories of the Islamic tradition. The changing sky announces the transition from day to night-time. The exact timing of the instant of transformation from day to night, or from night to day were debated constantly both by the scholars of orthodox law, and the mystics of Sufism. The following quotation from 'Arabî also illustrates the significance of Mesîhî's verses on the changing colors of the skies symbolizing the instant of transformation:[6]

The ulemâ of the Shariah have disagreed on the moment of the night salat in two places concerning the first of its moment and the last of its moment. Some say the first of its moment is the absence of the red dusk. I agree with this view. Others say the first of its moment is the absence of the white that is after red.

The exact timing of this natural transformation had a crucial importance since it dictated the timing of daily practices. The order of mundane daily life was organized after the visible and invisible orders of macrocosm. According to Mesîhî,'s poetry, as the planet Mercury is observed in the daytime before sunset, and the horizon appears to be gilded in yellow color, the sky is illustrated where Mercury becomes a pencil writing the beauty of the beloved onto the skies, as if a pen is writing on a gilded page. As the sun sets and the color of the sky begins turning to red, the story of Yusuf is remembered. In Islamic mythology Yusuf symbolizes beauty. Yusuf symbolizes an enlightened person according to 'Arabî. However, his

imaginative faculties are limited to the capacity of an ordinary human being. He can never become a real mystic.

The redness of the sky becomes a metaphor for the blood on Yusuf's shirt. Yusuf's sorrowful story engages the whole theme of the night-time as the darkness surrounds the horizon. The glittering stars become tears shed as the skies weep for Yusuf's unfortunate faith. And by these tears the skies are transformed into dew falling upon the earth. The sound of the night occupied with nature screaming and howling becomes metaphors for the sorrow of Yusuf's father who thinks his son is killed. However, according to the legendary story, Yusuf was not killed. He was only imprisoned in a well.

Mesîhî refers to the misleading appearance of the sky with all the stars and the planets, standing as a static picture. Thus he reminds the reader about the dynamism and change in time. As the sky is depicted in transforming colors, revolving as a wheel, each planet changing its location, air is transformed into dew changing its state of matter, the poet reminds the reader of the dynamism of the cosmos and of the concept of transmutation.

As the night passes, and it is time for the sun to rise, the poet again recalls the story of Yusuf. The brightness that will appear in the east of the sky just before the dawn is the herald of good news from Yusuf, as well as the messenger for the approaching morning. And when the sun rises above the ground, like a gilded pattern drawn on the sky, it appears as a golden coin, as another day gifted to the human beings—as another portion of their stipend in this world.

So, like the whole universe, the night transforms into the day, darkness into daylight, sorrow into good news, as the golden color changes to purple, to red and then to black. The air changes its state of gas into liquid. The whole world transmutes. Each moment of this transformation is presented as another page opened. The movement of the pages following one another also suggests the movement of the universe.

Mesîhî portrays the universe made out of opposites that transform into one another in constant transmutation. This dynamic and circular transformation of the day into night, night into day, air into water, water into air, sorrow into happiness and happiness into sorrow is narrated by allegorical stories. The order of the cosmos, tradition and daily rituals are presented in harmony. Knowledge of the stars, the story of Yusuf, the order of religious practices, all unite in the harmony of the cosmos. Science, tradition and religion are contingent on one another.

Out of this dynamic order of the universe, the city of Edirne unfolds. In the third part, Mesîhî illustrates the city of Edirne. The most apparent theme in the narration is his constant comparison of the city to the paradise garden. He mentions gardens, mosques, the art of ceramics, the Tunca River running through the city and its pleasant weather. The river and the beautiful men swimming; the gardens relieving the heart, a view of minarets compared to the cypress trees, or the sight of the beloveds with beautiful bodies going for a swim appear as detached fragmented scenes.

The narrative jumps from one scene to another in the depiction of a city. However, each one of these fragmented scenes is animated. The poem illustrates gardens, rivers, clouds, minarets, one after another. It is as if there were a screen in front of the poet and he is narrating changing images on this screen. It is important to remember here that the very first of these images was the mihrab wall that Mesîhî depicted in the first part of the poem. Thus after the image of the mihrab wall, this virtual screen reflects one picture after another. It is hard to attain a unified panoramic image of the city from such fragmented descriptions. However, these parts are all depicted as if they were located in front of a continuous background of the paradise garden:[7]

>Such a city that its gardens and meadows
>Gives the individual the serenity of paradise
>
>Its waters handsome and flowing with charm
>Clouds flowing by are refreshing
>
>If you watch every one of these minarets
>Turn into a beloved with a posture like a cypress
>
>Beauties getting naked go into Tunca
>Unfolding their breasts, tiny bellies
>
>One seeing this city, with reference to this picture
>Would think that the number of paradises has become nine
>
>Such a celebrated joyful paradise where all the sinful ones would enter
>See the dissident with the conformist together represented in it

Mesîhî's depiction of the fragmented parts of the city on a screen in the background of the paradise garden recalls 'Arabî's description of the realm of imagination as a garden, as a veil, as a screen between the human being and divine knowledge: "The garden is named 'Garden' because it is a curtain and a veil between you and the Real for it is the locus of the appetites of the souls."[8]

In the fourth part of the poem, Mesîhî tells about the beauty of 46 young men, each one with his name—*Mahmud, Halil, Haydar, Abdi*—and / or with a family name such as *Ferraşoğlu, Semercioğlu, Tuzcuoğlu*, and / or with the name of the trade he is associated with, as the tailor, fruit-seller, barber, moneylender, needle maker, sweeper, mercer, felt-seller, salt-seller, camel-rider, musician, silk-embroiderer, cap-maker, cotton-fluffer, sherbet-maker, oil-seller, or saddler. These listed men have different names of Muslim, Jewish, Armenian, or Greek origin. They come from lower-middle-class guilds. The poem concludes by referring to a specific beloved who is called Hacı Bayram Veli. This acknowledges Mesîhî's associations with the *Melâmî-Bayramis*.[9]

As if recalling 'Arabî's reference to the "heart as place of constant fluctuation,"[10] Mesîhî acknowledges his fluctuating heart. He describes his

admiration for the multiplicity of beloved ones. Since he is never satisfied with a single beloved, he falls in love with one beloved after the other. However, he acknowledges that he still carries the desire to unite with the real beloved.

'Arabî explains the multiplicity of beloved ones by the dynamism of love. According to his philosophy, love is dynamic and it enables the sustainability of the macrocosmic life: "If there were no love, the world would be frozen."[11] The dynamism of love is sustained by the forces of attraction and separation. The force of attraction aims to unite the whole cosmos as one entity. Attraction is enforced by the will to attain divine knowledge. However, the attainment of divine knowledge also necessitates "separability." During the attainment of divine knowledge, things from different realms would meet in a different medium of the imagination. Meaning, form, and the imagining subject are all separate things and belong to different realms. The imagining subject would compare, contrast and interpret the meeting of a meaning and a form. In this way, he will get closer to the divine knowledge. However, the subject would not attach himself to a single form or a specific meaning. Attachment would disable the dynamism of this interactive process. The subject is expected to separate himself from that meaning and that form, and continue his search with others. Attachment to a particular meaning or form is called fantasy or illusion and it would result in an understanding of a static form-meaning unification.

Only when the heart is not attached to a single beloved, but flows from one beloved to another, would the self be able to continue to attain divine knowledge. The city will become a place of seeking for divine love and truth, a place where imagination is nourished, a pool of bodies which the appetite will desire one after the other, where the heart will look for the divine beauty in each thing, but never attach to a single one. And by stirring the city, the city will become a pool of bodies to be contemplated by imagination in the process of gaining divine knowledge. Then the heart would become a mirror reflecting divine knowledge. When the heart reflects divine knowledge, it would become a space for the illustration of truth in the phenomenal world. Thus, the heart would reflect concepts and idea–images from the realm of imagination to the phenomenal world. This would suggest the creation of new ideas, new forms and new concepts. Corbin names this process of "objectivization" and explains it as the creative power of the heart or as the "creative imagination" (imaginatrix).[12]

Representation of the unity in multiplicity enables attainment of divine knowledge, but also enables the creation of novel forms and ideas. The city provides a storehouse for the faculty of imagination to contemplate. Thus, in Mesîhî's Şehrengiz, the city becomes an intermediary realm where the faculty of imagination is practiced. By studying the variety of loci, things, and beloved ones in the city, Mesîhî introduces novel concepts. He describes the shop of a blacksmith compared to a mosque decorated with horse-shoes hanging all over its walls along with other narrations, portraying a meadow of Edirne compared to the paradise garden. He acknowledges a tailor, a fruit-seller, a

barber, as beloved ones along with the legendary character Yusuf from the Islamic mythology and the *Bayrami* master Hacı Bayram Veli. Going beyond the visual imagery of the classical Ottoman cosmology, Mesîhî introduces other spaces and unknown beloved ones for contemplation.

Şehrengiz of Istanbul, Vize and Çorlu by Kâtib (1513)

Kâtib's *Şehrengiz* is a mystical love story. The main character of this story is the poet himself. The story begins with a *gazel*. The *gazel* indicates that the story is told in a garden, if not, in a private garden party, or a private party, where poetry is recited, and other stories are told. The significance of Kâtib's *gazel*, is that he uses the word 'rose' to make the arts of pun in his *gazel*. Thus it becomes a rose *gazel*. The main story is introduced after the rose *gazel*. This rose *gazel* directs the reader or the listener of the poem into imagining a rose garden. After constructing this symbolic rose garden, the poet introduces the main story and his aim for telling this story. The following verses clearly indicate that this mystical love story is to be imagined against the background of a symbolic rose garden:[13]

> I have used roses to compose a beautiful *gazel*
> To build up a text where God is the beloved of lover

In the second part of the poem, the poet challenges the scene of the rose garden with an image of the earth. The image of the earth, as the poet describes, is like a picture adorned by many. In this picture the earth is painted as bejeweled. The poet refers to the beauty of this celebrated image of earth with enthusiasm. This joy enables him to celebrate life and all creation. In order to see and learn more about life, he decides to go on a journey and sets himself on the road. His journey brings him to the city of Istanbul:[14]

> Lord has bejeweled the earth as such
> One would assume the world has enlivened better as such

> Many desired to praise it
> Hence (*the painter*) Mani would die to depict it

> At once I set myself on the road
> I found myself in the city of Istanbul

He begins to tell of his travels in the city of Istanbul. He acknowledges that the city had been conquered by Fatih Sultan Mehmed II, and informs the reader that he is amazed that the city is populated by so many people.[15] He observes the variety of people walking in the city. Then, very briefly, he writes about certain monuments. First, he depicts his visit to Hagia Sophia. He describes the site as a picture. In this picture, the city becomes the background and the mosque is located in front of this background. He compares this scene to the

gardens of paradise, and asserts several times that whoever would see this setting would think that this is the second paradise. He then walks around the monument, and tells about its courtyard and gardens. He describes the fountain in the courtyard compared to the rivers of paradise. The following verses describe his impression of the scene:[16]

> There is nothing comparable to account for it
> There is nothing similar to it in this universe
>
> Fashioned this magnificent mosque in the city
> Mâni won't be able to inscribe as such in the city
>
> Those who see it say this it is the second Paradise
> It smiles as if it is alive
>
> See the fountain of Paradise flowing in its courtyard
> Thus the rivers of Paradise are flowing together with this water
>
> All attributes are impotent to describe its qualities
> In reverence the paradise cannot utter a single word

After informing the reader about the magnificence of Hagia Sophia, the poet travels to the Fatih and Beyazıd Mosques. He talks about these mosques briefly, in reference to their patrons: Fatih Sultan Mehmed II (1444–1481) and Beyazıd II (1481–1512). He mentions the recent Sultan, Yavuz Selim I (1512–1520). The poet then commemorates the memory of two celebrated religious figures, Ebu Eyyub-i Ensari and Sheikh Vefa (Sheikh Musliddin Mustafa Vefa). Afterwards he travels to Galata and cites beautiful young men that he meets in the Galata region.

The poet mentions a significant beloved. Since one part of the poem is missing, it is not possible to identify this significant beloved. When the poet meets this significant character, his travels turn into a journey chasing after the beloved. On the one hand, he describes the city with pleasure. Thus he has begun his journey joyfully to celebrate the beauty of the "bejeweled earth." On the other hand, he falls in to a deep longing and sorrow after meeting this significant beloved. Thus, his journey becomes a desire to see the beloved again and again. He conducts a lonesome search walking in the streets of the city. Sometime later he finds his beloved, as depicted in the following verses:[17]

> With misery I recognized this charming beloved
> Again sighed in sorrow
>
> On the road that I had set myself, flowing like water
> Met this slender beloved walking

The poet realizes that his beloved attends the prayer ceremony at the mosque of Yenicami every day throughout the month of Ramadan. Thus he would be able to see him for the whole month. However after Ramadan, he loses

sight of the beloved. So he continues traveling. From Istanbul, he goes to the provincial town of Vize. He is accompanied by a friend. In Vize, they stay at another friend's house. The story tells about the province and the beautiful young men living in Vize. Hearing that his beloved has been seen in the town of Çorlu, the poet travels to Çorlu with the desire to see the beloved. However, upon his arrival to Çorlu, he realizes that his beloved had already returned to Istanbul. Chasing after him, the poet also gets back to the city. Finally the story is concluded as the poet meets his beloved in Istanbul.

The poet illustrates spaces as framed pictures but shifts from one space to another. He uses the term "picture" whenever he refers to a different scene. He elaborates the definition of a picture as the depiction of a place adorned in front of the eyes of the beholder. This picture is not static. It is depicted as having life. In the beginning of the poem, he constructs the image of a garden with roses. Referring to the rose garden, or making the word "rose" as a pun is one of the various conventional uses of natural elements in the arts of poetry. However, there are other possibilities of interpretation. There are three different ways of explaining why the poem starts with a rose *gazel*. The first possibility is that the story was told in a rose garden. Second, the individual roses collected in a garden were compared to the structure of the whole story made up of words, thus the story is metaphorically associated with a rose garden. Third, the rose garden is a symbolic garden. It is introduced with the purpose of setting up a background for the rest of the story, similar to the realm of the imagination represented as a garden by 'Arabî.

Thus, illustrating a symbolic rose garden at the beginning of the narrative leads the rest of the story to be imagined in a rose garden. However, after describing the rose garden, the story continues in various kinds of real places and in symbolic gardens, such as the paradise garden. These shifts from one imaginary space to another, from imaginary spaces to real spaces, designate an experimental realm, which was outside the circle of the traditional arts of poetry. The traditional arts of poetry would depict gardens or imaginary ideal spaces of divine or historical significance. However, Kâtib first illustrates an imaginary rose garden, then a generic image of earth as "bejeweled," and then the provinces of Vize and Çorlu, along with the city of Istanbul and its various spaces. To put it in more simple words, the poet describes events or objects as if on a stage. The background of this stage always changes, from gardens to city spaces, from symbolic gardens to real places, or the change occurs in the opposite direction from real to ideal gardens or to symbolic spaces.

Kâtib's *Şehrengiz* maps a territory that includes several locations, within and outside the city of Istanbul. The poet travels in two different scales. One, he travels within the city of Istanbul. Second, he travels within a larger geographical area from one city to another. The first route in Istanbul depicts places of pilgrimage in the city. The second route connects the city of Istanbul to a larger web of routes, including Vize and Çorlu.

Vize and Çorlu were small provincial settlements in the Thrace region. This second route might be considered as a larger pilgrimage route, especially of

Melâmîs, who might possibly be visiting their masters in those provinces. These provinces accommodated a considerable amount of *Melâmî-Bayrami* adherents in the sixteenth century. *Melâmî* pole and poet Sârbân Ahmed's dervishes Alâeddin Efendi and Gazanfer Efendi were living in Vize in the first quarter of the sixteenth century. Sârbân Ahmed was living in another province called Hayrabolu close to Vize.[18]

As well, parts of Kâtib's *Şehrengiz* can be compared to other *Melâmî* poems written in the same century. Kâtib's verses below:[19]

> Sultan Mohammed has conquered it
> Inside full with "Ahmed" (Human being / light) of various kinds

recall *Melâmî* poet Sârbân Ahmed's verses where the multiplicity of human population is acknowledged as reflections of the beloved one:[20]

> Those lovers wishing to see the beloved
> Watch carefully every human being you see
> Know that the body of the human being is a reflection of God
> Come look at this body; see the Beloved in it
> Your secret word "Ahmed," don't expose it to the ignorant

Kâtib's *Şehrengiz* that is probably told at a private party that takes place in a rose garden, narrates the travels of the poet in and out of the city of Istanbul. In Istanbul, the poet travels to those places that are acknowledged as the pilgrimage sites for the orthodox Muslim community. These sites are Hagia Sophia, imperial mosques of the sultans and the tombs of Eyyub-i Ensari and Seyh Vefa. Each one of these monuments had significant importance in the transformation of the Byzantine Constantinople into an Islamic city and the capital of the Ottoman Empire.[21] Outside Istanbul, however, the poet travels to provinces that did not have any significance except as being important places for the development and expansion of the *Melâmî-Bayrami* philosophy. These provinces housed heterodox communities who carried an anti-imperial agenda and who were under the threat of the orthodox authority.

Kâtib's journey between the imperially significant places of the orthodox capital and peripheral provinces which housed anti-imperial heterodox communities is an attempt to reconcile these two opposed worlds and their adherents within the imaginary realm of his poetry.

Şehrengiz of Edirne by Taşlıcalı Yahya (1520s)

Yahya's *Şehrengiz of Edirne* is a beautifully written story about the poet's journey to the city of Edirne. It is one of the most explicit *şehrengiz* poems, which portrays the standpoint of the poet in clarity. At the beginning of the story, Yahya explains his ideas about mystical love. Then he tells about his disappointment in a recent experience of love. He describes how he suffers in pain, because his beloved would not respond and respect his love.

Yahya, in a miserable condition, arrives at the city of Edirne. In Edirne, late at night, as he is walking in by himself in misery, he sees a total stranger coming out of a populated house. The stranger, who has a bright and enlightened expression, also catches sight of Yahya. This stranger, upon seeing the poet, realizes that he suffers the pains of love. He approaches the poet and begins to talk to him. The stranger tries to comfort the poet by telling him stories. Yahya portrays this stranger as a storyteller. The following verses depict the poet's encounter with the stranger:[22]

> As I was staying in the city of Edirne sad
> A sun-faced came out of a populated house
>
> Immediately, to this poor
> He said "You, the wise traveler of world!"

So, the storyteller recounts stories all night long and throughout the next day:[23]

> "How come this shameful beauty would appreciate you?
> Thus he has never been able to appreciate himself?"
>
> That day and night, engaged to me with concern
> He comforted me a great deal this way
>
> I told "Wisdom is your share, you, moon-faced,
> Don't stop or the city of flesh will go up in flames."

The stories told by the storyteller constitute the main body of Yahya's narrative. Yahya conveys the following stories as if told by this character. The storyteller's story begins as he acknowledges himself as a mystic lover like Yahya:[24]

> Like myself, rivers run through this city
> All spirits glowing with the light of love walk, their heads down

He tells Yahya that there are many beloved ones in the city of Edirne and that he would inform him about all of them. He would convey the pleasant conversations that take place in the assemblies of these beautiful people in the city of Edirne. In the stranger's accounts, Edirne is portrayed as "the house of *gazîs*":[25]

> Tell the news from the conversing of the beauties
> Thus they say recognition of life is actually the experience of it
>
> The storyteller of tales
> Told this delightful story with respect to this picture
>
> Hence, by no means, in this universe
> There is an identical to the city of Edirne
>
> Place for dervishes of the divine truth, terrain of lions
> The eternal city, house of *gazîs*

The storyteller first gives a physical description of the city. From his accounts, it is understood that the poet and he must be at a neighborhood in the vicinity of the old castle. He accounts for the meadows of the city, in summer and winter. He then describes the practices of the common folk and how they spend their Fridays almost like a ritual activity. He tells in detail about these ritual activities, which begin after the usual Friday prayer that takes place at noontime. Then, he gives a long list of the beautiful beloved ones of the city.

Finally, when the stories are concluded, the poet acknowledges that listening to these stories made him imagine the beautiful people of the city. His imagination has been stirred up with respect to descriptions and events that are told throughout the stranger's narrative. His heart has become a mirror reflecting many forms. Thus poetry becomes an imperative for imagination:[26]

> This loving heart is like a mirror
> A variety of images is reflected on it

In his story, after describing the city of Edirne and mentioning its old castle briefly, the storyteller depicts the meadow along the Tunca River. He playfully illustrates the meadow. Among various other flowers, he portrays daffodils and violets ornamenting the green lawn. Cypresses and juniper trees are planted along the riverside. There is one plane tree, and there are many roses in this lively scene. There are water lilies on the river and nightingales are singing. The storyteller portrays nature praying as it is challenged by the joy of life. This scene, as the storyteller asserts, can only be truly perceived by the eye of the heart.[27]

After illustrating a picture of the Tunca meadow, the storyteller illustrates a series of events. According to his story, a group of common folk used to go to a Sufi lodge after the usual Friday prayer:[28]

> All the public after the Friday prayer
> Go to the Sufi lodge to view

The storyteller tells about going to the lodge, describes its architecture, its circular dome, illustrates the dance performance and portrays the audience. It is evident that the storyteller attends this performance as an audience along with many others, who listen to the *mesnevi* and watch the whirling dances of dervishes performed under a dome. The dancers would turn around along a circle, which represents the world (*felek*) as acknowledged by the storyteller. He comments further on this performance as actual worshipping, not as a metaphorical dance, as some others would consider it. So, as told in the story, after the dance ritual is concluded, the crowd continues enjoying the rest of the day together. If the weather is nice, everybody goes to the meadows along the Tunca River:[29]

> After viewing the ceremony at the Sufi lodge
> They would go the promenade of Tunca one by one

This crowd accommodates poets and citizens of upper social status along with a lot of young intimates, most of them coming from poor families. These people would stroll down to the riverside. At the meadow, most commonly, they walk barefoot in the water, swim naked in the river, and converse with one another. The association with the river, swimming naked and walking barefoot in water are represented as activities that relieve the sorrowful state of the lovers—the fire of their burning hearts as described by the storyteller, who are in misery longing for the beloved.

In the wintertime, when the weather is cold, only the young people travel to the Tunca River after the Sufi performance. Most of the others go to a closed place the storyteller calls "Sırça Saray." The young ones who prefer to go to the riverside would have a lot of fun. They would skate on the frozen river. The storyteller acknowledges that it is quite delightful to watch these people playing on the ice, gliding smoothly or falling over one another. He describes this activity as a play. But the lovers would consider this as a metaphorical play, which provides the opportunity to get closer to the beloved ones. This leisurely play of skating is considered as a washing out of the sins of the lovers. These activities performed in the meadow along the Tunca River are considered to be purifying.[30] In the story, the riverside is called *"güzergah," "seygah," "cennet"* and *"ol yir."*

The long story told by the storyteller is concluded with a narrative describing the beautiful young men of Edirne. The stranger cites 13 men with their names and portrays their different natures. The storyteller himself is portrayed as a gardener. The city is compared to a rose garden and the flowers to the common folk:[31]

> There is no end to the beauties of this city
> I have witnessed those who I have seen
>
> Watch, go find a gardener,
> Flowers worth a rose-garden

The purpose of alluding to a number of young men is explained as way to understand the unity of being through meditating on the multiplicity of its reflections. Those who would be able to appreciate the multiplicity of creation in this world, would be able to get closer to comprehend the knowledge of the divine world:[32]

> The beauties of this city are many
> There is no equal to it in terms of the beauty of public
>
> Listen to this conversation of love
> If you desire for the taste of the two worlds

In the first part of his *Şehrengiz*, Yahya gives an explicit account of his ideas on mystical love. He argues that metaphorical love is the preliminary stage for mystical love. The whole creation, and especially human beings, who reflect

the essence and beauty of the universal truth, should be contemplated and loved in order to develop a better understanding of this truth. The following verses convey his ideals:[33]

> Watch the beloved with the eye of your heart
> Look at the reflection of beauty and observe
>
> Go, recognize the Sublime
> Thus the reflection of His beauty has developed into two worlds,
> Here and hereafter
>
> The spirit of the beloved cheers this world
> This is why He displays Authority in creation
>
> What is the reason of Mecnun's (*lover*) heart burning?
> What is this expression on Leyla's (*beloved*) face?

Yahya's accounts are like a short summary of 'Arabî's doctrines on mystical love. There are also many references to the *Melâmî* poetry. Yahya explains the principles of divine love as embodied in the human being. He illustrates the mutual relationship between the creation and the creator. He discusses how they need and necessitate one another.[34] And, as if with reference to Molla Fenari's explanation about poetry as the best medium for the expression of love, Yahya declares language to be the best medium to express this ideal. The following verses portray this thesis explicitly:[35]

> Thus when the one with black eyebrows is desired
> The reflection of language is filled with love
>
> If you burn a candle from the light of God
> Everywhere there will be a station of paradise for you
>
> The ones who acquired the True knowledge would stay away from this world
> Their body flashes light in a divine way like lightening
>
> This unknown mystery associated with God
> Is not known to anyone but to God

In his poem, Yahya briefly illustrates the three different groups which represent different religious preferences within Ottoman society. He mentions the esoteric teachings of mysticism, the exoteric practices of Orthodox Islam, and idolatry, which stands outside the sphere of Islam:[36]

> My heart would always prefer the esoteric
> Some hearts prefer idolatry to (orthodox) prayer

Then, successfully he describes the co-existing practices of mysticism and the Shariah. He compares the esoteric practice of mystic love with the exoteric worshipping of prayer. In this comparison, he uses the metaphors of the

body, language, vision, meditation and space. According to Yahya, the body, vision, and real spaces are related to exoteric teachings. Language, poetry, contemplation and love are related to esoteric practices. Thus language is used to construct imaginary realms the heart would contemplate and travel into:[37]

> My flesh is here, my tongue together with the beloved
> My eye at the mihrab, my mind is far-off

During the sixteenth and seventeenth centuries, most of the orthodox scholars and jurists viewed *Melâmîs* outside the sphere of Islam due to their extensive assertion of individuality and their extreme interpretation of Ibn al'Arabî's doctrines. *Melâmî* masters were considered heretics, and their adherents as dissidents. However, *Melâmîs* struggled to portray themselves within the world of Islam and the world of the Ottoman authority. They presented their philosophy as a Sunni way of life. They asserted many times that they were not prone to idolatry; they did not have Shi'i or Ismaili inclinations.[38]

Even though it is not certain whether Yahya was a *Melâmî* or not, he most probably had *Melâmî* inclinations, or participated in groups which had philosophies similar to that of the *Melâmîs*; he participated in a community who practiced the doctrines of Ibn al'Arabî. These associations were enough for orthodox jurists to accuse him of being a heretic. However, Yahya chose to present his art as a medium to reconcile orthodox and heterodox tendencies. He presented his account of the guild boys as an attempt to introduce them to the Sultan. Thus, by his poetry, he claims that he presented the house of *gazîs*, the city of Edirne and the ordinary guild boys to the imperial court.

Şehrengiz of Istanbul by Taşlıcalı Yahya (1520s)

Following Yahya's *Şehrengiz of Edirne*, his *Şehrengiz of Istanbul* does not have an explicit story like the former. The activities suggested in the poem do not necessarily refer to specific ritual activities or specific places as in the previous *Şehrengiz*. Though again, the first part of the poem is extremely clear in posing the poet as a mystic lover and portraying his aim to stir up the imagination of lovers by his poetry. Yahya uses the metaphor of two worlds several times.[39] In this first part of his poem, he cites mystic practices and especially the remembrance of the name of God as a way to attain knowledge of the universal truth:[40]

> Those masters of mystic language who utter the name of God
> Would open a way to the science of mystery

> Who repeats this Glorious Name
> Would hear mysteries by revelation inspired by the Creation

> To a companion on the way to mysticism
> It is enough for the individual, single word of Allah

Yahya describes the creation as it originated from the water. Then he compares the beauties of creation to the precious stone pearl. He acknowledges that beauty, originated from water and embodied in things, is only revealed by individual enlightenment and that individual enlightenment is made possible by the art of poetry. Thus poetry triggers imagination and cognitive powers of the heart:[41]

> Out of a drop of water, He creates a beautiful form
> His cheeks shining like moon rose colored
> ...
> By will, the individual becomes a bright pearl
> By pure understanding and by the power of poetry

Poetry, which constantly plays with the multiplicity of forms and meanings, is a practice to comprehend and attain divine knowledge. Contemplating creation by means of poetry will reveal universal knowledge:[42]

> Watch all creation, constantly
> The power of God will unfold like daylight

He swears that his purpose for writing this poem is not to cite the names of the beloved, but to remember and understand the unknown knowledge of God himself, in the recognition of the oneness of God in the multiplicity of his subjects. He proposes that every other name of the beloved is the name of the God himself.[43] Though, not only does he acknowledge the importance of contemplating the individual beloveds, but he also refers to the significance of other creations, other things such as nature, rivers, wells and cities that deserve to be appreciated and adorned, just like the prophets, or the ordinary people:[44]

> All of Ahmed and Mahmûd and Ādem (human being)
> All *Yeşrib* (the city of Medine) and *Bathâ* (a river around Mekke between two mountains) and *Zemzem* (a well around Kabe)

> All the higher-ranking Idris and *Isa* (Christ)
> All the adventures of *Nuh* (Noah) with *Musa* (David)

> All desire for the beauty of the beloved
> All are longing for the beloved

After explaining that his purpose for writing this poem is to acknowledge mystic love, Yahya cites the prophet and his four caliphs and then he honors Sultan Süleyman and his Grand Vizier Ibrahim Pasha, locating his poetry within the orthodox world of the Ottoman authority. If the *Şehrengiz of Istanbul* is compared to the *Şehrengiz of Edirne*, the part where Yahya meets the mystic storyteller in the city of Edirne is replaced by the appraisal of the prominent figures of the orthodox tradition and the Ottoman court. In the *Şehrengiz of Edirne*, the storyteller refers to Edirne as the city of *gazîs*. However,

in *Şehrengiz of Istanbul*, the poet replaces the memory of *gazîs* with a tribute to the prominent figures of the Shariah.

The poet again acknowledges his desire for love and the beloved. He prays for his metaphorical love to be developed into true love. Thus he prays for his poem to be enjoyed by all lovers. He wishes that the multiplicity of the beloved ones depicted in this poem will eventually turn into the delight of comprehending the unity of the single beloved.

Before beginning to tell the central story of the narrative, namely the part about the multiple beloveds, Yahya describes a pleasant spring day where nightingales are singing and different kinds of flowers—daffodils, roses, and tulips in blossom—are ornamenting the grass paving of a meadow. He acknowledges that he has decided to write a beautiful story upon seeing this pleasing sight and picturing this stimulating spring day.

The story told in the poem begins with a depiction of the city of Istanbul. He describes the city as prosperous in every respect and superior to paradise. He illustrates it as populated by a lot of beautiful people. He depicts the city as a place where the two worlds meet, where the esoteric and the exoteric worlds, the Tariqat and the Shariah meet, similar to the meeting place of two seas. Like many other mystics, especially those who consider themselves as disciples of Khidr,[45] Yahya uses the metaphor of the meeting of two seas when illustrating the city:[46]

> Graceful and slender lovers like the young bodies of plants ornament the city
> Two seas merge into one another at its edge

He compares the city with the paradise garden:[47]

> Such a city that all its verses are prosperous
> The houris of the Heaven realized their shortcomings looking from the Heaven

Yahya carries on using Sufi metaphors. As if to represent the Sufi lodge and the Sufi dance performance, he represents the city in the form of different objects that are all circular. He illustrates the city as a silver anklet or as the ring of the King Solomon:[48]

> As a beautiful lover
> The waters has become an anklet around her ankle
>
> Her body as the ring (the stamp-ring of the Sultan) of Süleyman
> For her the sea has become a silver circle (ring)

or as a belt:[49]

> The ones who are watching its elongated walls
> Said it resembles a lover with a silver belt

Instead of particularly depicting a significant event where poetry is read, he mentions that the beautiful beloved ones of this city are acquainted with a

lot of poems, and, that they cite these poems in wine and music assemblies. Yahya illustrates these beautiful beloved ones swimming naked:⁵⁰

> Taking off their clothes get into the water naked
> Breasts like rose buds, silver bodies unfold
>
> Upon seeing them naked in the water
> One may take them for fresh roses on water

Though again unlike his *Şehrengiz of Edirne*, the narrative does not mention any particular river, riverbank, or meadow. It does not indicate a specific location where the beloved ones might be swimming. Then, as conveyed by Yahya, these beloved ones would sail to Galata in small boats. In Galata, they would stroll and enjoy themselves. Then he cites the names and occupations of 58 young men. The young men are from all over the city, from the neighborhoods of Eyüp, Yedikule, Galata, from the bazaars: "*Astarsuz Mehemmed Beg-oglı,*" "*Nakkaş Bâlî-oglı Rahmi,*" "*Yeniçeri Safer Bâli,*" "*Bıçakçızâde,*" "*Lokmân,*" "*Hammâmcı-zâde,*" "*Bostancı-zâde,*" "*Katib Hamza Bali,*" "*Tozkoparan-oglı,*" "*Helvâcıbaşı-oglı,*" "*Hasırcıbaşı,*" "*Attar,*" "*Hallac,*" ..."the anonymous lad from one of the Sufi lodges," "a doctor," "Janissary corps," "a painter," "an officer," "sherbet-maker," etc.

Among these 58 young men, three of the characters suggest further interpretation. These characters are: a janissary, who was responsible for the public peace of the common parks and gardens, a musician, and a certain figure called Hamza Bali.

The janissary corp (*Bostancı*) is the gardener and the guardian who is responsible for the maintenance and control of open spaces like gardens, vineyards, or meadows. Yahya portrays him as someone who would neither participate nor interfere with the party, but who would simply watch the assembly.⁵¹ Yahya mentions a musician called Ca'fer. Ca'fer plays music at the assembly.⁵²

The third character has the same name as a prominent *Melâmî* character Hamza Bali, the *Melâmî* master of the Balkan Peninsula, who was well known in the second half of the sixteenth century. This part of the poem, citing the name of the *Melâmî* pole Hamza Bali could even be an invocation in honor of his name, or a reference of sympathy to the *Melâmî-Bayrami* order.⁵³

Yahya refers to his poem as a notebook of beloved ones, or as a rose garden.⁵⁴ He explains that it has been composed to bring joy to all lovers.⁵⁵ He conveys the wish that his poem would become famous and be cited in assemblies of lovers. He also wishes that it would be recognized and appreciated by the mystics. Finally, Yahya expresses his wish that his words would come true and the mystics would approve his poem. Then the mystics allow his poem to be recognized in the city and Yahya to become famous because each of its verses that make up the story is like a jewel to be appreciated. Upon hearing the decision of the scholars regarding the success of his poem, Yahya becomes quite excited and happy. First he mentions that upon accepting this approval,

he goes to a holy lodge, to a Sufi lodge. Then, in the following verses, he rephrases that this holy lodge is actually the abode of the Sultan. And the story concludes, as the poet feels happy and cheerful about his accomplishment.

In the *Şehrengiz of Istanbul*, the story seems to take place on a more abstract level. Unlike the *Şehrengiz of Edirne*, composed by the same poet, there is no suggestion of a performance or the whirling Sufis. There is no explicit indication of a Sufi lodge that can be located within the city. There is no description of a specific riverside meadow, where the common folk would go and enjoy themselves, wash out their sins by bathing in the river, joyfully playing or mediating on the arts of poetry and conversing. There is no reference to a particular pavilion, kiosk, or any covered space that the participants of this group used to meet for poetry parties.

However, the narrative clearly refers to each one of these activities without referring to particular locations. The *Şehrengiz of Istanbul* becomes a similar account of the Friday afternoons as told in the *Şehrengiz of Edirne* however, devoid of any reference to identifiable loci.

It is most probable that by constantly repeating the circle metaphor, Yahya tries to evoke a Sufi gathering. His account of boys swimming gives the idea that he is by a river. It is most probable that Yahya alludes to a Sufi gathering at a meadow by the river. The poet and the guild boys gather in this open space. They dance, swim, listen to music and read poetry. The *Bostancı* who is responsible for taking care of this open space notices them, but he prefers not to interfere with the party. He only watches this gathering from a distance.

Şehrengiz of Istanbul by Kalkandelenli Fakiri (c. 1534)

Praying for his sins, Fakiri introduces himself as a lover. He praises the Sultan Süleyman and the prophet Mohammed. After portraying a spring scene, he begins to tell of the city of Istanbul. He mentions a single lover, again returns back to the depiction of the city, cites 43 beloved ones and concludes his story.[56]

In Fakiri's *Şehrengiz*, the city is represented in a circular shape:[57]

>Such a city with a beautiful view like a bride
>The throne of the Sultan of the seven worlds
>
>Its darkness (gardens, vineyards, meadows, fields) is a land to seek refuge
>Its brightness is where the two seas converge
>
>With a circular wall, the city of the Sultan
>Captured all the months within
>
>Regarding the invitations of the Heavens or the Angels
>Drawing a circle upon the ground
>
>Either this city is a lover with a silver belt
>That all its citizens are addicted to

> Or a lover this bejeweled city is
> That the sea rubs its face upon his feet
>
> Either the sea has put on an anklet on his slender wrist
> Or it is a silver colored bird from the kingdom of birds
> ...
> There is no similar to it in terms of beauty
> Has won the love of the lands and the sea

Istanbul is compared first to the paradise garden, second to a Sufi lodge, third to a Sufi dervish. The city is described as having a beauty above the paradise garden. Surrounded by walls on one side and the sea on three sides, it is depicted in a circular form, as a Sufi lodge. Then the whole city is depicted as the body of a dervish. The interior of the city is described as a paradise garden. Thus, entering the city through its doors, one feels that one is entering the paradise garden:[58]

> If the Holy Spirit had seen the festivities of this city
> He would complain about the Holy Pavilion
>
> Thus watching the festivities of this city
> Doors have opened with amazement
>
> A charming lodge, it is a coast to the sea
> Tied to its belt, its ships are the prayer's bowl
>
> The radiant bodies encircle
> Worship this city night and day
>
> If you watch the city walls and fortifications
> Doors open to the palace of the paradise

Throughout the poem, dwellers are depicted as happy and satisfied in a paradise-like city compared to the legendary Garden of Iram:

> Like the Iram Garden, all its places are prosperous
> A tender breeze makes all its citizens happy and pleasant[59]
>
> Every sinful getting into this prosperous state
> Watch and adore this paradise like place[60]
>
> There is nothing similar to it, it is the one and only in this world
> Such a gracious such a beautiful city[61]

Beloved ones are compared to beautiful trees and rose blossoms:[62]

> Whenever it is springtime, cypress and pine trees
> Graceful bodies like lovely blossoming roses
> They either scroll in the fields, or swim in the river:[63]
>
> They either scroll out in the fields bashfully
> Or, like a rose utter their desire for the sea

Fakiri describes the recreational activities related to the sea at length. He describes people enjoying themselves in rowing boats. As they sail to the place of gathering, they watch their reflection in the water. Each one of them is like the sun in the darkness of the dark water, or the moonlight reflecting on the river. Those who sail watch their environment and the city in pleasure. They also swim in the sea. People watch and admire this joyful setting. The city forms the background of the setting. In the foreground, the beloved ones sail and swim in the sea, resembling precious stones:[64]

> The beautiful view of this city is the mother of pearl
> Beauties are pearls and jewels within

> Nevertheless the one who has the wisdom of the present-day lovers
> Has depicted some of them into a string of pearls

> Thus the mind falls short of comprehending
> The wise man has not seen anything comparable

> With meaning and pearls, this view
> Becomes almost like the essence lined on string of pearls

> Composing jewels into a text, the wise man of this world
> Has narrated one by one this city

> Fairy-faced angelic-scenes
> Beauties with elongated posture, tulip cheeks

> Thus every one of them is an amulet for the essence
> Day and night has become a riddle on my tongue

Fakiri illustrates the city by using Sufi metaphors. He recalls the dancing of dervishes along a circle, the circular layout of Sufi lodges, the prayer bowl of the Sufi dervishes and the dervish belt. He describes the city as an object, as a space, as a body by using Sufi metaphors. These descriptions suggest that the poet proposes an image of the city. This image is both an ideal representation and a real one. Ideally the city within the city walls is represented as a garden, either similar to the paradise garden, or similar to the legendary Garden of Iram whose magnificence preceded the beauty of the former. As well, the geographical location and the topography of the city are described. The city is presented as a real space.

In Fakiri's *Şehrengiz*, there is a constant emphasis on visuality. Similar to the ideal and real images of the city, visuality also develops in ideal and real realms. The poem narrates the vision of the angels as they see the city from above. It also narrates the vision of ordinary people watching the city and its environs. The poem uses a variety of words to describe a setting, a scene, or a panorama (*manzar, suret, hûb-manzar, mazâhir, melek-manzarları*) and the act of watching (*itdi seyran, temaşa eylesen, temaşa eyleyen, seyran iderler, eyler seyr-i dîdâr*). Throughout the narrative, there is a constant emphasis on watching

the city, watching the city in the background, watching a view, an event, or the people.

It is most likely that the poet is seated on one of the hilltops overlooking the city. He could either be in the Galata region, Sütlüce, or above Eyüp overlooking the Golden Horn. The city with the seven hills unfolds in the background as the poet describes it. In the foreground there is the canal where beautiful young guild boys are sailing. Some are swimming and some are traveling to the meadows at the skirts of this hilltop.

Şah u Gedâ by Taşlıcalı Yahya (1540s)

Taşlıcalı Yahya's famous collection of five stories includes the story called *Şah u Gedâ*, which is listed under the category of *Şehrengiz* by Levend. *Şah u Gedâ* is a love story that takes place in Istanbul. It narrates the platonic love of *Gedâ* (the beggar) for the *Şah* (a boy who is actually called Ahmed and personified as an emperor). Yahya's story is about metaphorical love. It mentions that True Love can only be attained after experiencing metaphorical love.[65]

The poem illustrates the city of Istanbul, where the story takes place, talks about a Friday afternoon when the congregation is gathered at Hagia Sophia. It describes the building and its environs, displaying the dynamism of this city space vividly. After some spatial descriptions, it evokes four beloved ones. Later in the poem the story of Gedâ and Şah begins.

The city of Istanbul is represented in Sufi metaphors similar to those in the previous poems. However, the city is also represented as the throne of the Ottoman Empire. The name for the city is given as "*Konstantınıyye.*" It is represented as a space where the two seas meet. The poem depicts the city as surrounded by walls; some of the city doors open to the sea. The beauty of the city precedes the beauty of paradise garden. It is populated with countless buildings. Domes resemble vessels in the sea.

The poem narrates a Friday prayer at Hagia Sophia. On Fridays, people flow to this space like water. The space and the congregation also resemble the paradise garden. It illustrates the eight doors, the dome as seen from the interior and the exterior, arches, minarets, pillars, the minbar, and the Sultan's prayer space. In a couple of verses, it also mentions various kinds of marble used in the building, describing their color, value and properties. The narrative animates architectural features of the space with metaphors from nature. Marble columns resemble cypress trees, glowing oil lamps resemble yellow flowers, and the worshippers resemble roses in a garden:[66]

> How extraordinary like the gardens of Paradise
> That place has eight doors
>
> As if it has become the rose garden of the heavens
> Cypresses are the green columns there

> Oil lamps burn glowing
> Like yellow tulips and daffodils
>
> Worshippers wearing white caps
> Ornament this garden like white roses

The poem also illustrates the Hippodrome, as it becomes a populated place on Fridays with people flowing there from all the surrounding streets. People who are going to Hagia Sophia gather at the Hippodrome. The poem compares the open space to a tent accommodating travelers as guests. Taşlıcalı Yahya further describes the Hippodrome, the Serpentine Column, the column of Constantine and the Egyptian Obelisk, and refers to the view of the Marmara Sea as it can be seen from the end of the Hippodrome. The poem describes the Hippodrome and the city similar to the paradise garden:[67]

> The Hippodrome is very nice with the fountains
> Fountains have become similar to the rivers of the paradise garden
> ...
> This city has almost become the garden of paradise
> Thousands of young men filled it at once

Şehrengiz of Istanbul by Tab'î Ismail (before 1562)

Tab'î Ismail's *Şehrengiz* calls the city "Stanbol" and depicts its four neighborhoods briefly. These four sites resemble four columns supporting the city. First one is Eyüp, the second one is Kağıthane, the third, Yenikapı, and the fourth one is Beşiktaş. Kağıthane and Yenikapı are acknowledged as meadows.[68] The dating of the poem is not certain. Levend argues that it must have been composed before 1562.

Şehrengiz of Istanbul by the Anonymous Poet (before 1566)

The story begins as the poet illustrates a rose garden. He narrates the roses talking to one another. The anonymous poet becomes so extremely excited about the garden scene he is illustrating that he begins to portray the city with pleasure. He compares the city to paradise. He states that this city could have been paradise itself, since it is as beautiful and as pleasing as paradise. Thus all of its places are populated with beloved ones and with God. He describes the whole city as a pearl in the vast universe.

The poem calls the city "şehr-i Stanbul" (city of Istanbul). He compares the sight of the city with its numerous monuments to a scene depicted in a well-known legendary anecdote which takes place before the flood. This legend narrates the pavilion of the seventh heaven "*Firdevs*" as located within the area around Ka'be. According to the story, this pavilion was relocated on earth together with Adam, as he was descended from the Heavens. The

poet reminds the reader about this story, and compares the buildings of the city of Istanbul to the heavenly pavilion and Kaaba. He describes each one of the mosques in the city as divine as Ka'be, and equates the Sultan's palace to the heavenly pavilion of the tale. He further describes the fountains of the city. He personifies the numerous fountains with their gushing water evoking them as lovers who have burst into tears. Then he acknowledges that the city of Istanbul has become a site of pilgrimage. Thus it has become a true path for the friends of God. He briefly refers to the beloved ones walking in water without illustrating any specific location within the city. Then he discloses 25 beloved ones from the city and concludes his story. The verses below render part of the poet's depiction of the city of Istanbul:[69]

> If Adam had ever seen that bejeweled location
> The heart would have forgotten the Paradise
>
> Every one of its mosques is a divine reflection of Ka'be
> Sultan's palace is Beyt-i ma'mur
>
> Its numerous fountains are passionate
> Burst into tears upon seeing the beloved
>
> The people of the world at all times visit
> As if it turns into a spacious path for the friends of God
>
> The beloved ones walk into the waters
> You would take them for the reflection of fish on water

Şehrengiz of Istanbul by Defterdarzade Cemâli Ahmed (1564)

Cemâli's story begins as he talks about his divine love for the Beloved. Cemâli describes himself as a sinful person. He reveals that his desire and passion for the beloved ones disable him from performing daily prayers as requested by the religion. Like Mesîhî, he narrates day and night, and then begins to tell his story about sailing on the waters of Bosphorus.

The main story begins as the poet recounts his arrival in the city. He acknowledges the geographical location of the city with respect to the two seas merging into one another: the Black Sea and the Mediterranean:[70]

> That day my eyes wide open I have been born into this world
> I have found myself in a glorious city
>
> It is not the sun or the moon, but still the center of the world
> The skies have looked upon this world with two eyes
>
> How wonderful this nice city ornamented with jewels
> How populated it is as the assembly of friends
>
> To its north, seas converge delightfully
> Its seven hills are beautiful and handsome

> All belong to it, both the Black Sea and the Mediterranean
> The sea of trees and the sea of men

As if the poet is sailing, he portrays the panorama of the city from the sea. He describes the city with numerous minarets extending beyond the skyline of seven hills. The poem describes activities that take place either on the Golden Horn or the Bosphorus. It acknowledges a festivity performed by rope dancers and acrobats. A group of guild boys watch the performance and enjoy themselves. The poem also narrates people swimming. The poem describes the panorama of the numerous boats and ships, maritime vessels sailing. Then it portrays the sultan and his court sailing. As well, it tells about common people who enjoy sailing. The poem states that with these activities the city becomes more festive than paradise:[71]

> If ever participate in the festivities there
> One will not even desire to ascend to the heavens

The poem talks of numerous boats sailing from one station to another, as lovers wandering after beloved ones. Boats carry beautiful young boys. Lovers are delighted to watch them. The poem refers to neighborhoods along the Bosphorus and the Golden Horn, which are landing points for the ones sailing. It lists these in the following order: Kağıthane, Göksu, Anadolu Hisarı, Anadolu Kavağı, Kadıköy, Üsküdar, Tavşan Island, Eyüp, Sütlüce, Beşiktaş, Galata, Yenibahçe, and Davudpaşa. City dwellers bathe and swim in the muddy waters of Kağıthane. The new castle and its environs are acknowledged as favorable sites to visit, surrounded by imperial gardens. Göksu, Kavak and Kadıköy are depicted as paradise-like places. Eyüp is recognized as a site of pilgrimage. Greeks prefer traveling to Tavşan Island. Galata is represented as a foreign country. Overall, the city is described as a garden. The streets resemble flowerbeds and city dwellers resemble a grove:[72]

> Such a garden this bright city is
> Streets are beautiful flowerbeds

The beauty of the city surpasses the beauty of all the other cities of Egypt, or the city of Damascus. It resembles the paradise garden with its beautiful coastline and its cypress groves:[73]

> Its coastline and ornamented cypress groves
> This is the paradise garden if there is anything similar to it

The narration of the city concludes as the poet acknowledges that by traveling to this city and contemplating its beauties, he thinks he has seen the whole world:[74]

> I have completed my voyage watching and journeying in the city
> Believed I have traveled the whole world at that moment

> Of all the numerous things that are beautiful and cherished
> I have contemplated and watched them carefully

After the portrayal of the city he praises the beauty of the guild boys and concludes his poem by acknowledging his wish that his festive Şehrengiz shall be cited in the assemblies of the wise, and thus it shall become famous within the city of Istanbul.[75]

One can argue that this poem was composed and read out loud for the first time in a bath-house, since throughout the story, the narrative is constantly interrupted by scenes from a bath-house. It describes hot and cold spaces, the water system, architectural details and courtyard of a bath-house with people washing themselves. Or, one can also suggest that this particular poem implies bath-houses as meeting places of the beloved ones, just like gardens or other city spaces mentioned in different şehrengiz poems.

Cemâli, who composed the *Şehrengiz of Istanbul*, also composed another poem for the province of Siroz. In the *Şehrengiz of Siroz*, the poet acknowledges that he was suffering in pain because of his beloved and he left Istanbul and traveled to Siroz. Cemâli accounts for 24 beloved ones in his *Şehrengiz*. At the end of the poem, he wishes that his accounts will be gathered as a book of divine love leading the listeners to divine knowledge:[76]

> Collect all my divine words into a book
> Open a door for me to the world of love
>
> Turn the sea of language into the sea of divine
> Turn the text of heart into the meadow of knowledge

Şehrengiz of Istanbul by Yedikuleli Mustafa Azizi (before 1585)

Azizi's *Şehrengiz* is different from all the others since it is the only *şehrengiz* poem that depicts women as the beloved ones. The poem narrates a private party gathered at the poet's house. The poet Azizi hosts this party. He acknowledges that his friends have honored him by visiting his house. They were joyful and they brought happiness to his sorrowful house. As each one of the guests took a seat and sat without any purpose, they suggested that they should make use of this meeting and organize a party. Thus, with this convincing proposal, they began to enjoy themselves drinking wine and conversing. They sing many songs and recite many poems, especially *şehrengiz* poems. Upon reciting a certain *şehrengiz* poem, one of the guests initiates a discussion. He suggests that there should also be one *şehrengiz* describing the beauty of different women. Different natures, characters, qualities and kinds of beauty of women should also be illustrated and learned. He wonders that if all things created reflect the

beauty of the divine being, the beauty of women should not be ignored. It should also be contemplated. He asserts that if there were no women and no beloved ones, the world would have been devoid of any meaning. While discussing the beauty of women, the guests insist that Azizi should compose a new *şehrengiz* about women. First the poet refuses to accomplish his guests' wish. However, upon their insistence, he begins to compose a new *şehrengiz*. He tells about 50 women with different names, different character traits and different kinds of beauty. Some of these women are the daughters of the guilds. Some practice their own professions.

The names of the women given appear to be symbolic, such as *Zaman* (Time), *Cennet* (Paradise), *Penbe* (Cotton), *Alem* (World), *Ak Alem* (White World), *Küçük Kamer* (Little Moon), *Ak Güvercin* (White Pigeon), *Eğlence* (Festivity). The beauty of the women is described with natural metaphors. A variety of character traits are displayed. The following verses are examples from the depiction of three different ladies. The names of these ladies as *Meryem*, *Cennet*, and *Fatimane* can be transcribed as Iris, Paradise, and Shining:

> One is Iris, the most insane of all women
> I have become a lace to tie her mad hair[77]

> One is known as Paradise, her lips like wine
> Let me my Lord experience this moment with comfort[78]

> One is Shining, the daughter of the candle-maker
> I have become dust burning with her light[79]

Şehrengiz of Edirne by Neşati Ahmed Dede (1674)

Neşati was a *Mevlevi* dervish from the Edirne lodge and a *Melâmî* sheikh at the same time. In his poem, he states that he has written this poem to give pleasure to the world, to enjoy and to intoxicate the ones who are fond of conversing. His poem does not have any spatial references or depictions to any particular place. His language is rather difficult compared to other *şehrengiz*. He recalls 14 beloved ones, the last one of which is called Bayram. The poem dwells longer upon Bayram than on the other ones.[80]

Neşati's *Şehrengiz* is important since it suggests that *şehrengiz* poems were acknowledged in *Mevlevi* assemblies or *Melâmî* circles. His reference to the joy of conversing is also important because conversing was one of the *Melâmî* practices which was acknowledged as leading the mystics on the path towards God. It should also not be unintentional that his *Şehrengiz* concludes by recalling a beloved named Bayram. Similar to Mesîhî's *Şehrengiz* which concludes by recalling Hacı Bayram Veli, Neşati might also be recalling the leading figure of the *Melâmî* tradition.

The Last Şehrengiz

The last *Şehrengiz* known and listed in the study of Agah Sırrı Levend is by the Mehmed Vahid Mahtumî.[81] Mahtumî was a poet and a close friend at the court of Ahmed III. Yet due to unknown reasons, he was forced to flee the city in 1717. He returned to the city of Istanbul in 1730 after the Patrona Halil Rebellion and died in 1732. His *Şehrengiz* must have been written before the death of the poet in 1732. The title of the poem is *Lâlezar* and it is a *Şehrengiz* about the city of Yenişehir-i Fenâr (the city of Larissa in present day Greece) where the poet lived for some time before returning to Istanbul. Vahid Mahtumî acknowledges that he left the city of Istanbul and moved to Yenişehir. He was disappointed by the infidelity of Istanbul's people, thus he moved to Yenişehir and acquired new friends, who forced him to compose a *Şehrengiz* about enjoying the leisurely places with the beautiful young people of the city.[82]

The Liberated Order of the *Şehrengiz* Rituals

Şehrengiz poems suggest gatherings in the spaces of a sufi lodge (*Şehrengiz of Edirne* by Mesîhî, 1512); in a blossoming garden (*Şehrengiz of Istanbul* by Taşlıcalı Yahya, c. 1540s); in a rose garden (*Şehrengiz of Istanbul, Vize and Çorlu* by Kâtib, 1513); in a populated house (*Şehrengiz of Edirne* by Taşlıcalı Yahya, c. 1520s); at a meadow (*Şehrengiz of Istanbul* by Taşlıcalı Yahya, c. 1520s; *Şehrengiz of Istanbul* by Fakiri, 1534), at a private house (*Şehrengiz of Istanbul* by Azizi, before 1585), or at a bath house (*Şehrengiz of Istanbul* by Cemâli, 1564).

Şehrengiz poems narrated rituals that took place within the variegated multiplicity of diverse city spaces, or at least they narrated such spaces. There are two different aspects concerning *şehrengiz* rituals. There is a common theme and motive concerning all the poems, yet the events in different poems do not follow a specified order. The common theme in all *şehrengiz* poems is traveling and experience of city spaces. However, it is not possible to define a specific order of spaces or events experienced. Though some poems suggest similar patterns of discovery, there is no specific sequence of events that concerns all the poems.

Şehrengiz rituals include diverse experiences such as: praying at a mosque, praying at a Sufi lodge, dancing rituals at Sufi lodges, walking down the hills from a Sufi lodge to the meadow, traveling from one city to another, visiting different cities and provinces, staying at friends' houses, walking in the streets, visiting guild shops at the bazaar, visiting imperial mosques and tombs, attending private parties in gardens, attending parties in meadows, going to bath houses, visiting populated houses, visiting private spaces for friendly gatherings and reading poetry, storytelling, playing in meadows, skating on a frozen river, walking by the river, walking in rivers, swimming in rivers and canals, sailing, looking at the city and its beauties, talking about the

city and the prominent figures of the city, acknowledging the arts and crafts of different guilds, recounting the names and natures of guild boys.

Şehrengiz poems frequently illustrate that the citizens are in favor of journeying to and within the city. As in Fakiri's Istanbul, different types of movement in various city spaces are depicted, whether in the fields or at the sea:[83]

> They either scroll out in the fields bashfully (*seyr*)
> Or like a rose utter their desire for the sea

In Yahya's *Şehrengiz*, the beautiful young men of the common public are depicted wandering in the city space and traveling to Galata:[84]

> Getting on a ship many beloved ones
> Go to Galata for a visit (*ayak seyranı*)

Or in Lami's Bursa, strolling and watching the beauties of the city is portrayed as part of the imperial tradition:[85]

> I have been informed that the Sultan
> Would come to visit and see the city of Bursa (*seyran*)
>
> Let his high spirited shadow that offers happiness
> To stroll and watch it all over (*temaşa*)

Experiences recollected in different examples of the *Şehrengiz* genre change from one poem to another. Even though the poems more or less follow a specific structure, which will be studied in the following pages of this chapter, the events and spaces experienced do not follow a specific order. *Ilahi*, which is another poetic genre in mystic literature initiated by Hacı Bayram Veli and later flourished during the same period as the *Şehrengiz* genre, also shares this lack of a definite composition.[86]

The rituals of *şehrengiz* are accounts of individuals' experience in the city. This experience is both a metaphysical and a physical journey that take place in the ideal and real spaces of the city. The rituals portray the city as a place of pilgrimage. Sufi literature accounts for metaphysical and physical journeys that take place concurrently. In many examples, individual enlightenment aimed at by way of spiritual journeying actually corresponds to a physical journey.[87]

Hagiographies also narrate physical and spiritual journeys. In the sixteenth century, there is an increase in the genre of dervish hagiographies (*menâkıbnâme*). Among many, there is one *Melâmî* hagiography called *Mir'ât'ül-Işk* by Abdurrahman el-Askeri. It maps the development of the *Melâmî* society between Edirne, Istanbul and Aksaray, in the first half of the sixteenth century. Concerned with the growing hostility towards *Melâmî* society, this hagiography aims at portraying *Melâmî* philosophy within the restrictions of the orthodox law. It defines *Melâmî* philosophy as an "orthodox

mystical system based on pantheism, while severely criticizing those sheikhs and dervishes who have wandered too far from the path of the sharia."[88]

In Islamic tradition, traveling is associated with the attainment of knowledge. Whether in the form of "pilgrimage, trade, scholarship, adventure" as Gallens argues, the Islamic civilization is accumulated by a "constant movement."[89] "Abundant journeying" is one of the common Sufi doctrines. The journey is the path followed to unify the Self with God. As Gallens further argues, sufis were obliged to travel: "For departing from their homes they were called 'strangers'; for their many journeyings they were called 'travellers'."[90] Sufi literature narrates symbolic journeys from one garden to another. In the famous Persian epic tale *Haft Paykar* by Nizâmî, the hero Bahrâm travels from one garden to another in the course of the story. Traveling in this way symbolizes his "inward journey."[91] 'Arabî defines traveling as an endless action which covers both the spiritual and the bodily journeys. According to 'Arabî, with the initiation of creation—since the first instant when things are manifested—the journey had begun and it continues:[92]

You will never cease being a traveler as you are now. You will never reach a place of rest, just as you never ceased traveling from *wujûd* to *wujûd* in the stages of the cosmos as far as the presence of *Am I not your Lord?* (7:172) You never ceased undergoing transferal from waystation to waystation until you came to dwell in this alien, elemental body. You will travel through this body each day and night, crossing waystations of your lifespan until a waystation named 'death.' Then you will not stop traveling...

In the same way you will never stop traveling through your bodily deeds and through breaths, from deed to deed...

Şehrengiz also narrate journeys within a city or several cities. The path followed in each *Şehrengiz* is different from the others. However, it can be argued that there are grand journeys and subordinate journeys. The grand journey takes place between cities and provinces: between Istanbul and Edirne, Siroz, Yenişehir, Yenice, Vize, Çorlu, Gelibolu, Belgrad, Bursa, Antakya, Manisa, Rize, Sinop, Beray-ı Taşköprü, Kashan, and Diyarbakır. Subordinate routes take place within each city and / or within each province. The order of events in the subordinate routes change from one poem to another.

Yahya's *Şehrengiz of Edirne* has an explicit order in terms of the itinerary of the journey within the city. It narrates the order of events, which take place on a Friday afternoon. It depicts the experience of a group of people composed of dervishes, educated intellectuals and poor guild boys. The inventory of events consists in attending Friday prayer at a mosque and then a Sufi dance ritual at a lodge; enjoying themselves freely by the riverside; and finally gathering at a private place to converse, read poetry and enjoy being together.

Yahya's *Şehrengiz* suggests two kinds of movement within the city that most of the other poems follow. The first type of movement is circular. It explicitly concerns the Sufi lodge and the Sufi dance ritual. It narrates the architectural features of the lodge and depicts it in circular forms. The dance

is also depicted to follow in a circle. The symbolism of the circle is referred to in almost all the other poems. The second type of movement is free movement. The poem depicts free movement of individuals by the riverside. It depicts people running, walking in the river, by the riverside, skating on the frozen river, collapsing on one another, holding one another.

The narration of these two types of movement also divides the narrative into two parts. The first part includes the prayer at the mosque and the dance ritual at the Sufi lodge. The second part includes play by the riverside and conversation at the private place. In the first part of the ritual, the orthodox and Sufi faiths are associated with one another since they both constrain the movement of the individuals by imperative patterns. The second part of the ritual is concerned with the free movement of the individual in space. The circle represents the unity of the cosmic rhytm.[93] It represents the order of creation. It is acknowledged as the most perfect form. The center of the circle is acknowledged as the origin of all things, thus the divine being. The symbolism of the circle is used in most şehrengiz poems. For example, the city is depicted with circular metaphors:[94]

> As a beautiful lover
> The waters has become an anklet around her ankle

> Her body as the ring (the stamp-ring of the Sultan) of Süleyman
> For her the sea has become a silver circle (ring)

or as a belt:[95]

> The ones who are watching its elongated walls
> Said it resembles a lover with a silver belt

or the city is represented as a circle housing opposites within its body:[96]

> Its darkness (gardens, vineyards, meadows, fields) is a land to seek refuge
> Its brightness is where the two seas meet

> With a circular wall, the city of the Sultan
> Captured all the months within

Sufi dance (*devr*) is also composed of circular movements dancing in a circle.[97] Different Sufi orders had different rules concerning Sufi practices and the Sufi dance. *Rufai, Kadiri, Halveti* and *Gülşeni* orders practice dancing in circles while the participants of the dance hold hands with one another. *Nakşibendi* members do not practice dancing, but they are still seated in the form of a circle during their rituals.[98] Early Sufi treatises portray Sufi dance as a free movement of the body expressing spiritual outbursts. However, all kinds of movements in Sufi dances were determined by strict regulations of the sixteenth century. There was no place for free movements of the individuals any more.

In a late thirteenth-century treatise, Sufi dance is illustrated to allow for free movements of the body. Jumping, hopping, holding another person in one's arms, inviting the public to the dance, tapping, hitting one another, are portrayed as normal practices of the dance ritual. In later centuries, such free body movements became unacceptable and the whole dance ritual was ordered into a strict conformity.[99] In a fifteenth-century treatise on Sufi dance (Istanbul Fatih Library 5335), the spiritual birth of dance is dated to the creation of the world, together with music. This manual describes four kinds of dancing that illustrate four different kinds of movement patterns. *Çarh* (wheel) is whirling; *Raks* is (dance) dancing while the torso stays static— it is the moving of the arms, hands, legs, and head; *Muallak* (hanging object) is moving vertically, leaping or jumping; *Pertav* (physical forward projection) is moving horizontally.[100] The treatise explains the movement of the body in relation to the spiritual movement and the order of the universe. The whole dancing ceremony is full of symbolism. The dancing space symbolizes the year. The leader of the group symbolizes the sun while the dancers become stars and the planets turning around him. The four types of dancing symbolize the four seasons and the four substantial elements of all creation. The music played has 12 tonalities standing for the 12 months of the year.[101]

According to the *Mevlevi* tradition, the circle is also acknowledged as the course of divine movement. *Mevlevis* assume that the circle is divided into two equal parts. The right half of the circle embodies the realm of the manifest, the left half of the circle embodies the non-manifest. The circle joins the two realms within its circumference. Thus, metaphorically, the circle unites the invisible realm of God to the visible realm of human beings. The turning of the circle enables the two realms to unite. Within the circle these two realms are divided by a line bisecting the center. Thus this line is the diameter of the circle. The point of the diameter that intersects the circumference at the top of the circle symbolizes the beginning of creation. The bottom point symbolizes the end of creation. The top point is where the divine being is located, and the point at the bottom houses the human being.[102] *Mevlevi* rituals follow the geometry of the circle. *Mevlevi* rituals are performed in circular spaces called *semahane*. *Semahane* is divided into two halves axially, similar to the metaphorical division of the circle. There is an invisible line that bisects the circular room into two. This line is called *hatt-ı istiva* (equator). The master of the ceremony is seated at the top point of this linear axis, the equator. The seat of the master symbolizes the divine nature. Correspondingly, the bottom point of the axis symbolizes human nature. The equator line symbolizes the shortest distance between the human being and God. Thus, it is the shortest distance between the lover and the beloved. The dancers do not step on the equator line. The right half of the *semahane* symbolically houses the manifest world, the world of the human being. The left half of the *semahane* houses the non-manifest world, the divine being.[103] The circle is acknowledged as embodying concentric circles. Each concentric circle represents different stages of the spiritual journey ascending from the circumference towards the

center. Correspondingly, the dance ceremony is also performed in successive stages in spaces of successive concentric circles.

'Arabî's definition of the circle is rather complex. The circle represents the movement of all things manifested. Once a thing is manifested it moves away from its source of creation. However, the course of movement continues as the manifested thing returns back to its point of origin. Thus, all movement in the universe is circular and it represents the unity of the universe:[104]

> The affair occurs (with an inclination toward circularity) because things proceed from God and return to Him. From Him it begins and to Him it goes back. In the world of shape the affair has no escape from taking the form of a circle, since it does not go back to God by the path on which it emerged from Him, but extends until it reaches its place of origin.

'Arabî defines the center point of the circle as the locus of the non-manifest. Thus, the center point is the beginning of all creation and it houses the divine being. All creation is manifested in concentric circles growing out from a single center. The circumference of the circle represents the realm of manifest. However, since all manifest things embody the knowledge of the non-manifest, each point on the circumference of the circle also acts like a center. Thus, each of these centers also stands as a locus of the non-manifest. All creation is represented as contained within the body of different circles moving away and towards the divine being. 'Arabî portrays these circles as storehouses where all the species and genera are contained. These storehouses are numerous. They are like sets that embody non-manifest essence in different degrees, as well as the manifested things in different realms as the multiplicity storehouses in two sets:[105]

> The storehouses are restricted according to the restriction of the species of known things. Although the storehouses are many, they all go back to two—the storehouse of knowledge of God, and the storehouse of knowledge of the cosmos. In each of these storehouses are many storehouses, such as the knowledge of God in respect of His Essence by rational perception and in respect of His Essence by traditional (sam'î) Shari'ite perception; knowledge of God in respect of his names; knowledge of Him in respect of His descriptions, …

> The other storehouse, which is the knowledge of the cosmos, also compromises many storehouses, and within each storehouse are found other storehouses. The storehouses are first, knowledge of the entities of the cosmos in respect of its possibility, in respect of its necessity, in respect of its essences that abide through themselves, in respect of its engendered qualities, in respect of its colors, in respect of its levels, and in respect of its place, time, relations, number, circumstance, …

In another explanation of the cosmos as a circle, 'Arabî illustrates concentric circles that encompass one another. Circles closer to the center house "precedent attributes." Circles closer to the circumference house "secondary and subsidiary attributes." Moving towards the center symbolizes enlightenment. Moving towards the periphery symbolizes moving backwards in the stages

of creation. However, backward movement is also positive and creative since the light of the center displays itself by means of the peripheral circles.[106] The cosmos, made out of "a series of intersecting circles and semicircles," facilitates movement in two different directions—centripetal and centrifugal.[107]

In their study of symbolism in the Sufi tradition, Ardalan and Bakhtiar give an explicit definition of this two-fold definition of movement in the symbolism of the circle. All human beings, constituting centers of their own existence, orient themselves towards the absolute truth by surpassing their limits. This creates a centrifugal force and enables an outward movement. However, the absolute truth, as the center of all creation, orients all creation towards itself and attracts all things towards the center. This creates a centripetal force and enables an inward movement.[108]

'Arabî's definition of the cosmic order, made out of various circles intersecting one another, illustrates a complex diagram. This diagram proposes multiple centers for each one of the circles representing different storehouses. Thus, according to this diagram, the movement of the universe does not follow a single path around a single center, but there are different paths of movement that govern different storehouses. Similar to Ibn al'Arabî's explanation of a complex pattern of circular movements around multiple centers, şehrengiz poems also suggest different patterns of movement within the city space. Each şehrengiz proposes a different path within the city space. Each şehrengiz is unique in terms of its itinerary as well as its participants. Yet what they share is that they encourage and enable the perception of the city as a paradise on earth, as a space of reconciliation and a meeting space for those beloved ones.

Şehrengiz Genre

The *Şehrengiz* genre has generally been considered as artless and dull in form. It uses simple vernacular Turkish understandable to the common public. The most important study of the genre was conducted by Agah Sırrı Levend. Levend made a list of all *şehrengiz* poems and transcribed parts of the poems about the city of Istanbul.[109] The genre has been discussed with respect to two different arguments. First, it is portrayed as a genre carrying pornographic content because they depict beautiful young men of the guilds extensively. Second, the genre has been acclaimed for its lively depictions of the city life. Within the line of the second argument, it has also been classified as travelers' chronicles.[110] Emergence of the *şehrengiz* genre in the sixteenth century has been discussed in relation to the emergence of a new genre in miniature painting. The emphasis on realism and on the extensive depiction of guild boys in *şehrengiz* poems is compared to the procession of guilds in the Hippodrome during the imperial circumsicion festival and its depiction in the *Book of Festivities* (*Surnâme-i Hümayun*, 1582, TSM H1344)[111] (Figures 4.1 and 4.2).

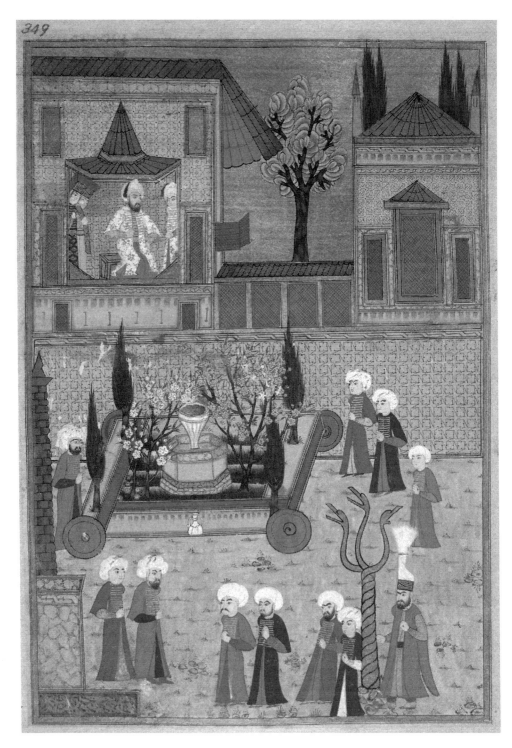

4.1 "Procession of guilds: Gardeners" in
Surname-i Hümayun (1582–1584). TSMK H.1344, 349a.

4.2 "Procession of guilds: Sufis of Eyyub-i Ensari" in *Surname-i Hümayun* (1582–1584). TSMK H.1344, 53a.

The first *şehrengiz* poem was composed by Mesîhî in 1512.[112] There are many discussions about the origin of the genre, whether it is an original Ottoman invention or a canon derived from Persian poetry. Mine Mengi cites Browne and Hammer's suspicion that the *Şehrengiz* genre was originated by Fakiri.[113] She refers to two Persian poems—Vahidi's poem about the city of Tabriz, and Harfi's poem about Gilan—which carry similar characteristics to that of the *Şehrengiz* genre.[114] However, Riehle acknowledges that most of Mesîhî's contemporaries envied him for the originality of his poetry, and that even Persian poets had copied him.[115] According to Gibb, the originality of Mesîhî[116] came from his liberated standpoint differing from the conventional and traditional framework of Persian poetry: "...it deserves attention for being the result of mere personal observations of the objects and landscape."[117] Gibb classifies the genre as non-metaphysical poetry. Levend argues that *şehrengiz* poetry is not necessarily written for the purpose of depicting mystical love. However, he also remarks that in some of the poems there are explicit references to "metaphorical love" as a guide to the "true love":[118]

There is no doubt that the feeling of love the poet talks about is not related to the mystic love. The poet does not feel any obligation to hide this or curtain his love by the veil of mysticism. However, from time to time he wishes from God that this "metaphorical" love would lead him to True love.

Fashioned by Mesîhî in 1512, the literary critics of the sixteenth century acknowledged the originality of the genre and the art of Mesîhî. Ottoman poets admired him as the master of the genre, and practiced *şehrengiz* poetry referring to Mesîhî and his art, and referring to the concept of love in Mesîhî's poetry as a measure of perfection.

Admiring the work of Mesîhî, Gibb criticizes Mesîhî's poetry for being formless, coarse and dull in form. The most peculiar characteristic of this poet according to Gibb is its simplicity that can be understood even by the most humble members of the uneducated groups of society, its use of daily Turkish language as opposed to using artful phrases made up of Persian and Arabîc. Gibb questions whether *şehrengiz* poetry talks about the real characters of the city under the name of 46 young boys or if these characters are mere products of Mesîhî's imagination. Gibb examines Mesîhî's *şehrengiz* in three major parts, like most of the latter examples of this genre. The first one is the "Introduction" (*dibaçe*); the second one is the part citing names of 46 city boys; and the third part is the "Final" (*mukaddime*).[119] Levend analyses Mesîhî's *Şehrengiz* into five main parts: prayer (*münacat*), depictions of day and night, depictions of young men, *tetimme*, and the final part as the *ihtitam* that is made up of two *gazels*.[120] Most of the other *şehrengiz* poems follow the same order: they begin by praying, continue by recalling general themes of Islamic legends, depict city space, make a long list of young men who were supposedly the beautiful members of the guilds and conclude by one or more *gazels*.

Mesîhî's poem was composed in the form of "*mesnevi*." Other *şehrengiz* poems were also composed in *mesnevi* form. In order to get introduced to the context of *şehrengiz* poems, it is important to have a general knowledge of the *mesnevi* form. Holbrook argues that different examples of the genre from the thirteenth to the late eighteenth centuries are intertextually related to one another.[121] Accordingly, this study will try to locate the *şehrengiz* genre within the general historiography of the *mesnevi* form. It will mainly use and refer to the literary studies conducted by Holbrook, Levend and Gölpınarlı.

The *mesnevi* form was used in the composition of long poems mainly written about mystical love stories. In this line of development from the thirteenth to the late eighteenth centuries, different examples of *mesnevis* are written concerning three main subject areas: mystic love, metaphorical love and health. *Mesnevis* of five different poets stress these different topics: Mevlana Celaleddin Rumi's *Mesnevi*; Şeyh Galip's (1757–1779) *Hüsn-ü 'Aşk*; Tâcizâde Câfer Çelebi's (1452–1515) *Heves-nâme*; Fuzuli's (1480–1556) *Sıhhat ü Maraz* (*Hüsn-ü 'Aşk*), and finally Fâzıl-ı Enderûnî's (1756–1810) works—*Defter-i Aşk*, *Hûbân-nâme*, *Zenân-nâme* and *Rakkas-nâme* (*Çengî-nâme*).

Mevlana Celaleddin Rumi's *Mesnevi* and Şeyh Galip's *Hüsn-ü 'Aşk* depict mystical love stories. Victoria Holbrook studies the two texts intertextually.[122] Tâcizâde Câfer Çelebi's *Heves-nâme* and Fâzıl-ı Enderûnî's works depict metaphorical or real love stories. Agah Sırrı Levend classifies works of both poets carrying similar qualities to the genre of *Şehrengiz*.[123] Fuzuli's *Sıhhat ü Maraz* (*Hüsn-ü 'Aşk*) depicts the importance of health and the human body. It stresses the harmony of all cognitive faculties with respect to the experience of love.[124]

Rumi and Şeyh Galip's *Mesnevi* depicts mystic love, but they have different viewpoints approaching the text of love. Rumi emphasizes the impossibility of the union with the beloved. Galip emphasizes the possibility of the union with the beloved. Both illustrate symbolic spaces. For example, Galip's story takes place in symbolic spaces called the Garden of Meaning, Fortress of Form, School of Proper Conduct, and the Castle of the Heart. Câfer Çelebi's *Mesnevi* depicts metaphorical love. The poem narrates the lover's attraction to a beautiful young woman. The story illustrates real spaces of the city of Istanbul: Kağıthane meadows, Hagia Sophia, Topkapı Palace, Hippodrome, Fatih's mosque complex. Enderûnî depicts both the city of Istanbul and other countries from India to the American continent.

Rumi narrates a series of stories in his *Mesnevi*. One of them, which is about three brothers' love for a Chinese princess, is taken as a model by Şeyh Galip in the construction of his own *Mesnevi*. In Şeyh Galip's story there are three main characters – a girl called Beauty, a boy called Love, and a friend called Poetry. The story begins as the girl falls in love with the boy who at first is indifferent to her love. Poetry introduces love in the heart of the once indiffirent beloved, where the main characters of the story—the lover and the beloved—exchange positions. In an encounter within a garden, Poetry acts as an interface between the lover and the beloved. The former beloved,

Love, becomes the lover of Beauty. Throughout the story Love experiences several difficult tests on a journey. During his journey, Poetry guides Love away from misconception and attachment to false beloved ones. At the end of the adventurous journey, Poetry again guides Love to the Palace of Beauty, where he unites with his beloved within the premises of his lifetime. The main idea of the narrative is that true love is attained by improving the cognitive faculties. Intellect and spirit would mislead the self by the beauty of the body's physical form, but the heart will always be able to comprehend true love beyond physicality.[125]

In Rumi's *Mesnevi*, which had been a model of reference for Galip's *Mesnevi*, the end of the story is left without a conclusion. The lover appears in the form of three characters. Each one symbolizes one of the intellectual faculties: intellect, spirit, and heart. And as well, this multiplicity can also symbolize the multiple lovers of a single beloved. Though in each case, none of the lovers unites with the beloved princess, unlike the conclusion of Galip's story. There are three lovers in Rumi's story; two of the lovers are killed. The story reminds the reader that lovers would only be able to unite with the beloved in the afterlife. The story concludes without describing the fate of the third lover. According to the critics of *mesnevi*, the two lovers killed symbolize the Intellect, and the Spirit, and the third one, who was able to survive, symbolizes the Heart. In Galip's story, there is one lover, who at the end of the story unites with the beloved. Galip's story is made up of abstract characters, places and events, similar to Mevlana's *Mesnevi*. Galip strongly criticizes the use of literal references in poetry. He argues that reference to real places precludes the imagination, thus the purpose of poetry.[126]

The story of Galip, narrated in the spatial world of a tribe's daily life, illustrates two different garden spaces. The first one is a real garden occupied by worldly bodies, of which reality leads the self away from true love. The second one is an abstract garden in which the lover encounters the beloved with the help of poetry. Poetry becomes a perfect medium for exercising imagination.

Schmimmel elucidates the agency of mysticism in Islamic poetry where the interaction between the profane and sacred orders are resolved into a unique image by the use of the arts, and cites the art of poetry as a medium relating religious narratives into a virtual imagination of aesthetic quality allowing a harmonius unity of the "spiritual, psychic and sensual":[127]

> ... certain religious ideas that form the center of Islamic theology, certain images taken from the Koran and the prophetic tradition, or whole sentences from the Holy Writ or the hadith can turn into symbols of a purely aesthetic character. Thus poetry provides almost unlimited possibilities for creating new relations between worldly and otherworldly images, between religious and profane ideas... the tension between the worldly and the religious interpretation of life is resolved... in a perfect harmony of the spiritual, psychic and sensual components.

Câfer Çelebi's *Heves-nâme* is an account of a real love affair with the wife of a man from the *ulema*. Câfer Çelebi, who was devoted to beautiful women,

dedicated his *Mesnevi* to all the pretty girls.¹²⁸ Şentürk acknowledges *Heves-nâme* as the origin of a new genre narrating adventures (*Sergüzeşt*). The poem is considered to be a contribution to the literary changes, since its theme was different to those repeated love stories of the classical Persian tradition.¹²⁹ It also informs about daily life in Istanbul. It presents the poet's thoughts regarding women, literature and poetry. It illustrates the monuments of Istanbul.¹³⁰ The atmosphere of the city is depicted as relieving the heart, and its refreshing air as keeping away the spirit from all kinds of ennui with its rose-smelling water, its soil fragrant with delightful musk and amber pampering the Spirit and caressing the Heart:¹³¹

> Its air refreshing the heart and nourishing the spirit
> Water like rosewater, soil smells musk and amber
> Beautiful places are lands charming the heart, with pleasing buildings
> Lands with ample gardens, meadows, and trees akin to the Paradise

The pleasant ambience of the urban space is almost an illustration of the paradise depicted in the Koran as the promise of the calm garden under the shading trees:¹³²

> There is no equal to her in the whole universe
> There has not been a similar city in the entire history
> Beautiful places are heart-embracing spaces
> Paradise gardens like those favored of Heavens

The superiority of the city is expressed by evoking its magnificent kiosks and palaces, its splendid festivities, and delightful atmosphere relaxing the Spirit, enjoying the Heart, and embracing the body with its delightful air, and enjoying the vision with its scenery. The following verses from *Heves-nâme* compare the palace to the paradise garden:¹³³

> To some its dome is the dome of the heavens
> To some its field is the finest of the paradise garden (*sixth garden of the heavens*)
> Its fountain and the central pool is similar to the *Kevser*
> All its doors are more blessed and fortunate than the eight gardens of the Paradise

Heves-nâme employs realism and symbolism at the same time in the depiction of the countryside meadows. The poem refers to real places Kağıthane and Göksu, but illustrates these real places in allegorical stories.¹³⁴

The sixteenth-century chroniclers Latifi, Aşık Çelebi and Hasan Çelebi criticized Câfer Çelebi. Though the poet was known to be an "intellectual and academic," he was accused of lacking "sincerity" and "true love."¹³⁵ It is very interesting that Aşık Çelebi accuses Câfer Çelebi's poetry of lacking in true love, because he expressed an interest in women. As quoted from Erünsal below, his contemporaries acknowledged and depreciated Câfer Çelebi because he preferred to express his love for women, thus he preferred metaphorical love to divine love:¹³⁶

He defends the idea that metaphorical love is a means to divine love, throughout the Hevesname, he seems content to pursue the means with scant attention to the end, and the passion he describes is explicitly carnal. He feels that those who suffer because of love are fools; no man of good sense would choose such a course.

Though *Heves-nâme* narrates the poet's love with a woman, it also accounts for a multiplicity of beautiful young men as ornaments of the urban space:[137]

> Graceful and slender lovers like young plant bodies ornament the city

Câfer Çelebi declares his desire that the city of Istanbul would become the place of reconciliation between esoteric and ascetic ideals. This ideal also embodies the poet's wish that such reconciliation would also bring together divine and natural love. Thus the poet's portrayal of a beautiful woman and his representation of the beautiful young men in the same story represent the desire to unify the experience of the divine and natural loves. The appreciation of the multiplicity of beautiful young men represents the contemplation of apparent bodies where natural love would lead the poet to divine love. The desire for a woman represents natural love, which would only satisfy the poet's worldly desires:[138]

> Two seas merge to one another on its edge

The late eighteenth-century poems of Fâzıl-ı Enderûnî also depict the multiplicity of the beloved ones. *Defter-i Aşk* depicts the adventures of the poet concerning his love affairs. *Hûbân-nâme* and *Zenân-nâme* depict, consecutively, beautiful young men and women of the world from India to America. *Rakkas-nâme (Çengî-nâme)* depicts the dancers of the city of Istanbul.[139]

Fuzuli's *Mesnevi* emphazises the importance of health in love different from the other two themes of the *mesnevi* form. The human being is made out of four parts: spirit (intellect), soul (desires), body (form) and heart. Health is explained as a harmonic balance between these different parts. Fuzuli's story takes place at spaces called Land of the Body, Castle of the Mind, City of the Liver, City of the Heart, Garden of Self-Depreciation and Valley of Betrayal.[140]

The depiction of the human body as a space is a common theme in Islamic culture. The dynamics of the human body and the whole universe is represented by spatial metaphors. The fifteenth-century Ottoman health treatise called *Hazâ'inü's-Saâ'dât* (Treasures of Happiness) acknowledges health as the only treasure of happiness. Health is seen as the harmony of body, soul, spirit and heart. In this treatise, the sustainablity of health is related to the harmony of the whole universe. The treatise depicts this harmony through a metaphor of the "city."[141]

Participants of *Şehrengiz* Rituals: Poets and Guild Boys

Şehrengiz rituals are gatherings in which city dwellers of lower status meet others from a higher status. The participants of the ritual comprised both court poets and guild boys of all ranks. The genre was developed mostly by court poets who were competent in articulating Persian or Arabîc language and the most complicated arts of poetry. However, when composing *şehrengiz* poems, these court poets preferred to use simple Turkish, which made the poems understandable to common public.

Mesîhî was called as the "city-boy" (*şehir oğlanı*). Levend mentions that Vizier Ali Pasha called Mesîhî a "city-boy" since he was used to getting lost within the city. Mesîhî was known to spend most of his time in *Tahtakale*, gardens and common grounds (*mesire yerleri*) and wine-houses.[142] Riehle acknowledges Mesîhî as a *rind* (dissident).[143] Riehle acknowledges that during most of his lifetime, Mesîhî was literally committed to worldly joy and pleasures as opposed to platonic love:[144]

> His poetry about wine and love is not a product of an old tradition. It is obvious that for a certain period of time, he had lost himself in worldly pleasure. He was spending his leisure time in the *Bozhane* assemblies during the winter, strolling in *Tahtakale*, and in the winehouses of *Galata*.

With his daring claims simply declaring his desire for worldly joys, Mesîhî had a *rind* nature. The *rind* nature is a major characteristics attributed to many poets. As a *rind*, Mesîhî became a role model for the definition of the concept of "city-boy" in the early sixteenth century. It should be questioned why anybody would ever love to get lost in the city, what could be the driving force for practicing worldly joys other than mere entertainment? How would a person in such an intimate relationship with the city, perceive the city? What is a city for the *rind*? In order to further understand the *rind*, it is necessary to analyse the poet as a subject as that takes its source in the school of 'Arabî, constituting different cognitive faculties empowered by spirit, soul, body, and heart.

According to Gibb, the originality of Mesîhî was his liberated standpoint differing from the conventional and traditional framework of the Persian poetry, and "it deserves attention for being the result of mere personal observations of the objects and landscape."[145] Mesîhî was a well-known talented poet who lived during the reign of Beyazıd II (1481–1512).[146] He was acknowledged as an original character by the Ottoman literary critics. According to Gibb, he was talented, and his poetry was sincere, liberated, daring and realistic, and at the same time, quite moving.

Similar to Mesîhî, who was acknowledged as a city-boy, other *şehrengiz* poets (Figures 4.3, 4.4, 4.5 and 4.6) also display dissident characteristics. They were known for their protest attitudes against general conventions, explained in their ideas, outfits, or lifestyles. Though most of them were also court poets,

4.3 "*Şehrengiz* poet Taşlıcalı Yahya (d. 1582)." Portrait from *Meşa'irü'ş-şu'ara* by Aşık Çelebi. AETRH 772, 135a.

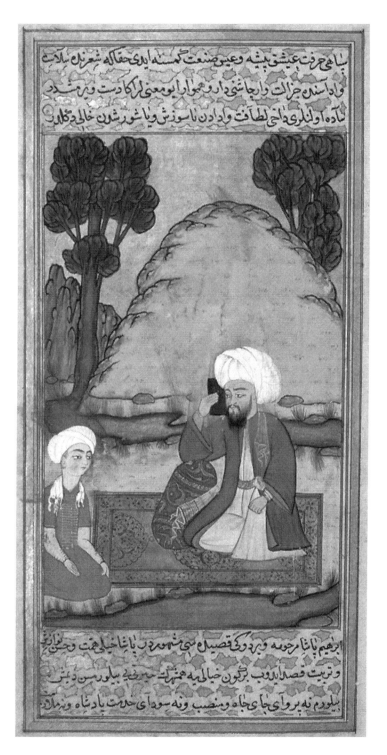

4.4 "*Şehrengiz* poet Hayreti (d. 1534)." Portrait from
Meşa'irü'ş-şu'ara by Aşık Çelebi. AETRH 772, 129a.

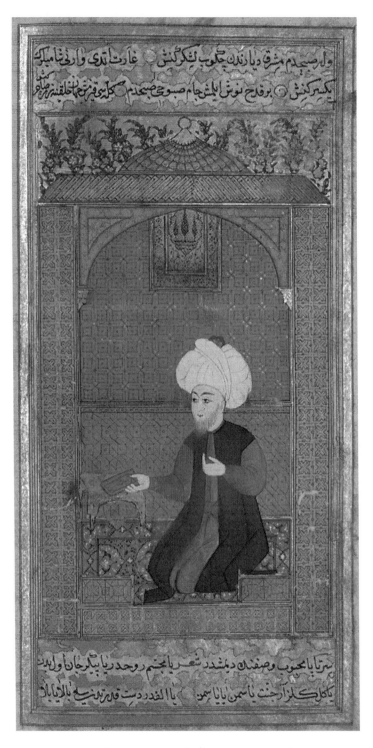

4.5 "*Şehrengiz* poet Usuli (d. 1538)." Portrait from *Meşa'irü'ş-şu'ara* by Aşık Çelebi. AETRH 772, 66b.

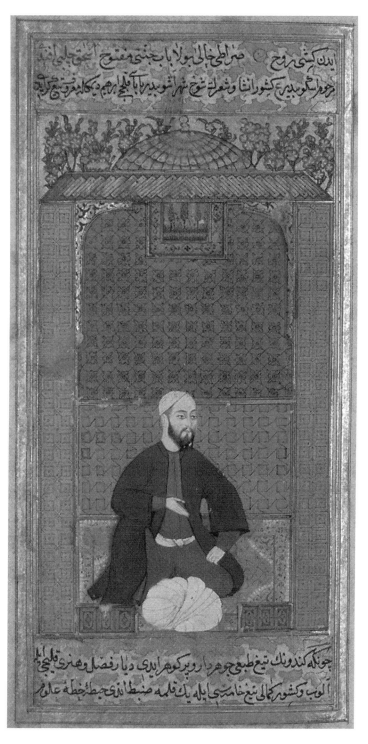

4.6 "*Şehrengiz* poet Ishak Çelebi (d. 1538)." Portrait from *Meşa'irü'ş-şu'ara* by Aşık Çelebi. AETRH 772, 62a.

they can be recognized as occupying marginal positions within the general public and court life.

Câfer Çelebi, whose *Mesnevi Heves-nâme* was a source of inspiration for other *şehrengiz* poems, was a protest character. He was a well-known scholar and poet and was also involved in politics. His father was one of the consultants of Beyazıd II (1481–1512). He worked as a teacher and a kadı in Simav, as a teacher in Istanbul (Mahmud Pasha Medresesi), and as an administrator of the Beyazıd II Foundations in Edirne. In 1497, he was appointed to the Sultan's court. However, his post was taken from him when he was suspected of collaborating with Şehzade Ahmed in favor of Şehzade Selim. The latter was enthroned as the Sultan with the support of the Jannisaries, and Câfer Çelebi was executed in 1515 as the result of a slander. Erünsal, who examined Çelebi's work, acknowledges that there are similar verses in the poems of Câfer Çelebi, Mesîhî, İshak Çelebi, Zâtî and Revani, suggesting a certain interaction between these poets who lived during the same epoch.[147]

Vardar Yeniceli Usuli (Figure 4.5) was a member of the *Gülşeni* tariqat. Upon the death of his Şeyh, he returned to his hometown and died in poverty, refusing to accept any patronage. Usuli was known to be a believer and strong defender of the doctrines of the Unity of Being. His poetry had a didactic tone in acknowledging the priorities of the doctrines of the Unity of Being. However, chronicler Aşık Çelebi accused Usuli of being a non-believer and a follower of Nesimi, the fourteenth-century Turkish poet from Baghdad, who was accused of being against the orthodox rules of Islamic Law and was executed.[148]

Ishak Çelebi (Figure 4.6) was a well-educated person from Üsküp. He worked as a teacher in many schools of various cities. He was a man of free behaviors.[149] Though his poetry was tender and caressed the soul, he was well known for his outrageous and inappropriate behavior, unconventional love affairs, and liaisons, and his hatred of women.[150]

Zâtî was a shoemaker born in the small village of Balikesir in 1471. For the sake of being a poet, he left his hometown, and migrated to Istanbul. He had a small store in the courtyard of the Beyazıd Mosque. In his small shop he used to tell fortunes by reading the numbers and signs that appear on sand. His shop was frequently visited by the renowned poets of the period; young and talented poets like Baki.[151] He was a very ugly person, almost deaf, and his body was not strong. Though he won the courtship and admiration of other poets and the intellectuals of the capital city, he was not able to get proper support in order to sustain his life, because he was not a healthy man and could not regularly participate in the courts of the elite. Thus, he stayed as a self-employed poet during his whole lifetime.[152]

Both *şehrengiz* poets and the guilds formed the participants of the city rituals. It is quite obvious that *şehrengiz* rituals both included people and depicted the presence of city dwellers of different social status. The recognition of the multiplicity of city-dwellers within the city with reference to their different professions recalls the procession of guilds in the 1582 festival (Figures 4.1

and 4.2): rope dancers, glassmakers, bed-quilt makers, silk workers, bathcloth weavers, yarn dealers, mat weavers, sword makers, paper-glazers, comb makers, mirror makers, lion tamers, archers, incense sellers, kaftan makers, clockmakers, stonemasons, builders, seamen, herbalists, gardeners, cooks, fruiterers of Üsküdar, greengrocers, coffee-house owners, coffee dealers, barbers, jewelers, Rumelian veterans, Anatolian theological students, Koran reciters, preachers, Sufis of Eyyub-i Ensari, dervishes of Hacı Bayram Veli, dervishes of Ebu Ishak Veli, Redcaps become Muslim, muezzins, scholars, crippled beggars, those imprisoned for debt, etc.[153]

The system of guilds ordered all the subjects of the Sultan into groups that anchored them to the imperial authority. Guilds formed the foundation of the Ottoman economy, but they also formed the main body of the Sultan's subjects. The imperial authority used guilds as a tool in repopulating and urbanizing the city of Istanbul after the conquest.[154]

Şehrengiz poems represented themselves and their poetry as a medium of interaction where the subjects would encounter the Sultan. Especially Taşlıcalı Yahya, who must have also carried the fear of getting punished for promoting ordinary poor guild boys as beloved ones, declared that his intention was only to introduce the guild boys to the Sultan. Thus, he presented himself as a delegate between the Sultan and his subjects.

Yahya also declared that *şehrengiz* poems depict secret meetings that should not be declared openly. In his *Şehrengiz* of Edirne, Yahya advises confidentiality. He addresses the mystics who acquired knowledge of *şehrengiz* rituals and advises them to act as "storehouses of secrecy" (*mahzenü'l-esrâr*).[155] Similarly, the *Melâmî* pole and poet Sârbân Ahmed also refer to confidentiality and call *Melâmî* masters of the "storehouse of secrecy" (*mahzeni esrâr ehliyüz*).[156]

Şehrengiz Rituals and the City

Şehrengiz rituals took place in various spaces within the city. These spaces were not private gardens or spaces representing the imperial authority. *Şehrengiz* rituals suggested an image of the city like paradise. However, this image was different than the generic image of the paradise garden reproduced by the *gazel* rituals.

While *şehrengiz* poetry developed representing various city spaces, the Ottoman authority was also interested in the representation of city spaces. The Ottoman authority used the arts of cartography as a tool to represent their authority and power. Most of these maps, produced under imperial authority, were highly circulated.

Ottoman maps comprised cosmological maps ("Ottoman version of the world map of Ibn Al-Wardi" in *Zübdetü't-tevârîh* by Seyyid Lokman, dated 1520–1569), siege plans, maps used for engineering and military sieges, maps of holy places, pilgrimage and travels, chronicles of history, architectural plans and waterway maps.[157]

After the conquest of the city, its representation had become a challenge both to the Ottoman and to the Western artist in terms of representing a historically loaded space that was conquered by a new culture which aimed to construct an empire. Çiğdem Kafescioğlu studied the Western and the Ottoman patrons' struggle to assert an imperial perspective regarding the image of Istanbul by means of a newly flourishing genre of painting "city views."[158] Kafescioğlu argues that there are two maps most possibly commissioned by Mehmed II representing Ottoman Istanbul: the 1480 version of the Buondelmonti map and the map of Vavassore dated c. 1520–1530. These two maps represented Istanbul as an Ottoman city in two different styles. The 1480 Buondelmonti map portrayed an ideal image of the city in a symbolic manner. The latter map of Vavassore portrayed a more realistic image of the city giving more emphasis to its topography. The change in the style, as Kafescioğlu argues, was related to the birth of realism and the flourishing interest in the representation of cities in Europe, from the medieval to early modern period. Late medieval maps were called "city ideogram" and represented ideal images of the city. By the end of the fifteenth century, ideal images of the city were replaced by naturalistic representations, and in the early modern period, perspective plans were introduced that represented cities in a more realistic manner.[159]

The Buondelmonti view—also called Isalorio—was originally illustrated in 1410 by Christoforo Buondelmonti. It was drawn in the late medieval period style of the bird's eye view. Until the sixteenth century, there had been several reprints of Buondelmonti's Isalorio. Kafescioğlu argues that copies of the map were highly circulated, not only in Europe, but also in Ottoman lands. A 1410 copy depicted the city walls and few columns and monuments in the city. Later versions of the map reproduced after the Ottoman conquest of the city in 1453 did not depict any evidence for the presence of Ottomans in the city, with the exception of one particular copy, the 1480 Düsseldorf manuscript. Kafescioğlu claims that this copy was most probably commissioned by the Ottoman court. In the 1480 print, the city was represented with its new Ottoman identity illustrating the Ottoman monuments; the new palace, Hagia Sophia, Hippodrome, the bedestan, the whole complex of the New Mosque of Fatih Sultan Mehmed II including its madrasas, the grave of Ayyub al-Ansari, the dense fabric of Pera and "cannons" at the Bosphorus. However all the elements of the city float on the picture plane as if in empty space. Thus, the 1480 Ottoman version of Buondelmonti's Isalorio depicts an ideal image of the city. It aimed at portraying the new Ottoman identity of the city.[160] However, the Vavassore map dated c. 1520–1530 was drawn in a realistic way. In the Vavassore map the monuments were embedded in a densely depicted urban fabric on a precisely drawn topographical site.[161] Both the Vavassore map and the Buondelmonti prints were highly circulated.[162]

An Istanbul map, dated 1537, in *Beyan-ı Menazil-i Sefer-i Irakeyn* by Matrakçı Nasuh, illustrates an ideal image of the city as a garden (Figure 4.7). It

represents the city as a densely populated garden.¹⁶³ The Map of *Hünernâme*, dated 1584, proposes various viewpoints from within and outside the city. It suggests the ceremonial shift from within the city to the Golden Horn.¹⁶⁴ Maps in the *Kitab-ı Bahriye* (Book of Seafaring) which was produced in 1521, revised in 1526 and reproduced until 1700, suggests the experience of the city from the sea.¹⁶⁵

The circulation of maps provided an image of the city as a representation of imperial power. They presented the city within a larger landscape; as a garden; and as a prosperous space, in relation to its surrounding neighborhoods, with respect to its topography. It provided an image of the city from a bird's eye view and also suggested multiple viewpoints.

Ideal Spaces of *Şehrengiz* Rituals

Şehrengiz poems illustrate opposites; Edirne—the house of *gazîs*, as opposed to Istanbul—the house of imperial court; the capital city as opposed to its provinces; imperial gardens as opposed to public open spaces; night as opposed to day; spring as opposed to winter; land as opposed to sea; sultan as opposed to his subjects; the Shariah as opposed to the Tariqat. This kind of comparison of opposites is called *tanzîh*. It is also used in the *gazel* genre, in which the opposites are contrasted to one another in terms of superiority. However, in the genre of *Şehrengiz*, the opposites unite in harmony. The city unites opposites within its body. It becomes a space of reconciliation where the opposites reside side by side. *Şehrengiz* poems depict the city as a *barzakh*, as an intermediary space bringing together opposites. The verses below from Mesîhî depict the city as a place of reconciliation:¹⁶⁶

> Such a celebrated joyful paradise where all the sinful ones would enter
> See the dissident with the conformist together represented in it

Yahya also presents the city as place where the two worlds reside. According to Yahya, the city is a space where both metaphorical and divine love can be experienced. Thus it embodies the knowledge of both the phenomenal and the divine worlds.¹⁶⁷

> Listen to this conversation of love
> If you desire for the taste of the two worlds

Taşlıcalı Yahya Bey describes the city as a gathering place of lovers. The city is illustrated as a garden. The lovers are symbolized as flowers in this symbolic garden of reconciliation. The meeting of the lovers symbolizes the meeting of form and meaning, hence the attainment of knowledge:¹⁶⁸

> Graceful and slender lovers like young plants bodies ornament the city
> Two seas merge to one another on its edge

Fakiri also portrays the city as a meeting place of the two seas. This is a metaphor portraying the city as a meeting place of opposites. As well, as it is a truth illustrating the meeting of the Mediterranean Sea and the Black Sea:[169]

> Its darkness (gardens, vineyards, meadows, fields) is a land to seek refuge
> Its brightness is where the two seas meet

As has already been discussed earlier, the metaphor of "the two seas" was also a common metaphor both in 'Arabî's work and that of his followers, such as the seventeenth-century Ottoman Sufi poet Niyazi-i Mısrı (1618–1694). Below, Terzioğlu explains Niyazi-i Mısrı's interpretation of the concept of "two seas":[170]

In his explication of the Quranic verse "He has set two seas in motion that flow side by side together / with an interstice (barzakh) between them which they cannot cross." (Rahman, 19–20), Mısrı explained that the relationship between the two seas was analogous to the relationship between shari'a (the religious law, the object of the study of the ulama al-zahir) and hakika (divine reality, the object of the quest of the 'ulama al-batin).

In Islamic tradition, water symbolizes the origin of all creation.[171] In all *şehrengiz* poems, there is a constant emphasis on water, traveling by water, river, swimming, skating on a frozen river. In a story told by Evliya Çelebi, when Edirne was proclaimed to be the capital of the Ottoman Dynasty, the Muslim community entered the city through the river, guided by Hacı Bektaş Veli.[172]

Water is the most important element in the paradise garden.[173] It symbolizes the source of divine knowledge. In the third century BCE, King Sargon II of Assyria was born out of water and he was recognized as the "gardener of his people." The story of Gilgamesh is an account of the search for the "secret of eternal life" that is located in the far-away seas.[174]

Resemblance between knowledge in the form of illuminating light and the source of life in the form of water is symbolized in the rock crystal lamps of the Islamic tradition. Rock crystal lamps, ornamented with precious stones and pearls used in mosques, symbolize divine knowledge and the rivers of paradise. Shi'i tradition also uses the metaphor of water for divine knowledge.[175]

Taşlıcalı Yahya acknowledges water as the source of the creation of beautiful things, thus the beloved. He also stresses the association of water with divine knowledge. However, divine knowledge is attained by the individual self who is determined to do so. Thus, Yahya asserts the importance of individuality when associating the participants of *şehrengiz* rituals to the natural elements of the city:[176]

> Out of a drop of water, creates a beautiful form
> His cheeks shining like moon, rose colored
> ...
> By will, the individual becomes a bright pearl
> By pure understanding and by the power of poetry

Şehrengiz poems also compare the city spaces to the gardens of paradise. However, şehrengiz poems portray the paradise garden as an intermediary space uniting all kinds of city spaces, different from *gazel* poems which depict the paradise garden as an interior space with superior as opposed to the exterior spaces. In şehrengiz rituals, each of the city spaces, meadows, gardens, rose gardens, imperial gardens, rivers, canals, seas, mosques, Sufi lodges, streets, open public spaces, populated houses, bath houses, palaces, private houses of friends and poets, castles, hills, spring waters, city walls, bazaars, guild shops, and neighborhoods is represented with paradisiacal qualities. For example, Mesîhî compares the city of Edirne to the paradise garden:[177]

> Such a city that its gardens and mountains
> Gives the individual the serenity of Paradise

> Its waters handsome and flowing with charm
> Clouds flowing by are refreshing

> If you watch every one of these minarets
> Turn into a beloved with a posture like a cypress

> Beauties getting naked go into Tunca
> Unfolding their breasts, tiny bellies

> One seeing this city, with reference to this picture
> Would think that the number of paradises has become nine

> Such a celebrated joyful paradise where all the sinful ones would enter
> See the dissident with the conformist together represented in it

Similarly, Fakiri presents the city of Istanbul as a paradise:

> Like the gardens of Paradise, all its places are enjoying
> A tender breeze makes all its citizens happy and pleasant[178]

> Every sinful getting into this prosperous state
> Watch and adore this paradise-like place[179]

> There is nothing similar to it, it is the one and only in this world
> Such a gracious such a beautiful city[180]

The anonymous poet also places the city above the paradise garden:[181]

> If Adam had ever seen that bejeweled location
> The heart would have forgotten the Paradise

Foreign travelers also narrate the beauty of the city of Istanbul. Similar to the depictions of the city in *şehrengiz* rituals, travelers also portray the city possessing divine beauty. The following quotation is the impression of an anonymous Venetian who had been to Istanbul in 1534:[182]

The city is about 18 miles round; it occupies seven little hills of no great height, ... the site of Constantinople is such that one can, not only, describe it fully but not even fully conceive its beauty. Indeed we are disposed to regard it rather as divine than anything else, nor can he who has seen it hesitate to deem it worthy to be preferred to all other places in the world.

Similarly, geographer George Braun, who traveled to the city in 1575, also portrays Istanbul with natural beauty and well maintained by its citizens. He declares that, "The city is so magnificent that it seems to have been raised not by the hand and labors of man, but by the felicity of nature and the aid of the elements."[183] Henry Austell, who was in Istanbul in 1586, praised the prosperity of the well-built city and its panorama ornamented with beautiful houses, monuments and mosques:[184]

We arrived at the great and the most stately city of Constantinople, which for the situation and proud seat thereof, for the beautiful and the commodious houses and for the great and sumptuous building of their temples, which they call Mosches, is to be preferred before all the cities of Europe.

George Sandys, who traveled to the city in the early seventeenth century, glorified the beauty of the city. He portrayed the image of the city as a garden with beautiful monuments embedded in a cypress grove:[185]

It stands in a cape of land near the entrance to the Bosphorus; in form triangular; on the east side washed with the same, and on the north side with the haven, adjoining on the west to the continent; walled with brick and stone, intermixed orderly; having four and twenty gates and posterns; whereof five do regard the land and nineteen the water; being about 13 miles in circumference. Than this there is hardly in nature a more delicate object, if beheld from the sea or adjoining mountains; the lofty and beautiful cypress trees so intermixed with buildings that it seemeth to present a citie in a wood to the pleased beholders, whose seven aspiring heads, for on so many hills and no more they say it is seated, are most of them crowned with magnificent mosques, all of white marble, round in form, ...

By the end of the seventeenth century, Grelot illustrates the city as an "enchanted town" set in a densely planted garden:[186]

Nothing can be seen or imagined more charming than the approach to Constantinople. When I arrived there for the first time, I thought I was entering an enchanted town; I found myself in the midst of three great arms of the sea, one coming from the north east, another from the north west, and the third formed by the meeting of the other two, discharging itself into the great basin of Propontis. These great arms of the sea as far as the eye can reach both shores rising insensibly, hill above hill, all covered with country houses, gardens and kiosks, which become thicker as the town is approached. They are set one above the other, as in an amphitheater, the better to enjoy so fair a prospect. Amidst these houses printed of various colours, there rise an incredible number of great domes, cupolas, minarets, and towers, ascending far above the ordinary buildings. ...The verdure of cypresses, and other trees of many gardens, add much to the agreeable confusion which charms the eyes of the stranger.

Şehrengiz poems use metaphors of the paradise garden to picture the city. Though foreign traveler accounts also acknowledge the city of Istanbul as having a divine beauty, suggesting that the *şehrengiz* poems might have not depicted an ideal image of the city, but a real image of the city, which was actually beautiful.

In contrast to the natural beauty of the city of Istanbul, the *şehrengiz* poems also criticize the status of the city for maintaining an imperial agenda and housing the imperial court. In the *şehrengiz* poems of Edirne, there is a clear subtext that criticizes the imperial agenda for asserting central authority.

Yerasimos, who researched the intertextuality of historical texts about the city of Istanbul and its monuments after the Ottoman conquest of the city, argues that almost a century after the capture of the city—from 1453 until the 1560s, the Ottoman culture proposed conflicting histories considering the newly flourishing imperial identity associated with the capture of the city of Istanbul, its monuments, and its Byzantine heritage. The official chronicles commissioned by the court, like Aşıkpaşazade, Neşri, and Tursun Bey, did not depict the foundation of the city; on the contrary, the unofficial chronicles illustrated its founders, its monuments and its faith.

The early unofficial chronicles depict the foundation of the city within the circles of Rome–Alexandria–Istanbul, or Troy–Rome–Istanbul; and emphasize its pagan and Christian heritage for the sake of proposing an antiimperial agenda during the Ottoman appropriation of the city in the second half of the fifteenth century. The latter chronicles, which carry an imperial agenda, however, associate the city with that of other holy cities of the Islamic tradition: Mecca, Medina, and Jerusalem. They convey the faith of the city as associated with the Orthodox Islamic tradition and blessed by Prophet Muhammed.[187]

Interestingly, the anti-imperial arguments were mostly presented by authors from Edirne. The city of Edirne was a challenge to the city of Istanbul. Edirne, which represented anti-imperial tendencies, was the house of *gazîs* who wished to sustain their freedom and power. On the other hand, upon its conquest Istanbul, became the symbol of the imperial agenda, which subjected all the populace to a centralized authority, including the *gazîs*.

Yerasimos has shown that among these texts, the first relevant chronicles written with an anti-imperial agenda were composed by *Melâmî-Bayrami* authors from Edirne. Two *Melâmî-Bayrami* authors, Yazıcıoğlu Mehmed and Yazıcıoğlu Ahmed, were brothers.[188] *Dürr-i meknun*, by Yazıcıoğlu Bican Ahmed composed c. 1453, formulated the background of the anti-imperial agenda upon which the later anti-imperial texts were constructed. *Dürr-i meknun* was a highly circulated book even in the seventeenth century. Its simple language enabled the text to be understood by everyone. It was used as a textbook for teaching Ottoman to foreigners. Also classified as a book of geography, *Dürr-i meknun* describes mountains, animals, cities and buildings, and concentrates on the history of the city of Istanbul. At the end, it announces an apocalypse associated with the history of the city.[189] It also makes a list of

the monuments of the city as a huge mirror, a miraculous building that tells about the faith of the lost people, a copper hand that estimates just exchange for trading people, the Eqyptian Obelisk and the Serpentine Column.[190]

A Russian chronicle dated c. 1453 narrates the city as located between the two seas. Although this is a foreign chronicle, it also conveys an apocalyptic end for the city, and takes part within the "intertextual web" of the chronicles that compose the anti-imperial agenda:[191]

This city will be called the city with the Seven Hills; it will have fame and fortune more than all the other cities in the world, but because it is located between the two seas, the waves of these two oceans beating upon it, it will incline once to this side and once to the other.

Since, throughout Yerasimos' well-documented work, it is assured that these chronicles were all well circulated in the Ottoman lands, enabling construction and transformation of such an agenda, it is also possible to argue that these chronicles were also available to the *Şehrengiz* poets. They were most probably not only considering political–social agendas, but like Cemali, were taking into account even the simple geographical depictions such as the location of the city as in between the two seas of the Mediterranean and the Black Sea.

The 1468 dated history of the city of Istanbul by Oruç Bey, and its second version dated 1497, and the 1512 dated chronicle composed by Edirneli Ruhi were also anti-imperial accounts whose authors were from the city of Edirne.[192]

The 1491 dated anonymous *Kuruluşundan Sonuna Kadar Konstantiniye Tarihinin Öyküsü* narrated the history of the city from its foundation until the sultanate of Beyazıd II, citing each one of its founders and its rulers. Yerasimos states that the story is an original Turkish version of the history of the city. The story depicts the construction of Hagia Sophia in a very peculiar way. The emperor wishes to build a church that had no equal in the whole world. So, upon consulting a 1,700 years-old wise man, the emperor organizes a contest to find the most talented architect for the design and building of this church. He poses a simple structural question. Among the participants of the contest, a poor young man from the guild of bath houses is also forced to propose a solution to the problem of the emperor. This poor man, who is not at all aware of any of the incidents about the emperor and his problem, is being helped by a spirit only seen to him. Thus, with the spirit's help, he not only proposes the correct answer regarding the structural problem, but he also becomes the architect of the church. Again with the help of the spirit he also proposes a "picture" of the church to be built for the approval of the emperor. The story also depicts the Arab conquests of the city and narrates the legendary story of the Eyyüb Ensari, who participated in the siege of Istanbul and whose place of burial had become a holy shrine. The anonymous chronicle reports that besides Ensari's burial, there was a holy spring which was also favored by the citizens of the Byzantine city. The Ottoman emperor, upon seeing his own citizens visiting the location of the burial, felt himself obliged to commission the building of a mausoleum for Eyyüb Ensari.[193]

The important features of this story, as related to the discussions on the genre of *Şehrengiz* are, first, the attempt to construct an imperial identity related to the material history of the city. Second, is the criticism of this imperial attempt and accusing the imperial agenda, which forces individual citizens to become subjects. The important point is that the story constructs new characters and refers to historical persons in the history of the city. Among these characters, there is the imaginary person called Yanko Bin Madyan, who is an anti-hero. Another character is the legendary Muslim Eyyub Ensari and his tomb with its holy spring that carries divine associations even for the non-Muslim community of the city. The fourth important point is the refernce to Yunus Emre,[194] which proposes associations with Islamic mysticism and the foundation of the city. The fifth important point is the real occupation of the architect of Hagia Sophia, who is depicted as a poor guild boy of the bath-houses. The sixth, and the least important point for the discussion of identity, but prominent in terms of perception, is the use of the concept of the "picture" of Hagia Sophia as displayed to the public and the emperor by the guild boy, again directed by the divine spirit. The first one of these points is discussed by Yerasimos in detail throughout the whole of his intertextual study. The last two points are introduced for their relevance to issues brought about by the genre of *şehrengiz*, though all six points are related to the genre.

There are two chronicles from the fifteenth century which depict the topography, monuments and miraculous features of the city. Both chronicles are considered as compilations of former sources. The first one, which is anonymous, depicts Hagia Sophia, its interior, its courtyard, the Hippodrome, miracles of the city, manastır, and the water supply system. The second one is a compilation of Arabic texts, books of geography, hagiography, and pilgrimage. It was composed by Ali bin Abdurrahman and called *Acaib ül-Mahlûkat*. It portrayed the city plan, city walls and the Hippodrome.[195] The diverse influence and different places of interest depicted in these chronicles resemble the depiction of different places in the various *Sehrengiz* poems.

One chronicle, which depicts the foundation and history of Hagia Sophia in favor of an imperial agenda, is a translation made by Şemsüddin in 1480. The author reinterprets the Byzantine texts and translates them in such a way as to be cherished by a centralized power and its Muslim community. Şemsüddin's story locates the emperor above the architect. In this story, the emperor was divinely inspired by Khidr three times in his dreams about the design and construction of the church.[196]

The anonymous *Tarih-i Bina-i Ayasofya*, written during the sultanate of Kanuni Sultan Süleyman, is another chronicle of the imperial agenda which shifts the discussions about the faith of the city within an Islamic circle, different than most of the previous chronicles association of the city with its Byzantine and Christian heritage. The text focuses on Hagia Sophia mainly through the eyes of former Islamic mythology, which reflected the capture of the city by Ottomans, as predicted by the prophet Muhammed. When Muhammed had ascended to the heavens, Gabriel had shown him all the

levels of paradise. In the garden of the seventh paradise, Firdevs the prophet was amazed to see a replica of Hagia Sophia.[197]

By the sultanate of Yavuz Sultan Selim II, the anti-imperial arguments, which depict the history and foundation of the city or its monuments, became almost totally replaced by chronicles that serve for the centralized imperial agenda. The *Tarih-i Konstantiniye* by Ilyas Efendi, dated 1562, is a chronicle that represents the city as a haven totally blessed by God. It begins with a geographical description, and cites the founders of the city. The Chronicle abandons any irritating parts of the previous chronicles with their claims for an anti-imperial agenda and warning of the inevitable future apocalypse of the city. In the blissful and pleasant story of the city, Ilyas appraises the city and its monuments. He depicts the Fatih Mosque, the *medrese*, similar to Paradise; pictures of the Beyazid Mosque, citing its location close to the Old Palace, and mentions the mosques that were commissioned by Kanuni Sultan Süleyman. Thus, with Ilyas' story, the imperial project was made into a success story. The Süleymaniye Mosque was compared to the Kabe, the prophet's mosque at Medina and *Mescid-i Aksa*, at Jerusalem.[198]

With respect to all the various narratives about the foundation of the city of Istanbul; there are two main chronicles, which depict the importance of the city of Edirne as the house of *gazîs*, in rivalry with the city of Istanbul. These chronicles are dated from the late fifteenth to the early sixteenth centuries, parallel to the dating of the anti-imperialistic arguments, and as well parallel to the development of the genre of *Şehrengiz*.

The *Saltukname*, dated 1475–1480, narrates the capture of Edirne by the *gazîs* and their leader Sarı Saltuk. It conveys a story where Sarı Saltuk meets Khidr and Elias in the place called *Hıdırlık* (The Grove of Khidr) and talks about the faith and fortune of the city as the house of *gazîs* and the center of the world.[199]

The *Hikaye-yi hekim Beşir Çelebi ve Edirne'de olan Eski Camii Tevarihi ve Yeni Saray ve Hisar-ı Edirne*, dated c. 1520 by Beşir Çelebi, tells about the foundation of the city of Edirne. According the argument of Yerasimos, the author conveys the city as blessed, and dedicated to Islam, contrary to the cursed city of Istanbul.[200] In the story, Ilyas, as the founder of the city, predicts that in the future Edirne will be the house of the *gazîs*. Hadrianus builds the first hagiasma of the town and predicts the future occupation of the city by a Muslim community, which would conquer the whole world from this station point. In the text, four holy places of the city are narrated: first the hagiasma of Hadrianus; second *Hıdırlık*; third, a mosque built by Murad III; and fourth Dar-ül Hadis, a religious school. The text links the heritage of the city to Islamic legend by referring to "two black stones that were brought back from Kabe" in the Old Mosque (1414). According to the story, Hacı Bayram Veli, who visited this mosque, had a revelation from Prophet Muhammed during his visit, ensuring that this mosque would serve his commune, and that it would never be deserted.[201]

Edirne, the house of *gazîs*, and its provinces had a significant *Melâmî* population. When the central authority had threatened *Melâmîs* with hostility,

the prominent figures of the society had chosen to live outside the city of Istanbul, in the provinces of Edirne and the Balkans. When Hacı Bayram Veli visited Edirne upon the Sultan's invitation, he acquired many adherents in the region. Melâmî pole Ismail Maşuki (d. 1539) and his companion Pir Ahmed-i Edirnevî traveled between the cities of Istanbul and Edirne until Maşuki was executed in Istanbul.[202] Melâmî pole and poet Ahmed-i Sârbân (d. 1545) was living in Hayrabolu, a province of Edirne.[203] Melâmî pole Hamza Bali (d. 1561–1562) carried the philosophy to Thracia and the Balkans, in the environs of Edirne, Tekirdağ, Vize, Hayrabolu, Zlovnik, Gracanica, Dolnja Tuzla, Gornja Tuzla and Hersek.[204] These regions formerly housed the followers of Şeyh Bedreddin. Bedreddin had a lot of disciples and admirers in Edirne, its provinces and the Balkans. There was also a prominent Bektashi population in the area.

Real Spaces of *Şehrengiz* Rituals

Şehrengiz poems are constructions. These constructions are stories, books, a pearl necklace, and thus a city. They construct images by words and evoke forms in imagination. While the city is being constructed in the imagination, the narrative leads the reader or the listener to experience the events of the city. This is enabled by telling stories within stories, creating different panoramas within the continuity of the same text, providing multiple viewpoints. *Şehrengiz* poems depict various scenes from different spaces, both real and imaginary. The poems as a whole demonstrate the multiplicity of characters, stories, events and the multiplicity of city spaces.

The *şehrengiz* poems illustrate spaces of the city such as: meadows, gardens, rose gardens, imperial gardens, rivers, canals, seas, mosques, Sufi lodges, streets, open public spaces, populated houses, bath houses, palaces, private houses of friends and poets, castles, hills, spring waters, city walls, bazaars, guild shops, neighborhoods. The *şehrengiz* poems also illustrate different cities apart from Istanbul.

Within the city of Istanbul, the *şehrengiz* poems depict spaces from within the walled city and from without. Within the walled city, Hagia Sophia, its interior space and courtyard, the Hippodrome and populated streets leading to the Hippodrome, the mosques of Beyazıd (r. 1481–1512) and Fatih (r. 1444–1481) are narrated. Outside the walled city, Yedikule, Eyüp, Galata, Üsküdar, Yenikapı, Beşiktaş, Kağıthane, Anadolu Hisarı, Göksu, Kavak, Kadıköy and Davudpaşa neighborhoods are cited. The poems also depict scenes from bath-houses and private residences, or shops which cannot be located in the city. There is a constant emphasis on water, indicating either the Bosphorus, the Golden Horn or a river which could be the Kağıthane or the Göksu River.

Some of these neighborhoods and spaces were manifestations of the imperial order. In the 1537 map of Istanbul by Matrakçı Nasuh, the city

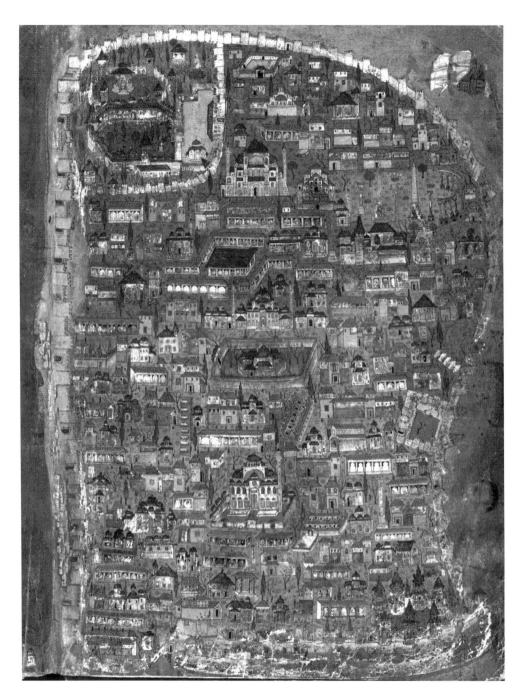

4.7 "Istanbul" in *Beyan-ı Menazil-i Sefer-i Irakeyn* (1537) by Matrakçı Nasuh. IUK TY 5964, 8b.

representation is a display of imperial ideology (Figure 4.7).[205] İffet Orbay, in her unpublished thesis study, examines the 1537 map.[206] The 1537 map actually presents a diagrammatic ideogram of the imperial ideology with the former Byzantine ceremonial axis of the Mese transformed into the new Ottoman imperial axis furnished with Ottoman imperial monuments along with the Byzantine heritage. Thus, Hagia Sophia, the Hippodrome, the old palace, Beyazıd Mosque and the Fatih Complex are drawn on a straight axis inhabiting the center of the walled city.[207]

As if using the 1537 Istanbul map of Matrakçı Nasuh as a guide, an Italian traveler to the city also depicts the monumental imperial mosques along the main axis he visited after Hagia Sophia:[208]

> There is the mosque of Sultan Mohammed, which has an imaret attached to it that is like a hostel; in which they lodge anyone, of any nation or law, who may wish to enter, and they give him food for three days honey, rice, bread, and water, and a room in which to sleep… Near this they have baths and some fountains, most beautiful and delightful to behold. There are the mosques of Sultan Beyazid, Sultan Selim, and other Signors, which are very beautiful and exceedingly well-built.

The 1537 Istanbul map illustrates the imperial image of Istanbul with its neighborhoods. The 1537 map also announces another imperial ideal, which is representing the Ottoman city as a garden. Thus, the map depicts the monuments of the city with the background of a green garden, planted with colorful trees and flowers of all kinds.

Though *şehrengiz* travels include spaces which exhibit the imperial ideology, they are not limited to them. *Şehrengiz* poems present every corner of the city as a paradise, including the Galata region. Moreover, the emphasis on the spaces outside the walled city is more than the ones inside.

Meadows are also important spaces of the *şehrengiz* rituals. Different from gardens, meadows in the countryside along the Bosphorus or at Kağıthane provided a multiplicity of spaces where city dwellers used to enjoy themselves. Such meadows were called *mesire*. *Mesire* have always been an important part of Ottoman culture. In the sixteenth century, the *mesire* experience is usually narrated through the personification of natural elements. Allegorical stories are narrated depicting the rose's passion for the river, the nightingale's hopeless desire for the rose over which he had shed his blood, the shivering willow, the birds gently accompanying the wind blowing foresee a mythical atmosphere, and the space is defined in terms of Nature. The space has a Spirit of its own narrating her own stories, and with its beauty gently reflecting the beauty of God. The countryside becomes a representation of divine aesthetics. As the poet wanders out in the countryside, Kağıthane and Göksu are presented as favorable spots in the countryside, embracing, caressing and refreshing the spirit and the heart.

Evliya Çelebi makes a long list of private and public *mesire* areas "where everybody can stroll without any restraint."[209] Within the city, Evliya Çelebi

names 16 places as *mesire* including promenades, open spaces, and gardens of the mosques, or religious complexes. These *mesire* listed are: Atmeydanı, Ağa Çayırı, Yenibahçe, Baruthane, Vefa, Beyazıd-ı Veli, Süleymaniye, Fatih, Atpazarı, Arabacılar, Selimiye, Kadırga Port, Şehzade, Yedikule, Valide Mosque, and Ayasofya. Ten city doors including docks listed as public squares (*meydan*) are Eminönü, Odun Kapısı, Ayazma Kapısı, Büyük Ayazma İskelesi, Eyüp Ensari Kapısı, Kumkapı, Langa Kapısı, Samatya Kapısı, and Murad Paşa Kapısı. Langa Sea-Bath, vineyards of Langa, Buçak, and Lalezar are the other places in Evliya Çelebi's record, among which the public can visit without any restraint.

Outside the city, Evliya lists Süleyman Sahrası outside the Silivri Kapısı. According to Çelebi's account, the place is described as a big empty space, most likely a lawn, less probably a meadow, where there is fountain of "life-giving water" and a high-rise pavilion (*yüksek köşk*). The *mesire* of the Yenikapı Mevlevihane Tekkesi; the promenades of the Topçular, Otakçılar, Yavedud, Cirit Meydanı on the way to Kağıthane; Bayram Paşa and Kasım Ağa vineyards are listed as public places outside the city. Evliya Çelebi records the village of Alibeyköy, with 40 houses, and a mosque, "ornamented" with about 70–80 plane trees as a place for strolling.

Other *mesire* listed are still diverse in their typology. They are villages, open spaces, or dervish lodges.[210] Some of these places were named after a single artifact like a pool, or a specific garden that the site accommodates. The sites of *mesire*, as depicted by Evliya Çelebi, were favorable locations for "lovers" and "friends" to meet and converse. Among these *mesire* were: the Dervish Lodge of the Indian Kalenderis, the *mesire* of Emir Gune Garden, which was once built in honor of Emir Gune, the captured ruler of Revan, which later became a garden for the public to visit; the *mesire* of Cendereci village; *mesires* of Çaybaşı, Sultan Osman pool, the mountains of Istranca, the dairy farm of Selim Han, the Terkos Lake Hunting Site, Çekmece lakes, and Okmeydanı.

Evliya Çelebi records the *mesire* of Kağıthane as a favored place among the citizens of Istanbul and even among the Arabs, Persians, Indians, natives of Yemen, and travelers from Habesh. He praises its waters and its air. Its river is surrounded by plane trees, cypresses, and willows. It is a famous place for washing clothes in the river, whose water bleaches the dirtiest garments naturally. One of the major sites of interest was the *Mesire* of Lalezar, famous for its tulips. Another well-known site was the *Mesire* of Imrahor Pavilion, which had a "bejeweled timber pavilion" as Çelebi describes it, constructed on a meadow beside the Kağıthane River. Evliya recites the plants of the site, the high qualities of grass types such as "*kara karık, sarı karık*," clover and appreciates other kinds of various weeds of this particular meadow, comparing it to some other meadows in the eastern provinces of the empire, like Erzurum, Muş, Van, and Bingöl. The site was mostly enjoyed during the holidays by the old and the young "lovers" who arrived at the *mesire* by boat. These visitors used to gather in groups, converse and enjoy themselves in parties of poetry, and music. Evliya Çelebi also portrays the large number

of people who used to swim in the river, wearing blue cloths on their naked bodies. *Kağıthane Tekkesi* is illustrated as "a place for conversing," described as having a dervish lodge which had rooms, corridors organized for "lovers" (poets), a kitchen having 70 stoves, a storage space, one oven, one coffeehouse, a mosque, and a water well. Evliya records that the visitors were able to board at the lodge for about five to ten days.

Another site for strolling in *Kağıthane Mesiresi* is called the Promenade of "Jewelry-Makers" (*Kuyumcular Gezinti Yeri*). This place was identified as the gathering location of the guilds of jewelry-makers, who used to meet at the site and enjoy themselves by conversing for 20 days every 40 years. Evliya Çelebi describes the activity as an old tradition of the guilds, established during the time of Süleyman, who had himself learned the art of jewelry-making when he was a prince. The Sultan also used to participate in these gatherings. The imperial tent would be constructed at the site among the many other tents of the guild members who had traveled to Istanbul from all the other provinces of the empire. The members of the guilds, according to tradition, would visit the imperial assembly. The Sultan was expected to offer a present to the master of the guild, and in turn, the master of the guild was required to present him a set of gifts. There are accounts of other guilds which used to gather at Kağıthane every 20 years. And the site would mostly be enjoyed by the public, who would camp in tents before the holy month of Ramadan. This activity, which used to last for about one month, was called "şeb-bük" as accounted by Evliya Çelebi, and within this month the public would enjoy themselves celebrating the arrival of the holy month. Located at the entrance of Kağıthane valley, Evliya Çelebi identifies *Baruthane*, which was a site of gunpowder production. This place is also listed under the title of *mesire*, for the joy and excitement of watching the sight of powder-mills. He narrates the playful and amazing movement of the mills, the sound of the machinery and workers as a delightful sight that is located along the river.[211]

Busbecq, who traveled to Istanbul in the second half of the sixteenth century, describes a countryside meadow from an outsider's point of view. He illustrates a particular meadow between Edirne and Istanbul as a prosperous place ornamented with flowers:[212]

> We stayed one day in Adrianople and then set out on the last stage of our journey to Constantinople, which was now close at hand. As we passed through this district we everywhere came across quantities of flowers—narcissi, hyacinths, and tulipans, as the Turks call them. We were surprised to find them flowering in mid-winter, scarcely a favorable season. There is an abundance of narcissi in Greece, and they possess so wonderful a scent that a large quantity of them causes a headache in those who are unaccustomed to such an odour. The tulip has little or no scent, but it is admired for its beauty and the variety of its colours. The Turks are very fond of flowers, and, though they are otherwise anything but extravagant, they do not hesitate to pay several *aspres* for a fine blossom.

He also illustrates another meadow in Istanbul: "The next day we left Scutari and journeyed through fields of fragrant plants, especially lavender."[213]

Busbecq also describes Istanbul and environs as ornamented with gardens of the sultan. These gardens were housed in "charming valleys:"[214]

> I had a delightful excursion, and was allowed to enter several of the Sultan's country-houses, places of pleasure and delight ... I also saw numerous parks belonging to the Sultan situated in charming valleys. What homes for the Nymphs! What abodes of the Muses!

Another neighborhood cited frequently in *şehrengiz* poems is Eyüp. Eyüp is located at the end of the Golden Horn. Ebu Eyyub-i Ensari was a friend of the prophet Muhammed, and died during the Arab siege of Istanbul. According to the legend, he was buried in the skirts of the city walls, outside the city. Later, when Fatih conquered Istanbul, the exact site of Ebu Eyyub-i Ensari's tomb was located.

Evliya Çelebi recounts that Eyüp, located outside the city of Istanbul, was two hours away from the main center of the city. As Evliya further describes, there was no empty land between the city and Eyüp, though it was known to be a separate town with 26 neighborhoods, numerous vineyards, and gardens. Fatih Sultan Mehmed had built a mosque in this town, in honor of the Muslim saint who was killed during the first Arab conquest of the Byzantine Constantinople. Evliya tells that this monumental site of Muslim pilgrimage was visited on Fridays: "Every Friday thousands of men come to visit *Hz. Eba Eyüb*, thus its bazaar and market place becomes like a sea of men. The gentlemen of pleasure are seated at the balconies of the 'desert' (*kaymakçı*) shops drinking fresh milk, and eating cheese with pure honey."[215]

Among the sites for visiting, Evliya lists Eyüb Promenade, which used to embody the *Küplüce* Hagiasma with its "life-giving water," located on a hillside overlooking the sea; *Ağa Eskisi* Promenade, a meadow looking over the Golden Horn; *Harp Meydanı* (Promenade of War), a place famous for riding and the art of musketeering; *Kalamış*, a spectacular site favored for fishing, and traveling by boat; *Deniz Hamamı Gezinti Yeri* (Sea-Bath Site of Journeying), islands in front of the town of Eyüb, where on every Friday, friends visit by boat and enjoy themselves sitting on its serene grassland after swimming in the Golden Horn. The site of a well in a house located in the cemeteries north of Eyüb was known as *Can Kuyusu Gezinti Yeri* (the Well of the Spirit). This well was known to have magical powers in guiding people to finding their lost goods or beloved intimates, who were lost. The gardens of a dervish lodge that belonged to the *Bayrami* order, called the İdris Köşkü (Idris Pavillion), was another site in the vicinity. This dervish lodge as recounted by Evliya Çelebi, was demolished by Mustafa I (1622–1623), who accused the master of the order of being a non-believer. Its garden, as Çelebi mentions, was still a place of pleasure with its big fountain, pool, plane trees and lawn. Evliya Çelebi says that this site was favored by the dervishes and the friends of the tariqat as a place of gathering and joy.[216] Other *mesires* listed are: *Kırk Selviler* (Forty Cypresses), *Ağa Kırlığı* (The Meadow of the Aga), and *Bülbül Deresi* (The River of the Nightingale).

The town of Sütlüce was famous for its prosperous gardens and beautiful palaces.[217] Evliya Çelebi lists a number of gardens such as the garden of Ali Ağa, Eski Yusuf, Gani-zade, and the gardens of private residences—gardens of the Karaağaç waterfront mansion, which belonged to the imperial household, and where sultans used to enjoy watching people going to Kağıthane by boat; the garden of Ebussud, the vineyard of Bezirganbaşı, and the gardens of İbrahim Han-zade. Other favorable grounds of the town are listed as the gardens of dervish lodges; Caferâbâd, Hasanâbâd, and Abdüsselâm. The Caferâbâd Lodge, located on a hilltop and decorated with a variety of trees, was among the favorable sites which Sultan Süleyman used to visit. Evliya Çelebi presents Hasanâbâd as a place of gathering, where at the beginning of each month, parties of reading and singing were organized, and the people of Istanbul, "whoever loves journeying," were invited. The "paradise-like" gardens of the Abdüsselâm Lodge were favored by the members of the guilds. For the town of Kasımpaşa on the Golden Horn, Evliya Çelebi accounts for ten sites of *mesires*:[218] Tirendazlar Tekkesi, Ayazma, Hasan Karlığı, Pota Yeri, Divdar Çeşmesi, Piyale Paşa Tekkesi, Söğütçük Ayazması, Hacı Ahmet Bostani, Boşnak Bağı, and Dede Bostanı. Among these promenades, Hasan Karlığı, Didar Çeşmesi, and Piyale Paşa Tekkesi are recorded as places of convivial gatherings of friends for conversing.

Sandys, who traveled to Istanbul, reported on the neighborhoods of Eyüp and Kağıthane, and their use by the imperial court. He described the sword-girding ceremonies of the sultans at Eyüp and the imperial gardens at Kağıthane where the sultans used to hunt:[219]

All the suburbs that this city hath, lie without the Gate of *Adrianople*; adjoining to the North west angle thereof, and stretching along the uppermost of the Haven. Where within a stately monument, there standeth a Tomb of principal repute in the *Mahometan* devotion: the Sepulcher of *J(E)upe Sultan* a *Santon* of theirs, called vulgarly and ridiculously, the Sepulcher of Job. To which the *Caption Bassa* doth repair before he sets forth, and at his return; there performing appointed Orai-ons and Ceremonies, and upon a victory obtained, is obliged to visit the same every morning and evening, for the space of three weeks. Before this in a Cypress Grove there standeth a Scaffold, where the new *Sultans* are girt with a Sword by the hands of the *Mufti*, their principal Prelate, with divers solemnities.

Now speak we of the Haven, rather devoured than increased by a little River called formerly *Barbysez*, now by the Greeks, *Chartaricon*, and *Chay* by the Turks; much frequented by Fowl, and rigorously preserved for the Grand Signiors pleasure, who ordinarily hawks thereon; insomuch that a servant of my Lord Ambassadors was so beaten for presuming to shoot there, that shortly after he died (as it is thought of) the blows. This falleth into the west extent of Haven: throughout the world the fairest, the safest, the most profitable.

Many of the *şehrengiz* travels included Galata. Galata was famous for its wine houses. Evliya Çelebi counts a number of wine types such as: "*Ankona, Sakoza, Mudanya, Edremit, Bozcaada*" sold in the taverns of Galata. Evliya gives the names of some of these taverns as "*Kefeli, Manyeli, Milhalaki, Kaşkaval,*

Sünbüllü, Konstantin, Saranda." The total number of taverns in Galata was about 200, as recorded by Evliya Çelebi.[220] There were also about 200 taverns (*meyhane*) and places selling soft drinks (*bozahane*) in Kara Piri Paşa, and 100 taverns in Hasköy.[221]

Though in *şehrengiz* poems there is no account of drinking alcohol, it would not be daring to assume that wine was part of *şehrengiz* rituals like that of the *gazel* rituals. Traveling to Galata, *şehrengiz* rituals might propose enjoying the taverns of Galata as well. Busbecq illustrates the scene of taverns by "accounting for drinking wine with the Turks who had enjoyed it enourmously:"[222]

The drinking of wine is regarded by the Turks as a serious crime, especially among the older men; the younger men can commit the sin with greater hope of pardon and excuse. They think, however, that the punishment which they will suffer in a future life will be just as heavy whether they drink much or little, and so, if they taste wine, they drink deep; the punishment being already deserved, they incur no additional penalty, and they count their drunkenness as all to the good. Such are their ideas about drinking and others are still more absurd. I once saw an old fellow at Constantinople, who, when he had taken the cup into his hand, began to utter loud cries. When we asked our friends the reason of this, they declared that he wished by these cries to warn his soul to betake itself to some distant corner of his body or else quit it altogether, so that it might not participate in the crime which he was about to commit and might escape pollution by the wine which he was about to swallow.

In *şehrengiz* poems, there is a strong emphasis on the tradesmen and guilds. Though the space of the bazaars is not depicted directly, if the locations of these bazaars are mapped on the late fifteenth-to-sixteenth-century maps of Istanbul, it can be understood that these spaces of trading were established around the major *külliye*s and monuments that are mentioned in some of the *şehrengiz*, and they constitute the continuity of city space. Doğan Kuban gives a detailed list of the shops as accounted after the conquest until the early sixteenth century. There were many shops built around the Fatih complex. Sultan's Bazaar had 286 shops, *Saraçlar Çarşısı* (bazaar of leather goods and saddlers) had 110 shops. There were ironsmiths and coppersmiths located around the *Saraçhane*. Other shops were juxtaposed on top of the Byzantine commercial quarters, between the port area and the Mese. Near Forum Tauri, there were the textile shops. Near the Column of Constantine, Fatih had commissioned the Old Bedesten (İç *Bedesten/Eski Bedesten*), which had 126 shops. Around the bedesten there were about 800 shops. There was no ethnic discrimination in the ordering of the Grand Bazaar. Muslim, Jew, and Christian merchants worked together within the same space. Şimkeşhane in Beyazıd accommodated the silver and gold embroided fabrics, and the Saraçhane housed 80 shops. The bazaar of the Ayasofya had 48 shops and Dikilitaş had 77. Near the Mahmud Paşa Complex there were 265 shops.[223]

Along with the bazaars and guild shops, *şehrengiz* depicted meadows, gardens, rose gardens, imperial gardens, rivers, canals, seas, mosques, Sufi

lodges, streets, open public spaces, inhabited houses, bath houses, palaces, the homes of friends and poets, castles, hills, spring waters, city walls and neighborhoods. Through *şehrengiz* rituals, each one of the urban spaces illustrated and experienced was recognized as intermediary spaces, each as a *barzakh*. The city came to be experienced as a collection of intermediary spaces between the invisible realm of the celestial and the visible realm of material space. *Şehrengiz* rituals came to be spiritual and physical journeys of the individuals in the city. Each *şehrengiz* proposed a different path within the city. Each path defined various spaces as realms of imagination and as storehouses. These different city spaces involved imperial spaces, but they mainly engaged in spaces beyond the imperial power. *Şehrengiz* rituals involved free movement of the body. It asserted the importance of free movement participating in the cosmic order. Free movement enabled the liberation of the self. *Şehrengiz* rituals were practiced by marginal groups and involved participants from all ranks of society—court poets, guild boys and dervishes. It aimed at introducing the subjects of Ottoman rule to see themselves as individuals.

The first known example of a *şehrengiz* poem is about the city of Edirne, and in other examples, *Şehrengiz* poetry offers journeys to Edirne and its provinces from Istanbul. Throughout history, Edirne housed heterodox groups, as well as groups with anti-imperial tendencies who were hostile towards the centralized imperial power growing in the city of Istanbul. When in the sixteenth century, the central authority had threatened *Melâmîs*, prominent figures of the society chose to live outside Istanbul, moving towards Edirne and the Balkans. This caused Edirne to have a significant *Melâmî* population. Thus, this going back and forth, between the capital in the center of Ottoman cosmology and to provinces on the periphery, offers a certain intertextuality weaving Ottoman lands, as well as constructing Ottoman urban and landscape culture, presenting each city, different city spaces, gardens and promenades, as parts of the paradise garden.

Contrary to the poetical traditions of the court, *şehrengiz* poems were not about private gardens or garden parties, but instead praised public gardens and promenades, or ordinary spaces of a friend's house as long as they provided a meeting place for the common public. Different from the poetical traditions of the court, this genre did not focus on the central power and magnificence of the ruling authority as was linked to divine power, but instead, narrated multiplicity and beauty of the Sultan's common subjects meeting in the market place, in coffeehouses, wine houses, and taverns of the cities mentioned. Private gardens, on the other hand, accommodated exclusive garden practices for reinforcing imperial authority through the *gazel* tradition; fragments of urban spaces and countryside—imagined as fractions of the Paradise Garden ornamenting the mundane world—came to be enjoyed by a public engaged in the discovery of individualism through the *Şehrengiz* genre. Such fragmented visions of mapping urban city spaces and countrysides plotted in different scales provided a unique understanding of

the image of the Ottoman city and landscape. Thus, each one of the urban spaces had been constructed into a paradisical landscape vision of the city, as the genre had stimulated and encouraged the construction of free will and the individual self in the pre-modern Ottoman world.

Notes

1 Mesîhî's *Şehrengiz* has three major parts, like most of the later examples of this genre: Introduction (*Dibaçe*); Names of the city boys—46 different characters are presented in this part; and the third part as the Final (*Mukaddime*); E.J.W. Gibb, *Osmanlı Şiir Tarihi*, 451.

2 Agah S. Levend, *Türk Edebiyatında Şehr-engizler ve Şehr-engizlerde Istanbul* (Istanbul: Baha Matbaası, 1958): 17–18.

3 Ahmet Atilla Şentürk, *Osmanlı Şiiri Antolojisi* (Istanbul: YKY, 1999): 138:

 Beş on gün eylesem ger savma niyyet / Bozar ol niyyetim ger 'ıyd-i vuslat; Elüm kaldursam illerle du'âya / Sanuram el uzattum merhabâya; Çü mescîd içre tutam kıbleye yüz / Cemâl-i yar olur mihrâb düpdüz

4 *Ibid.*, 138:

 Ne katre kim akar bu çeşm-i terden / Meniydür kim gelür hazz-i nazardan

5 In the first part of his *Şehrengiz*, complaining about his soul (*nefs*), Mesîhî uses the following expressions: "Giriftar-ı kemend-i nefs-i dûnam," "nefs-i şerîr," "nefs-i sâhî," "seg-i nefsüm," "şîr-i şerze." Similarly Arabî refers to the soul, especially the appetitive soul, which will never give comfort to the human; William C. Chittick, *The Self-Disclosure of God: Principles of Ibn al-'Arabî's Cosmology* (Albany, NY: State University of New York Press, 1998), 344.

6 For further information on the discussions related to the day–night relationship see: William C. Chittick, *ibid.*, 262–265.

7 Ahmet Atilla Şentürk, *Osmanlı Şiiri Antolojisi*, 138:

 'Aceb şehr ol ki anuñ bâg u râgu /Virür kişiye cennet ferâgı; İçinde suları mevzun u reftâr/ Bulutlar başı ucunda hevâdâr; Temâşâ eyleseñ her bir minaret/ Dönüpdür serv-kâmet bir nigâra; Soyunup Tuncaya girer güzeller/ Açılur ak güğüsler ince beller; ... Gören bu şehri bu resme kıyâmet/ Sanur bunuñla tokuz oldı cennet; Zihi cennet ki girer her güneh-kâr / Görür 'âsi vu 'âbid anda didâr

8 William C. Chittick, *The Self-Disclosure of God*, 395, n.18.

9 Riehle acknowledges Mesîhî's tendency to *Melametiye* in his own verses; Klaus Riehle, *Leben und Literarische Werke Mesîhîs = Mesîhî'nin hayati ve edebi eserleri* (Prizren: BAL-TAM, 2001), 128:

 Sınsa Mesîhî câm-ı vakârun 'aceb mi kim / Seng-i melâmeti ana ol yâr-ı cân atar

10 William C. Chittick, *The Sufi Path of Knowledge: Ibn al-'Arabî's Metaphysics of Imagination* (Albany, NY: State University of New York Press, 1989), 106.

11 Annemarie Schimmel, *Mystical Dimensions of Islam* (Chapel Hill: The University of North Carolina Press, 1975), 293.

12 Henry Corbin, *Creative Imagination in the Sufism of Ibn 'Arabî*, trans. Ralph Manheim (Princeton, NJ: Princeton University Press, 1969), 224.

13 Agah S. Levend, *Şehr-engizler*, 20:

 Redif itdüm güli didüm gazel hûb / Gele inşae Rahman yâra mahbub

14 *Ibid.*, 20:

 Zemini eyle zînet itdi Yezdan / Sanasın yiğ ki can bulmışdı devran; Nice methidebile kişi anı / Ki Mâni can virüp yazmaya anı; Heman dem yollara girdüm durışdum / Gelüben şehr-i İstanbula düşdü

15 *Ibid.*, 94.

16 *Ibid.*, 94:

 Anun misli beyan hergiz serpilmez / Ana benzer dahi âlemde olmaz; Bir ulu câmi' itmiş şehr içinde / Ki Mâni yazamaz hiç şehr içinde; Görenler dir budur firdevs-ı sânî / Güler güldükçe vardur sanki canı; Akar sahnında görün havz-ı kevser / Ki kevser birle ol sudur beraber; Bunun vasfında âciz cümle vassaf / Bunun katında cennet uramaz lâf

17 *Ibid.*, 20:

 Girü yâdeyledüm ol nâzenîni / Figan ile yine itdüm enîni; Başım alup yola oldum revâne / Yetişdüm geldüm ol serv-i revâna

18 *Melâmî* dervishes felt safer not going to the city of Istanbul after the execution of the *Melâmî* master Oğlan Şeyh in Istanbul in the early 16th c.; Abdülbaki Gölpınarlı, *Melâmîlik ve Melâmîler* (Istanbul: Gri Yayın, 1992, c. 1931), 55–68.

19 Agah S. Levend, *Şehr-engizler*, 94:

 Anı fetheylemiş Sultan Muhammed / İçi topdoludur envâr-ı Ahmed

20 Abdülbaki Gölpınarlı, *Melâmîlik ve Melâmîler*, 59:

 Ey talib olan âşık seyretmeğe cânânı / Dıkkatla temâşa kıl her gördüğün insânî!; âyinei insanî bil sureti Rahmandır, / Bu âyineye gel bak; gör anda o sultan!; Surette görünmez can ger derse münafıklar; / Sen cana nazar kılsun görmek dileyen anı!/ Esrar sözün "Ahmet" keşfeyleme nâdâna

21 Çiğdem Kafescioğlu, "The Ottoman Capital in the Making: The Reconstruction of Constantinople in the Fifteenth Century," Unpublished PhD diss. (Harvard University, Cambridge, MA, 1996).

22 Mehmed Çavuşoğlu, ed. and trans., *Yahya Bey Divanı* (Istanbul: IÜEF, 1977), 231; translated from Taşlıcalı Yahya's *Şehrengiz of Edirne*:

 Tururken Edirne şehrinde mahsûn / Gelüp bir âfitâb-ı rub-ı meskûn; Fakîre kendü lutfından hemân-dem / Didi ey zû-fünûn-ı devr-i âlem

23 *Ibid.*, 231:

 Ne bilsün kadrüni ol mâh-ı garrâ / Ki bilmez kendünün kadrini katâ; O gün ol gice idüp bana meyli / Tesellî itdi bu vech ile hayli; Didüm hikmet Hakundur ey kamer-veş / İnende urma ten şehrine âteş

24 *Ibid.*, 232:

 Benüm gibi o şehr içinde enhâr / Yürür boynın burup 'ışk ile her bâr

25 *Ibid.*, 232:

 Bize kıl hûblar vasfını takrîr / Marîzü'l-kalb olanlara şifâ vir; Cihânda var mıdur ol denlü mahbûb / Ola bir nüktedânun sözleri hûb; Güzeller sonbetinden vir

haberler / Ki zikru'l-ayş nısfu'l-ayş dirler; Zebân-ı kıssa-perdaz-ı maânî / Bu resme kıldı bu şîrîn beyânı; Ki cümle kâinât içinde aslâ / Bulınmaz Edrine şehrine hem-tâ; Erenler yiri arslanlar yatağı / Kadîmî şehr gâziler ocağı

26 *Ibid.*, 242:

Sınuk âyînedür bu kalb-i meyyâl / Göründi anda nice dürlü eşkâl

27 *Ibid.*, 233:

Kaçan kim irişe fasl-ı bahârî / Çiçeklerle tolar Tunca kenârı; Ne vaz eyler çemende bülbül-i zâr / Tevâzu birle dinler anı eşcâr; İbâdet üzredür cümle nebâtât / Zebân-ı hâl ile eyler münâcât; Kıyâm içre olup her serv ü arar / Benefşe hâlikına secde eyler; Çınâr el kaldurup eyler niyâzı / Nihâl-i gül kılur turmaz namâzı; Döküp zerrîn-kadehler jâleden yaş / Tefekkür birle salar aşağa baş; Sararup benzi Zünnûn gibi gûyâ / Sâlar su üzre nîlüfer musallâ; Yüri var cân gözini eyle bîdâr / Rükû u secde durur her ne kim var

28 *Ibid.*, 233–234:

Kılup Cuma namâzın halk-ı âlem / Giderler seyr-i mevla-haneye hem; Okuyup mesnevîsin mesnevi-hân / Takar gûşına halkun dürr-i meknûn; Sipihre benzer ol tâk-i muallâ / Sevabitdür ana ehl-i temâşâ; İçinde sâyiri seyyârelerdür / Hevâ-yı ışk ile âvârelerdür; Bunun n'idügüni bilüp müretteb / Dönerler gird-i bâd-ı ışk ile hep; Felekdür halka-i sohbet hemânâ / Meleklerdür dönen ashâb-ı takvâ; Avâmü'n-nâs içinde hâşlardur / İbadet bezmine rakkâşlardur; Bilür mest-i Elest olan bu râzı / Bu cevlâna dimez raks-ı mecâzî

29 *Ibid.*, 234–235:

Çü mevlâ-hâne seyri ola âhir / Giderler Tunca seyranına bir bir; Bu şehrin içi zînetlerle tolmış / Meric u Tunca yüzi suyı olmış; Suya girer nice mihr-i cihan-gîr / Görinür sanki mirât içre tasvîr; Siyeh fûteyle her mihr-i münevver / Hemân nısfı tutulmış aya benzer; Ne vuslatdur bu kim her zâr u giryân / İde uryan iken cânânı seyrân; Perîler cüft olup ider anı zeyn / Kırân eyler sanursın gökde sadeyn; Temâşa eylesen her mâh-peyker / Suya konmış gül-i ranâya benzer / Perî-sîmalar âb-ı dil-güşâda / Görinür sanki yıldızlar semâda; Ol ortalıkda niçe âşık-ı zâr / Yürürler Tunca üzre hâr u has-vâr; Yürür şu üzre uşşak-ı belâ-keş / Sanasın cem olur âb ile âteş; Merice irüp olmış Tunca cârî / Olupdur şan Alinün Zü'lfikârı

30 *Ibid.*, 235–236:

Kaçan kim erbaîn irişe ol dem / Döner sırça saraya cümle âlem; Güzeller bu zamanı hoş görürler / Derilüp Tunca üzre yüz ururlar; Bu demde gösterüp halka kerâmet / Yürür su üzre her ehl-i velâyet; Buz üzre her perî-ruhsâr dildâr / Uçup uçup gelür gökde melek-vâr; Oyunda gâh olurlar kim şaşarlar / Biribirinün üstine düşerler; Olurlar gül gibi handân u mesrûr / Görenler dir ana nûrun ala-nûr; Niçe âşık olan rind-i cihânâ / Ara yirde olur oyun bahâne; Güzergâha gelüp bî-kibr ü kîne / Olur dildâr ile sine-be-sîne; Kamu gamnâkler ol yirde mesrûr / Kamu güstâhlıklar anda mazûr; Görüp cennet didüm ol seygâhı / Ki anda kimsenün olmaz günâhı

31 *Ibid.*, 242:

Bu şehrün hûbına yokdur nihâyet / Gözüm gördügine itdüm şehâdet; Melekler vasfın itdüm eyleyüp cuş / Umarın cânib-i Hakka gelem hoş; Temâşâ eyle var bir bâgbâna / Çiçekler kim deger bir gülistana; Safâ ile bezensen ögsen anı / Sevinüp şâd olur cisminde cânı; Cihanda bir kişi girmez günâha / Ögerse kullarını pâdişaha

32 *Ibid.*, 236:

 Bu şehrün dilber-i ranâsı çokdur / Güzellikde kamunun misli yokdur; Kulag ur dinle bu cân sohbetini / Dilersen iki âlem lezzetini

33 *Ibid.*, 227:

 Gönül gözüyle rûy-ı yârı gözle / Bakup âyîne-i dîdârı gözle; Yüri zikr eyle nâm-ı Zü'lcelâli / Ki kevneyn oldı mirât-ı cemâli; Ruh-ı cânân virür dünyâya behcet / İder bu yüzden ol izhâr-ı kudret; Nedendür kalb-i Mecnûnda harâret / Nedendür çihre-i Leyîde hâlet

34 *Ibid.*, 228:

 Kamunun hâlıkı bi'z-zât sensin / Kamuya kâdîyü'l-hâcât sensin

35 *Ibid.*, 227:

 Çü ebrû-yı siyaha oldı mail / Tolar sevdâ ile âyine-i dil; Yakarsan nûr-ı Mevlâdan çerâgı / Olur her yer sana cennet turagı; Yakîn ehli taallukdan olur dûr / Vücûdı Kabesinden berk urur nûr; Bu esrâr-ı nihanı mâ hüve'l-hak / Hudâdan gayrı bilmez kimse mutlak

36 *Ibid.*, 229:

 Bu gönlüm her zamân bâtıllıg eyler / Namâza kalb olur câhıllıg eyler

37 *Ibid.*, 228:

 Tenüm bunda dil-i âvâre cânda / Gözüm mihrâbda aklum yabanda; Vücudum nefs-i dûnumdan zebûndur / Bana tesbîh zencîr-i cünûndur

38 Ismail E. Erünsal, "Abdurrahman el-Askeri's Mir'atü'l-Isk: A New Source for the Melâmî Movement in the Ottoman Empire during the 15th and 16th Centuries," in *Wiener Zeitschrift für die Kunde des Morgenlandes* 84. Band (Vienna, 1994), 95–115.

39 Mehmed Çavuşoğlu, ed. and trans., *Yahya Bey Divanı*, 244; 245; 250:

 "Elifdür birligine râst şâhid / Ki olur Pâdişah-ı Ferd ü Vâhid;" "Zihî zât-ı 'ulüvv-ü sân-ı a'zam / Anun bir kulıdır Fahr-i dü-'âlem;" "İki alemde bir ma'bûdsın sen / Eger Ahmed disem Mahmûdsın sen;" "Sehî-katmerler ile zeyn olupdur / Kenârı mecma'ü-l bahreyn olupdur"

40 *Ibid.*, 244:

 Derûn-ı dilden ol kim diye Allâh / Açar 'ilm-i beyân esrârına râh; Bu ism-i a'zamı kim kılsa tekrâr / Tuyar ilhâm-ı Rabbânîden esrâr; Tarîkat râhına olmaga hem-râh / Yiter insane zikr-i lafzatu'llâh

41 *Ibid.*, 245:

 Yaradur katradan bir sûret-i hûb / Kamer-fer 'ârızı gül-reng mahbûb; Nigârun kâkülin dâm-ı dil eyler / Belâ-yı 'ışkı gayet müşkil eyler; Olur kadr ile merdüm dürr-i meknun / Virür idrâk-ı pâk ü tab-ı mevzûn

42 *Ibid.*, 245:

 Nazar kıl cümle mevcûdâta her gâh / Olur gün gibi zâhir kudretu'llâh; Zihî Rezzâk-ı mahlûkat-ı 'âlem / Zihî Tevvâb-ı ma'şıyyat-ı âdem

43 *Ibid.*, 250:

 'Inayet eyle 'afvüni sened kıl / Gönül derdine lutfundan meded kıl; Çü sırrı-ı kudretündür dilde fikrüm / Güzeller adı olsa n'ola zikrüm; İki alemde bir

ma'bûdsın sen / Eger Ahmed disem Mahmûdsın sen; N'ola 'afvünle cânum gelse vecde / Namâzı bâtıl itmez sehv secde

44 *Ibid.*, 250:

Bi-hakk-ı Ahmed ü Mahmûd u Adem / Bi-hakk-ı Yeşrib ü Bathâ vü Zemzem; Bi-hakk-ı rif'at-i İdrîs ü 'Isâ / Bi-hakk-ı mâcerâ-yı Nûh u Mûsâ; Bi-hakk-ı ârzu-yı vuslat-ı yâr / Bi-hakk-ı iştiyâk-ı ruy-ı dildâr

45 Hugh Talat Halman, "'Where Two Seas Meet': The Quranic Story of Khidr and Moses in Sufi Commentaries as a Model for Spiritual Guidance," Unpublished PhD diss. (Duke University, Durham NC, 2000).

46 Mehmed Çavuşoğlu, ed. and trans., *Yahya Bey Divanı*, 250:

Sehî-kametlerile zeyn olupdur / Kenârı mecma'u'l-bahreyn olupdur

47 Agah S. Levend, *Şehr-engizler*, 95:

Ne şehr ol kim anun her beyti ma'mur / Kusurın bildi cennetden görüp hûr

48 *Ibid.*, 95:

Açılmış bahra anun nice bâbı / Kanad açmış sanasın murg-ı âbî; Ne hüsnile bir mahbûb-ı zîba / Gümüş halhâldur pâyinde derya; Vücudı hâtem-i mühr-i Süleyman/ Ana bir halka-i sîm oldı umman

49 *Ibid.*, 95:

İdenler sûr-ı memdûdını manzar / Didi simin kemerlu hûba benzer

50 *Ibid.*, 96:

Soyunup suya gireler sera-ser / Açılur gonca-lebler sim-tenler; Görürsün anları suda soyunmış; Sanasın taze güller suya konmış

51 Mehmed Çavuşoğlu, ed. and trans., *Yahya Bey Divanı*, 261:

Bostancı-zâde didükleri serv-i bâladur; Biri Bostancı-oglı serv-i dil-cû / Akar kaddine gönlüm nitekim su; Eger 'âşıkların buldukca her gâh / Yalınuz seyr ider gün gibi ol mâh; Bizümle birlige yitmez ne care / Gerekdür ektilige de sitâre

52 *Ibid.*, 265:

Bir gûyende dilber-i garrâdur; Biri Sâzende Ca'fer oldı nâmı / Müşerref kıldı sâzı her makâmı; Kaçan kim sâza dem-sâz ola bî-bâk / Olur çarh üzre Zöhre zehresi çâk; Makâm-ı gamda oldı kâmetüm çeng/ İdelden perde-i 'uşşâka âheng"

53 Mehmed Çavuşoğlu, ed. and trans., *Yahya Bey Divanı*, 265:

Biri bir hûb kâtib Hamza Bâlî / Ki olmaz hüsn-i hattınun misâli; Yazar 'ışk ehlinün hâlini her bâr / Kirâmen kâtibîn olmışdur ol yâr; N'ola alnında olsa hâl-i hindû / Yazılur evvel-i ser-nâmede hû

54 *Ibid.*, 272; 272; 273;

"Kitab-ı Çâr k'oldı çâr gevher / semâdan nâzil olmışdur mukarrer"; "Nitekim devr ide bu devr-i 'âlem / Bu defterden birisi olmasun kem"; "Okınmağa açılsa bu gülistân/ Sabâ-veş dahl iderse ana nâdân"

55 *Ibid.*, 250:

Göreler cân gibi her yirde makbûl / Ola 'âşıklarun eglencesi ol; Okındukca bu nazm-ı silk-i gevher / Sadef gibi kulak tutsun güzeller

56 Agah S. Levend, *Şehr-engizler*, 31–33; 97–101.

57 *Ibid.*, 97:

Ne şehr ol bir arûs-ı hûb-manzar / Serîr-i padişah-ı heft-kişver; Sevâdı Melce'-i kevneyn olupdur / Beyazı mecmau'l-bahreyn olupdur; Müdevver sûrile bu şehr-i şâhî / İhata eyleyüpdür cümle mâhi; Felek yahut perîler da'vetine / Çeküpdür dâyire levh-i zemine; Ya bir simin kemerlü dil-rûbadur / Ki halk-ı âlem ana mübtelâdur; Ya bir mahbûbdur bu şehr-i zîbâ / K'ayagına sürer yüzini derya / Ya sâk-ı arşa derya takdı halhâl / Ya mürg-i devlete bir sîm-gûn bâl; Yahud bir halkadur takdı zamâne / Arûs-ı gerden gûş-i cihana; Nazîri yok güzellikde bu şehrün / Giripdür gönline berrile baharun

58 *Ibid.*, 97–98:

Bu şehrün Ruh-ı kudsi gorse sûrın / Bulurdı Beyt-i ma'mûrun kusurın; Çü sûrını bu şehrün itdü seyran / Açup ağzın kapılar kaldı hayran; Zihî dergeh ki derya sâhilidür / Miyan-bendinde keştî keçkülidür; Alup etrafını sîmîn-bedenler / Bu şehre gice gündüz hidmet eyler; Temâşa eylesen her bûrc ü bâru / Açupdur cennetûn kasrına kapu

59 *Ibid.*, 98:

İrem bağı gibi her beyt-i mamur / Nesim-i hulki eyler halkı mesrur

60 *Ibid.*, 98:

Zihi devlet girüp her bir güneh-kâr / Bu cennet içre eyler seyr-i didâr

61 *Ibid.*, 98:

Naziri yok cihanda bidedeldür / İken nâzûk iken şehri güzeldür

62 *Ibid.*, 99:

Bahar oldıkça her serv ü sanavber / Lebi gonce gül-i nazük-bedenler

63 *Ibid.*, 99:

Çıkıp Eyyubiler seyran iderler / Varup âşıkların hayran iderler; Binince keştiye bir mâh-peyker / Kıran eyler hilâle mihr-i enver; *İderler naz ile geh seyr-i sahra* / Kılurlar gül gibi geh azm-i derya; Girürler gül gibi âb-ı revâna / Olup can câna vü gönlek yabâna; Talup deryaya her yana yüzerler; Deniz malikleri olmış güzeller; Nazar kılsan suda her mâh-tâba / Güneşdür gûyya girmiş sehâba

64 *Ibid.*, 100–101:

Sadefdür işbu şehr-i hûb-manzar / Dür ü gevher içinde güzeller; Velî sarrâf-ı uşşâk-ı zamâne / Getürmiş bir kaçın silk-i beyâna; Ki ta'rîfinde kasır akl-ı insan / Nazîrin görmemiş sarrâf-ı devran; Maâni dürlerile bu mazâhir / Olupdur gûyya silk-i cevâhir; Güherler nesr idüp sarrâfı dehrün/ Getürmüş nazma bir bir işbu şehrün; Perî-peyker melek-manzarlarında / Sehî-kâd lâle-had dilberlerinde; Ki her birisi anun hırz-ı candor / Dilümde rûz u şeb vird-i zebandu

65 E.J.W. Gibb, *Osmanlı Şiir Tarihi*, vol. 2, 92–102.

66 Agah S. Levend, *Şehr-engizler,* 103:

Ne acebdür ki bâğ-ı cennet vâr / Ol makamun sekiz kapusı var; Gül-şen-i cennet oldı ol gûyâ / Servilerdür yeşil direkler ana; Anda kındîller yanar par par / Sarı laleyle nergise benzer; Mü'minün başı üzre destârı / Ak gülile bezer o gül-zârı

67 *Ibid.*, 105:

Hûbdur çeşmelerle mabeyni / Çeşmeler oldı kevserün aynı; Oldı bu şehr sank bağ-ı cihan / Vardürir anda nice bin gılman

68 *Ibid.*, 40–41.

69 *Ibid.*, 105:

Göreydi âdem ol zîbâ makamı / Unudurdı dilâ Daru's-selâmı; Anun her câmi'i bir Ka'be-i nur / Saray-ı şah olupdur Beyt-i ma'mur; Olup âşüfte her bir çeşme-sârı / Gözinden yaş döker gördükçe yârı; İder halk-ı cihan dayim ziyaret / Olupdur san bu şeh-rah-ı velâyet; Girer suya güzeller anda gâhî / Düşer bahra sanasın aks-ı mâhî

70 *Ibid.*, 106:

O gün çün göz açup dünyaya geldüm / Beni ben bir ulu şehr içinde buldum; degül şems ü kamerle merkez-i hâk / İki gözile bakdı hake eflâk; Acep şehr-I lâtif ğ nakş ü zînet / O denlu halk cem' olmak vilâyet; Şimali mecma'u'l-bahreyn-i ra'nâ / Yedi tâğ-ı musavver hûb u zîbâ

71 *Ibid.*, 107:

İderse anda beğlikile âlem / Dahi uçmak hevâsın itmez âdem

72 *Ibid.*, 109:

Heman bir bahçedir ol şehr-i mahsun / Sokaklar oldı anda tarh-ı mevzun; Leb-i derya vü servistan-ı zibâ / Budur firdevs ger varise hemtâ

73 *Ibid.*, 109:

Leb-i derya vü servistan-ı zibâ / Budur firdevs ger varise hemtâ

74 *Ibid.*, 112:

Temamet eyledim bu şehri seyran / Bütün dünyayı san geştitdüm ol an; Ne denlû var ise makbul ü ra'na / Varup karşusına kıldım temaşa

75 *Ibid.*, 43.

76 *Ibid.*, 44:

İlahi her kelâmum bir kitab it / Bana ışk aleminden feth-i bâb it; İdüp dil nehreini deryâ-yı umman / Gönül yazusın it sahrâ-yı ırfan

77 *Ibid.*, 125:

Biri divane Meryemdür zenânun / Saçı zencirine bendoldum anun

78 *Ibid.*, 126:

Birinün namı Cennet la'lii kevser / Huda itsinanı bana müyesser

79 *Ibid.*, 127:

Birisi mumcu kızı Fatimane / Kül oldum ışkı ile yana yana

80 Mahmut Kaplan, ed., *Neşati Divanı* (Izmir: Akademi, 1996).

81 Agah S. Levend, *Şehr-engizler*, 58–59.

82 *Ibid.*, 59.

83 *Ibid.*, 99:

İderler naz ile geh seyr-i sahra / Kılurlar gül gibi geh azm-i derya

84 *Ibid.*, 96:

 Binüp keştiye dahi nice dilber / Kalatada ayak seyranın eyler

85 *Ibid.*, 26:

 Haber aldum ki Şahenşah-i devran / Gelürmiş Bursa şehrin ide seyran; Salup zıll-i saadet-güsterini / Temaşa itmel içün her yirini

86 Walter Feldman, "Mysticism, Didacticism and Authority in the Liturgical Poetry of the Halvetī Dervishes of Istanbul," *Edebiyât* n.s. 4.2 (1993), 243–265.

87 Miriam Cooke, "Introduction: Journeys Real and Imaginary." *Edebiyât* n.s. 4.2 (1993): 151–154; Julie Scott Meisami, "The Theme of the Journey in Nizami's Haft Paykar," *Edebiyât* n.s. 4.2 (1993), 155–172.

88 Ismail E. Erünsal, "Abdurrahman el-Askeri's Mir'atü'l-Isk: A New Source for the Melâmî Movement in the Ottoman Empire During the 15th and 16th Centuries," *Wiener Zeitschrift für die Kunde des Morgenlandes* 84 (Vienna: 1994), 100.

89 Sam I. Gallens, "The Search for Knowledge in Medieval Muslim Societies: A Comparative Approach," in *Muslim Travellers*, ed. D.F. Eickelman and J. Piscatori (NY; London: Routledge, 1995, c. 1990), 51.

90 *Ibid.*, 5.

91 Julie Scott Meisami, "The Theme of the Journey in Nizami's Haft Paykar," 164.

92 William C. Chittick, *The Self-Disclosure of God*, 68.

93 Keith Critclow, *Islamic Patterns: An Analytical and Cosmological Approach* (New York: Schocken Books, 1976), 150–171; Ahmet Karamustafa, "Cosmographical Diagrams," in *The History of Cartography Vol. 2 Book 1 Cartography in the Traditional Islamic and South Asian Societies*, eds. J.B. Harley and David Woodward (Chicago; London: University of Chicago Press, 1992), 71–89.

94 Agah S. Levend, *Şehr-engizler*, 95:

 Açılmış bahra anun nice bâbı / Kanad açmış sanasın murg-ı âbî; Ne hüsnile bir mahbûb-ı zîba / Gümüş halhâldur pâyinde derya; Vücudı hâtem-i mühr-i Süleyman/ Ana bir halka-i sîm oldı umman

95 *Ibid.*, 95:

 İdenler sûr-ı memdûdını manzar/ Didi simin kemerlu hûba benzer

96 *Ibid.*, 97:

 Sevâdı Melce'-i kevneyn olupdur / Beyazı mecmau'l-bahreyn olupdur; Müdevver sûrile bu şehr-i şâhî / İhata eyleyüpdür cümle mâhı

97 Metin And, *A Pictorial History of Turkish Dancing from Folk Dancing to Whirling Dervishes, Belly Dancing to Ballet* (Ankara: Dost Yayınları, 1976), 32–36.

98 Metin And, "Mevlana Celaleddin Rumi," in *Mevlana Celaleddin Rumi and the Whirling Dervishes*, ed. Talat Halman and Metin And (Istanbul: Dost Publication, 1983), 49–50.

99 Abdülbaki Gölpınarlı, *Mevlânâ'dan Sonra Mevlevîlik*, 2nd ed. (Istanbul: Inkılâp ve Aka Kitabevleri, 1983), 380–381.

100 Metin And, "Mevlana Celaleddin Rumi," 68.

101 *Ibid.*, 69–70.

102 Abdülbaki Gölpınarlı, *Mevlânâ'dan Sonra Mevlevîlik*, 385.

103 Metin And, "Mevlana Celaleddin Rumi," 70–71.

104 William C. Chittick, *The Self-Disclosure of God*, 224.

105 *Ibid.*, 230–231.

106 William C. Chittick, *The Sufi Path of Knowledge*, 25.

107 William C. Chittick, *The Self-Disclosure of God*, 229.

108 Nader Ardalan and Laleh Bakhtiar, *The Sense of Unity: The Sufi Tradition in Persian Architecture* (Chicago; London: The University of Chicago Press, 1973), 11.

109 Agah Sırrı Levend, *Şehr-engizler*.

110 İskender Pala, "Şehrengiz," in *Dünden Bugüne İstanbul Ansiklopedisi*, 1994, vol. 7, 150–151; İskender Pala, *Ansiklopedik Divan Şiiri Sözlüğü* (Ankara: Kültür Bakanlığı Yayınları, 1989); Baki Asıltürk, *Osmanlı Seyyahlarının Gözüyle Avrupa* (Istanbul: Kaknüs Yayınları, 2000).

111 Derin Terzioğlu, "The Imperial Circumcision Festival of 1582: An Interpretation," in *Muqarnas* 12 (1995), 84–100; Walter Andrews, "Literary Art and the Golden Age: The Age of Süleyman," in *Süleyman the Second and His Time*, ed. by Halil İnalcık and Cemal Kafadar (Istanbul: Isis, 1993), 353–368.

112 Mesîhî's *Şehrengiz* is called "Şehrengiz Der Medh-i Cuvanan-ı Edirne" written in 1512, during the last year of Beyazıd II's (1481–1512) reign. According to Levend, Mesîhî had followed the Sultan's campaign from Istanbul to Edirne for the sake of looking for a patronage to sustain his life after the loss of his former patron Hadım Ali Pasha; Levend, *Şehr-engizler*, 16–18.

113 Mine Mengi, *Mesîhî Divanı* (Ankara: Atatürk Kültür Merkezi Yayınları, 1995).

114 "Shahrangîz, or Shahrâshûb," *The Encylopedia of Islam New Edition*, vol. 9 (Leiden: E.J. Brill, 1995), 212–214; G. Scarcia "Lo `Sehrengiz-i maglup` di Mirza Shafi'," in *Studia Turcologica Memoriae Alexii Bombaci dicata*, eds. A. Gallotta and U. Marazzi, I.U.O., Seminario di Studi Asiatici: Series Minor, XIX (Naples: Istituto Universitario Orientale, 1982), 481–485.

115 Klaus Riehle, *Leben und Literarische Werke Mesîhîs = Mesîhî'nin hayati ve edebi eserleri* (Prizren: BAL-TAM, 2001), 268.

116 Levend acknowledges that Mesîhî, as a poet, had been depicted more than 15 times in Ottoman literary anthologies and in historical chronicles by Sehi, Latifi, Aşık Çelebi, Beyani, Niyazi, Katip Çelebi and others; Levend, *Şehr-engizler*, 18.

117 E.J.W. Gibb, *Osmanlı Şiiri Tarihi*, vol. I, 448.

118 Agah S. Levend, *Şehr-engizler*, 13.

119 E.J.W. Gibb, *Osmanlı Şiir Tarihi*, vol. I, 450–451.

120 Agah S. Levend, *Şehr-engizler*, 17–18.

121 Victoria Rowe Holbrook, *The Unreadable Shores of Love: Turkish Modernity and Mystic Romance* (Austin, TX: University of Texas Press, 1994).

122 *Ibid.*

123 Agah S. Levend, *Şehr-engizler*, 59–64.

124 Abdülbaki Gölpınarlı, ed., *Şeyh Galip: Hüsn ü Aşk* (Istanbul: Altın Kitaplar, 1968).

125 Victoria Rowe Holbrook, *The Unreadable Shores of Love*, 49.

126 *Ibid.*, 40–44.

127 Annemarie Schimmel, *Mystical Dimensions of Islam*, 288.

128 Ismail E. Erünsal, *The Life and Works of Tâcî-zâde Ca'fer Çelebi, with a Critical Edition of his Divan* (Istanbul: Istanbul University, 1983), LVII.

129 Ahmet Şentürk, *Osmanlı Şiiri Antolojisi* (Istanbul: YKY, 1999), 121–122.

130 Ismail E. Erünsal, *The Life and Works of Tâcî-zâde Ca'fer Çelebi*, XLVIII.

131 Agah S. Levend, *Şehr-engizler*, 68–71:

Hevâsı dil-guşâ vü ruh-perver / Suyı mâverd ü hâki misk ü anber; Güzel yerler dil-âra buk'alardur / Kamu cennet misâli ravzalardur; İder rûchânını firdevs teslim / Sığar bir gûşesine yidi iklîm; İçi kat kat binadur gonce asa / Miyân-ı lâle denlu yok tehî câ

132 *Ibid.*, 68–69.

133 *Ibid.*, 71–73:

Kemîne kubbesi çarh-ı muallâ / Kemine ravzası firdevs-i a'lâ; Miyân-ı havz ü çeşme ayn-ı kevser / Bihişt-i heştden bir bâb her der

134 *Ibid.*, 92–94:

Spacious terrain surrounded by mountains / Trees and orchards and rose gardens; Trees offering shadow / Their trunks hand in hand; Cypresses holding hands with box / The wind blows over them watching; Festivals, performances and entertainments / Enjoy their whole life with pleasure; Day and night pleading to the Lord / That nothing should damage this orchard; In the middle a river is running / Its infinite perimeter furnished with grass; Meadows flourished with roses and tulips / Roses are fireballs; tulips sparkle; Blossoms laugh upon seeing / The passion between the rose and the river; You are seen once in a year says the space / Washes the rose's feet with cool waters; Water and the willow makes life pleasing / Sincerely devoted to the river with his soul; Whether strong or mild / Yavuz would not like the wind blowing; That's why even when there is a gentle breeze / Willows tremble upon the river running; Birds waking up sing in harmony with the wind blowing / All over their bloodshed flowing; As our eyes have seen this location / We have forgotten the Garden of Paradise; Presenting our gratitude to our Lord / That he has carried us to another spring.

Geniş sahrası çevre yanı kuhsar / Dırahistan ü sebzistan ü gülzar / Dıraht-ı sâye-perverler irişmiş / Budaklar biribirini el verişmiş / Dutarlar el ele servile şimşad / Seyirdüp kalkar üstünden geçer bâd / İdüben dahi nice lub ü bâzî/ Sürerler zevkile ömr-i dirazî / Ki rûz u şeb niyaz idüp İlaha / Gezend irişmeye bu sebze-gaha / Aralık yerde bir ırmak revâne / Çemenlerdür kenar-ı bîgerane / Çemen pür lâle vü güldür serâ-ser / Gül âteş-pâredür her lâle ahker / Gülişir gonceler idüp nezâre / Gülile macerâ-yi cûy-bâra / Ki yılda bir görinürsüz diyü cû / Döker verdün ayağına soğuk su / Suyile bîd idüp hoş zindegânî / Sever cânı gibi âb-ı revânı / Anun üstünden er irü eğer kiç / Yavuz sel esdüğini istemez hiç / Anunçündür ki bâd oldukça cünban / Olur ab üstine her bid lerzan / Dirülüp kuşlar ider ana ahenk / Gider zârileri ferseng ferseng / Çü gördi gözlerimiz ol

makamı / Unutduk ravza-i Darü's-selâmı / Biraz şükreyleyüp Perverdigâra / Ki irgürdi bizi yine Bahara.

135 E.J.W. Gibb, *Osmanlı Şiir Tarihi*, vol. I, 476.

136 Ismail E. Erünsal, *The Life and Works of Tâcî-zâde Ca'fer Çelebi*, LIX.

137 Agah S. Levend, *Şehr-engizler*, 95: "Sehî-kametlerile zeyn olupdur."

138 *Ibid.*, 95: "Kenârı mecma'u'l-bahreyn olupdur."

139 Ahmet Atilla Şentürk, *Osmanlı Şiiri Antolojisi*, 633–636.

140 Victoria Rowe Holbrook, *The Unreadable Shores of Love*, 131.

141 Eşref bin Muhammed, *Hazâ'inü's-Saâ'dât* (1460), ed. Bedi N. Şehsuvaroğlu (Ankara, Türk Tarih Kurumu, 1961), 1–4 (1b–4b); 7–8 (6a–6b):

amma adem vücudunun sağlığı, sayruluğu dört nesnesindedir. Ol dört nesnesi sağ olan tamam sağdır. Birisi sayru olan dürlü sayrudur. İkisi sayru olan iki dürlü nesnesi sayrudur. Dördü bile sayru olan tamam sayrudur. Evvel bedendir kim ol dört asıldan olmuştur. İkinci Candır kim ol beden sohbetinden ol dahi sayru olur. Üçüncüsü akıldır kim bu alemin sohbetinden ol dahş sayru olur. Dördüncüsü gönüldür kim gerekmez nesneleri adet edenleri görmekten ol dahi hasta olur, neuzibillahil azim. Bu dördünün her biri birmani sebebile sağlığını saklamayı başaramaz (ise) sayru olur. Bu avam (halk) arasında meşhur olub şöhret tutan beden hastalığıdır. Kimin bedeni hast aolub yatarsa filan hastadır derler, bedeni hastadır demezler. Anıniçün kim bilmezler, can hastalığı nedir? Bilmezler, akıl hastalığı nedir? Bilmezler, gönül hastalığı nedir? Hemen hastalık ol beden hastalığı sanurlar. Ana ilâç etmekiçün tıb ilmidir kim anda bunca kitablar düzmüşlerdir. Tıbbı ebdan oldur. Ama can ilacı için ahlâktır. Zira can hastalığı oldur kim hulklar yaramaz ola. Bir adamın kim hulkları yaramazdır, canı hastadır. Zira huşk can sıfatlarındandır. Pes ilmi ahlâk can hastalığına ilâç etmekçündür. Ama akıl ilâciçün ilmi tedbir, ilmi siyasettir. Akıl hastalığı tedbiri, fikri savab düşmemektir kim ehli menziliyle ya cemi' halkla dirlik nice gerek başarmıya; ol kişinin akılı hasta olmuş olur. İlmi tedbür ve ilmi siyaset anın ilâcıçündür. Amma gönül ilâciçün tefsir, hadis usulü din, ilmi fıkıhtır. Zira gönül hastalığı nifak, şekdir; Kimde itikat olmıya şek ve güman olur kim ol nifaktır. Yakîn gerektir.

Bil imdi kim her ademin bedeni temam olunca kim can gelip diri olmaya layik ola, dört mertebede dört keyfiyet bulsa gerek. Evvel mertebede Erkândır kim, ana Ecza-yı evvelî derler. Hak taalâ celle celâlühu kemali kudretinden evvel ol erkânı yarattı; Ol dörttür: Biri od (ateş), biri hava, biri su, biri yerdir, biri toprak. Bunlara eczayı evvelî derler, Şol sebebden kim bedenün terkibi anlardandır. Erkân derler, şol sebebden kim asıl beden de anlardır. Od har, yabıstır, yani ıssıdır, kurudur. Hava har ratibtir, yani ıssıdır, yaşdır. Su barid ratibtir, yani soğuktur, yaştır. Toprak barid, yabistir, yani soğuktur, kurudur. Hak taala kemali hikmetile bu dört muhtelif eczayı biribirine karıştırdı ... İkinci mertebe Mizacdır kim ana Tabiati saniye derler. Mizac demek yuğrulmak manasınadır. Tabiat ile mizac bir mayadır. Amma tabiat evvelidir. Ol mananın mizac tamamıdır.

142 Agah S. Levend, *Şehr-engizler*, 16:

Kaynaklar Mesîhî'yi 'rind, laubali-meşreb' bir şair olarak kaydederler. Aşık Çl.'den aldığımız şu satırlar onun bu halini çok iyi anlatmaktadır: 'Hiç bir zamanda Paşa nesne yazmağıçün Mesîhî için şol şehir oğlanını bulun dimezdi ki hazır buluna veya hidmeti için muntazır oluna. Elbette kapıcılar ya Tahte'l-

kal'a'da ya deyr-i muganda ya mahbublarla guşe-i gülistanda bulurlardı. Ol sebepden Paşa dil-gir olurdu. Uslana diyü terbiyet ve terakkisi their olur.

143 Klaus Riehle, *Leben und Literarische Werke Mesîhîs*, 260–261.

144 *Ibid.*, 260–261; translated from Turkish.

145 E.J.W. Gibb, *Osmanlı Şiir Tarihi*, vol. I, 448.

146 Originally born in a small town in Albania, he migrated to Istanbul at a young age and won a reputation in calligraphy. Due to his talent in the arts of writing and poetry, Mesîhî gained the patronage of Vizier Ali Paşa and was appointed as the divan-secretary. Vizier Ali Pasha supported Mesîhî. After Ali Pasha's death in 1511, Mesîhî searched for the patronage of other royalties like Câfer Çelebi. However, he never had the prosperity of the former days he spent under the patronship of Ali Pasha and died in poverty one year after his patron; E.J.W. Gibb, *Osmanlı Şiir Tarihi*, vol. I, 445–446.

147 Ismail E. Erünsal, *The Life and Works of Tâcî-zâde Ca'fer Çelebi*.

148 Ahmet Atilla Şentürk, *Osmanlı Şiiri Antolojisi*, 223.

149 *Ibid.*, 231–232.

150 E.J.W. Gibb, *Osmanlı Şiir Tarihi*, vol. II, 41–43.

151 *Ibid.*, 45–52.

152 Ahmet Atilla Şentürk, *Osmanlı Şiiri Antolojisi*, 235.

153 Nurhan Atasoy, *1582 Surname-i Hümayun: An Imperial Celebration* (Istanbul: Koçbank Publications, 1997).

154 Halil İnalcık, *Osmanlı İmparatorluğu Klasik Çağ 1300–1600*, trans. Ruşen Sezer (Istanbul: YKY, 2003, c. 1973), 156–169.

155 Mehmed Çavuşoğlu, ed. and trans., *Yahya Bey Divanı*, 243.

156 Abdülbaki Gölpınarlı, *Melâmîlik ve Melâmîler*, 215.

157 Cevdet Türkay, *Osmanlı Türklerinde Coğrafya* (Istanbul: Milli Eğitim Bakanlığı, 1999); A. Adnan Adıvar, *Osmanlı Türklerinde İlim* (Istanbul: Remzi Kitabevi. 2000, c. 1943); Cevat İzgi, *Osmanlı Medreselerinde İlim*, vol. I–II (Istanbul: İz Yayıncılık, 1997); Ahmet Karamustafa, "Introduction to Ottoman Cartography," in *The History of Cartography Vol. 2 Book 1 Cartography in the Traditional Islamic and South Asian Societies*, eds. J.B. Harley and David Woodward (Chicago; London: University of Chicago Press, 1992), 206–208.

158 Çiğdem Kafescioğlu, "The Ottoman Capital in the Making: The Reconstruction of Constantinople in the Fifteenth Century," 213–214; Ahmet Karamustafa, "Military, Administrative, and Scholarly Maps and Plans," in *The History of Cartography Vol. 2 Book 1 Cartography in the Traditional Islamic and South Asian Societies*, eds. J.B. Harley and David Woodward (Chicago; London: University of Chicago Press, 1992), 209–210.

159 *Ibid.*, 219–224

160 *Ibid.*, 224.

161 *Ibid.*, 240–258.

162 *Ibid.*, 224–239. Kafescioğlu argues that later versions of the Vavassore map present the city as a prosperous "Ottoman House;" "Civitates Urbis Terranum"

by Braun and Hogenberg dated 1572 which illustrated the city under the title of "Byzantium now Constantinople," and later maps by Dilich and Lorichs.

163 İffet Orbay, "Istanbul Viewed: The Representation of the City in Ottoman Maps of the Sixteenth and Seventeenth Centuries," Unpublished PhD diss. (Cambridge, MA, MIT, 2001), 29–72.

164 J.M. Rogers, "Itineraries and Town Views in Ottoman Histories" in *The History of Cartography Vol. 2 Book 1 Cartography in the Traditional Islamic and South Asian Societies*, eds. J.B. Harley and David Woodward (Chicago; London: University of Chicago Press, 1992), 248–251; Orbay, "Istanbul Viewed," 73–116.

165 Orbay, "Istanbul Viewed," 117–298.

166 Ahmet Atilla Şentürk, *Osmanlı Şiiri Antolojisi*, 138:

Zihi cennet ki girer her güneh-kâr / Görür 'âsi vu 'âbid anda didâr

167 Mehmed Çavuşoğlu, ed. and trans., *Yahya Bey Divanı*, 236:

Bu şehrün dilber-i ranâsı çokdur / Güzellikde kamunun misli yokdur; Kulag ur dinle bu cân sohbetini / Dilersen iki âlem lezzetini

168 Agah S. Levend, *Şehr-engizler*, 95:

Sehî-kametlerile zeyn olupdur / Kenârı mecma'u'l-bahreyn olupdur

169 *Ibid.*, 97:

Sevâdı Melce'-i kevneyn olupdur / Beyazı mecmau'l-bahreyn olupdur

170 Derin Terzioğlu, "Sufi and Dissent in the Ottoman Empire: Niyazi-i Misri (1618–1694)," PhD diss. (Harvard University, Cambridge, MA, 1999), 270.

171 Annemarie Schimmel, "The Water of Life," in *Environmental Design* 2 (1985), 6–9.

172 Mehmed Zıllîoğlu Evliya Çelebi, *Evliyâ Çelebi Seyâhatnâmesi*, vol. 5, trans. Zuhuri Danışman (Istanbul: Çetin Basımevi, 1971), 304.

173 Emma Clark, *Underneath Which Rivers Flow: The Symbolism of the Islamic Garden* (London: The Prince of Wales Institute of Architecture, 1996); John Brookes, *Gardens of Paradise: The History and Design of the Great Islamic Gardens* (London: George Weidenfeld and Nicolson Ltd, 1987); Annemarie Schmimmel, "The Celestial Garden in Islam," in *The Islamic Garden*, eds. Elisabeth B. MacDougall and Richard Ettinghausen (Washington, DC: Dumbarton Oaks Publications, 1976), 11–40; Mehdi Khansari, *The Persian Garden Echoes of Paradise* (Washington, DC: Mage Publishers, 1998).

174 Mehdi Khansari, M.R. Moghtader and Minouch Yavari, *The Persian Garden: Echoes of Paradise* (Washington DC: Mage Publishers, 1998), 34–35.

175 Avinoam Shalem, "Fountains of Light: The Meaning of Medieval Islamic Rock Crystal Lamps," *Muqarnas* 11 (1994), 1–11; 5–6

176 Mehmed Çavuşoğlu, ed. and trans., *Yahya Bey Divanı*, 245; the first and the last verses from the fragment below:

Yaradur katradan bir sûret-i hûb / Kamer-fer 'ârızı gül-reng mahbûb; Nigârun kâkülin dâm-ı dil eyler / Belâ-yı 'ışkı gayet müşkil eyler; Olur kadr ile merdüm dürr-i meknun / Virür idrâk-ı pâk ü tab-ı mevzûn

177 Ahmet Atilla Şentürk, *Osmanlı Şiiri Antolojisi*, 138:

"'Aceb şehr ol ki anuñ bâg u râgu /Virür kişiye cennet ferâgı; İçinde suları mevzun u reftâr / Bulutlar başı ucunda hevâdâr; Temâşâ eyleseñ her bir minaret / Dönüpdür serv-kâmet bir nigâra; Soyunup Tuncaya girer güzeller/ Açılur ak güğüsler ince beller; ... Gören bu şehri bu resme kıyâmet / Sanur bunuñla tokuz oldı cennet; Zihi cennet ki girer her güneh-kâr / Görür 'âsi vu 'âbid anda didâr

178 Agah S. Levend, *Şehr-engizler*, 98:

İrem bağı gibi her beyt-i mamur / Nesim-i hulki eyler halkı mesrur

179 *Ibid.*, 98:

Zihi devlet girüp her bir güneh-kâr / Bu cennet içre eyler seyr-i didâr

180 *Ibid.*, 98.

Naziri yok cihanda bidedeldür / İken nâzûk iken şehri güzeldür

181 *Ibid.*, 105.

Göreydi âdem ol zîbâ makamı / Unudurdı dilâ Daru's-selâmı; Anun her câmi'i bir Ka'be-i nur / Saray-ı şah olupdur Beyt-i ma'mur; Olup âşüfte her bir çeşme-sârı / Gözinden yaş döker gördükçe yârı; İder halk-ı cihan dayim ziyaret / Olupdur san bu şeh-rah-ı velâyet; Girer suya güzeller anda gâhî / Düşer bahra sanasın aks-ı mâhî

182 *The Turks in MDXXXIII, A Series of Drawings made in that Year at Constantinople by Peter Coeck of Aelst (1502–1550)*, ed. Sir William S.M. Bart (London; Edinburgh: MDCCCLXXIII), 32; quoted from *Cose de Turchi* (Venice 1539).

183 *The Turks in MDXXXIII, A Series of Drawings made in that Year at Constantinople by Peter Coeck of Aelst (1502–1550)*, ed. Sir William S.M. Bart (London; Edinburgh: MDCCCLXXIII), 35; quoted from George Braun et Fr. Hogenberg, *Civitates Orbis Terrarum*, vol. 1 (1576–1621), 51.

184 *The Turks in MDXXXIII, A Series of Drawings made in that Year at Constantinople by Peter Coeck of Aelst (1502–1550)*, ed. Sir William S.M. Bart (London; Edinburgh: MDCCCLXXIII), 35–36; quoted from *The Voyage of Master Henry Austell 1586 in Hakluyt's Navigations* (London: 1599–1601), vol. 2, 196.

185 *The Turks in MDXXXIII, A Series of Drawings made in that Year at Constantinople by Peter Coeck of Aelst (1502–1550)*, ed. Sir William S.M. Bart (London; Edinburgh: MDCCCLXXIII), 37; quoted from George Sandys, *Sandys travels: containing an history of the original and present state of the Turkish Empire, their laws, government, policy, military force, courts of justice, and commerce, the Mahometan religion and ceremonies, a description of Constantinople, the Grand Signior's seraglio, and his manner of living. A Relation of a Journey begun An Dom: 1610 Fovre Books the sixt edition London: Printed for Philip Chetwin, 1610,* 7th ed. London: Printed for John Williams Junior, 1673, 30–31.

186 *The Turks in MDXXXIII, A Series of Drawings made in that Year at Constantinople by Peter Coeck of Aelst (1502–1550)*, ed. Sir William S.M. Bart (London; Edinburgh: MDCCCLXXIII), 38–39; quoted from G. Joseph Grelot, *Relation nouvelle d'un voyage de Constantinople* (Paris: 1680), 68–71.

187 Stefanos Yerasimos, *Türk Metinlerinde Konstantiniye ve Ayasofya Efsaneleri*, trans. Şirin Tekeli (Istanbul: İletişim Yayıncılık, 1993, c. 1990).

188 Yerasimos associates the content of the chronicles composed by these two *Melâmî-Bayrami* authors; *Risale-i Muhammediye* by Yazıcıoğlu Mehmed, and

Envar ül-aşikin (dated 1451, the life of the prophet) and *Dürr-i meknun* (dated c.1453, classified as a book of geography) by Yazıcıoğlu Bican Ahmed.

189 Stefanos Yerasimos, *Türk Metinlerinde Konstantiniye*, 61–62.

190 *Ibid.*, 117.

191 *Ibid.*, 70.

192 *Ibid.*, 207; 220–221.

193 *Ibid.*, 13–49.

194 *Ibid.*, 86–87.

195 *Ibid.*, 105–106.

196 *Ibid.*, 118–129.

197 *Ibid.*, 252–253.

198 *Ibid.*, 239–246.

199 *Ibid.*, 223–224.

200 *Ibid.*, 222.

201 *Ibid.*, 222–223.

202 Abdülbaki Gölpınarlı, *Melâmîlik ve Melâmîler*, 46; Ahmet Yaşar Ocak, *Osmanlı Toplumunda Zındıklar ve Mülhidler 15.–17. Yüzyıllar* (Istanbul: Tarih Vakfı, 1998), 254.

203 Ahmet Yaşar Ocak, *Osmanlı Toplumunda Zındıklar ve Mülhidler*, 261.

204 *Ibid.*, 290–304.

205 1537 maps depict territorial gains of the Ottoman ruling class who appropriated the Shi'i cities of Baghdad, Najaf, Karbala, and Hilla; Rogers, "Itineraries and Town Views in Ottoman Histories," 228–255.

206 İffet Orbay, "Istanbul Viewed," 29–72.

207 Cyril Mango, "The Urbanism of Byzantium Constantinople," *Rassegna* 72 (1997), 19; Stefanos Yerasimos, "Ottoman Istanbul," *Rassegna* 72 (1997), 24–36.

208 Albert H. Lybyer, *The Government of the Ottoman Empire in the Time of Suleiman the Magnificent* (Cambridge, MA: Harvard University Press, 1913), 239–261; from Benedetto Ramberti, *Libri Tre delle Cose de Turchi* (Venice: 1543), 131–146.

209 Mehmed Zıllîoğlu Evliya Çelebi, *Evliyâ Çelebi Seyâhatnâmesi*, vol. 2, 146–147.

210 *Ibid.*, 148–150.

211 Mehmed Zıllîoğlu Evliya Çelebi, *Evliyâ Çelebi Seyâhatnâmesi*, vol. 2, 144–147.

212 Busbecq, Ogier Ghislain de, 1522–1592. Epistolae quatuor. *The Turkish Letters of Ogier de Busbecq Imperial Ambassador at Constantinople 1554–1562*, trans. from the Latin Elzevier edition of 1633 by Edward Seymour Forster (Oxford, UK: Clarendon Press, 1968, c. 1927), 25–26.

213 *Ibid.*, 43.

214 *Ibid.*, 39–40.

215 Mehmed Zıllîoğlu Evliya Çelebi, *Evliyâ Çelebi Seyâhatnâmesi*, vol. II, 81.

216 *Ibid.*, 82.

217 *Ibid.*, 90–91.

218 *Ibid.*, 99–100.

219 George Sandys, *Sandys travels: containing an history of the original and present state of the Turkish Empire*, 29.

220 *Ibid.*, 108–109.

221 Mehmed Zıllîoğlu Evliya Çelebi, *Evliyâ Çelebi Seyâhatnâmesi*, vol. 2, 92–93.

222 Ogier Ghislain de Busbecq, *The Turkish Letters of Ogier de Busbecq*, 9–10.

223 Doğan Kuban, *Istanbul: An Urban History* (Istanbul: Türk Tarih Kurumu, 1996), 225–226.

Nedîm's Poetry and New Rituals of the Tulip Period (1718–1730): The Construction of Gardens at Kağıthane Commons

The Tulip Period spans a short-lived era of 12 years from 1718 to 1730. It spans Damad Ibrahim Pasha's entire appointment as the Grand Vizier during the final phase of Ahmed III's reign (1703–1730). During the Tulip Period, refinement of the capital city and refurbishment of urban life became a state policy in the Ottoman court. The Ottomans produced new spatial and social models, and metaphors for describing earthly happiness moved away from traditional comparisons with the promised paradise garden. A new model was built upon the bricolage of elements borrowed from the arts, architecture and gardens of European and Persian cultures outside Ottoman territory. This innovative modeling brought about a prosperous urban culture. It lasted for a short period of 12 years, allowing the pleasures of daily life to be celebrated by festivities in the streets and gardens of the city of Istanbul. It was named the Tulip Period because of the love of and craze for tulips that developed then.

Elite circles were introduced to a new awareness of the pleasures of conversation in joyful courts held in gardens dispersed all over the city. These courts reveled mainly in poetry and history accompanied by festive meals, songs and dancers. However, other sections of society grew discontented with this new way of living with its excessive indulgence in consumption, and became concerned about the emerging appreciation of profane pleasures that entered into conflict with Orthodox customs. The turmoil these groups stirred within Istanbul society culminated in the Patrona Halil Revolt, which lasted for 40 days and put an end to the Tulip Period in 1730.

By the beginning of the eighteenth century, Ottoman history again experienced the enduring rivalry between Edirne and Istanbul, when the citizens of the capital reacted against Sultan Mustafa II's abandonment of the city of Istanbul and his political and economical negligence in favor of a retreat in the Edirne Palace. Social groups took part in this eighteenth-century rivalry of the two cities and their motives were different from those of social groups that fought for and against the dominance of the cities over one another. However, the constant struggle between the two cities and its impact on the

establishment, development, and transformation of Ottoman urban culture has an undeniable continuity in history that has to be stressed and studied.

On July 18–21, 1703, merchants and artisans joined rebelling Janissaries in front of the Sultan Ahmed Mosque in Istanbul. On August 1, 1703, scholars, students, merchants, and artisans joined the Janissaries marching towards Edirne to battle against the lesser number of feudal forces protecting the Sultan in Edirne. However, on August 22, 1703, the Sultan's forces joined the rebels. Finally, Sultan Mustafa II was defeated and dethroned. Instead, his nephew Ahmed III was enthroned.[1] Thus, the Tulip Period began and ended by the revolting acts of Janissaries. From the long sixteenth century to the early eighteenth century, the status of the Janissaries—from the assertion of imperial power through conquering and maintaining land on the frontiers— had been transformed into a self-defeating system at the center of the empire. Janissaries, who were once established to maintain the empire, developed into a self-centered "war machine" that destroyed the same empire which created them.[2] The Janissaries who acted against the precedent of Sultan Ahmed III in the 1703 Edirne Event, terminated his reign in 1730 with yet another revolt. In 1703, the Edirne Event paved the way to possibilities of modernization and urbanization in the following 27 years. But the rebellion in 1730 prevented the eventual transformation and modernization of the Ottoman culture for a long period of time.

After 1683, the army was not as victorious as it had been before. Signing the 1699 Karlofça Treaty, after four unsuccessful attempts to capture Vienna (1683–1699), the Ottoman Empire lost a significant amount of land to the Austrians, Russians and Venetians. Following the defeat at the Austrian border, with the 1718 Pasarofça Treaty, they also lost Eflak, Bogdan, Belgrad, and north Serbia (1715–1718) on their western frontier. In contrast, the Ottoman Empire was in a superior state on its northern and the eastern frontiers. Russians neighboring the empire at the north and the Safavids in the east were in vulnerable conditions. The Russians were fighting with the Swedish and the Safavid Dynasty was hardly surviving for the last years of its reign. However, the Ottoman regime preferred not to try taking advantage of circumstances or simply was not able to do so. Since the Ottoman sultans were not able to sustain the imperial agenda by extending their power over new territories, by the end of the seventeenth century they abandoned the city of Istanbul, which was the symbol of the imperial tradition. The court preferred to stay out of sight and they retreated back to the Edirne Palace until the 1703 revolt.

During the Tulip Period, Damad Ibrahim Pasha employed the imperial order in a different way. Instead of battling on the frontiers, he sent ambassadors to the east and to the west of the empire. In 1719, the second treasurer Ibrahim Pasha went to Vienna. In 1720–1721, Yirmisekiz Mehmed Çelebi visited France. In 1721, Ahmet Dürri Efendi went to Tehran. In 1722–1723, Nişli Mehmed Aga was sent to Moscow, and in 1730, Mustafa Efendi was appointed to Vienna, and Mehmed Efendi to Poland.[3] Each one of the chronicles depicting the travel notes of the ambassadorial offices frequently

illustrated landscapes of the countries visited. Similar to the sixteenth century maps of Matrakçı Nasuh, who had illustrated each city visited during the military campaign to Iraq, the early eighteenth-century chronicles narrated landscapes, cities, towns, and gardens observed by diplomatic envoys.

Ibrahim Pasha, who visited Niş, Belgrad and Vienna (Beç), describes towns, cities and their surrounding landscape in the 1719 chronicle. The chronicle pictures the city of Vienna, tall buildings—with eight to nine stories—within the city walls, and depicts the Danube as artificially guided through the city. The chronicle refers to the joyful life within the city walls and illustrates the shops in detail, where the sight of glass lanterns hanging from front facades created a charming sight. It portrays the living quarters of the city as picturesque and delightfully ornamented, referring to the name of each district. The villages surrounding the city are said to be like small cities in terms of planning and splendor. The chronicle also mentions prosperous and appealing vineyards and gardens surrounding Vienna.[4]

In the 1721 chronicle of Ahmet Dürri Efendi's visit to Tehran, there are interesting anecdotes to be mentioned with reference to the arguments discussed in this work, apart from the textual illustration of landscapes. First is an important reference to a private garden party hosted by the Grand Vizier of the Persian court in honor of the Ottoman emissary. At this party, which is described as being similar to the private garden parties of the Ottoman tradition where poetry was enjoyed, the chronicle acknowledges that the Persian courtiers were quite surprised to observe the Ottoman emissary's familiarity with the tradition of private garden parties, his knowledge of poetry and his proficiency in the Persian language.[5]

The second important reference is the Ottoman ambassador's description of the city of Istanbul to the Persian Shah. In this description, the Ottoman officer presents the city as a paradise. When they converse, the Persian Shah asks Ahmet Dürri Efendi if the Ottoman Sultan was living in Istanbul for the rest of his time. The ambassador receives this question doubtfuly, and says that he was not able to understand the underlying motive for asking such a question. The ambassador cites the Shah as he further elaborated and explained his question as such: "Some places are famous for their water, some for their fruits and weather, and some for their promenades. Which one of these would the Sultan prefer?" The Ottoman ambassador responds to the Shah's question with certainty and informs him that Istanbul is the paradise on earth that no human being would dare to leave for any other place. Then he tells the Shah about the atmosphere, natural beauties, promenades, palaces, gardens and wonders of Istanbul.[6]

Third, it should be noted that the Ottoman chronicle refers to the Persian landscape as impoverished in contrast to the other chronicles that depict the splendor of the Austrian or French landscapes.[7]

Yirmisekiz Mehmed Çelebi, who was sent as an ambassador to France, came back to Istanbul, bringing various novelties that influenced and accelerated the transformation of the Ottoman culture. The printing press was one of them.

He also published his impressions of the French gardens and landscape.[8] It is remarkable that the narrative of French life in gardens seems to have inspired and transformed the Ottoman culture as much as the printing press did, since upon the same site of Kağıthane, the Sultan commissioned the construction of Sa'd-âbâd Palace as well as a paper factory, following observations by Çelebi. Traveling to Kağıthane Commons was not only a journey into the countryside, but also into the Ottoman dreamscape made of the gardens of France.

Venetian ambassadorial chronicles depict the construction of Sa'd-âbâd Palace after French models: "Nothing succeeded more in holding his interest than the construction of buildings on the shore of the Sweet Waters. Mehemet Efendi had brought designs from France, among which one of Fontainebleau inspired Ibrahim to erect a kiosk 'equal to the Sultan's dignity' and a large palace."[9] The Venetian chronicles also refer to the French influence in the design of other gardens, like in the restoration of Hüsrevabâd at Alibeyköy close to Kağıthane Commons:[10]

Achmet delighted in flowers, gardens and everything in imitation of the designs from France. Many thousands of trees had been planted in one part adjoining Cladabut. The other part had been divided among ministers; each one, commencing with the vizier, had constructed kiosks, which were decorated with different colors and had trees and vines at the sides.

At the same time, the Grand Vizier Damad Ibrahim Pasha initiated new social and cultural reforms in the city. The first two public libraries, the Enderûn Library (1719), and the Library of the New Mosque were founded. Intellectual groups for discussions were formed at the court of Ibrahim Pasha. Literary works such as *Aynî Tarihi* (*Ikd-ül-cüman fi tarih-i ehl-iz-zaman*, 24 volumes, from Arabic) by Antepli Bedreddin Mahmud, *Habib-üs-siyer* (from Persian) by Hondmir, *Cami-üd-düvel* (from Arabic) by Mevlevi Ahmed Dede, *Matla'ussa'deyn* (from the Ilhanids) by Kemalüddin Abdürrezzak, and works of Aristotle were translated into Ottoman Turkish as a consequence of the flourishing historical consciousness. By July 1727, the first press printing Ottoman Turkish had been founded by Said Efendi (who traveled to France with his father, Yirmisekiz Mehmed Çelebi, in 1720–1721 during his emissary service and studied publishing in France) and the Hungarian Müteferrika Ibrahim Efendi.[11]

During the Tulip Period, the city was refurbished with fountains, lodges, pools, libraries and gardens. As can be observed in miniatures depicting festivals of that period, all citizens were encouraged to build gardens and cultivate flowers. This period saw the breeding of more than 200 types of tulips, each valued as a fortune. Scenes from the royal gardens ornamented the walls of living quarters. Floral depictions ornamented fountains that were dispersed like jewels within the urban fabric. Gardens, hunting parks, and vineyards were favored more than ever by all ranks of society. The city was bursting with flowers and gardens, or with their representations disseminated in fragments.[12] The flurry of garden creation is illustrated in Levni's *Surnâme* miniatures for the 1720 circumcision festival (Figures 5.1

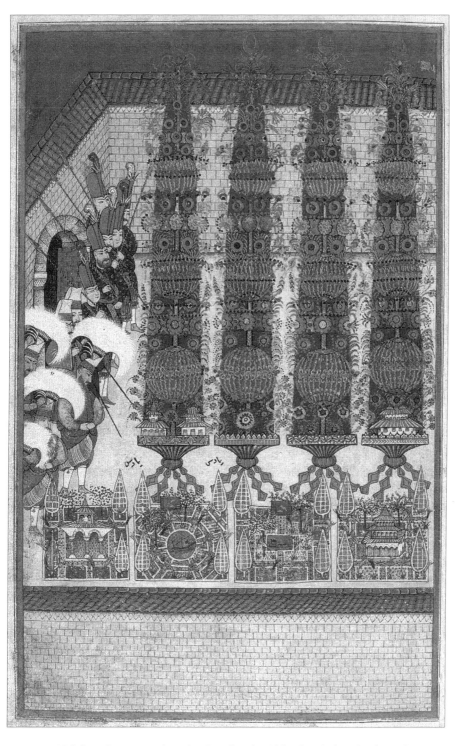

5.1 "Nahıls and sugar gardens displayed at the Old Palace before the festival" in the 1720 circumcision festival in *Surname-i Vehbi* (1727–1733). TSMK A.3593, 7a.

5.2 "The display of sugar gardens during the procession" in the 1720 circumcision festival in *Surname-i Vehbi* (1727–1733). TSMK A.3593, folio 163a.

and 5.2). Garden models—made out of sugar—were constructed for display during the festival. Sedad Hakkı Eldem, who has studied these sugar models, proposed garden plans from his observations[13] (Figures 5.3 and 5.4).

Gardens, pavilions, kiosks and gardens were built on both sides of the Bosphorus. Tülay Artan, who studied the building activity along the Bosphorus during the entire eighteenth century, argued that the Bosphorus had become a social space favored by all ranks of society by these extensive building activities. It became a promenade of spectacle.[14]

In addition, the Ottoman ambassador to France, Yirmisekiz Mehmed Çelebi's accounts of French gardens and landscape in his emissary chronicles without illustrations provided novel garden forms and uses, enriching the Ottoman imagination. Thus, shortly after the Ottoman envoy's return from France, a new imperial palace was built in Kağıthane, accompanied by numerous neighboring mansions of the Ottoman elite, each with splendid gardens, adjacent to a public promenade, already a favorite retreat among common people for a long time. Arel makes an explicit list of these activities with the dates of building activities: initiation of building activities at Kağıthane (1720), endowment of land to the elite for building kiosks and gardens at Kağıthane Commons (1722–1723); on the Bosphorus building of Kandilli Palace and gardens (1719), Çırağan Palace of Damad Ibrahim Pasha (1719), Beşiktaş Palace (1720), Amn-âbâd Palace (1725); building activities at Ortaköy and the building of Ortaköy Mosque (1721–1722), building activities at the Hümayun-âbâd Gardens at Bebek (1725), building of Neşat-âbâd Palace at Defterdar Burnu; restoration of Çubuklu Garden (1721–1722); refurbishment of Fener Gardens at Üsküdar (1727–1728), Vineyard of Halil Efendi at Rumelihisarı (1727–1728), Pavilion of Kethüda Mehmed Pasha (1727–1728), Şeref-abâd Palace (1728).[15]

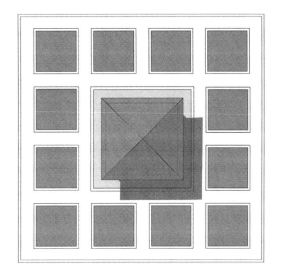

5.3 "Garden types with central kiosks." Plans emulating gardens of the early eighteenth century as reconstructed after the garden models displayed during the procession of the 1720 festival in *Surname-i Vehbi* (1727–1733). TSMK A.3593, 7a. Plans by Çalış-Kural drawn after Eldem, *Türk Bahçeleri* (1978), 210–211, and TSMK A.3593, 7a.

5.4 "Garden types with central pools." Plans emulating gardens of the early eighteenth century as reconstructed after the garden models displayed during the procession of the 1720 circumcision festival in *Surname-i Vehbi* (1727–1733). TSMK A.3593, 162b. Plans by Çalış-Kural drawn after Eldem, *Türk Bahçeleri* (1978), 216–217 and TSMK A.3593, 162 b.

About 216 fountains were built during the sultanate of Ahmed III.[16] These fountains were larger in scale compared to the fountains of earlier periods, which were embedded within the mass of a building—a mosque—within the body of another structure in general. The later ones were free-standing sculptural objects, defining a center within the city space by themselves. Shirine Hamadeh, in her study of eighteenth-century Ottoman urban culture, discusses that these fountains became "public" meeting points. Most of these fountains were called *meydan çeşmesi*, alluding to their locations within public spaces, creating a focus point for gathering. The term was first used in 1682 for the Silahdar Mustafa Aga Fountain in Salacak. Ahmed III's imperial fountain built in 1728–1729 outside the Topkapı Palace is an example of this new type of monument. These fountains were ornamented with natural motifs, inscribed with religious verses and with poetry. Besides the Sultan, different members of the society were identified as patrons of these fountains; Hatice Sultan Fountain in Ayvansaray (1711), Nevşehirli İbrahim Pasha Fountain in Şehzade (1719), İbnül'emin Ahmed Aga in Kasımpaşa (1727), and Rakım Pasha in Rumelihisarı (1715).[17]

The *Kağıthane Mesiresi* (Kağıthane Commons) was a site of experiment where social and cultural projects of the Tulip Period (1718–1730) were tested. Kağıthane Commons had always been a favorable meadow housing a *hagiasma*, with its fresh air and open fields fitting for the arts of sports. There was a tradition of going to *hagiasma* in the Byzantine era in hope of a better life and good health. It was much visited by the Byzantine and the Ottoman elites and the common public for different purposes, as discussed in Chapter 4.

The Kağıthane Commons was located along a river in a secluded valley outside the dense fabric of the city of Istanbul, and beyond the reach of people's gaze from the city (Figure 5.5). During the Tulip Period, it flourished

5.5 "Location of Kağıthane at the end of the Golden Horn." Map by Çalış-Kural.

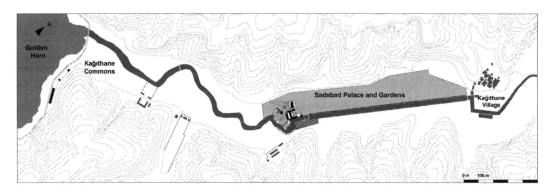

5.6 "Site Plan of Kağıthane during the Tulip Period showing the palace grounds and the public commons." Site plan by Çalış-Kural, drawn after various reconstruction drawings and etchings in Eldem, Sa'dabad (1977), 8–9; 16–17; 20–21; 34–35.

as a meadow where more than 40 mansions belonging to the Ottoman elite, each with splendid gardens, were built. It was surrounded by a public park. It also housed the Sa'd-âbâd Palace built in 1722/23 for the court (Figure 5.6). City people went there almost as on a pilgrimage in search of "a new way of life" enjoyed in pleasure and prosperity. Different social groups used the Kağıthane Commons with gender, purpose of visit, with varying temporality. It was totally destroyed in 1730, during the Patrona Halil Riot that put an end to the Tulip Period.

Emergence of New Rituals and Nedîm's Poetry

The court and the elite lived a festive life in the city of Istanbul during the Tulip Period. Every occasion was turned into a celebration. Religious days like the Ramadan holidays or the birthday of the Prophet were commemorated with celebrations. The imperial family organized festivities for the births, marriages and circumcisions of the princes and sultans. The court, elite and public enjoyed winters conversing at dessert parties (*helva sohbeti*) and summers at garden parties (*lale çırağanı*). New year's day (*Nevruz*) was celebrated. Even the promenade of the harem (*halvet*) in the city and the Sultan's visits to imperial abodes around the city became festive ceremonies.[18]

The most renowned celebration of the period was the 1720 festival which was organized for the circumcision of the princes Süleyman, Mustafa, Mehmed and Beyazıd; the wedding of Ayşe Sultan with the Grand Vizier Damad Ibrahim Pasha; and the wedding of Emetullah Sultan with Sirke Osman Pasha. The festival is depicted in several chronicles. One of these chronicles is *Dürrî Biraderi Sa'di'nin Sûr-ı Hümayûn Tarihidür* (*Sıhhatnâme ve Sûr-ı Hıtâna Müteallik Kasâ'id*, TSM Revan No. 826, folios 31a–23b). It shows the participants of the festival who gathered at the open space of Ok Meydanı. The chronicle compares persons in the crowd attending the celebrations to roses in a garden, to rose buds in an imperial garden, and to the date palm in the paradise garden:[19]

> Each one is a blossoming rose bud in the imperial garden
> Each one is a jewel in the rose garden of the world[20]

> Now the "Ok Meydanı" is the gathering place of beloved ones of the city
> The world has become lively with the lover and the beloved[21]
>
> Variety of fruits ornament the procession
> Remind the palm tree in the garden of paradise[22]

The 15-day festival is also illustrated by Vehbi in the book of festivities (*Surname-i Vehbi*) which was completed in 1727–1728. The book of the festival was widely circulated among both the elite and the public. Atıl mentions 25 copies still existing today.[23] Garden models made out of sugar were also displayed during this festival, and most probably these garden plans as exemplary constructions were also widely circulated among both the elite and the common public. (Figures 5.1, 5.2, 5.3 and 5.4)

In 1722, Venetian ambassadorial chronicles depict the Sultan's visit to Damad Ibrahim Pasha's shore palace. The chronicle depicts this instance as an unusual event and notes that it was not common for an Ottoman sultan to visit his grand vizier.[24] However, during the Tulip Period, the Sultan's visits to the shore palaces and gardens of the grandees are frequently recorded. The change in the courtly rules of conduct and flexibility in the court hierarchy was also apparent in the use of urban space and urban festivities. In 1723, the birth of Ahmed III's fifth son was celebrated and the festival was extended to celebrate the birth of the Grand Vizier's son. In 1724, the marriages of Ümmü, Atika and Hatica Sultans with Ali, Ahmed and Mehmed Pashas were celebrated.

The court poet Nedîm is closely associated with the festive life of the Tulip Period. Nedim composed artful poems using all means of the Ottoman poetic tradition. At the same time, though, he composed poems using plain Turkish. These poems were comprehensible to the common people. In his poetry, he employed daily urban themes common to and experienced by all city dwellers.[25]

Nedîm's poetry depicted real places in Istanbul, instead of ideal places of the metaphysical world. His poetry stressed a new development in the appropriation of the Ottoman creative imagination. The real places of the city formed the "pool" necessary for contemplation by the imaginative faculty. By referring to real gardens and spaces, his poetry also challenged the Ottoman cosmology. Such appreciation of daily life and the mundane physical environment was also evident in the *şehrengiz* poetry. However, *şehrengiz* poems were only known to members of a small group. When some of them attained more powerful positions within Ottoman society during the early eighteenth century, enjoyment of daily life, real spaces and daily pleasures flourished more openly. (See Table 5.1.)

Out of 110 poems (*Kasîdes, chronograms*, and *mesnevis*) in total, there are 65 poems referring to real places or events. The above table shows the classification of his 65 *kasîdes, chronograms*, and *mesnevis* according to different places or events referred to.[26]

Table 5.1 Inventory of real places and events in Nedîm's *kasîdes*, *chronograms*, and *mesnevis*

CITY SPACES IN NEDÎM'S POETRY	NO. OF POEMS
Fountains	14
Private Places in the City Palaces, gardens, vineyards, kiosks, pavilions, water-front mansions, etc.	21
Public Places Bath houses, market places, bazaars.	4
Religious Institutions Mosques and Sufi lodges.	5
Other Institutions *Külliyes*, schools, *caravanserais*, court houses.	6
Social Events Visits to friends' houses; leisurely travels of the Sultan in the city; desert parties; private garden parties; celebrations of holy-days and new year.	15

Out of 28 songs in total, there are 16 songs depicting real places (11 songs illustrate real gardens and the pleasure of their experience) and events (five songs are invitations to events or recount visits to anonymous gardens, or indicate movement and traveling in the city space). However out of 162 *gazels*, there are only four *gazels* depicting real places in the city.

Kasîde is a long poem composed for the purpose of praising—a person, a holy day, an event, a festival, an artifact, a building or a place.[27] *Mesnevis*, as discussed in Chapter 4, are long poems about love stories. *Chronograms* are poems written in honor of a particular event or of the building of an artifact. The main purpose of a *chronogram* is to date a particular event—the establishment or foundation of a building, fountain or garden.[28] Songs were composed to be recited with music. They used plain language. Their subject matter was metaphoric and natural love, mundane pleasures. Nedîm is acknowledged as the most innovative poet in composing songs.[29]

In his *kasîdes*, Nedîm compares the city to the heavens, and especially praises the Kağıthane Commons by referring to the Sa'd-âbâd Palace and its gardens built as a sealing monument of the period. In the verses below written in honor of Vizier Ibrahim Pasha with reference to the city of Istanbul, Nedîm presents valuable documentation concerning daily life and the spirit of the period in which the use of green space was secularized and the public quest for joy replaced the contemplation of nature for the sake of its divine beauty:[30]

> Holy paradise! Is it under or above the city of Istanbul?
> My Lord, how nice its atmosphere, its water and weather!
> Each of its gardens is a pleasing meadow,
> Each corner is fertile, a blossoming assembly of joy.
> It is not proper to exchange this city for the whole world
> ...
> Or to compare its rose gardens to paradise!
> Quality of these novel festivities
> Only a book will be able to tell about!

Ramazanniye Kasîdesi also gives a very lively account of a Ramadan day, beginning with a description of how people used to sleep until noontime when they were fasting. In this poem, Nedîm tells of his travel plan that he would carry out after Ramadan to go and visit Sa'd-âbâd, which he portrays as the highest level of paradise. He gives an account of particular places that he would like to visit for pleasure. He mentions the pool and the palace. Then he mentions Hürrem-âbâd. He accounts for rowing in the pool. Thus, he proposes to go to the other side of the pool by boat, where he intends to spend a couple of hours enjoying himself.[31]

Another *kasîde* illustrates the festivities of the Ramadan holiday in detail. Nedîm portrays the court ceremonies to which foreign diplomats were also invited. He argues that neither Alexander had envisioned such a festival in his imagination (*hûlya*), nor Feridun had ever fantasized about such a court assembly and organization in his dreams (*ru'ya*). Nedîm further describes the celebrations and he tells that all the beloved ones would soon populate the open spaces at the Hippodrome (*Atmeydanı*) and at Tophane (*meydan-ı Top-hâne*). He says that most of the public would pay a visit to the tomb of Eyyub Ensari at Eyüp. He also lists the neighborhood of Üsküdar as another favorable place to visit and enjoy. Then he depicts Sa'd-âbâd Palace in detail.[32]

Nedîm begins his description by illustrating a bridge. This bridge was a semi-enclosed bridge. It was covered with an ornamental ceiling. Nedîm personifies this bridge as a lover who is watching the beautiful beloved ones walking by. Then he describes *Hayr-âbâd* (The Lodge of Mohammed), explaining that it is a place of joy and delight that had been the pilgrimage place of masters of pleasure. At this point it is not clear whether *Hayr-âbâd* was a dervish lodge, but Nedîm cites the place as a pilgrimage lodge for those dervishes who knew how to enjoy themselves. Then he continues depicting other elements at the site. He says that it is impossible to describe the pleasure of contemplating the sight of the waterfall, that one should see it for real. Then he cites *Kasr-ı Cinân* (The Pavilion of Paradise) for having an unparalleled beauty. He further describes *Çeşme-i Nur* (The Fountain of Light) and *Cetvel-i Sim* (The Pool of the Silver Ruler). He praises *Kasr-ı Neşât* (The Pavilion of Eternal Gaiety) for its site chosen with such careful consideration. Nedîm expresses that even though it was quite small, its fame was significant. Then Nedîm tells of another artifact in the garden, which is called *Nev-Peyda* (The New Bridge), which was probably a covered deck

protruding over the pool. He cites it as an original invention. He further mentions two other pavilions. This couple of pavilions was called *Ferkadan* (The Constellation of Ursus Majoris and Beta Ursus Majoris), resembling the two brightest stars of the Ursa Minor constellation. He also designates two other pavilions: *Hürrem-âbâd* (The House of Sultan) and *Cesr-i Sürur* (The Pavilion of Happiness), which were located close to the site of *Ferkadan*. Then he tells about a very long column called *Sütun-ı Bâla* (The Tall Column) gilded at the top, making a sight worthy of adoration. Illustrating the garden, Nedîm refers to Sultan Ahmed III as its owner. He further alludes to other rulers of Persia and Turan, the legendary characters of Feridun, Dârâ, Husrev, Iskender and Cem. He compares Iskender's affection for Aristotle to Ahmed III's affection for his son-in-law Damad Ibrahim Pasha, the Grand Vizier. Nedîm praises Damad Ibrahim Pasha, for all his decisions thus he became the cure for many. Finally, he concludes his poem by stating that upon seeing Sa'd-âbâd, even King Solomon would bite his fingers out of jealousy.[33]

In another *kasîde* describing Sa'd-âbâd, Nedîm portrays the site as the new construction of Istanbul, whose pure water and fine weather would prolong the life of the citizens of the city. In his long appraisal of the site, Nedîm explains the pool *Cetvel-i Sim*, which would carry the ones rowing on its waters to the shores of paradise. He argues that even though describing this sight is impossible, he would compose a *gazel* that would survive in honor of Sa'd-âbâd. He concludes the poem by affirming that the court should enjoy themselves at Sa'd-âbâd, or at other waterfront mansions on the Golden Horn or the Bosphorus, while their enemies would get bored [34]

In another *kasîde* about the city of Istanbul, Nedîm describes the city as beyond comparison to any other city in the world. The city of Istanbul by itself would be worth the whole land of the East. Nedîm's portrayal of the city between the two seas is similar to the earlier depictions used in the *Şehrengiz* and many Sufi poems. Further, Nedîm argues that Istanbul is superior to all the gardens of paradise, that all of its gardens, meadows, lawns, all of its places are beautiful, and that he would not exchange the city for the whole world. In this city, everybody would satisfy his / her own desires. Nedîm refers to all the mosques in the city, both the grander Friday mosques, and the smaller mosques, which are less significant. He praises the hills, vineyards, gardens, kiosks, and pavilions of the city, without being specific, or naming any of them. Then he mentions Sa'd-âbâd, which he portrays as the new representation of pleasure and joy. Nedîm argues that the qualities of Sa'd-âbâd would fill a single book on its own.[35]

Out of 11 songs that mention real places within the city, five of them evoke Sa'd-âbâd.[36] Others depict kiosks and pavilions of Şevk-âbâd[37] and praise of the Sultan's kiosk at Neşât-âbâd;[38] the beauty of Şeref-âbâd.[39] Another mentions the tradition of strolling in along the Bosphorus[40] and one refers to Feyz-âbâd and Asaf-âbâd as places one must to visit on the way to Sa'd-âbâd.[41] One song cites the neighborhood of Beşiktaş.

The first song about Sa'd-âbâd is an invitation to visit, enjoy and contemplate the palace and gardens, depicting its grounds as a promenade worth traveling to.[42] The second one compares the garden of Sa'd-âbâd to the *char-bagh* of Isfahan, narrating the former's superior qualities and paradise-like gardens. Nedîm describes how the place that once was simple ground has become a prosperous garden, illustrating the range of activities one can contemplate on its varied and expanded site. Suggesting that the organization of the site is like a book, Nedîm states that it should be appreciated from above the surrounding hills. In this way, one can see its elongated pool carved out of the ground as if precisely drawn on paper.[43] Another song mainly about Nedîm's interest in a particular beloved, depicts the site of Sa'd-âbâd, telling how this beloved had escaped from the poet and traveled to the gardens of the palace. The song tells how the beloved enjoyed the site, watched the sultan's ceremonial procession to the palace and traveled around the kiosk.[44]

In another song about love, Nedîm compares the river running into the site of Sa'd-âbâd to the burning heart, desirous to occupy and experience the site, with many beloveds wandering in its gardens.[45] The final song about Sa'd-âbâd is an invitation by Nedîm composed to convince his beloved to travel to the site. He offers to go to the site on a Friday afternoon by boat.[46] He claims that they should enjoy the gardens, and as well drink water from its new fountain designed in the form of a dragon. Then he proposes to promenade along the pool, and regard the beauty of the kiosk. He recommends singing songs or reciting poetry in this picturesque location:[47]

> Let us give a little comfort to this heart that is wearied
> Let us visit Sa'd-âbâd, my swaying Cypress, let us go!
> Look there is a swift caique all ready at the pier below,
> Let us visit Sa'd-âbâd, my swaying Cypress, let us go!
>
> There to taste the joys of living, as we laugh and play,
> From the new built fountain *Nev-Peyda* drink the water of life,
> Then watch the enchanted waters flowing from the gargoyle spout of this dragon,
> Let us visit Sa'd-âbâd, my swaying Cypress, let us go!
>
> For a while we'll stroll by this pool, and then by another one
> Off we'll go and view the Pavilion of Paradise and be aroused by its sight
> Then we will sing a ballad and become a composer
> Let us visit Sa'd-âbâd, my swaying Cypress, let us go!

Upon the arrival of spring, Nedîm compares blossoming nature to himself. He suggests that like blossoming roses and tulips, they should also begin to enjoy the gardens and the meadows.[48]

There are five other songs that depict anonymous places that seem to be illustrated with reference to real places. These songs are like invitations to visit and enjoy gardens and private parties in gardens. Most of them indicate a sense of movement as suggested by the invitation. The first of these songs is an invitation to enjoy the spring days, to travel and to contemplate gardens,

especially tulips.⁴⁹ The other two songs announce the time for the spring celebrations, known as Light Festivals (Çerâgan), which were favorable during the Tulip Period.⁵⁰ The fourth one is an invitation to a private party,⁵¹ and the fifth to a garden party.⁵²

It is interesting that Kağıthane was recognized as a whole continuous space, and was called a single entity by the name of *mesire*; despite being composed of different elements and being extremely long—four kilometers. Kağıthane was not considered as a distant retreat from the city, but like all the other *mesire*, it was one of many leisure places within easy reach of the city.

There are 41 chronograms of Nedîm dedicated to the building of waterfront mansions, libraries, palaces, fountains, pavilions, kiosks, gardens, vineyards, bath-houses, mosques, schools, bazaars, *caravanserais* and the restoration of fountains and mosques. These chronograms cite the names, locations and properties of artifacts. They also cite the patron of each artifact. These chronograms depict the artifacts, praising their splendor and beauty.⁵³ Hamadeh, who studied chronograms, argues that changes in the patronage of building activities shed light upon the eighteenth-century urban culture of Istanbul and the variety of patrons inform about different participants in the renewal of the urban space. Previously, members of the court exercised such patronage. However, during the Tulip Period, a new elite group emerged close to the Grand Vizier Damad Ibrahim Pasha. They were friends, sons-in law and relatives of the grand vizier who were appointed to high-ranking governmental positions. They became the new patrons of urban space development.⁵⁴

As opposed to Nedîm's other poems, which depict real places and events, out of his 162 *gazels*, only four *gazels* refer to real places. These *gazels* briefly depict the Göksu and Çubuklu promenades, Sa'd-âbâd Palace, the city in general and compares Istanbul to Isfahan in Iran.⁵⁵

Participants of the New Rituals: Confrontation of the Court and the Public

The court and the elite had always enjoyed private garden parties prior to the Tulip Period. However, during the Tulip Period, private parties and spaces where the court and the elite enjoyed such parties became visible to the eyes of the common public. As well, the participants of the court and the elite engaged in festive activities that challenged the hierarchy of the classical Ottoman cosmology.

The court, the elite and the common public utilized various kinds of space at the same time. The 1720 circumcision festival, illustrated in *Surname-i Vehbi* (1727–1728), provides an example. The festival brought all ranks of society together; The sultan, the grand vizier, Janissary corps, *kethüda*, *defterdar*, *enderûn*, religious scholars, pages, poets, historians, painters, various kinds of guilds, foreign ambassadors and the common public at Ok Meydanı. Vehbi illustrates the common public watching and enjoying the festival (TSM

A3593, folios 42b–43a, 46b–47a, 51b–52a, 53b–54a, 59b–60a, 64b–65a, 83b–84a, 89b–90a, and 168b–169a).[56]

Similar to Vehbi's depiction of the common public peeping into the imperial festival and enjoying the processions, in an illustration of Kağıthane Commons dated after the Tulip Period, from D'Ohsson, the court and the public are depicted mutually enjoying the two halves of the same open space, divided by a garden wall. This allows the participants of each side to observe the other due to the gently sloping site, allowing views of the imperial gardens to be observed by the commoners at Kağıthane Commons, comparable to the vista of the Kağıthane meadows seen directly from the imperial gardens.

In her unpublished thesis, Artan also argues that during the eighteenth century, Bosphorus had become a public promenade where the court and the public enjoyed the spectacle of urban life and urban landscape.[57]

The participants of this spectacle not only observed the court and the elite groups' use of space and their festive lives, they recognized the changing balance in the social hierarchy. Until the Tulip Period, the Sultan constituted the center of the society. The imperial court followed him in hierarchy. However, during the Tulip Period, the Grand Vizier Damad Ibrahim Pasha almost constituted a second center in terms of hierarchy. He employed a group around him similar to the imperial court around the Sultan. This new group, composed of poets, scholars, historians, court officers of high ranks and their relatives, was visible to the eyes of the common public. From the fifteenth to the early eighteenth centuries, the demography, or harmony of the society, had been transformed a lot, and still all the groups who participated in shaping Ottoman society were each fighting for their ideals, either for moral or material benefits. In different ways, each was fighting for survival, or dominance.

The society of religious scholars constituted diverse groups in terms of their socio–political standpoints. Some, like the chief religious authority (*Şeyhülislam*) of Mustafa II was exploiting his powerful status and eliminating any kind of reforms by using his authority. At the same time, the supporters of the Kadizadelis were still acting against the more liberal Sufi orders like the *Melâmî-Bayramis*, who were the followers of the school of 'Arabî. Factions of the *Mevlevi* society supported such groups against the development of *Melâmî* society. Meanwhile, however, *Melâmî* society, in order not to be harmed by such opponents, developed in secret. As discussed in Chapter 2 concerning the followers of Ibn al-'Arabî's philosophy of the Unity of Being, by the Tulip Period, the adherents of the *Melâmî* philosophy increased in the upper classes of society. Court officers were appointed to the court service, such as grand viziers, and religious scholars, such as the *Şeyhülislam*, who were prominent *Melâmîs*—even poles.

In the early eighteenth century, Şehid 'Ali Pasha (1713–1716), who was the grand vizier, was also the leader of *Melâmî* society (*Melâmî pole*). Following him, the Grand Vizier Damad Ibrahim Pasha, court poet Nedim, Habeşizade Mevlevi Abdürrahim Efendi known as poet Rahimi, La'lizade Abdülbaki,

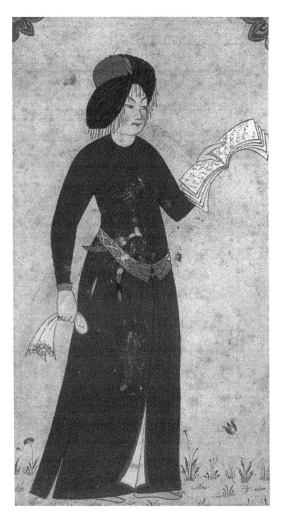

5.7 "Young man reading a poem" by Levni. TSMK H.2164, 17a.

Reisülküttab Mustafa Efendi, Ahmed Arifi Paşa, Defterdar Sarı Mehmed Paşa, historian Mehmed Raşid, Mustafa Sami, Osmanzade Taib were all *Melâmîs*, as discussed in Chapter 2.

The society of guilds, as merchants and artisans, was still a diverse group of society, where every other group participated in different Sufi orders and were influenced by different principles of these orders.

During the Tulip Period, poetry was still enjoyed and it constituted an important part of Ottoman culture. The poets of the period were Mehmed Nesîb Dede (d. 1714), Dürr-i Yekçeşm (d. 1724), Selim (d. 1725), Nedîm (d. 1730), Râsih (d. 1731), Arpaeminizade Sâmî (d. 1733), İshak Efendi (d. 1734), Enîs Receb Dede (d. 1734), Mustafa Sâkıb Dede, İzzet Ali Paşa (d. 1734), Râşid (d. 1735), Seyyid Vehbî (d. 1736), Neylî (d. 1748), Nahifî Süleyman Dede (d. 1738) and Atıf Efendi (d. 1742). Among all these poets, Nedîm is commonly associated with the festive spirit of the Tulip Period. His poetry also constituted the dual nature that was innate to the Tulip Period: the shared experience of the common public on the one side, and the newly flourishing elite groups on the other side.

As already mentioned, Nedîm was a court poet. He composed poems using an artful language. But he also composed simple poems using plain Turkish. He was able to employ all the conventions and canons of Ottoman poetry artfully. But he was also able to employ the daily language and common terms of everyday life. Nedîm is recognized as a participant of the *Türkî-i Basit* (Simple Turkish) Movement. *Türkî-i Basit* was initiated by Edirneli Nazmî and Tatarlı Mahremî at the end of the fifteenth century. Sılay acknowledges the adherents of the *Türkî-i Basit* Movement as rebels who tried to use simple Turkish in their poetry. Using simple Turkish was associated with being "vulgar, peasant-like, rude, stupid, ignorant, artless." Using a complex language mixed together with Persian and Arabic words, phrases and rules, was considered to be "sophisticated, cultivated, clever, precious, knowledgeable and musical."[58] The opposition between plain Turkish and artful court language had always been an issue of debate. *Kâbûsnâme* by Mercümek Ahmed, written in the first half of the fifteenth century, praises the use of plain language understandable to the common public. Sılay shows

that Sümbülzâde Vehbi's eighteenth-century treatise titled *"Kasîde on Poetry Written by Imperial Order and Decree"* criticizes those poets using artless and plain language.[59]

Nedîm was an inventive poet who introduced common phrases from public life into Ottoman poetry. He was inspired by folk literature, troubadour poetry, and, especially, Yunus Emre. He depicted street language and daily life. Similar to the realist portrait paintings of Vehbi, there was an emphasis on realism in Nedîm's poetry.[60] Like Vehbi, Nedîm illustrated the common people of the city (Figure 5.7 and Figure 5.8).

Nedîm didn't accept the conventions of the idealized beauty imprisoned in the imagery of classical court poetry. Instead he looked into the city as a source of beloved ones. For him the ideal beauty was a mere dream. In his *gazel* below, he criticizes the concept of idealized beauty:[61]

> Nowhere in this city is the beloved
> you describe, Nedîm!
> It was only an illusion that appeared
> to you with a fairy-face.

Construction of Gardens at the Kağıthane Commons

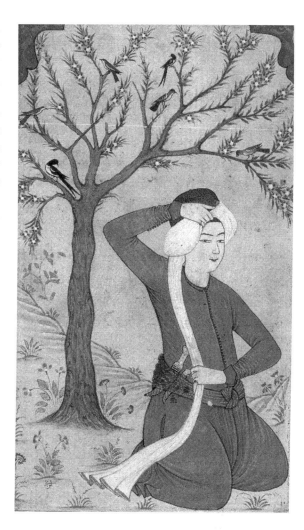

5.8 "Young man unwrapping his turban" by Levni. TSMK H.2164, 13a.

During the Tulip Period places which were favored and frequently visited by the common public were re-discovered by the members of the court. Different countryside meadows were favored by different sections of the public for different reasons throughout the centuries since the conquest of Istanbul in 1453. Either grown out of an ascetic tradition for contemplation, or an ordinary citizen's desire for fresh water and weather for healing purposes, visiting meadows had been a common leisure practice for the citizens of Istanbul since the Byzantine times.[62] Ritual journeys to the groves and meadows surrounding the earlier temples of Byzantium, later pilgrimage sites of the holy springs of Constantinople, had been transformed by the Ottoman citizens and adapted to a variety of new uses. From the late fifteenth to the early eighteenth centuries, these meadows had become spaces of leisuretime joy.

Evliya Çelebi gives a brief idea of how these countryside meadows were used by the common public and how they were part of the urban fabric which the citizens used to visit and enjoy for leisure purposes in the late seventeenth century. Evliya Çelebi's accounts were examined at the end of Chapter 4, when discussing the urban practices which *Şehrengiz* poetry was influenced by and which was an inspiration for. Kağıthane was one of those places that had multiple uses, favored by different ranks of society.

Kağıthane was located at the end of the Golden Horn, continuing towards the Kağıthane valley along the former Barbyzes, the later Kağıthane River. (Figure 5.5 and Figure 5.6) The place had been known since the Byzantine Empire, and it had been favored both by the Ottoman elite and the court, and the public since the late fifteenth century. It had been depicted as a place of private gatherings and parties for both the elite and the public. It had been a gathering place for the private parties of the guilds. It had been a favorable retreat for Selim I and a royal hunting area for Süleyman I.[63] Apart from merely social and joyful assemblies, it had also been used for the meeting of ascetics and for contemplation, as discussed in Chapter 4.

In the early eighteenth century, the Ottoman court rediscovered places like Kağıthane, and renovated them by extensive building activities. These rediscovered places were reintroduced for the use of the court as well as the public. The court began to enjoy these meadows and countryside in the same way as the public, who had been enjoying these sites for centuries. However the confrontation of the public and the court was a new experience in Ottoman culture. As well, the extensive expenditure of the court on luxury was a visible contradiction with the modest public use of the same space.

Until the early eighteenth century, Ottoman historical chronicles frequently referred to the Kağıthane Commons. In 1530, the historical chronicle of Peçevi mentioned the site as "Kağıthane Open Space" (*Kağıthane Sahrası*).[64] In a 1614 document, the site and its surrounding neighborhoods were acknowledged for being a hunting area expanding towards the Aqueducts (şikar-gâh olan Kağıthane ve Kemerlerde ve sair ol etraflarda olan mahallelerde). The chronicle said that the hunting area was only open to the court of Ahmet I and those Venetians who entered the area for hunting were punished and warned not to trespass again.[65] In a 1630–1640 document compiled during the sultanate of Murad IV, visiting Kağıthane is acknowledged offering a pleasurable visit and sightseeing (*seyre giden*). "Scholars with their books, dervishes with their prayer rugs, writers with their pens, ink and other stationeries" were allowed to enjoy their sightseeing activities.[66]

In the 1721 chronicle of Raşid, an interesting story is told. In 1721, the Sultan ordered the conservation and maintenance of a countryside meadow in Alibeyköy, close to Kağıthane. The chronicle names this countryside meadow as *mesire*. The chronicle states that this meadow had long been favored and had been visited by the common public. It refers to these former visitors as the masters of strolling and leisurely pleasure (*erbab-ı geşt ü güzâr*). The site is depicted as a beautiful place with its water and

fine weather. It had a comforting mild breeze and trees casting soothing shade. The chronicle states that the site was assured to be a pleasant place according to the testimony of all the public (meşhûd-ı cümle-i efrad), who had been enjoying the site for such a long time. The Sultan had commanded the upholding of the place like those other mesires, and he demanded the building of pools and sofas—small open spaces used for assembly or for praying—at the site. The Sultan's unexpected ordering of the conservation of the place created curiosity among the public. The public of Istanbul (bi'l-cümle Istanbul ahalisi) who had been using the site for such a long time and who knew the place "by heart" were concerned about the new building activities at the site. Hearing that the Sultan and his Grand Vizier were having their meals at this particular location during the month of Ramadan, some members of the concerned public decided to visit the site in order to see and understand what was going on. Then, as the chronicle narrates, the public were totally amazed and overwhelmed upon seeing the new constructions on the site. The chronicle concludes by asserting that all the building works were completed. The prosperous new site, which now contained three pools, one bridge, and various settings of assembly (sofa), was named Hüsrevâbâd. This name can be translated as the Sultan's House or the Hüsrev's House, referring to the legendary character of Hüsrev in the mystical love story of Hüsrev and Shirine.[67]

The same chronicle also tells about the conservation and reconstruction of another site, which was depicted as pleasant countryside for visiting, contemplation and visual enjoyment. The site is Kağıthane, which had a public promenade (nüzgetgâh-ı hass-ü âm olan mesire-i dilnişîn).[68] A chronicle depicts the construction of a neighborhood (mahallât) on this site in 1721–1722. The new neighborhood was called Sa'd-âbâd, with several buildings, including an imperial pavilion called Kasr-ı Cinan, and its harem building called Harem-i Hümayûn, Kasr-ı Hümayûn, a marble cascade, three piers, fountains, a mosque, four bridges, and a pool.[69]

Building activity in the Kağıthane district[70] was narrated by the eighteenth-century historian Raşid, who also writes further about the construction of the new neighborhood of Sa'd-âbâd. The necessary marble for the construction was carried from the dismantled tower of the Kuleli Gardens. The Grand Vizier visited the construction site frequently. There was a palace for the Sultan and a harem. The text mentioned the construction of a canal and marble pools, several fountains, including a peculiar one with a spout in the shape of a dragon. As well, many other mansions were being built on the banks of the river, between the Sultan's new palace and the Golden Horn. These mansions resembled the water-front mansions along Bosphorus. The total number of these mansions was recorded as 170. All the mansions built were unique in style. They were painted in different colors. Their gardens and vineyards were planted with trees. There are several accounts ordering the transportation and planting of 450 already grown trees[71] in the garden and along the main pool.[72]

Sa'd-âbâd was portrayed as a place for strolling and spectacle (*Temaşgah-ı Sa'dabad*).⁷³ The names of the new constructions on the site were as follows: Pavilion of Paradise (*Kasr-ı Cinân*); Pavilion of the Head Stabler (*Kasr-ı Mirâhur*); Pavilion of Happiness (*Kasr-ı Sürûr*); New Pavilion of the Sultan (*Kasr-ı Şehinşah-ı Cedid*); Harem (*Harem-i Şerif*), and Palace of the Court Women (*Feriye-i Hürrem-âbâd*). Six new bridges were recorded (*Sırat, Fil, Kovanlı, Nevpeyda, Ebyaz, and Ahmer*). Four new piers were documented: the Pier of the *Hayr-âbâd* Lodge, the Pier of Everybody, the Pier of the Vizier, and the Pier of the Sultan (*Hayr-âbâd, Eyyü-hennas, Vezir, Hünkar*). The new neighborhood also had two dervish lodges at either side of the main garden of the Sultan's palace—The Blessed Lodge of Muhammed (*Hayr-âbâd*) and The Lodge of the Vizier (*Asaf-âbâd*). Only two of the gardens that are known were given names, both within the property of the Sultan. These were called The Garden of Iram (*Bağ-ı İrem*) and the Garden of the Sultan (*Bahçe-i Has*). The pools were named as the Pool of the Sea, the Pool of the Silver Ruler and the Two-headed Pool (*Havz-ı Deryâ, Cetvel-i Sîm, Havz-ı Dü-ser*). In the gardens there were also cascades, the Column of Pole / Arrow (*Sütun-ı Tîr*) and the Dragon Fountain (*Ejder-i Cârî*), fountains of Marble and Gilded Bowls (*Kâse-i Mermer, Kâse-i Summâki*). There were documented two seating locations—Paradise Sofa (*Sofa-i Cinân*) and the Sofa of the Guests (*Sofa-i Mihmân*). There was a market place called the New Bazaar (*Sûk-ı Cedid*).⁷⁴

The palatial grounds were reached by boat. Sa'd-âbâd was planned to be accessed through the canal. Thus, there were four different piers serving different visitors of the palace. One pier for the use of the Sultan, one for the Vizier, and another one for the use of public; each named after its users, as the pier of Everybody, Vizier, and the Sultan (*Eyyü-hennas, Vezir, Hünkar*). The fourth pier belonged to the Hayrâbâd Lodge, and was named after it.

Sa'd-âbâd Palace was built in 1722/23 after the ambassador Yirmisekiz Mehmed Çelebi returned from his travels to France. In France, Çelebi visited many palaces and their gardens during his stay (November 21, 1720– September 6, 1721 / Muharrem 20, 1132–Zilhicce-i Şerif 16, 1133). His emissary accounts are compiled in a chronicle.⁷⁵ It is also known that he brought back plans of several French palaces: Marly, Versailles and Fountainebleau.⁷⁶ Irepoglu, in her study of the Ottoman archives, identifies a large number of books of European print (Figure 5.9 and Figure 5.10). Some of these books are dated prior to 1720, which might have been brought back by Çelebi from France.⁷⁷ There is also one book in German and another one in Italian dated prior to 1720.

The common feature of these European printed books in the Topkapı Archive is that they are all about gardens. They include specific or generic plans and site plans of gardens, palaces in gardens, elements of garden design, various ways of planting of flower beds, arrangements of trees, different types of pools, engineering plans for the construction of waterways for different types of pools, various decorative elements, fountains, jet spouts, fences, grottoes, sculptures, and vases. The books also picture the festive life in the

5.9 "Site plan for the palace and gardens of Chantilly" from a French book on gardens found in Topkapı Palace Library. TSMK H.2605.

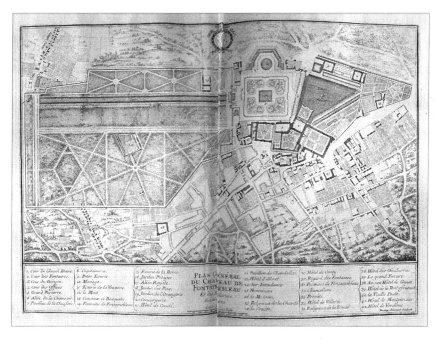

5.10 "Site plan of the palace and gardens of Fontainebleau" from a French book on gardens found in Topkapı Palace Library. TSMK H.2605.

gardens in perspective engravings, illustrate decorative elements like flowers arranged in vases and even birds that enliven gardens.

Though there is such a vast amount of material on European gardens, mainly French, general scholarship avoids the comparison of Sa'd-âbâd and French gardens and palaces, arguing that there are no formal similarities. The following argument from Sedad Hakkı Eldem illustrates this perspective:[78]

> The greatest and the finest example of 18th century domestic architecture is visible in the Sa'dabad Gardens at Kağıthane... Whenever mention is made of cascades and the Sa'dabad installations, it is customary to talk about the French influence. I must admit that I am unable to find any reminiscent of French art, with the possible exception of the Cetvel-i-Sim (Silver Line)... Thus it is futile to look for similarities between Sa'dabad and Marly.

Eldem asserts that there are more similarities between Sa'd-âbâd and the Indian or Safavid gardens in terms of architectural form and details. Recently, Hamadeh also calls attention to the importance of Persian inspiration in Sa'd-âbâd gardens:[79]

> We must also note the curious kinship of the newly acquired names of Ottoman imperial and grandees' palaces and gardens with those of the Safavid, like Sa'd-abad with Sa'adet-abad, one of Shah Abbas's private gardens in Isfahan, both meaning the Abode of Happiness. In an entry in his personal diary dated 10 August 1722, the bureaucrat Mustafa Efendi reported that in the wake of the construction of Ahmed III's palace the place previously known as Kağıthane was increasingly referred to as Sa'dabad. These eponymous associations with Safavid monuments and, more generally, the trend of ascribing garden palaces of the imperial and ruling elite with poetic names in the manner of their Persian counterparts, as with Feyzabad, Hurremabad, and Neşatabad, dated only to the reign of Ahmed III (r. 1703–1730).

Hamadeh asserts the Persian influence in the architectural iconography, in order to claim a counter-argument against the general conviction that modernization of the Ottoman culture during the Tulip Period is associated with Westernization. Thus, she asserts the presence of an Eastern model against the Western one. She presents the early eighteenth century as a period of innovation with respect to early modernization. She presents the manifestation of terms and phrases "repeatedly used" in Ottoman poetry which describe innovation and novelty in architecture and the arts of the period, such as:[80]

> ...*nev* (new), *cedîd* (new), *nev-îcad* (new invention), *tâze* (fresh), *ihtirâ'* (invention), *hayâl* (imagination), *bedî'* and *ibdâ'* (original, to create from scratch), and vaguer allusions to novelty such as *hüsn-ü diger* (a different sort of beauty) and *üslub-i ferîd* (a unique style)...

Hamadeh's argument about the Persian impact in Ottoman culture is correct. However, such impact was not limited to the eighteenth century. Ottomans had not only used Persian, but all other imperial traditions of the Near East as models since the fifteenth century.

As well, the Ottoman vocabulary on novelty was also repeatedly used since the early sixteenth century in describing Sufi practices, as discussed in Chapter 2; and in *Şehrengiz* poetry illustrating the experience and image of the cities by marginal groups, as discussed in Chapter 3. Nevertheless, Hamadeh's and Eldem's discussions and also Evyapan's arguments regarding the formlessness of Ottoman gardens are suited in reference to formal analysis of architectural and site plans. However, it is also obvious that the festive life observed in French gardens and palaces became an essential model for Ottoman court practices during the Tulip Period.

Çelebi's textual accounts of life and narrations of different spaces have become a source of inspiration for the building and use of Sa'd-âbâd Palace, its surrounding gardens and restoration of the Kağıthane Commons. The French gardens constituted a new source of ideas for the Ottoman imagination. This pool of images was constructed upon both textual and visual depictions.

Both the textual accounts of Yirmisekiz Çelebi and the printed plans of the French gardens formed the new storehouse of Ottoman imagination. The court preferred to use Western iconography instead of the Eastern one. The reason for this sudden fascination with the Western models was limited in visual and architectural idioms. The subtext for such fascination was already produced from within the dynamics of the society since the early sixteenth century. Thus, the Ottoman culture produced its ideal spaces within the continuity of its artistic and social tradition. However, it borrowed forms to accommodate these ideals from different storehouses. Once it borrowed the imagery of Persian and Near Eastern imperial traditions, then it referred to the Byzantine tradition. Though, during the Tulip Period it also borrowed images from the French landscape.

In his chronicle, Çelebi does not use a certain method, like dating or a thematic content, but he tells about places and events as he experiences them. The story begins with his entry into France and continues. The text tells about Çelebi's travels in the French landscape. He arrives at a city, a village, a town, a garden; meets the French bureaucrats, the young king; he visits a palace and wanders in a garden, leaves it and travels to another one. Çelebi describes French gardens and palaces as "the paradise of infidels." He continuously stresses his amazement upon seeing different palaces, different gardens, innovations, beauties. He expresses the impossibility of imagining these novelties, the impossibility of illustrating them in words and asserts the necessity to see them in reality.[81]

Canals and traveling by canals is a constant theme throughout the chronicle.[82] Çelebi is impressed at traveling through artificial canals. He describes them as providing comfort for travelers and merchants carrying people and goods.[83] The second common theme that endures throughout the whole narrative is Çelebi's experience of the French gardens. Another common theme is the portrayal of the public. Çelebi describes crowds of people enjoying themselves both in the gardens, and in the villages and

cities he visited. He notes that both the common public and the court included a lot of women.[84] Thus, the whole chronicle can be summarized as the story of a journey from one garden to another through canals where, at the same time, both the French court and the common public—including women—were traveling freely in the open space and enjoying themselves.

Çelebi depicts the gardens and palaces of Vincennes, Villeroi, Tuileries, Meudon, Versailles, Marly, Chantilly, St. Cloud, Fontainebleau and Orleans.[85] He explains his desire to see nice buildings several times throughout the text. He especially likes Paris.

He is fond of St. Cloud and its tree-lined walkways. He talks about a pool on a site covered with trees, where a jet spout shoots out water to a very high elevation that he recorded higher than the surrounding trees. Then he describes a cascade and a pool with great interest. He portrays the cascade made out of stairs and these stairs were covered with the running water spilling out from the pool. He notes that there were many fountains in the garden. He says that he observed many fountains in the shape of the mouth of a dragon.[86]

Çelebi portrays Versailles as a single garden made out of four different gardens and four different palaces.[87] At Versailles, Çelebi is amazed at the number of the fountains he has seen. He counts 39 fountains. Each of these fountains is part of a single story. Çelebi compares the story told in the garden of Versailles to the stories of *Hümayunnâme*.[88] He describes two kiosks made out of colorful marble that were located on the sides of the pool. In Marly, Çelebi illustrates another cascade, whose sight impressed and overwhelmed him.[89]

Chantilly[90] is portrayed as another garden Çelebi was impressed with. He depicts the palace in a unique style, which was different from the other palaces they had visited previously. The palace was similar to a big castle with towers. On one side of the castle there was a river, which was designed as a deep pool. Thus the palace surrounded by this pool was entered over bridges. From the interior of the palace, Çelebi had the impression of being in a water-front mansion like those on the Bosphorus. The garden of Chantilly was also accessed via bridges. It had many pools and was planted with different kinds of trees. Çelebi wrote about a hunting party within the forests of Chantilly. He also depicted the gardens at night illuminated with thousands of candles, which he was invited to enjoy watching from a room overlooking the garden and the pool. Çelebi depicts two different pools in the gardens of Fontainebleau—one large enough to accommodate people rowing and the other as extremely long.[91]

Çelebi also describes the festive life in the French gardens. He is amazed by the festive life, how the emperor enjoys himself in the gardens. He describes joyful assemblies that take place during the daytime and celebrations at nighttime. He narrates his experience of an opera performance. He describes the rules of conduct and explains the seating

arrangement at the opera, where everyone is seated according to his or her status within the society.[92] In another anecdote, he refers to the illumination of the gardens at nighttime and the impressive sight of fireworks.

As at Versailles, many mansions were built along the Kağıthane River in order to accommodate Ottoman grandees accompanying the Sultan and taking part in the celebrated life of the Sa'd-âbâd Palace. The newly-built palaces, pavilions, kiosks, pools and gardens were given poetic names like in the stories of *Hümayunnâme*, following Çelebi's observations about French gardens recalling stories.[93] Thus, the Ottoman artifacts were named as if symbolizing spaces within a larger story that takes place all over the city: *Sa'd-âbâd* (House of Eternal Happiness), *Şerefâbâd* (House of Eternal Honor), *Emnâbad* (House of Eternal Security), *Hüsrevâbâd* (House of Eternal Hüsrev), *Neşatâbâd* (House of Eternal Gaiety), *Hümâyunâbâd* (House of Eternal Ruler), *Şevketâbâd* (House of Eternal Desire).[94]

The depiction of individual elements in the gardens of St. Cloud resemble those in the gardens of Kağıthane; tree-lined walkways along the grand canal, a jet spout in the shape of a dragon and the cascade in the form of a staircase.[95] The site plan of Chantilly as described by Çelebi partially resembles the site plan of Sa'd-âbâd.[96] Çelebi depicts a castle beside a river, which was built into a pool and he illustrates a palace surrounded by this pool entered over bridges. Similarly, Sa'd-âbâd was located along a river turned into a pool and it was accessed via bridges. Similarly, at Kağıthane, people used to row on the river, and likewise, the River of the Silver Pool was extremely long.

Using the elements from the French gardens, Kağıthane however, became a site which housed an ideal garden whose image had already been part of Ottoman culture for 200 years. Even though it is not possible to reconstruct the site plan with accuracy, the names given to the elements of design suggest a certain relationship. For example, the Garden of Iram was considered the representation of the paradise garden on earth.[97] There was also a bridge called *Al-Siraat or Sırat*. Most probably, the special Garden of Iram was reached passing over the *Al-Siraat* Bridge. In the Islamic tradition, the *Al-Siraat* Bridge is known as the bridge that would carry the believers to their eternal abodes in the afterlife, to hell or to heaven. Therefore, the Garden of Iram at Sa'd-âbâd was the paradise on earth accessed via the *Al-Siraat* Bridge.

One of the chronicles depicting the use of the new garden by the court suggests that the guests had to leave the garden grounds in a ceremonial way, following the ordering of the spaces, and passing through a via a particular bridge, whose name was not cited openly.[98] Sedad Hakkı Eldem has illustrated a hypothetical plan of Sa'd-âbâd according to the inventory of spaces narrated in Nedîm's poetry and other historical chronicles. Following Eldem's plan, this study proposes a new reading by reordering the hypothetical location of garden elements in Eldem's plan (Figure 5.11).

5.11 "Plan of Sa'd-âbâd Palace gardens and the neighboring Kağıthane Commons."
Plan by Çalış-Kural, reconstructed and drawn after Eldem, *Sa'dabad* (1977), 20–21.

LEGEND FOR THE PLAN:

GARDENS:

1. *Bahçe-i Has*: Imperial garden; the main open space accommodating Cirit Meydanı.

2. The Garden of Iram / Paradise Garden on Earth: Proposed location of the Garden of Iram between the main royal garden (*Bahçe-i Has*) and the public grounds.

3. Public grounds.

WATER ELEMENTS:

A. Two-headed Pool.

B. Pool of the Sea.

C. Pool of Silver Ruler.

OTHER GARDEN ELEMENTS:

a. *Kasr-ı Sürûr*: Pavilion of Happiness.

b. *Kasr-ı Cinan*: Pavilion of Paradise.

d. *Ferkadan*: Twin Pavilions of Stars.

e. Underground water channels.

f. *Çeşme-i Nur*: Fountain of Light.

Sa'd-âbâd Palace and gardens were located along the Kağıthane River, almost parallel to the hills bordering the Kağıthane Valley. The Kağıthane River was made into a long canal of 28 meters wide and 1,100 meters long. The palace complex stood on one side of the canal. On the other side was the public garden. The palace complex was reached through the canal and there are piers successively where the approaching guests land according to their status. When guests arrived, they followed a certain ceremonial route in order to approach the gardens beyond the palace complex. Once the guests went by the palace, they reached a huge open space called *Cirit Meydanı*. This space was used for sports activities and for accommodating huge banquets. This part of the garden must have been called the Garden of the Sultan (*Bahçe-i Has*). This open space ran through the whole length of the canal, and on the other side, it was bordered by natural topography sloping softly upward towards the low hills enclosing the valley.

There were three cascades close to the palace complex. These cascades were used to join the three different pools to one another. These pools were the Two-headed Pool, the Pool of the Sea and the Pool of the Silver Ruler. The palace was sited along the Two-headed Pool. There were fountains of Marble and Gilded Bowls at the Two-headed Pool. The Two-headed Pool was followed by the Pool of the Sea and then the Pool of the Silver Ruler.

The cascades between the Pool of the Sea and the Pool of the Silver Ruler turned into a walkway and connected the Garden of the Sultan to a smaller garden. This small garden was actually located between the huge imperial garden and the public garden—the Commons. This smaller garden might be the Garden of Iram—Paradise Garden on Earth. Iram is a renowned garden in the Islamic tradition. The Koran refers to it as the legendary garden built on earth whose beauty surpassed the beauty of the paradise gardens:[99]

Shaddad, the ancient king of Yemen, South Arabia... constructed earthly rival of Paradise by building the garden of Iram in his kingdom. The story relates that a messenger was sent by God to Shaddad, warning him not to challenge the Almighty. When Shaddad ignored the warning, God destroyed the garden.

There were water channels running underneath this Garden of Iram at Sa'd-âbâd, connecting the artificial pools to the river. The flowing channels underneath the garden space also resembled the paradise garden. The Koran mentions paradise garden more than 120 times, and for over 30 times, it acknowledges paradise as "gardens underneath which rivers flow."[100]

The bridge connecting the Garden of the Sultan to the Garden of Iram might be the Bridge of Al-Siraat, whose name is documented in the chronicles. Thus, passing over this bridge, the guest might have accessed to the Garden of Iram overlooking the Two-headed Pool and the Pool of The Sea, both carrying resemblances to the concept of paradise garden in the Islamic tradition. The two fountains at the Two-headed Pool resembled the two fountains promised in the paradise garden. The verses below from *Sura ar-Rehman* (LV: 46–69) in the Koran exemplify such a resemblance clearly:[101]

> But for him who feareth the standing before his Lord there are two gardens
> Which is it, of the favors of your Lord, that ye deny?
> Of spreading branches.
> ...
> And beside them are two gardens,
> ...
> Dark green in foliage.
> ...
> Where in are two abundant springs.

The waters of The Pool of The Sea and the Fountain of Light might call to mind the Islamic ideal that water resembled eternal knowledge promised in the gardens of paradise.[102]

The Garden of Iram was located between two gardens: the Garden of the Sultan and the public garden. In Kağıthane Mesiresi, the palace and its private garden were built within public grounds. The court and the public are depicted enjoying their mutual presence in the two halves of an open space separated by a garden wall, yet allowing the participants of each side to observe the other.

It is not well documented whether the public grounds were open to visitors at the same time as the private garden was being used by the sultan. However, since there were other mansions along the Kağıthane valley, other than the Sultan's retreat in Sa'd-âbâd, it is more than likely that these smaller private gardens and the public grounds might have been enjoyed at similar times.

There are accounts of the Sultan's and his Grand Vizier's visit to the site on a Wednesday and the following Thursday.[103] A chronicle dated after the Tulip Period accounts for the use of gardens by the Sultan, and the public at different times. However, it is not known whether this was a precaution taken after the rebellions of the Tulip Period, which totally destroyed the gardens and palaces of the Kağıthane, where the public was able to see the elite in their private gardens.

During the Tulip Period, both the court and the common city dwellers enjoyed the city. The court and the elite enjoyed traveling from one private garden to another, while common city dwellers enjoyed traveling through the city and indulging in the serenity of different city spaces located side by side with the gardens of the court and the elite. The court poet Nedîm celebrated this festive life celebrated in all kinds of city spaces.

During the Tulip Period, the Ottoman court built new spaces and restored old ones and engaged in a festive life. These spaces consisted of palaces, pavilions and gardens that provided new spaces for practicing garden parties. These garden parties differed from the *gazel* parties, since their spaces were visible to the common public.

The Ottoman court was in search of a new architectural vocabulary. They used French garden models and palaces as a new storehouse of images, along with the former traditional models of the Middle and Near East, especially in the production of Sa'd-âbâd Palace and Kağıthane Promenade. They used

these images in the construction of an ideal garden of Iram between the court garden of the sultan and the public promenade. Thus Iram—representing the mythological garden on earth whose beauty surpassed the beauty of the paradise garden—was built between the spaces court and the common public.

The subtle placing of the Garden of Iram can be perceived as an ideal of *Melâmî* philosophy following the doctrines of Ibn al-'Arabî; being an intermediary space, a garden of reconciliation between the sultan and his subjects; between the court and the public. It was a symbolic garden representing the realm of imagination between two worlds.

Sa'd-âbâd Palace and its gardens built at Kağıthane Commons display a significant difference compared to the gardens of the Topkapı Palace. The Topkapı Palace was well protected from public gaze with high walls, where the Sa'd-âbâd and its gardens, surrounded by low walls, was located within a public meadow. When the emperor enjoyed himself at the shores of the Topkapı Palace, the gardeners used to throw stones at the sea in order to prohibit strangers from coming nearer. However, Sa'd-âbâd and its gardens were visible to the eyes of the common city dwellers.

The new palaces and gardens of the Tulip Period were given thematic names, each symbolizing different stories like those narrated in *Hümayunnâme* and similar to the thematic allocation of spaces in the gardens of the French Palace of Versailles, as observed and documented by its Ottoman visitors. Correspondingly, the Ottoman court and public came to play a part in these festive stories by traveling from one garden to another. Thus the city was enjoyed by all its inhabitants, where each one of the newly built palaces, mansions and restored promenades was called after allegorical names resembling the stories of *Hümayunnâme*.

Nedîm's poems also depicted the experience of traveling in the city. Different than the garden parties enjoyed at private gardens, Nedîm's poems also described enjoying different city spaces: palaces, gardens, vineyards, kiosks, pavilions, water-front mansions, but also fountains, mosques, Sufi lodges, Külliyes, schools, caravanserais, court houses, bath-houses, market places, bazaars; and depicted visits to friends' houses, leisurely travels in the city and public celebrations. Such experiences shared by all the city dwellers recall *şehrengiz* rituals where individuals used to travel and experience different city spaces. As well, similar to the *şehrengiz* genre, Nedîm also described common city dwellers as individuals.

Modernization of the society during the Tulip Period followed from a more open development of cultural attitudes illustrated by the *Şehrengiz* poets since the early sixteenth century. Nedîm, who expressed the experience of the city dwellers both from the point of view of the Ottoman court and the common public, and was involved in an intellectual group of the Ottoman elite, mastered by the Grand Vizier Damad Ibrahim Pasha. The participants of this intellectual group had important offices at the Ottoman court. Some of them, including Nedîm and the Grand Vizier Damad Ibrahim Pasha, were *Melâmîs*, and others were most probably familiar with the *Melâmî* doctrines.

This group of intellectuals were the architects of the Tulip Period who enjoyed a festive life in the gardens of the city. At the same time, they encouraged the Ottoman ruler to be visible to the public, suggesting a terrestrial role for him by traveling around the city This helped create a reconciliation, as at the same time, it reminded the Sultan of the presence of the public.

Notes

1. Stanford Shaw, *History of the Ottoman Empire and Modern Turkey Volume I: Empire of the Gazis: The Rise and Decline of the Ottoman Empire, 1280–1808* (Cambridge, UK: Cambridge University Press, 1976), 227–229.

2. See Gilles Deleuze and Felix Guatari, *A Thousand Plateaus Capitalism and Schizophrenia*, trans. by Brian Massumi (Minneapolis; London: University of Minnesota Press, 1987), 351–424 on the concept of "war machine."

3. Hadiye and Hüner Tuncer, *Osmanlı Diplomasisi ve Sefaretnameler* (Ankara: Ümit Yayıncılık, 1997), 48–84; Stanford Shaw, *History of the Ottoman Empire*, 233.

4. Hadiye and Hüner Tuncer, *Osmanlı Diplomasisi ve Sefaretnameler*, 48–56.

5. *Ibid.*, 77.

6. *Ibid.*, 79.

7. *Ibid.*, 84.

8. Abdullah Uçman, *Yirmisekiz Çelebi Mehmed Efendi Sefaretnâmesi* (Istanbul: Garanti Matbaacılık ve Neşriyat, 1975); Gilles Veinstein, *İlk osmanlı Sefiri 28 Mehmet Çelebi'nin Fransa Anıları "Kafirlerin Cenneti,"* trans. M.A. Erginöz (Istanbul: Ozgü Yayınları, 2002).

9. Mary Lucille Shay, "The Ottoman Empire from 1720 to 1734 as Revealed in Despatches of the Venetian Balili," in *Illınois Studies in the Social Sciences*, vol. 27, no. 3 (Urbana, Illınois: University of Illinois, 1944), 20–21.

10. *Ibid.*, 22.

11. İsmail Hakkı Uzunçarşılı, *Osmanlı Tarihi I–IV* (Ankara: Türk Tarih Kurumu, 1961), vol. IV, 153–156.

12. Ahmet Refik Altınay, *Lale Devri* (Istanbul: Sanayii Nefise, 1932); Orhan Erdenen, *Lale Devri ve Yansımaları* (Istanbul: Türk Dünyası AraştırmalarıVakfı, 2003).

13. Sedad Hakkı Eldem, *Türk Bahçeleri*, 208–219.

14. Tülay Artan, "Architecture as a Theatre of Life: Profile of the Eighteenth-Century Bosphorus," Unpublished PhD diss., MIT, Cambridge, MA, 1989.

15. Ayda Arel, *Onsekizinci Yüzyıl İstanbul Mimarisinde Batılılaşma Süreci* (Istanbul: 1975).

16. Hatice Aynur and H. Karateke, *III. Ahmed Devri Istanbul Çeşmeleri* (Istanbul: 1995), 70–71.

17. Shirine Hamadeh, "The Cities Pleasures: Architectural Sensibility in 18th Century Istanbul," Unpublished PhD diss., MIT, Cambridge, MA, 1999, 42–48; 105–114.

18 Tülay Artan, "Architecture as a Theatre of Life," 55–56.

19 Mehmet Arslan, *Türk Edebiyatında Manzum Surnameler Osmanlı Saray Düğünleri ve Şenlikleri* (Ankara: AYK Atatürk Kültür Merkezi, 1999), 104–105.

20 *Ibid.*, 104:

Her biri bir gonca-i zibâ-yı bağ-ı saltanat / Her birisi rub'-ı meskun gülşeninün zîneti

21 *Ibid.*, 104:

Şimdi Ok Meydânı oldı mecma-ı hûbân-ı şehr / âşık u şûk ile buldı cihân germiyyeti

22 *Ibid.*, 105:

Dürlü dürlü miveler resmi müzeyyen eylemiş / Andurur insâna hâkka nahl-i bağ-ı cenneti

23 Esin A. Atıl, "The Story of an Eighteenth Century Festival," in *Muqarnas* 10 (1993), 181.

24 Mary Lucille Shay, "The Ottoman Empire from 1720 to 1734," 20.

25 See Abdülbaki Gölpınarlı, *Nedîm Divanı* (Istanbul: Inkılap ve Aka Kitabevleri, 1972); Hasibe Mazıoğlu, *Nedîm* (Ankara: Başbakanlık Basımevi, 1988) and *Nedim'in Divan Şiirine Getirdiği Yenilik* (Ankara: TTK, 1957); Kemal Sılay, *Nedîm and the Poetics of the Ottoman Court: Medieval Inheritance and the Need for Change* (Bloomington: Indiana University, 1994); Ahmet Ömür Evin, "A Poem by Nedim: Some Thoughts on Criticism of Turkish Literature and an Essay," in *Edebiyat: A Journal of Middle Eastern and Comparative Literature* II/1 (1977): 43–55; Tunca Kortantamer, "Nedim'in Şiirlerinde Istanbul Hayatından Sahneler," in *Ege Üniversitesi Edebiyat Fakültesi Türk Dili ve Edebiyatı Araştırmaları Dergisi* IV (1985): 20–59.

26 Abdülbaki Gölpınarlı, *Nedîm Divanı*: for fountains see pages 137, 147–148, 149; 150–151, 176–177, 181–182, 186, 190–191, 193, 201, 207, 208, 208 (2), 221; private residences and gardens in 75–78, 79–84, 85–87, 111–113, 114–115, 138, 152, 153, 154, 162–163, 164, 165–167, 167–168, 170–177 172–173, 183–185, 196–198, 199–200, 209–210, 211, 216–217; public places in the following 38–43, 179–181, 221–222, 189–190; religious institutions in 175, 177–178, 178, 205, 211–212; other institutions in 30–32, 135–136, 169–170, 174, 179–180, 212–215; and social events in 44–47, 48–53, 93–95, 97–98, 99–100, 100–102, 103–104, 105–106, 107–108, 109–110, 118, 123–126, 158, 161–162, 225–227.

27 E.J.W. Gibb, *Osmanlı Şiir Tarihi*, 70–71.

28 For detailed information on chronograms, see Shirine Hamadeh, "The Cities Pleasures," 186–189. Chronograms are one of the major sources in the study of the history of architecture. In her book on the eighteenth-century Ottoman Istanbul, Shirine Hamadeh makes a broad study of chronograms. Hamadeh uses chronograms as a source which inform about building types and their patrons. These chronograms, which were written in order to celebrate the building of an artifact, to date its foundation, and recall its patron, were listed in magazines which compile the genre under subtitles of different architectural types of buildings.

29 E.J.W. Gibb, *Osmanlı Şiir Tarihi*, 77.

30 The verses below are translated from Şentürk, *Osmanlı Şiiri Antolojisi*, 599–580:

Altında mı üstünde mîdür cennet-i alâ / El-hâk bu ne hâlet bu ne hôş âb ü hevâdır (4); Her bağçesi bir çemenistân-i letafet / Her kûşesi bir meclis-i pur-feyz ü safâdur (5); İnsaf degüldür anı dünyaya değişmek / Gülzarların cennete teşbîh hatâdur (6); Şimdi yapılan 'alem-i nev-resm-i safânun / Evsâfı hele başka kitab olsa sezâdur (13); Nâmı gibi olmuştur o hem sa'd hem 'abâd / İstanbul'a sermâye-i fahr olsa revâdur (14); Kühsarları bağları kasrları hep / Güyâ ki bütün şevk ü tarab zevk ü safâdur (15).

31 Abdülbaki Gölpınarlı, *Nedîm Divanı*, 44–47; *Kasîde IX*, titled "İbrahim Paşa'yı medih zımnında Ramazaniyye."

32 Abdülbaki Gölpınarlı, *Nedîm Divanı*, 48–53; *Kasîde X*, titled "Bayram Törenini Anlatan ve Sultan III. Ahmed'i Öven *Kasîde*."

33 *Ibid.*, 75–78; *Kasîde XVI*, titled "Sa'd-âbâd'ı vasfeden *Kasîde*."

34 *Ibid.*, 79–84; *Kasîde XVII*, titled "Sa'd-âbâd'ı vasıf zımnında III. Ahmed'e *Kasîde*."

35 *Ibid.*, 85–87; *Kasîde XVIII*, titled "Istanbul'u vasf zımmında Ibrahim Paşa'a *Kasîde*."

36 *Ibid.*, 343, 344, 345, 346, 350, 351(Bosphorus), 353, 353–355, 356–357, 359.

37 *Ibid.*, 344; *Song III*.

38 *Ibid.*, 343; *Song I*.

39 *Ibid.*, 359; *Song XXVI*.

40 *Ibid.*, 350–351; *Song XIII*.

41 *Ibid.*, 352–353; *Song XVI*.

42 *Ibid.*, 344–345; *Song IV*.

43 *Ibid.*, 346–347; *Song VII*.

44 *Ibid.*, 348–349; *Song IX*.

45 *Ibid.*, 357; *Song XXIII*.

46 *Ibid.*, 356–357; *Song XX II*.

47 Ahmet Refik Altınay, *Lale Devri*, 52–53; Doğan Kuban, *Istanbul: An Urban History* (Istanbul: Türk Tarih Kurumu, 1996), 343.

48 Abdülbaki Gölpınarlı, *Nedîm Divanı*, 357–358; *Song XXIV*.

49 *Ibid.*, 345; *Song V*.

50 *Ibid.*, 353–354; 350; *Song XVII*; *Song XXVIII*.

51 *Ibid.*, 354–355; *Song XIX*.

52 *Ibid.*, 355–356; *Song XX*.

53 Shirine Hamadeh, *The Cities Pleasures*, 184–189.

54 *Ibid.*, 12.

55 Asaf Halet Çelebi, *Divan Şiirinde Istanbul* (Istanbul: Hece Yayınları, 2002), 112; 102–103; 101–102; 102:

Göksu bir nahoş heva şimdi Çubuklu bir ziham / Sevdiğim tenhaca çekdirsek mi Sa'd-âbâd e dek

'Uşşakın olsa nola feda nakd-I canları / Seyr itmedin mi dünkü fedai civanları; Şevk ateşine sen de tutuşdun mu ey Gönül / Gördün mü dün güreş tutan pehlivanları; Ol perçemin nazirini hatırda mı Gönül / Görmüş idin geçen sene sünbül zemanları; Çeng ü çengane zevki biraz ursun el-aman / Seyr idelim bu seyre gelen dilsitanları; Ma'lumdur benim sühanim mahlas iztemez / Fark eyler anı Şehrimizin nüktedanları.

Sıkılma bezme gel bigane yok davetlimiz ancak / Nedîma bendeniz var bir dahi sultanımız vardır; Bir söz didi canan ki keramet var içinde / Meyhane mukassi görünür taşradan amma; Bir başka ferah başka letafet var içinde / Eyvah o üç çifte kayık aldı kararım; Şarki okuyup geçti bir afet var içinde / Olmakda derununda heva aşet-I suzan; Nayin dilebilmem ki ne halet var içinde / Ey şuh Nedîma ile bir seyrin işitdik; Tenhaca varub Göksuya işret var içinde

İran zemine tuhfemiz olsun bu nev gazel / İr görsün Isfahana Sıtanbul diyarını

56 Esin A. Atıl, *Levni ve Surname*, 208–209; 204–205; 198–199; 192–193; 188–189; 174–175; 170–171; 168–69.

57 See Tülay Artan, "Architecture as a Theatre of Life."

58 Kemal Sılay, *Nedîm and the Poetics of the Ottoman Court*, 57–69. Also see, Mehmed Fuad Köprülü, *Milli Edebiyat Cereyanının İlk Mübeşşirleri ve Divan-ı Türk-i Basit* (Istanbul: Devlet Matbaası, 1928).

59 Kemal Sılay, *Nedîm and the Poetics of the Ottoman Court*, 7–56.

60 Kemal Sılay, *Nedîm and the Poetics of the Ottoman Court*; Ahmet Ömür Evin, "A Poem by Nedim: Some Thoughts on Criticism of Turkish Literature and an Essay;" Mehmet Kaplan, "Nedim'in Şiirlerinde Mimari, Eşya ve Kıyafet;" Tunca Kortantamer, "Nedim'in Şiirlerinde Istanbul Hayatından Sahneler," 20–59; Hasibe Mazıoğlu, "Divan Edebiyatında Sadeleşme Akımı," in *Dil Yazıları* 1 (Ankara: TKK Yayınları, 1998): 44–52, *Nedîm* and *Nedîm'in Divan Şiirine Getirdiği Yenilik* (Ankara: TTK, 1957).

61 Walter G. Andrews, *Poetry's Voice, Society's Song: Ottoman Lyric Poetry* (Seattle and London: University of Washington Press, 1985), 72; translates from Nedîm:

Yok bu şehr içre senin vasf ettigin dilber Nedîm / Bir peri suret görünmüş bir hayal olmuş sana

62 For Byzantine suburbs and places of retreat, see Doğan Kuban, *Istanbul: An Urban History*, 118–140. Along the Bosphorus outside the city, the Byzantines had mansions, monasteries and churches. These dwellings outside the city were either places of escape, as in the case of some monasteries, or palaces of pleasure for seasonal retreats. Most of the villages which were later identified as Ottoman suburbs were established in Byzantine times. The specific name given to the Byzantine suburban residence was "proasteion." Procopius talks about lofty mansions of the upper class along the Bosphorus: "nobles of Constantinople spent almost the entire year in their littoral proasteia, probably their suburban mansions." A general list of settlements along the Bosphorus, either identified by mansions or religious buildings on the European shore are Diplokionion (St. Mamas) at Beşiktaş (constituting a palace, a sanctuary, a market and the Temple of Zeus, and later a harbor was added.); St. Phocas at Ortaköy (later identified as Anaplus where Anaplus has a specific meaning as "the European shore of the Bosphorus"); Promotus / Hestiae at Arnavutköy; Sosthenion at İstinye: There is also a church of St. Michael; on the Asian shore are Argyronion at Macar Burnu (a monastery and a palace, which is later transformed into "a home for the destitute");

Sophianea at Çengelköy; Chalcedon (there was a small walled city with a hippodrome, theater, churches and a palace built by Constantine III by the beginning of the 7th century); Eutropiu at Kalamış; Hieria at Fenerbahçe (Justinian I and Theodora built a palace in Fenerbahçe. There was also a port, bath, and a church. It is also important that there was a public garden. Kuban talks about the transformation of Hieria from a sacred place into a place of pleasure: "In the Greek period there was a hierion of Hera, hence the name. This was a beautifully small promontory where Justinian I, at the suggestion of Theodora, built a palace with a small port, a bath, a church dedicated to the Mother of God and a public garden. Heraclius, after his victorious Persian campaign, used to stay in Hieria. Until the Comnenians, Hieria remained an important resort for the emperors.") Rouphinianai at Caddebostan; Bryas at Dragos; Poleaticon at Bostancı (Poleaticon was acting as a gate to the territory defined by Constantinople. There was an imperial mansion and a port. Forests within the vicinity accommodated the mansions of royal families); Damatrys at Alemdağı (a hunting lodge). On the Marmara shore there were Hebdomon at Bakırköy; Stronglyon at Zeytinburnu and Pege at Balıklı.

63 Nurhan Atasoy, *A Garden for the Sultan: Gardens and Flowers in the Ottoman Culture* (Istanbul: Mas Matbaacılık, 2002), 278.

64 Münir Aktepe, "Kağıthane'ye Dair Bazı Bilgiler," in *Ord. Prof. İsmail Hakkı Uzunçarşılı'ya Armağan* (Ankara: 1976), 340; Sedad Hakkı Eldem, *Sa'dabad* (Istanbul: Kültür Bakanlığı Yayınları, 1977), 141; from Ibrahim Peçevi, *Tarih*, vol. I (Istanbul: 1283), 155.

65 M. Münir Aktepe, "Kağıthane'ye Dair Bazı Bilgiler," 342–343; *Mühimme Defteri* 80, 217; Ahmed Refik, *Hicri Onbirinci Asırda Istanbul Hayatı 1000–1100* (Istanbul: Devlet Matbaası, 1931), 48.

66 M. Münir Aktepe, "Kağıthane'ye Dair Bazı Bilgiler," 340–341; from Hammer, *Devlet-i Osmaniye Tarihi* IX (Istanbul: 1335), 167.

67 M. Münir Aktepe, "Kağıthane'ye Dair Bazı Bilgiler," 344–345; from Raşid Mehmed, *Tarih-i Raşid* V (Istanbul: 1822), 305–306.

68 Sedad Hakkı Eldem, *Sa'dabad*, 142–143; from Raşid Mehmed, *Tarih-i Raşid*, vol. V, 443–446; vols. III, 111, 112, 113.

69 Sedad Hakkı Eldem, *Sa'dabad*, 143; from "Muhasabe Defteri," TSM H1134.

70 Sedad Hakkı Eldem, *Sa'dabad*, 143–146; from documents from Başbakanlık Arşivi

NE7724 dated 1721–23 and Başbakanlık Arşivi NE 7737 dated 1724.

71 Sedad Hakkı Eldem, *Sa'dabad*, 144; from "Ziyafet-i Asafi Bicenab-ı Şehriyar-ı İskender Nihad der Temaşgah-ı Sa'dabad," in Zeyl-i Raşid Küçük Çelebizade Ismail Asım, no. B. 22 folio 18a.

72 Sedad Hakkı Eldem, *Sa'dabad*, 146; from "Ziyafet-i Asafi Bicenab-ı Şehriyar-ı İskender Nihad der Temaşgah-ı Sa'dabad," in Zeyl-i Raşid Küçük Çelebizade Ismail Asım, no. B. 22 folio 18a.

73 *Ibid.*, 146; from "Ziyafet-i Asafi Bicenab-ı Şehriyar-ı İskender Nihad der Temaşgah-ı Sa'dabad," in Zeyl-i Raşid Küçük Çelebizade Ismail Asım, no. B. 22 folio 18a.

74 *Ibid.*, 143.

75 See Şevket Rado, ed. and trans., *Yirmisekiz Mehmet Çelebi'nin Fransa Seyahatnamesi* (Istanbul: Hayat Tarih Mecmuası Yayınları, Doğan Kardeş Yayınları, 1970); Abdullah Uçman, *Yirmisekiz Çelebi Mehmed Efendi Sefaretnâmesi* and Gilles Veinstein, *İlk Osmanlı Sefiri*.

76 Semavi Eyice, "Tarih İçinde İstanbul ve Şehrin Gelişmesi," *Atatürk Konferansları 1975* (Ankara: Türk Tarih Kurumu Basımevi, 1980), 134.

77 Gül İrepoğlu, "Topkapı Sarayı Müzesi Hazine Kütüphanesindeki Batılı Kaynaklar Üzerine Düşünceler," *Topkapı Sarayı Müzesi Yıllık* 1 (1986), 56–72; 174–197.

78 Sedad Hakkı Eldem, *Sa'dabad*, 132.

79 Shirine Hamadeh, "Ottoman Expressions of Early Modernity and the 'Inevitable' Question of Westernization," *JSAH* 63:1 (2004), 43.

80 *Ibid.*, 33.

81 The following quotations are listed consecutively from the following pages in Şevket Rado, *Yirmisekiz Mehmet Çelebi'nin Fransa Seyahatnamesi*: 32; 55; 57; 58; 63; 63:

"*Görülmedikçe havsalaya sığdırmak mümkin değildir.*"; "*Öyle güzel bir tertip temâşâ eyledik ki tabir olunmaz.*"; "*Bir saray temâşâ ettik ki, vasfı veçhile mümkün değil.*"; "*Gönüllere ferahlık veren bir saray ve gamlara devâ olan acaip düzen müşahede olundu ki güzellikleri dil ile anlatılamaz.*"; "*Bahçesi dahi öyle tanzim olunmuş ki, tâbiri mümkin değil. Bunda dahi türlü türlü fıskiyeler ve şadırvanlar etmişler ki anlatılamaz.*"; "*Öyle süslü bir keyif yeri müşahede olunmuştur ki misli yok.*"

82 Abdullah Uçman, *Yirmisekiz Çelebi Mehmed Efendi Sefaretnâmesi*, 15–19; 25; 26; 27; 28; 29; 30; 31, 32–33; 34; 36–38; 49; 65; 66; 67; 87–88; 93–97.

83 Şevket Rado, *Yirmisekiz Mehmet Çelebi'nin Fransa Seyahatnamesi*, 26.

84 Çelebi mentions the living population several times. See Abdullah Uçman, *Yirmisekiz Çelebi Mehmed Efendi Sefaretnâmesi*, 25; 27; 29; 31; 35; 36; 41–42; 44; 47; 50–52; 53, 59; 76–77; 77–78. The following quotations from Çelebi exemplify his amazement at seeing crowds which included women as well, in the consecutive pages of Şevket Rado, *Yirmisekiz Mehmet Çelebi'nin Fransa Seyahatnamesi*, 25, 32, 38:

Halkın çokluğu, hele kadınların fazlalığı öyle haddinden aşkın idi ki, tabiri mümkün değil ... Etraftan, bilhassa Monglir'den cümle kibar ve devletlusu karları ile gelüp bizi görmek için toplanmışlar.

Gece olsun, gündüz olsun halkın çokluğu, kadın ve erkek kalabalığı anlatılır gibi değildir. Kadın ve erkeğin devletlu ve kibarı, kimi tebdil, kimi aşikare gelmişler. Düğün evlerinin bu kadar kalabalık olduğu görülmemiştir.

Kralın tahtı yakınına varınca, iki tarata düğün evine konulan sedirler gibi, birkaç yüz sediri bibirinden yüksek koyup tertip etmişler. Bu sedirlerde ne kadar kibar karıları ve kralın hısımları var ise toplanıp mücevherlerle süslü, pırıl pırıl elbiseler ile oturmuşlar.

85 Abdullah Uçman, *Yirmisekiz Çelebi Mehmed Efendi Sefaretnâmesi*, 24–26; 27–29 (Toulouse); 29–32 (Bordeaux); 34–35 (Poitiers); 36–37 (Amboise, Chatellerault); 37–38 (Orleans); 41, 72–74, 76–77 (Paris); 49–52 (the palace and gardens of the emperor, most probably Louvre); 62–64 (St. Cloud); 64, 70–72 (Versailles); 64–66 (Meudon); 66–67 (Trianon); 67–70 (Marly); 87–92 (Chantilly); 93–94 (Fontainebleau); 57–58 (landscape models); 94–97.

86 Abdullah Uçman, *Yirmisekiz Çelebi Mehmed Efendi Sefaretnâmesi*, 62–63.

87 *Ibid.*, 155.

88 Şevket Rado, *Yirmisekiz Mehmet Çelebi'nin Fransa Seyahatnamesi*, 59.

89 Abdullah Uçman, *Yirmisekiz Çelebi Mehmed Efendi Sefaretnâmesi*, 69–70.

90 *Ibid.*, 87–91.

91 *Ibid.*, 93–94.

92 Şevket Rado, *Yirmisekiz Mehmet Çelebi'nin Fransa Seyahatnamesi*, 51.

93 *Ibid.*, 59.

94 Translations of the names of the palaces and gardens are in Tülay Artan, "Architecture as a Theatre of Life," 62.

95 Abdullah Uçman, *Yirmisekiz Çelebi Mehmed Efendi Sefaretnâmesi*, 62–63.

96 *Ibid.*, 87–91.

97 William L. Hannaway Junior, "Paradise on Earth: The Terrestrial Garden in Persian Literature," in *Islamic Garden*, ed. Elisabeth B. MacDougall and Richard Ettinghausen (Washington, DC: Dumbarton Oaks Publications, 1976), 41–68.

98 Sedad Hakkı Eldem, *Sa'dabad*, 146; from "Ziyafet-i Asafi Bicenab-ı Şehriyar-ı İskender Nihad der Temaşgah-ı Sa'dabad," in Zeyl-i Raşid Küçük Çelebizade Ismail Asım, no. B. 22 folio 18a.

99 Abdul Rehman, *Earthly Paradise: The Garden in the Times of the Great Muslim Empires* (Lahore: M. Shahid Adil for Dost Associates, 2001), 15.

100 *Ibid.*, 14.

101 *Ibid.*, 14–15.

102 Emma Clark, *Underneath Which Rivers Flow: The Symbolism of the Islamic Garden* (London: The Prince of Wales's Institute of Architecture, 1996).

103 Sedad Hakkı Eldem, *Sa'dabad*, 144–146; from "Ziyafet-i Asafi Bicenab-ı Şehriyar-ı İskender Nihad der Temaşgah-ı Sa'dabad," from Zeyl-i Raşid Küçük Çelebizade Ismail Asım, no. B. 22 folio 18a.

6

The "Storehouse" of Ottoman Landscape Tradition: Gardens and City Spaces as *Barzakh*

The "storehouse"—a term borrowed from Ibn al-'Arabî—of Ottoman landscape tradition included all kinds of spaces, regardless of scale. It was compromised of sacred and ordinary cities, provincial towns, all kinds of city spaces—gardens and parks, neighborhoods, streets, Sufi lodges, market places, bazaars, bath-houses or houses of friends, and the space of the human body. The "storehouse" of Ottoman landscape culture included both real and imaginary spaces: physical spaces of gardens, cities and the human body; and metaphysical spaces of paradise garden(s), cosmography and imagination. Ottoman landscape mapped both physical and metaphysical spaces, defining the limits of the Ottoman world territorially on land, heavenly in celestial space, and phenomenally in human perception and imagination.

Landscape is the mapping of those space(s) wherever cultural practices of society can be traced, and thus in turn exercised. An ordinary space becomes landscape when it gains a temporal quality that allows one to decipher transformations of cultural practices. Places attain the quality of being a landscape when they spell out the confrontation of social patterns of daily life and individual desires with space. Landscape is the conglomeration of culturally appropriated spaces pieced together. Individuals and groups that made up the society exercise diverse cultural practices; thus performing diverse spatial practices and generating novel forms of space. What binds diverse pieces of landscape together is not different from what binds the variegated faces of the society it belongs to. Landscape is a mirror reflecting different features of the multi-faceted society. It is the representation of dynamics between individuals and community, obedience and resistance, love and hatred, faith and cynicism, confidence and suspicion, dreams and reality. It includes everything pertaining to human life. Landscape expresses narratives of ideology, becoming, aesthetics, eroticism, citizenship, individuality and community. Landscapes are not bounded by visual or material boundaries; by enclosures, walls or barriers; but landscape boundaries follow the margins of cultural patterns drafted in space regardless of scale. Denis Cosgrove points out the symbolic content of landscapes as representing different ideologies mapped on nature:[1]

Landscape, I shall argue, is an ideological concept. It represents a way in which certain classes of people have signified themselves and their world through their imagined relationships with nature, and through which they have underlined and communicated their own social role and that of others with respect to external nature.

Cosgrove and Daniels explain the concept of landscape as a "cultural image" embedded in all forms of cultural production textually, visually and architecturally. Thus, the idea of landscape is not limited to the design of natural or man-made materials in space, but it comprises all kinds of "text"s written and all kinds of "texture"s woven in space by means of various media:[2]

A landscape is a cultural image, a pictorial way of representing, structuring or symbolizing surroundings. This is not to say that landscapes are immaterial. They may be represented in a variety of materials and on many surfaces—in paint on canvas, in writing on paper, in earth, stone, water and vegetation on the ground. A landscape park is more palpable but no more real, nor less imaginary, than a landscape painting or poem. Indeed the meanings of verbal, visual and built landscapes have a complex interwoven history.

Ottoman landscape culture mapped different cities from Istanbul to Diyarbakır, from Edirne to Kashan. It suggested traveling in the streets, in city spaces—bazaars, markets, bathhouses, coffee houses, houses of friends, gardens; from one city to another, from terrestrial to celestial worlds, generating a unique understanding of landscape where not only gardens under shade, but also supra-natural spaces blended to city spaces and spaces of the human body.

Movement through landscape triggers human cognition in terms of senses, perception and imagination and provokes individual interpretation. The instant experience residing in movement conditions the mutual construction and transformation of the human self and space with respect to one another. Michel Conan stresses the importance of motion related to the idea of landscape, which acts as an agency for individual development, in addition to the cultural development:[3]

Motion through a landscape metaphor engages visitors into a hermeneutical activity that reactivates the meaning of a cultural tradition at the same time that it enables them to bring new meaning to their lives. In that respect, intersubjectivity, as mediated by the experience of motion through a landscape metaphor, contributes to the development of the individual and the cultural community to which the individual belongs.

In the Ottoman poetic genre of şehrengiz, movement, traveling, exploration, and contemplation were major themes, and the city was a source of joy and pleasure and as well, was a source of knowledge. Şehrengiz poems accounted for the journey of the poet in the city. The city unfolds in a realistic manner, as the poet wanders along the different neighborhoods; looks around; utters affection for beautiful young men of the guilds; and broods over urban

culture, daily life, and different spaces of the city. These poems depicted not only Istanbul, but also 13 other provincial cities outside Istanbul. The genre developed until the early eighteenth century with poems mapping the poets' experiences in the city of Istanbul, going back and forth to other provinces, especially to Edirne. The genre documented the rituals of marginal Sufi groups bearing deviant philosophies of Sufi mysticism, in the real spaces of different cities and in ideal spaces of the Sufi imagination.

The Ottoman landscape culture developed as a result of the interaction of the diverse ideals proposed by the orthodox and different heterodox traditions, yet establishing an ontological understanding of the world. The Ottoman concept of space was structured as a multi-layered hierarchical understanding of spaces that informed the order of cosmography, where all the spaces of different layers comprised an interior and an exterior. The interior was the domain of essence and God. The exterior was the domain of form and the material world. The orthodox and different heterodox traditions challenged the superiority of the interior and the exterior spaces, arguing the superiority of one over the other. The Ottoman orthodox tradition argued for the superiority of the interior spaces. However, following after the doctrines of the Islamic philosopher Ibn al-'Arabî, Sufi mystics of the *Melâmî* philosophy argued the superiority of an intermediary space called *barzakh*.

Ibn al-'Arabî's philosophy was significantly instrumental in the development of Ottoman culture, though its influence was diverse. Interpretations of his doctrines differed fundamentally from one another. Ibn al-'Arabî proposed that the attainment of knowledge was possible by contemplation. Contemplation implied understanding the order of the cosmos and by doing so participating in this order. It involved all things existent in physical and metaphysical reality. Alluding to the dual nature of the Islamic cosmography made out of an interior and an exterior, 'Arabî explained all things as signs made of two parts: an invisible essence and a visible form. Contemplation aimed at understanding the relationship between the parts of a sign. Contemplation—thus, the attainment of knowledge—was enabled by the faculty of imagination. 'Arabî also asserted the importance of the space where the attainment of knowledge takes place. He defined such spaces as gardens. 'Arabî and following him, *Melâmîs*, asserted the importance of individual involvement in the attainment of knowledge since each individual was able to contemplate according to his own capacities.

The Ottoman orthodox tradition acknowledged gardens as spaces for the attainment of knowledge, thus spaces of contemplation. Gardens were designated as interior spaces allowing for communication of the divine essence resided in the interior spaces of the cosmography. Following the Ottoman orthodox tradition, gardens became ideal representations of the realm of imagination and designated as spaces for the attainment of knowledge. Each garden became an intermediary space (*barzakh*) and in turn, each intermediary space facilitating the faculty of imagination for the attainment of knowledge came to be experienced as a garden.

Yet, different than the orthodox tradition, the heterodox tradition of the *Melâmîs* adopted 'Arabî's three-tiered definition of space and cherished the encounter of interior and exterior spaces in the intermediary space of the *barzakh* to be superior to the former ones. Each space, whether a garden or not, that is designated as a place for the attainment of knowledge became a *barzakh* and came to carry qualities of the paradise garden. *Barzakh* became a space of meeting.

Melâmîs valued each human being as a beloved reflection of God. They regarded every single citizen as deserving objects of mystic love. In order to pursue this endeavor of meeting and getting to know the individual self and other individuals for the sake of the attainment of the knowledge of God, they contemplated the city offering a variety of spaces enabling an encounter with the other individuals. In different city spaces, each individual became a beloved one reflecting the divine qualities of God. Thus, through *Şehrengiz* rituals, spaces of the city were recognized as intermediary spaces, each as a *barzakh*. The city was experienced as a compilation of intermediary spaces between the invisible realm of celestial and visible realm of material space.

Rituals either performed by the Ottoman elite in the gardens or by marginal Sufi groups in various spaces of the city gave way to the production of new cultural patterns and in turn, implied the production of new spatial practices and new spaces. The differences in the temporal and spatial orders of the *gazel* and *şehrengiz* rituals, the contrast between their endeavors, gave way to the production of new spatial practices, and in turn to a different understanding of space. *Gazel* rituals informed the use of garden spaces. *Şehrengiz* rituals informed the use of different city spaces including the private gardens. They carried different ideological motives and defined their spaces of performance with different political perspectives. *Gazel* rituals aimed to anchor the imperial power within the secluded spaces of the gardens. On the contrary, *şehrengiz* rituals treated each one of the subjects of the Ottoman authority as individuals, aimed at liberating and directing them to their own theophany outside the secluded spaces of the gardens. *Gazel* rituals followed after an imperial tradition, governed strict modes of social behavior and involved pre-established cultural patterns. However, *şehrengiz* rituals followed after a marginal philosophy and each employed a liberated order. *Şehrengiz* rituals developed after marginal Sufi practices, also used Sufi metaphors extensively. The contrast and the clash between *gazel* and *şehrengiz* rituals gave way to open developments of new social and cultural patterns adapted by larger groups of city dwellers, who neither pursue the imperial agenda of the *gazel* rituals, nor carry the anti-imperial marginal perspectives of the *şehrengiz* rituals.

The court poets who were participants of the *gazel* rituals performed in private gardens of the sultan, or other members of the ruling class, also participated in *şehrengiz* rituals and acted as agents of social transformation. *Şehrengiz*, as a genre, presented commoners and the participants of guilds as the beloved ones, and narrated human love for the ordinary. The rituals

told in *şehrengiz* poems depicted common guilds as they were physically and mentally liberated from the customary orthodox traditions and prayers by a free practice of movement.

Şehrengiz poems described meadows, gardens, rose gardens, imperial gardens, rivers, canals, seas, mosques, Sufi lodges, streets, open public spaces, populated houses, bathhouses, palaces, private houses of friends and poets, castles, hills, spring waters, city walls, bazaars, guild shops, neighborhoods. *Şehrengiz* rituals made use of Sufi metaphors of contemplation and traveling. However, in time, these Sufi metaphors came to be used for profane practices as well and defined spaces of profane activity shared by the common conscious of the city dwellers. In time, common folk used to perform activities similar to the practices enjoyed in *şehrengiz* rituals, like watching and adoring the beauty of different city spaces. By means of the communication process, Sufi metaphors, which the *şehrengiz* rituals made use of, came to be used for profane purposes. Sufi metaphors of contemplation (*seyr, temaşa, teferrüc*) came to mean watching and adoring profane beauty. Even the Süleymaniye Mosque, which was once disregarded in *şehrengiz* rituals for representing the imperial power, was illustrated by Evliya Çelebi much later in the seventeenth century with the same metaphors used in *şehrengiz* rituals with reference to the elevated courtyard of the complex, overlooking the city to contemplate the world. Even these Sufi metaphors of contemplation (*seyr, temaşa, teferrüc*) came to be used in the identification of public promenades enjoyed by city dwellers, as places (*mesire, temaşa-gah, teferrüc-gah*) to go strolling and to enjoy contemplating the beauty of the sight of the city where the heart is freed from ennui.[4] In an early seventeenth-century document, visiting Kağıthane is acknowledged as going for a pleasurable visit and sightseeing (*seyre giden*).

The idea and the image of the city, regarding its perception and experience, were also shaped with respect to the encounter of contrasting ideals. The city was shaped in between the encounter of opposing forces, in between power struggles that shaped the society and its culture. It was neither *şehrengiz* rituals, *Melâmî* doctrines, individuals' assertion to express their identity nor *gazel* rituals, conventions of orthodoxy, or the control mechanism of the ruling class that shaped the city of Istanbul. However, their opposition and encounter constructed the city of Istanbul and its urban culture. Going forth between Edirne and Istanbul, between imperial and anti-imperial ideologies, between ideal and real spaces created in the city enforced a unique experience shared by its citizens. According to Ibn al-'Arabî, imagination had creative powers and provided the attainment of knowledge. Accordingly, the experience of the city of Istanbul and its urban culture was shaped in the intermediary realm of Ottoman imagination nourished from the orthodox and multiplicity of the heterodox philosophies, whether deviant or not. Whereas at the same time, Ottoman culture, society and the self were each shaped in a variegated landscape made out of gardens and urban spaces of different cities, each designated as paradise garden(s); each as a *barzakh*.

Notes

1. Denis Cosgrove, *Social Formation and Symbolic Landscape* (Wisconsin: University of Wisconsin Press, 1998, c. 1984), 15.

2. Denis Cosgrove and Stephen Daniels, eds., *The Iconography of Landscape: Essays on the Symbolic Representation, Design and Use of Past Environments* (Cambridge, UK: Cambridge University Press, 1988), 1.

3. Michel Conan, "Landscape Metaphors and Metamorphosis of Time," in *Landscape Design and Experience of Motion*, ed. Michel Conan (Washington, DC: Dumbarton Oaks Research Library and Collection, 2003), 307–308.

4. Ferit Develioglu, *Osmanlica-Turkce Ansiklopedik Lûgat* (Istanbul: Aydın Kitabevi, 2000) 626; 945; 1,072; 1,057.

APPENDICES

Appendix 1: Life of Ibn al-'Arabî[1]

Ibn al-'Arabî is also called Abu Bakr Muhammed ibn al-'Arab or *Şeyh Ekber Muhyiddin-i Arabi* in Turkish, on which the latter *Ekberiyye* tariqat is founded, referring to his name. He had traveled extensively in Muslim countries. 'Arabî was named after Plato as Ibn Aflatun.[2] In the history of world philosophy, Ibn 'Arabî has also been recognized as a Neo-Platonist, as the Tao of Islam.

Ibn al-'Arabî was born in Murcia, Andalucia, and died in Damascus. He traveled to Andalusia and North Africa, Fez, Tunis (1193–1200); to Mecca and Mosul (1201); Cairo; and Mecca (1207). He was invited to the Seljuk land by the Sultan, lived in Malatya, and in Konya, Diyarbakır (1210). He went to Baghdad (1211); returned to Mecca, and traveled to Aleppo (1214). Finally, he settled and died in Damascus (1223–1240). Ottoman Sultan Selim I built a mausoleum for him (1517) upon the conquest of the city of Damascus. Ibn 'Arabî's way of writing, thinking, and discussing is parallel to his discussions in the domains of ontology, epistemology, and hermeneutics.

His philosophy and his life correspond to one another in harmony. There are more than 400 books attributed to Ibn 'Arabî. One of the most important works of 'Arabî is *Fusus al-Hikam* (*The Gems of the Wisdom of Prophets*) written in 1229. It was about the wisdom of 27 prophets from Adam to Muhammed. His other most well-known book is *Kitab-al Futuhat ali Makkiya fi ma'rifat al-asrar al-malikiya wa'l mulkiya* (*The Book of the Revelations Received in Mecca Concerning the King and the Kingdom*), written between 1230 and 1237; it consisted of 560 chapters. It was mainly about Ibn 'Arabî's principles of metaphysics. The book had a complex structure with juxtaposed thoughts, both a theoretical and experimental text at the same time. As Nasr acknowledges:[3]

The *Futuhat* contains, in addition to the doctrines of Sufism, much about the lives and sayings of the earlier Sufis, cosmological doctrines of Hermetic and Neoplatonic origin integrated into Sufi metaphysics, esoteric sciences life Jafr, alchemical and astrological symbolism, and practically everything else of an esoteric nature which in one way or another has found a place in the Islamic scheme of things.

His style of writing can be depicted as a continuous practice of arguments listed one after another. It explains a particular way of thinking which is not linear or confined within a single body. It develops and unfolds into different arguments or contradictions as it continues. It is not a text to prove any hypothesis. However, it should be considered as a map of thinking which had been developed by writing. Writing was his actual practice of thinking; it was a technique of representation arguing for and against different concepts. Interpretations of 'Arabî's work may lead to different directions of thoughts and reasoning, or to contrasting results. These are due to these inherent qualities of the text. It was not an illustration of any profane idea, or objective, but a representation of the process of thinking which takes place in different territories of schools of thought. Thus, as a philosopher, 'Arabî's purpose and technique of writing, the structure of his text, and its content coincide with one another as a philosophy of inquiring True Knowledge through comparing and contrasting, discussing and explaining concepts in numerous ways, in an endless pattern. Thus, as Corbin acknowledges, 'Arabî's whole life and his entire work should be considered within the line of his arguments, where everything about him becomes part of a philosophical system compiled to respond to all phases of his life, without ignoring, but always welcoming every other kind of logic and reasoning—welcoming the reality of both the physical and metaphysical worlds as a quest for learning. "It is the work of an entire lifetime; Ibn 'Arabi's whole life was this long quest. The decisive encounter took place and was renewed for him through Figures whose variants never ceased to refer to the same Person."[4]

Notes

1 See the third chapter in Seyyed Hossein Nasr, *Three Muslim Sages: Avicenna, Suhrawardi, Ibn Arabi* (Cambridge, MA: Harvard University Press, c.1964, 1969). For more detailed arguments on 'Arabî's philosophy, see Henry Corbin and William C. Chittick, who discuss various concepts as constructed in the works of 'Arabî analytically and in detail; Henry Corbin, *Creative Imagination in the Sufism of Ibn 'Arabî*, trans. Ralph Manheim (Princeton, NJ: Princeton University Press, 1969); William C. Chittick, *The Sufi Path of Knowledge: Ibn al-'Arabî's Metaphysics of Imagination* (Albany, NY: State University of New York Press, c.1989); William C. Chittick, *The Self-Disclosure of God: Principles of Ibn al-'Arabî's Cosmology* (Albany, NY: State University of New York Press, c. 1998). For the translation of parts of Arabi's works into English, see Michel Chodkiewicz, ed., trans. William C. Chittick and James W. Morris, *The Meccan Revelations (al-Futuhat al Makkiya)* (New York, NY: Pir Press, 2002); Titus Burckhardt, trans., *The Wisdom of the Prophets (Fusus al-hikam)* (Aldsworth, Glos., UK: Beshara Publications, c.1975); Reynold A. Nicholson, ed., *A Collection of Mystical Odes (Tarjuman al-ashwaq)* (London: Royal Asiatic Society, 1911); R.W.J. Austin, trans., *The Bezels of Wisdom* (London: SPCK, 1980). For further reading on 'Arabî, see Sachiko Murata and William C. Chittick, *Vision of Islam* (New York, NY: Paragon House, 1994); Masataka Takeshita, *Ibn Arabi's Theory of the Perfect Man and its Place in the History of Islamic Thought*

(Tokyo, Japan: Institute for the Study of Languages and Cultures of Asia and Africa, 1987); Gerard Elmore, "Poised Expectancy: Ibn al-Arabî's Roots in Sharq al-Andalus," in *Studia Islamica* 90 (2000), 51–66.

2 Henry Corbin, *Creative Imagination in the Sufism of Ibn 'Arabî*, 40–41.

3 In Seyyed Hossein Nasr, *Three Muslim Sages*, 98.

4 Henry Corbin, *Creative Imagination in the Sufism of Ibn 'Arabî*, 44.

Appendix 2: Disciples of Ibn al-'Arabî in *Bayrami* and *Melâmî-Bayrami* Orders of Sufi Mysticism

Bayrami Order

SOME OF HACI BAYRAM VELIS'S DERVISHES

1. Göynüklü Salâheddini Tavil
2. Ince Bedreddin
3. Seykh Bedreddin (acknowledged as founder of the *Bedreddini* Order)
4. Akbıyık Abdullah
5. Ak Şemseddin (founder of the *Şemsiyye-yi Bayramiyye* Order)
6. Mehmet Bican
7. Ahmet Bican
8. Ömer Sikkini (founder of the *Melâmî* Order)

Development of *Bayrami* Order into *Melâmî* Order

Hacı Bayram Veli (1352–1429)

Bayramiyye Order

Ak Şemseddin (1389–1458)	Ömer Sikkini (d. 1474/76?)
Şemsiye Order	*Melâmî Order*
(*Şemsiyye-yi Bayramiyye*)	(*Melamiyye-yi Bayramiyye*)

Appendix 3: *Melâmî* Poles

NAMES OF THE POLES	GEOGRAPHY OF EXPANSION
Melâmî–Bayramis	
Ömer Sikkini (d. 1474/76?)	Northwest Anatolia
Bünyamin Ayaşi (d. 1522?)	
Pir Ali Aksarayî (d. 1528)	Central Anatolia
İsmaili Maşukî* (d. 1539)	Istanbul
Ahmed Sârbân (d. 1546)	Thrace and Balkans
Hâşimî Seyyit Osman (d. 1594)	Vize and Istanbul
Hüsameddin Ankaravi (d. 1556)	Ankara
Melâmî–Hamzavîs	
Hamza Bâlî (d. 1561)	Bosna
Hasan Kabadûz (d. 1601)	Northwest Anatolia
Idris-i Muhtefi (d. 1615)	Istanbul and Balkans
Hacı Bayram Kabayî (d. 1617)	Istanbul
Sütçü Beşir Ağa* (d. 1661)	Istanbul
Bursalı Seyyid Haşim (d. 1676)	Istanbul
Şeyhülislam Paşmakçızade Ali Efendi (d. 1711)	Istanbul court
Grand Vizier Şehid Ali Paşa (d. 1715)	Istanbul court

* Executed with several of his disciples.

Appendix 4: List of *Şehrengiz* Poems*

Sixteenth Century

1. *Şehrengiz-i Der Medh-i Cuvanan-ı Edirne* by Piriştineli Mesihi, İsa
2. *Şehrengiz-i Edirne* by Balıkesirli Zati Ivaz
3. *Şehrengiz of İstanbul and Vize* by Çorlulu Katib
4. *Şehrengiz-i İstanbul* by Taşlıcalı Yahya
5. *Şehrengiz-i Bursa* by Bursalı Lamii Mahmud Çelebi
6. *Şehrengiz-i Belgrad* by Yenicevardarlı Hayreti Mehmed
7. *Şehrengiz-i Bursa* by Üsküplü Kılıççızade İshak Çelebi
8. *Şehrengiz-i Yenice* by Yenicevardarlı Usuli
9. *Şehrengiz* by Bursalı Nihali Câfer Çelebi
10. *Şehrengiz-i Rize*
11. *Şehrengiz-i İstanbul* by Kalkandelenli Fakiri
12. *Şehrengiz-i İstanbul* (Persian) by Safi.
13. *Şehrengiz-i Edirne* by Edirneli Kerimi b. Mahmud
14. *Şehrengiz-i İstanbul* by Taşlıcalı Yahya
15. *Şehrengiz-i Gelibolu* by Gelibolulu Vechi
16. *Şehrengiz* by Moralı Kadı Firdevsi Çelebi
17. *Şehrengiz-i Yenişehir* by Bursalı Rahmi Pir Mehmed
18. *Şehrengiz-i Bursa*
19. *Şehrengiz-i Amid* by Diyarbakırlı Halife
20. *Şehrengiz-i İstanbul*
21. *Şehrengiz-i Bursa* by Bursalı Halili (Sarı Halil)
22. *Şehrengiz-i Edirne* by Tabii (Edirneli Feyzi Ali)
23. *Şehrengiz-i İstanbul* by Kastamonulu Kadı Kıyasi
24. *Şehrengiz* by Amasyalı Süluki Mehmed
25. *Şehrengiz* by Kemali
26. *Şehrengiz-i İstanbul*, Anonymous
27. *Şehrengiz-i İstanbul* by İstanbullu Tab'i İsmail

28. *Şehrengiz-i İstanbul* by İstanbullu Defterdarzade Cemali Ahmed
29. *Şehrengiz-i Siroz* by İstanbullu Defterdarzade Cemali Ahmed
30. *Şehrengiz-i Siroz*, Anonymous
31. *Şehrengiz-i İstanbul der Huban-ı Zenan* (*Nigarname-i Zevk-amiz Der Şehr-engiz*) by Azizi Mustafa, Yedikuleli
32. *Şehrengiz-i Manisa* by İstanbullu Ulvi Mehmed Terzizade
33. *Şehrengiz-i Sinop* by Sinoplu Beyani
34. *Şehrengiz-i Antakya* by Galatalı Siyami
35. *Şehrengiz Beray-i Hub-ruyan-ı Gelibolu* by Gelibolulu Mustafa Ali
36. *Şehrengiz-i Bursa* by Mani, Kadı Çalıkzade Mehmed

Seventeenth Century

37. *Şehrengiz-i Beray-ı Taşköprü*, Anonymous.
38. *Şehr-i Kaşan'un Vasfı ve Medh-i Cemilidür*, Anonymous.
39. *Şehrengiz* by Fehim-i Kadim, Uncuzade Mustafa, İstanbullu.
40. *Şehrengiz-i Edirne* by Edirneli Neşati Ahmed Dede
41. *Şehrengiz-i Bursa* by Bursalı Konya Kadısı Nazük Abdullah

Eighteenth Century

42. *Şehrengiz-i Cilve-resa ve Ayine-i Huban-ı Bursa* by Bursalı Beliğ İsmail
43. *Şehrengiz-i Bursa* by Bursalı Beliğ İsmail
44. *Lalezar* by Vahid Mahmudi, İstanbullu Mehmed

* List of *Şehrengiz* poems by Agah Sırrı Levend.

Bibliography

Abbott, G.F., ed. *Under the Turk Constantinople. A Record of Sir John Finch's Embassy, 1674–81*. London: Macmillan, 1920.

Abdülaziz Bey. *Osmanlı Adet, Merasim ve Tabirleri*. Edited by Kemal Arısan and Duygu Arısan Günay. Istanbul: Yapı Kredi Yayınları, 1995.

Abou-el-Haj, R. Ali. *Formation of the Modern State: The Ottoman Empire Sixteenth to Eighteenth Centuries*. Albany, NY: SUNY Press, 1991.

Addas, Claude. *Quest for the Red Sulphur: The Life of Ibn Arabi*, translated by Peter Kingsley. Cambridge: Islamic Texts Society, 1993.

Adıvar, A. Adnan. *Osmanlı Türklerinde İlim*. 1943. Reprint, Istanbul: Remzi Kitabevi. 2000.

Akalay (Tanındı), Zeren. "Osmanlı Tarihiyle Ilgili Minyatürlü Yazmalar: Şehnameler ve Gazanameler." PhD diss., Istanbul University, Istanbul, 1972.

Aktepe, M. Münir. "Damad İbrahim Paşa Devrinde Lale." İstanbul Üniversitesi Edebiyat *Fakültesi Tarih Dergisi* IV/7 (1952): 85–126.

———. "Kağıthane'ye Dair Bazı Bilgiler." In *Ord. Prof. İsmail Hakkı Uzunçarşılı'ya Armağan*, 335–63. Ankara: 1976.

———. "18. Yüzyılın İlk Yarısında Kağıthane ve Sadabad." *TTOK Belleteni* 72 (1984–1985): 14–19.

Akural, Sabri. *Continuity and Change*. Bloomington, IN: Indiana University Press, 1987.

Alemi, Mahvash. "Chahar Bagh." *Environmental Design,* no. 3 (Rome, 1986): 38–45.

———. "Urban Spaces as the Scenes for the Ceremonies and Pastimes of the Safavid Court." *Environmental Design,* no. 11 (Rome, 1991): 98–107.

———. "The Royal Gardens of the Safavid Period: Types and Models." In *Gardens in the Time of Great Muslim Empires*, edited by Attilio Petruccioli, 71–96. Leiden; New York; Cologne: E.J. Brill, 1997.

Altınay, Ahmet Refik. *Lale Devri*. Istanbul: Sanayii Nefise, 1932.

———. *Lale Devri*. Edited by Osman Okçu, translated by Dursun Gürlek. Reprint, Istanbul: Timaş Yayınları, 1997.

Ambros, Edith. *Candid Penstrokes: Lyrics of Meali an Ottoman Poet of the 16th Century*. Berlin: Klaus Schwarz Verlag, 1982.

Anadol, Cemal. *Türk-Islam medeniyetinde Ahilik Kültürü ve Fütüvvetnameler*. Ankara: T.C. Kültür Bakanlığı, 2000.

And, Metin. *A History of Theatre and Popular Entertainment in Turkey*. Ankara: Forum Yayınları, 1963–1964.

_____ . *A Pictorial History of Turkish Dancing from Folk Dancing to Whirling Dervishes, Belly Dancing to Ballet*. Ankara: Dost Yayınları, 1976.

_____ . *Istanbul in the 16th Century*. Istanbul: Akbank, 1994.

Andrews, Peter A. "The Felt Tents of Central Asia." *Ars Turcica*. Akten des VI internationalen Kongresses fur Turkische Kunst, Munchen, vom 3. bis 7. September 1979 (Munich: Editio Maris, 1987): 403–418.

_____ . "The Generous Heart or the Mass of Clouds: The Court Tents of Shah Jahan." *Muqarnas* 4 (Leiden: E.J. Brill, 1987): 149–165.

Andrews, Walter G. "Tezkire-i Şuara of Latifi as a Source for Critical Evaluation of Ottoman Turkey." PhD diss., University of Michigan, Michigan, 1970.

_____ . "A Critical Interpretative Approach to the Ottoman Turkish Gazel." *International Journal of Middle East Studies* 4/1 (1973): 97–111.

_____ . *An Introduction to Ottoman Poetry*. Minneapolis, MN: Bibliotheca Islamica, 1976.

_____ . *Poetry's Voice, Society's Song: Ottoman Lyric Poetry*. Seattle and London: University of Washington Press, 1985.

_____ . "The Sexual Intertext of Ottoman Literature: The Story of Meali, Magistrate of Mihalich." *Edebiyat: A Journal of Middle Eastern and Comparative Literature* III/1 (1989): 31–56.

_____ . "Singing the Alienated 'I': Guattari, Deleuze and Lyrical Decodings of the Subject in Ottoman Divan Poetry." *The Yale Journal of Criticism* 6/2 (1993): 191–219.

_____ . *Ottoman Lyric Poetry: An Anthology*. Austin, TX: University of Texas Press, 1997.

_____ . "'Yabancılaşmış Ben' in Şarkısı: Guattari, Deleuze ve Osmanlı Divan Şiirinde Öznenin Lirik Kod Çözümü." *Defter* 39 (Bahar 2000): 106–132.

_____ . *Intersections in Turkish Literature: Essays in Honor of James Stewart-Robinson*. Ann Arbor, MI: University of Michigan Press, 2001.

Andrews, Walter G. and Irene Markoff. "Poetry, the Arts, and Group Ethos in the Ideology of the Ottoman Empire." *Edebiyat: A Journal of Middle Eastern and Comparative Literature* I/1 (1987): 28–70.

Angelis, M.A. and T.W. Lentz. *Architecture in Islamic Painting: Permanent and Impermanent Worlds*. Cambridge, MA: Acme Printing, Fogg Art Museum / The Aga Khan Program for Islamic Architecture, 1982.

Arberry, A.J. *The Doctrine of the Sufis*. Cambridge, UK: Cambridge University Press, 1989, c. 1935.

Ardalan, Nader. "The Paradise Garden Paradigm." In *Conciousness and Reality Studies in Memory of Toshihiko Izutsu*, edited by Sayyid Jalal Al-Din Ashtiyani, H. Matsubara, T. Iwami and A. Matsumoto, 97–127. Leiden: E.J. Brill, 1999.

Ardalan, Nader and Laleh Bakhtiar. *The Sense of Unity: The Sufi Tradition in Persian Architecture*. Chicago; London: University of Chicago Press, 1973.

Arel, Ayda. *Onsekizinci Yüzyıl İstanbul Mimarisinde Batılılaşma Süreci.* Istanbul: 1975.

Armağan, Mustafa. *Bursa Şehrengizi.* Istanbul: İz Yayıncılık, 1998.

Arminius, Vambery. "Voyage dans l'Asie Centrale," *Le Tour du Monde,* Paris XII (1865): 96.

Arnaldez, Roger, ed. *Averroës: A Rationalist in Islam.* Translated by David Streight. Notre Dame, IN: University of Notre Dame Press, c. 2000.

Arslan, Mehmet. *Türk Edebiyatında Manzum Surnameler Osmanlı Saray Düğünleri ve Şenlikleri.* Ankara: AYK Atatürk Kültür Merkezi, 1999.

Arslan, N. *Gravür ve Seyahatnamelerde. Istanbul: 18. Yüzyıl Sonu ve 19. Yüzyıl.* Istanbul: 1992.

Artan, Tülay. "Architecture as a Theatre of Life: Profile of the Eighteenth-Century Bosphorus." PhD diss., MIT, Cambridge, MA, 1989.

——— . "The Kadirga Palace: An Architectural Reconstruction." *Muqarnas* 10 (Leiden: E.J. Brill, 1993): 201–211.

Asıltürk, Baki. *Osmanlı Seyyahlarının Gözüyle Avrupa.* Istanbul: Kaknüs Yayınları, 2000.

Aşkar, Mustafa. *Molla Fenari ve Vahdet-i Vücud Anlayışı.* Ankara: Muradiye Kültür Vakfı Yayınları, 1993.

Atasoy, Nurhan. "Türk Minyatüründe Tarihi Gerçekçilik." *Sanat Tarihi Yıllığı* I (1965): 103–109.

——— . "Türklerde Çiçek Sevgisi ve San'atı." *Türkiyemiz* 3 (1971): 14–24.

——— . *1582 Surname-i Hümayun: An Imperial Celebration.* Istanbul: Koçbank Publications, 1997.

——— . *A Garden for the Sultan: Gardens and Flowers in the Ottoman Culture.* Istanbul: Mas Matbaacılık, 2002.

——— and Filiz Çağman. *Turkish Miniature Painting.* Istanbul: R.C.D. Cultural Institute, 1974.

Atay, Hakan. "Heves-name'de aşk oyunu: Taci-Zade Cafer Çelebi'nin özgünlük ideali." Master's thesis, Bilkent University, Ankara, 2003.

Atıl, Esin A. "Surname-i Vehbi: An Eighteenth-Century Ottoman Book of Festivals." PhD diss., University of Michigan, Michigan, 1969.

——— ."Mamluk Painting in the Late Fifteenth Century." *Muqarnas* 2 (1984): 159–171.

——— . "On the Early History and Symbols of the Turkish Carpet." *Ars Turcica*: Akten des VI, internationalen Kongresses fur Turkische Kunst, Munchen, vom 3. bis 7. September 1979 (Munich: Editio Maris, 1987): 490–521.

——— . "The Story of An Eighteenth Century Festival." *Muqarnas* 10 (1993): 181–200.

——— . *Levni ve Surname Bir Osmanlı Şenliğinin Öyküsü.* Istanbul: APA Tasarım Yayıncılık ve Baskı, 1999.

Atlansoy, Kadir. *Bursa Şairleri.* Bursa: Asa Kitabevi, 1996.

Austin, R.W.J. *Sufis of Andalucia.* London: Ruskin House, 1971, 53.

Averroës. *On the harmony of religion and philosophy: A translation, with introduction and notes, of Ibn Rushd's Kitāb faṣl al-maqāl, with its appendix (Ḍamīma) and an extract from Kitāb al-kashf an manāhij al-adilla.* Translated and edited by George F. Hourani. London: Luzac & Co., 1961.

Aydın, Hakkı. *Islam Hukuku ve Molla Fenari*. Istanbul: Isaret, 1991.

Aynur, Hatice and H. Karateke. *III. Ahmed Devri Istanbul Çeşmeleri*. Istanbul: 1995.

Aypay, İrfan A. *Lale Devri Şairi İzzet Ali Paşa Hayatı Eserleri Edebi Kişiliği Divan Tenkitli Metin. Nigâr-nâme Tenkitli Metin*. Istanbul: 1998.

Ayverdi, Samiha. *Edebi ve manevi dünyası içinde Fatih*. Istanbul: Baha Matbaasi, 1974.

Babinger, Franz. *Mehmed the Conqueror and His Time*. Translated by R. Manheim. Princeton, NJ: Princeton University Press, 1992, c. 1453.

———. *Osmanlı Tarih Yazarları ve Eserleri*. Translated by C. Üçok. Ankara: Kültür Bakanlığı, 1992.

Badakhchani, S.J. *Contemplation and Action: The Spiritual Autobiography of a Muslim Scholar. Nasir al-Din Tusi. A New Edition & English Translation of Sayr wa suluk*. London: Tauris / Institute of Ismaili Studies, 1998.

Bagrow, Leo. *Giovanni Andreas di Vavassore. A Venetian Cartographer of the Sixteenth Century*. Jenkintown, PA: George Bean Library, 1939.

Bailey, Gauvin "The Sweet Smelling Notebook: An Unpublished Mughal Source on Garden Design." In *Gardens in the Time of Great Muslim Empires*, edited by Attilio Petruccioli, 129–139. Leiden, New York; Cologne: E.J. Brill, 1997.

Bakhtin, Mikhail. *Rebalais and His World*. Translated by Helene Iswolsky. Bloomington, IN: Indiana University Press, 1984.

Baldick, Julian. *Mystical Islam: An Introduction to Sufism*. London: I.B. Tauris & Company, 1989.

Balivet, Michel. *Şeyh Bedreddin: Tasavvuf ve isyan (Islam mystique et révolution armée dans les Balkans ottomans: Vie du Cheikh Bedreddîn le "Hallâj des Turcs" 1358/59–1416)*. Translated by Ela Güntekin. Istanbul: Tarih Vakfı Yurt Yayınları, 2000.

Barkan, Ömer Lütfi. *Süleymaniye Cami ve İmareti İnşaatı (1550–1557)*, 2 vols. Ankara: Türk Tarih Kurumu, 1972–1979.

Barkan, Ömer L. and Ekrem H. Ayverdi, eds. *Istanbul vakıfları tahrir Defteri 953 (1546) Tarihli*. Istanbul: Baha Matbaası, 1970.

Barsanti, Claudia. "Un panorama di Costantinopoli dal 'Liber insularum archipelaghi' di Cristoforo Buondelmonti." In *L'arte di Bisanzio e l'Italia al tempo dei Paleologi, 1261–1453*, edited by Antonio Iacobini and Mauro della Valle, 35–54. Roma: Argos, 1999.

Bayraktar, Mehmet. *Kayserili Davud*. Ankara: Kültür ve Turizm Bakanlığı, 1998.

Bayram, Mikail. *Ahi Evren ve Ahi Teşkilatının Kuruluşu*. Konya: Damla Matbaacılık, 1991.

Bayram, Sadi. *Silsile-name*. Ankara: Vakıflar Genel Müdürlüğü ile Vakıfbank Kültür Yayını, Grafik Ofset Matbaası, 2000.

Beldiceanu-Steinherr, Irene, "Un legs pieux du chroniquer Uruj." *Bulletin of the School of Oriental and African Studies*, XXXIII (London: 1970): 359–363.

Bello, Iysa Ade. "Ijma' and Ta'wil in the Conflict between Al-Ghazali and Ibn Rushd." PhD diss., University of Toronto, Toronto, 1985.

Benes, Mirka. "The Social Significance of Transforming the Landscape at the Villa Borghese, 1606–30: Territory, Trees, and Agriculture in the Design of the First

Roman Baroque Park." In *Gardens in the Time of Great Muslim Empires*, edited by Attilio Petruccioli, 1–31. New York; Cologne: E.J. Brill, 1997.

Bent, J. Theodore. *Early Voyages and Travels in the Levant. I. The Diary of Master Thomas Dallam 1599–1600. II. Extracts from the Diaries of Dr. John Covel, 1670–1679*. New York, NY: B. Franklin, 1964.

Berger, Albrecht. "Zur sogenannten Standtansicht des Vavassore." *Istanbuler Mitteilungen* 44 (1994): 329–355.

Berkeley, Jonathan. "Tradition, Innovations, and the Social Construction of Knowledge in the Medieval Islamic Near East." *Past and Present* 146 (February 1995): 38–65.

Berkes, Niyazi. "İbrahim Müteferrika." *Encylopedia of Islam*, new ed. vol. 3. Leiden: E.J. Brill, 1960): 996–998.

———. "İlk Türk Matbaa Kurucusunun Dini Ve Kimliği." *Belleten* XXVI 101–104 (1962): 715–737.

———. *The Development of Secularism in Turkey*. Montreal: McGill University Press, 1964.

Berque, Augustin. "At the Origin of Landscape." *Lotus* 101 *Everything is Landscape*. Milan: Elemond S.p.A., 1999: 42–49.

Beyani. *Tezkiretu's—Suara*. Ankara: Turk Tarih Kurumu, 1997.

Bianca, Stefano. *Hofhaus und Paradiesgarten Architektur und Lebensformen in der Islamischen Welt*. Munich: Verlag C.H. Beck, 1991.

Bierman, Irene, Rifat Abou-El-Haj and Donald Presiozi, eds. *The Ottoman City and its Parts: Urban Structure and Social Order*. New Rochelle, NY: Aristide D. Caratas, 1991.

Biller, Peter and Anne Hudson, eds. *Heresy and Literacy: 1000–1530*. Cambridge, UK: Cambridge University Press, 1994.

Birgul, M. Fatih, trans. and ed. Aşk risaleleri. Istanbul: Sır Yayıncılık, 2000.

Blair, Sheila S. and Jonathan M. Bloom, eds. *Images of Paradise in Islamic Art*. New Haven, CT: Trustees of Dartmouth College, 1991.

Blakstad, Ralph. "What is an Islamic Garden: Where is Paradise?" *Environmental Design*, no. 3 (Rome, 1986): 20–23.

Blaustein, Michael A. "Averroës on the Imagination and the Intellect." PhD diss., Harvard University, Cambridge, MA, 1984.

Bourassa, Steven C. *The Aesthetics of Landscape*. London and New York: Belhaven Press, 1991.

Boyd, Christopher Terence. "Philosophers and Theologians on the Intellect: The Averroist Controversy at the University of Paris in 1270." PhD diss., Harvard University, Cambridge, MA, 2000.

Brentjes, Buchard. "City, House, and Grave Symbolism in Central and South Asian Architecture." *Environmental Design,* no. 0 (Rome, 1984): 3–6.

Brookes, John. *Gardens of Paradise: The History and Design of the Great Islamic Gardens* London: George Weidenfeld and Nicolson Ltd, 1987.

Burckhardt, Lucius. "Cultural Landscape—A Transitory Phenomenon." *Topos* 6 (Munich: Callwey, March 1994): 38–43.

Bürgel, J.C. "Love, Lust, and Longing: Eroticism in Early Islam as Reflected in Literary Sources." In *Society and the Sexes in Medieval Islam*, edited by Afaf lutfi Al-Sayyid Marsot, 81–117. Malibu, CA: Undena Publications, 1979.

Busbecq, Ogier Ghislain de, 1522–1592. Epistolae quatuor. *The Turkish Letters of Ogier Ghiselin de Busbecq, Imperial Ambassador at Constantinople, 1554–1562*. Translated from the Latin of the Elzevier edition of 1633 by Edward Seymour Forster. Oxford, UK: Clarendon Press, 1968.

Butterworth, Charles E., ed. *Averroës' Three Short Commentaries on Aristotle's 'Topics,' 'Rhetoric,' and 'Poetics.'* Albany, NY: State University of New York Press, 1977.

Çağman, Filiz and Zeren Tanındı. "Remarks on Some Manuscripts from the Topkapı Palace Treasury in the Context of Ottoman–Safavid Relations." *Muqarnas* 13 (1996): 132–148.

Çam, Nusret. "Islam'da bazı Fikhî Meselelerin ve Mezheplerin Türk Cami Mimarisine Tesiri." *Vakıflar Dergisi* 21 (1990): 376–394.

Cantemir, Dimitrie. *The History of the Growth and Decay of the Ottoman Empire*. Translated by N. Tindal. London: 1734.

Careri, Francesco. *Walkscapes: Walking as an Aesthetic Practice*. Barcelona: Editorial Gustavo Gili, SA, 2002.

Cassirer, Ernst, Paul Oskar Kristeller and John Herman Randall, eds. *The Renaissance Philosophy of Man*. Chicago: University of Chicago Press, 1948.

Cataldi, G. and G. Pizziolo. "Territory and Tents in Southern Jordan." *Environmental Design*, no. 7 (Rome, 1988): 10–23.

Çavuşoğlu, Mehmed, ed. and trans. *Yahya Bey Divanı*. Istanbul: IÜEF, 1977.

Ceccherini, Rita, Gianni Celestini, Fabio Di Carlo and Raffaella Strati. "The Town as a Garden: The Case of Yemen." *Environmental Design: Journal of the Islamic Environmental Design Research Centre* 2 (Rome, 1986): 48–55.

Çeçen, Kazım. *Istanbul'un Osmanlı Dönemi Suyolları*. Edited by Celal Kolay. Istanbul: Omaş Ofset A.Ş., 2000.

Çelebi, Asaf Halet. *Divan Şiirinde Istanbul*. 1953. Reprint, Istanbul: Hece Yayınları, 2002.

Çelebioğlu, Amil. *Türk Edebiyatında Mesnevi* (1999).

Cemali: hayati, eserleri ve divani: inceleme, tenkidli metin. Cambridge, MA: Harvard University Press, 1994.

Cerasi, Maurice. "Open Space, Water and Trees in Ottoman Urban Culture in the XVIIIth–XIXth Centuries." *Environmental Design*, no. 2 (Rome, 1985): 36–49.

———. "'Frenk, Hind ve Sind' Real and Imaginary in the Aesthetics of Ottoman Open Space." *Environmental Design*, no. 4 (Rome, 1986): 16–23.

Chittick, William C. "Sadr al-Din Qunawi on the Oneness of Being." *International Philosophical Quarterly* 21 (1981): 171–184.

———. "The Divine Roots of Human Love." *Journal of the 'Ibn Arabi Society* 17 (1985): 55–78.

———. *The Sufi Path of Knowledge: Ibn al-'Arabî's Metaphysics of Imagination*. Albany, NY: State University of New York Press, 1989.

———. *Imaginal Worlds: Ibn-al Arabi and the Problem of Religious Diversity*. Albany, NY: State University of New York Press, 1994.

———. *The Self-Disclosure of God: Principles of Ibn al-'Arabî's Cosmology*. Albany, NY: State University of New York Press, 1998.

———. "The Five Divine Presences: From al-Qunawi to al-Qaysari." *The Muslim World* 78 (1998): 51–82.

———. *Sufism: A Short Introduction*. Oxford: Oneworld Publications, 2000.

———. *The Heart of Islamic Philosophy: The Quest for Self-knowledge in the Teachings of Afdal al-Din Kashani*. Oxford; New York: Oxford University Press, 2001.

Chodkiewicz, Michel. *An Ocean Without Shore: Ibn Arabi, the Book and the Law*. Translated by David Streight. Albany, NY: SUNY Press, 1993.

———. ed., *The Meccan Revelations (al-Futuhat al Makkiya)*. Translated by William C. Chittick and James W. Morris. New York, NY: Pir Press, 2002.

Clark, Emma. *Underneath Which Rivers Flow: The Symbolism of the Islamic Garden*. London: The Prince of Wales's Institute of Architecture, 1996.

Clark, Kenneth. *Landscape into Art*. London: John Murray, 1997.

Conan, Michel. "Landscape Metaphors and Metamorphosis of Time," in *Landscape Design and Experience of Motion*, edited by Michel Conan, 287–317. Washington, DC: Dumbarton Oaks Research Library and Collection, 2003.

Cooke, Miriam. "Introduction: Journeys Real and Imaginary." *Edebiyât n.s.* 4.2 (1993): 151–154.

Corbin, Henry. *Creative Imagination in the Sufism of Ibn 'Arabî*. Translated by Ralph Manheim. Princeton, NJ: Princeton University Press, 1969.

———. *Cyclical Time and Ismaili Gnosis*. London; Boston: Kegan Paul International / Islamic Publications Ltd, 1983.

———. *Spiritual Body and Celestial Earth From Mazdean Iran to Shî'ite Iran*. Translated by N. Pearson. London: Taurus Publishers, 1990.

———. *History of Islamic Philosophy*. Translated by Liadain Sherrard. London: New York: Kegan Paul International, 1993.

Corner, James. *Recovering Landscape: Essays in Contemporary Landscape Architecture*. New York, NY: Princeton Architectural Press, 1999.

Cornish, Vaughan. "Harmonics of Scenery: An Outline of Aesthetic Geography." *Geography* (1928): 14, 275–283; 383–394.

Cosgrove, E. Denis. *Social Formation and Symbolic Landscape*. Madison, WI: University of Wisconsin Press, 1998, c. 1984.

Cosgrove, Denis and Stephen Daniels, eds. *The Iconography of Landscape: Essays on the Symbolic Representation, Design and Use of Past Environments*. Cambridge, UK: Cambridge University Press, 1988.

Crane, Howard. *Risale-i Mimariye An Early Seventeenth-Century Ottoman Treatise on Architecture*. Leiden; NY: E.J. Brill, 1987.

Critclow, Keith. *Islamic Patterns: An Analytical and Cosmological Approach*. New York, NY: Schocken Books, 1976.

Curatola, Giovanni. "Gardens and Garden Carpets: An Open Problem." *Environmental Design*, no. 2 (Rome, 1985): 90–97.

Dağtekin, Hğseyin, "Bizde tarih haritacılığı ve kaynakları üzerine bir araştırma." In *VIII. Türk Tarih Kongresi Ankara 11–15 Ekim 1976*, vol. 2., 1148–1181. Ankara: Türk Tarih Kurumu, 1979–1983.

Daiber, Hans. *Bibliography of Islamic Philosophy*. Leiden; Boston: E.J. Brill, 1999.

Dankoff, Robert. "The Lyric in the Romance: The Use of Ghazals in Persian and Turkish *Mesnevis*." *Journal of Near Eastern Studies* 43 (1984): 9–25.

Davidson, Herbert A. *Alfarabi, Avicenna, and Averroës on Intellect: Their Cosmologies, Theories of the Active Intellect, and Theories of Human Intellect*. New York, NY: Oxford University Press, 1992.

De Boer, T.J. *The History of Philosophy in Islam*. London: Luzak & Company, 1933.

De Certeau, Michel. *The Mystic Fable Vol. 1: The Sixteenth and Seventeenth Centuries*. Translated by Michael Smith. Chicago: University of Chicago Press, 1992.

Demiriz, Yıldız. *Osmanlı Kitap Sanatında Natüralist Üslupta Çiçekler*. Istanbul: Acar Matbaacılık Tesisleri, 1986.

Denny, Walter. "A Sixteenth-Century Architectural Plan of Istanbul." *Ars Orientalis* 8 (1970): 49–63.

Develioglu, Ferit. *Osmanlica-Turkce Ansiklopedik Lûgat*. Istanbul: Aydın Kitabevi, 2000.

Dickie, James "The Islamic Garden in Spain." *The Islamic Garden*, edited by Elisabeth B. MacDougall, and R. Ettinghausen. Washington, DC: Dumbarton Oaks Publications, 1976: 87–106.

―――― . "The Mughal Garden: Gateway to Paradise." *Muqarnas* 3 (Leiden: E.J. Brill, 1985): 128–137.

―――― . "Garden and Cemetery in Sinan's Istanbul." *Environmental Design*, no. 5 (Rome, 1987): 70–85.

Dikmen, Hamit. "Seyyid Vehbi ve Divanının Karşılaştırmalı Metni." PhD diss., Ankara Üniversitesi, Ankara. 1991.

Dilke, O.A.W. "Cartography in the Byzantine Empire." In *The History of Cartography Vol. 1: Cartography in Prehistoric, Ancient and Medieval Europe and Mediterranean*, edited by J.B. Harley and D. Woodward, 258–275. Chicago and London: University of Chicago Press, 1987.

Doğan, Muhammed Nur. *Lale devrinde Yetişen İki Kardeş Şair Şeyhülislam İshak Efendi ve Şeyhülislam Es'ad Efendi Divanlarından Seçmeler*. Istanbul: Enderun Kitabevi, 1997.

Druart, Therese-Anne. "Averroës: The Commentator and the Commentators." In *Aristotle in Late Antiquity*, edited by Lawrence P. Schrenk. Washington, DC: Catholic University of America Press, 1994.

Duncan, J. and N. Duncan. "(Re)reading the Landscape." *Environment and Planning D: Space and Society*, vol. 6 (London: Pion Ltd, 1988): 117–126.

Duncan, James S. "The City as Text: The Landscape of Charismatic Rule in Kandy on the Eve of the British Conquest 1," *Design Methods and Theories*, vol. 23, no. 2. San Luis Obispo, CA: California Polytechnic State University, 1989: 998–1035.

―――― . *Place / Culture / Representation*. London: Routledge, 1993.

Düzdağ, M. Ertuğrul. *Şeyhülislam Ebusuud Efendi fetvaları ışığında 16. Asır Türk Hayatı*. Istanbul: Enderun Kitabevi, 1972.

Ebel, Kathryn Ann. "City Views, Imperial Visions: Cartography and the Visual Culture of Urban Space in the Ottoman Empire, 1453–1603." PhD diss., The University of Texas at Austin, Texas, 2002.

Eldem, Ethem. "18. Yüzyıl ve Değişim." *cogito Osmanlılar Özel Sayısı*, no. 19, summer 1999 (Istanbul: Yapı Kredi Yayınları, 1999): 189–199.

Eldem, Sedad Hakkı. *Sa'dabad*. Istanbul: Kültür Bakanlığı Yayınları, 1977.

———. *Türk Bahçeleri*. Istanbul: Kültür Bakanlığı Yayınları, 1978.

———. *Türk Evi: Osmanlı Dönemi*. Istanbul: Kültür Bakanlığı Yayınları, 1984–1987.

El Gohary, O. "Symbolic Meanings of Garden in Mosque Architecture." *Environmental Design*, no. 3 (Rome, 1986): 32–33.

Elmore, Gerard. "Poised Expectancy: Ibn al-'Arabi's Roots in Sharq al-Andalus." *Studia Islamica* 90 (2000): 51–66.

Enwistle, A.W. *Braj Centre of Krishna Pilgrimage*. Groningen: Egbert Forsten, 1987.

Ercan, Enver. *Bizanstan Günümüze Istanbul Şiirleri*. Istanbul: Alfa Basın Yayım, 2002.

Erdenen, Orhan. *Lale Devri ve Yansımaları*. Istanbul: Türk Dünyası Araştırmaları Vakfı, 2003.

Erdoğan, Kenan. *Niyâzî-i Mısrî Dîvânı*. Ankara: Akçağ Yayınları, 1998.

Erdoğan, Muzaffer. "Osmanlı Devrinde İstanbul Bahçeleri." *Vakıflar dergisi IV* (1958): 149–182.

Ersoy, Osman. *Türkiyeye Matbanın Girişi ve İlk Basılan Eserler*. Ankara: Güven matbaası, 1959.

Ertuğrul, İsmail Fenni. *Vahdet-i Vücud ve Ibn Arabi*. Istanbul: Insan Yayınları, 1997.

Erünsal, Ismail E. *The Life and Works of Tâcî-zâde Ca'fer Çelebi, with a Critical Edition of His Divan*. Istanbul: Istanbul University, 1983.

———. "Sehid Ali Pasa'nin Istanbul'da Kurdugu Kütüphaneler ve Müsadere Edilen Kitaplari." *I. Ü. Edebiyat Fakültesi Kütüphanecilik Dergisi: Belge, Bilgi, Kütüphane Arastirmalari*, I (Istanbul 1987): 79–87.

———. "Abdurrahman el-Askeri's Mir'atü'l-Isk: A New Source for the Melâmî Movement in the Ottoman Empire During the 15th and 16th Centuries." *Wiener Zeitschrift für die Kunde des Morgenlandes* 84. Band (Vienna, 1994): 95–115.

Esin, Emel. *Turkish Miniature Painting*. Vermont; Tokyo: Charles E. Tuttle Co., 1960.

Eşref bin Muhammed. *Hazâ'inü's-Saâ'dât*. 1460. Transcribed and edited by Bedi N. Şehsuvaroğlu. Ankara: Türk Tarih Kurumu, 1961.

Evin, Ahmet Ömür. "Nedim: Poet of the Tulip Age: The Beginning of Western Influences and Westernization in Turkey: 1718–1730." PhD diss., Columbia University, New York, 1973.

———. "A Poem by Nedim: Some Thoughts on Criticism of Turkish Literature and an Essay," *Edebiyat: A Journal of Middle Eastern and Comparative Literature* II/1 (1977): 43–55.

Evliya Çelebi, Mehmed Zıllîoğlu. *Evliyâ Çelebi Seyâhatnâmesi 1–15*. Translated by Zuhuri Danışman. Istanbul: Çetin Basımevi, 1971.

Evliyagil, Necdet. *Edebiyatimizda divan şiiri: şiirlerin açıklanmış şekilleri ile*. Ankara: 1958.

Evyapan, Gönül Aslanoğlu. *Eski Türk Bahçeleri ve Özellikle Eski İstanbul Bahçeleri*. Ankara: Orta Doğu Teknik Üniversitesi, 1972.

———. *Old Turkish Gardens: Old Istanbul Gardens in Particular*. Ankara: METU Faculty of Architecture Press, 1999.

Eyice, Semavi. "Tarih İçinde İstanbul ve Şehrin Gelişmesi." *Atatürk Konferansları 1975*. Ankara: Türk Tarih Kurumu Basımevi, 1980: 89–182.

———. "Kağıthane, Sadabad-Çağlayan," *TAÇ* I (1986): 29–36.

Eyüboğlu, İsmet Zeki. *Divan şiirinde sapık sevgi*. Istanbul: Broy, 1991.

———. *Türk şiirinde tanrıya kafa tutanlar*. Istanbul: Güney Yayınları, 1991.

———. *Divan şiiri*. Istanbul: Say, 1994.

Fakhry, Majid, ed. *A History of Islamic Philosophy*. New York, NY: Columbia University Press and Longman, 1983.

———, ed. *Philosophy, Dogma, and the Impact of Greek Thought in Islam*. Aldershot, Hampshire; Brookfield, VT: Variorum, 1994.

Faroqhi, Suraiya. *Osmanlı'da Kentler ve Kentler 1550–1560*. Translated by Neyyir Kalaycıoğlu. Istanbul: Tarih Vakfı Yurt Yayınları, 2000, c. 1993.

———. *Osmanlı Kültürü ve Gündelik Yaşam Ortaçağdan Yirmibirinci Yüzyıla*. 1995. Translated by Elif Kılıç. Istanbul: Tarih Vakfı Yurt Yayınları, 1998, c. 1997.

———. *Osmanlı Tarihi Nasıl İncelenir?* 1999. Translated by Zeynep Altok. Istanbul: Tarih Vakfı Yurt Yayınları, 2001.

Fazıl Hüseyin, Enderuni. *Defter-i 'aşk*. Istanbul, 1286.

Febvre, Lucien. *The Problem of Unbelief in the Sixteenth Century: The Religion of Rabelais*. Translated by Beatrice Gottlieb. Cambridge, MA: Harvard University Press, 1982.

Feldman, Walter. "A Musical Model for the Structure of the Ottoman Gazel," *Edebiyat: A Journal of Middle Eastern and Comparative Literature* I/1 (1987): 71–89.

———. "Mysticism, Didacticism and Authority in the Liturgical Poetry of the Halvetī Dervishes of Istanbul." *Edebiyât* n.s. 4.2 (1993): 243–265.

Fitter, Chris. *Poetry, Space, Landscape: Toward a New Theory*. Cambridge, UK: Cambridge University Press, 1995.

Fleicher, Cornell. *Bureaucrat and Intellectual in the Ottoman Empire: The Historian Mustafa Ali (1541–1600)*. Princeton, NJ: Princeton University Press, 1986.

Foltz, R.C., F.M Denny, and A. Baharuddin, eds. *Islamic Ecology*. Cambridge, MA: Harvard University Press, 2003.

Forster, Edward Seymour, trans. *The Turkish Letters of Ogier de Busbecq, Imperial Ambassador at Constantinople 1554–1562* translated from the Latin Elzevier edition (1633). Oxford: Clarendon Press, 1968, c. 1927.

Fox. *Mr. Harrie Cavendish, his journey to and from Constantinople, 1589 by Fox, his servant*. London: Office of the Royal Historical Society, 1940.

Galland, Antoine. *İstanbul'a ait Günlük Hatıralar, 1672–1673*. Translated by N.S. Orik. Ankara: Türk Tarih Kurumu, 1999.

Gallens, Sam I. "The Search for Knowledge in Medieval Muslim Societies: A Comparative Approach." *Muslim Travellers*, edited by D.F. Eickelman and J. Piscatori. NY; London: Routledge, 1995, c. 1990.

Ghazzali. *The Incoherence of the Philosophers Tahafut al-falasifah: A Parallel English–Arabic Text*. Translated by Michael E. Marmura. Provo, UT: Brigham Young University Press, 1997.

Gianotti, Timothy J. *Al-Ghazali's Unspeakable Doctrine of the Soul: Unveiling the Esoteric Psychology and Eschatology of the Ihya*. Leiden; Boston: E.J. Brill, 2001.

Gibb, E.J.W. *A History of Ottoman Poetry*. London: Luzak & Company, 1900.

———. *Osmanlı Şiiri Tarihi*, vol. I-II-III-IV. Istanbul: Akcag, 1943.

———. *Osmanlı Şiiri Tarihine Giriş*. Istanbul: Köksal, 1999.

Giese, F. and N. Azamat, eds. *Anonim Tevarih-i Al-i Osman*. Istanbul: Marmara Üniversitesi, 1992.

Gilles, Pierre. *The Antiquities of Constantinople*. Translated by John Ball. New York, NY: Italica Press, 1988.

Giray, Kiymet. *Istanbul resim ve heykel muzesi koleksiyonu'ndan orneklerle manzara*. Istanbul: Türkiye Iş Bankası, xxxx.

Göçek, Fatma Müge. "The Social Construction of an Empire: Ottoman State Under Süleyman the Magnificient." In *Süleyman the Second and His Time*, edited by Halil İnalcık and Cemal Kafadar, 93–108. Istanbul: Isis Press, 1993.

Gofmann, Erving. *The Presentation of Self in Everyday Life*. New York, NY: Doubleday, 1959.

Göktaş, U. "Kartpostallarla Kağıthane." *İlgi* 53 (1988): 28–31.

Gökyay, Orhan Şaik. "Lale Kitaplarından Öğrendiklerimiz." *Tarih ve Toplum* 13/77 (1990): 34–39.

Golombek, Lisa. "The Gardens of Timur: New Perspectives." *Muqarnas* 12 (Leiden: E.J. Brill, 1995): 137–147.

Gölpınarlı, Abdülbaki. *Melâmîlik ve Melâmîler*. Istanbul: Gri Yayın, 1992, c. 1931.

———. *Divan Edebiyatı Beyanındadır*. Istanbul: Marmara Universitesi, 1945.

———. *Yunus Emre ve Tasavvuf*, 3rd edition. Istanbul: Inkılâp Kitabevi, 1992.

———. "Islam ve Türk İllerinde Fütüvvet Teşkilatı ve Kaynakları." *İktisat Fakültesi Mecmuası* X (1949–1950): 6–354.

———. *Simavna Kadısıoğlu Şeyh Bedreddin*. Istanbul: Eti Yayınevi, 1966.

———, ed. *Şeyh Galip: Hüsn ü Aşk*. Istanbul: Altın Kitaplar, 1968.

———. *Nedîm Divanı*. Istanbul: Inkılap ve Aka Kitabevleri, 1972.

———. *Mevlânâ'dan Sonra Mevlevîlik*, 2nd edition. Istanbul: Inkılâp ve Aka Kitabevleri, 1983.

Goodrich, Thomas D. "Ottoman Americana: The Search for the Sources of the Sixteenth-Century Tarih-i Hind-i Garbi." *Bulletin of Research in the Humanities* 85 (1982): 269–294.

———. "Tarih-i Hind-i Garbi: An Ottoman Book on the New World." *Journal of the American Oriental Society* 107 (1987): 317–319.

Goodwin, Godfrey. "Landscape in Ottoman Art." *Landscape Style in Asia*. A Colloquy held 25–27 June 1979 (London: University of London, 1980): 138–149.

———. "Gardens of Death in Ottoman Times." *Muqarnas* 5. Leiden: E.J. Brill, 1988: 61–69.

Gothein, Marie L. *A History of Garden Art*, vol. I. Edited by W.P. Wright, London: 1928.

Gövsa, İ.A. "Unutulan Mesire Kağıthane." *Yedigün* 228 (21 Temmuz 1937): 14–15.

Grelot, Guillaume-Joseph. *A late voyage to Constantinople: Containing an exact description of the Propontis and Hellespont, with the Dardenelles ... as also of the city of Constantinople ... Likewise an account of the ancient and present state of the Greek church ... Illustrated with curious and exact draughts ... in fourteen copper-plates ... Pub. by command of the French king, by Monsieur William Joseph Grelot*. Translated by J. Philips. London: J. Playford, H. Bonwicke, 1683.

Grube, Ernst. *Studies in Islamic Painting*. London: The Pindar Press, 1995.

Güner, Ahmet. *Tarikatlar Ansiklopedisi*. Istanbul: Milliyet Yayınları, 1991.

Gürpınar, Hüseyin Rahmi. "Eski Kağıthane," *Resimli Tarih Mecmuası* 56 (Ağustos 1954): 3296–3300.

Gutas, Dimitri, ed. *Greek Wisdom, Literature in Arabic Translation: A Study of the Graeco–Arabic Gnomologia*. New Haven, CT: American Oriental Society, 1975.

———. *Greek Thought, Arabic Culture: The Graeco-Arabic Translation Movement in Baghdad and Early Abbasid Society (2nd–4th / 8th–10th Centuries)*. London; New York: Routledge, 1998.

Halman, Hugh Talat. "'Where Two Seas Meet': The Quranic Story of Khidr and Moses in Sufi Commentaries as a Model for Spiritual Guidance." Ph.D diss., Duke University, Durham, NC, 2000.

Halman, Talat Sait. "Poetry and Society: The Turkish Experience." In *Modern Near East: Literature and Society*, edited by C. Max Kortepeter, 35–72. New York, NY: New York University Press, 1971.

———. *Süleyman the Magnificent Poet*. Istanbul: Dost Yayınları, 1987.

Halman, Talat S. and Metin And, eds. *Mevlana Celaleddin Rumi and the Whirling Dervishes*. Istanbul: Dost Publication, 1983.

Hamadeh, Shirine. "The City's Pleasures: Architectural Sensibility in 18th-Century Istanbul." PhD diss., MIT, Cambridge, MA: 1999.

———. "Ottoman Expressions of Early Modernity and the 'Inevitable' Question of Westernization." *JSAH* 63:1 (2004): 32–51.

———. *The City's Pleasures: Istanbul in the Eighteenth Century*. Seattle and London: University of Washington Press, 2008.

Hannaway, Junior, William L. "Paradise on Earth: The Terrestrial Garden in Persian Literature." In *The Islamic Garden*, edited by Elisabeth B. MacDougall and Richard Ettinghausen, 41–68. Washington, DC: Dumbarton Oaks Publications, 1976.

Hans, Georg Mayer. "İctimaî Tarih Açısından Osmanlı Devletinde Ülemâ Meşayih Münasebetleri," *Kubbe Altı Akedemi Mecmuası* 9 (1980): 48–68.

Hantelmann, Christa von. *Garten des Orients: Paradiese auf Erden*. Köln: DuMont, 1999.

Harvey, John H. "Turkey as a Source of Garden Plants." *Garden History: The Journal of the Garden History Society,* vol. IV, no. 3 (London: Litho Duplicating Service, 1976): 21–46.

Hayreti. Divan: tenkidli basim. Istanbul: Istanbul Üniversitesi, 1981.

Heywood, Colin, Colin Imber and V.L. Ménage, eds. *Studies in Ottoman History in Honour of Professor V. L. Ménage.* Istanbul: The Isis Press, 1994.

Hirsch, Eric and Michael O'Hanlon, eds. *The Anthropology of Landscape: Perspectives on Place and Space.* Oxford: Clarendon Press, 1995.

Holbrook, Victoria Rowe. "Diverse Tastes in the Spiritual Life: Textual Play in the Diffusion of Rumi's Order." In *The Legacy of Mediaeval Persian Sufism,* edited by Leonard Lewisohn, 99–120. London: KNP, 1992.

———. "Originality and Ottoman Poetics: In the Wilderness of the New." *Journal of the American Oriental Society* 112:3 (1992): 440–454.

———. "A Technology of Reference: Divan and Anti-Divan in the Reception of a Turkish Poet," *Edebiyat* NS 4 (1993): 49–61.

———. "Ibn 'Arabî and Ottoman Dervish Traditions: The *Melami* Supra-Order," Parts One and Two, *Journal of the Muhyiddin Ibn 'Arabî Society* X (1991): 18–35; XII (1993): 15–33.

———. "Imagery, Ideology and Representation," *TASG News* 37 (November 1993): 30–35.

———. *The Unreadable Shores of Love: Turkish Modernity and Mystic Romance.* Austin, TX: University of Texas Press, 1994.

———. "The Intellectual and the State: Poetry in Istanbul in the 1790s." *Oriente Moderno* XVIII (LXXIX) (1999), 233–251.

———. "Who is Beauty? Subjectivity and Interpretation." In *God is Beautiful and Loves Beauty. A Festschrift in Honor of Annemarie Schimmel*, edited by Alma Giese and Peter Brugel, 267–289. New York, NY: Peter Lang, 1994.

———. "Rumi, Galib, and the Fortress of Forms," in *Poetry and Mysticism in Islam: The Heritage of Rumi,* edited by Amin Banani, Richard Hovannisian and Georges Sabagh, 11th Giorgio Levi Della Vida Biennial Conference Ser. Cambridge: Cambridge University Press, 1994: 178–197.

Holt-Jensen, A. *Geography: Its History and Concepts.* London: Harper and Row, 1981.

Hopkins, E.W. "The Sacred Rivers of India." In *Studies in the History of Religions*, edited by D.G. Lyon and G.F. Moore, 213–229. New York, NY: The Macmillan Company, 1912.

Hunt, John Dixon. *Gardens and the Picturesque: Studies in the History of Landscape Architecture.* Cambridge, MA: The MIT Press, 1992.

Ibn 'Arabî. *The Tarjuman al-ashwaq: A Collection of Mystical Odes (Tarjuman al-ashwaq).* Translated and edited by Reynold A. Nicholson. London: Royal Asiatic Society, 1911.

———. *The Wisdom of the Prophets (Fusus al-hikam).* Translated by Titus Burckhardt. Aldsworth, Glos., UK: Beshara, 1975.

———. *The Bezels of Wisdom.* Translated by R.W.J. Austin. London: SPCK, 1980.

———. *İlahi Aşk.* Translated by Mahmut Kanık. Istanbul: Insan Yayınları, 2002.

İnalcık, Halil. *The Ottoman Empire: The Classical Age 1300–1600*. New York: Praeger Publishers, 1973.

———. "Istanbul: An Islamic City." In *Essays in Ottoman History*, 249–271. Istanbul: Eren Yayıncılık, 1998.

———. *Osmanlı İmparatorluğu Klasik Çağ 1300–1600*. 1973. Translated by Ruşen Sezer. Istanbul: YKY, 2003.

———. *Şair ve Patron Patrimonyal Devlet ve Sanat Üzerine Sosyolojik Bir İnceleme*. Ankara: Doğu Batı Yayınları, 2003.

İnalcık, Halil and Cemal Kafadar, eds. *Süleyman the Second and His Time*. Istanbul: Isis, 1993.

İnciciyan, P.G. *18. Asırda Istanbul*. Translated and edited by H.D. Andreasyan. Istanbul: Istanbul Matbaası, 1976, c.1956.

Ipşiroğlu, Mazhar Ş. *The Topkapı Museum Paintings and Miniatures*. Translated by Adair Mill. London: Thames and Hudson, 1980

İrepoğlu, Gül. "Topkapı Sarayı Müzesi Hazine Kütüphanesindeki Batılı Kaynaklar Üzerine Düşünceler." *Topkapı Sarayı Müzesi Yıllık* 1 (1986): 56–72; 174–197.

İsmail Beliğ. *Bursali Ismail Belig*. Ankara: Gazi Üniversitesi, 1985.

Dünden Bugüne İstanbul Ansiklopedisi, vol. 1–8. İstanbul: Türkiye Ekonomik ve Toplumsal Tarih Vakfı, Ana Basım A.Ş., 1993–1994.

İstanbul manzaraları sergisi. Istanbul: Topkapi Sarayı Muzesi, 1959.

İzgi, Cevat. *Osmanlı Medreselerinde İlim*, vol. I–II. Istanbul: İz Yayıncılık, 1997.

Izutsu, Toshihiko. *A Comparative Study of the Key Philosophical Concepts in Sufism and Taoism: Ibn Arabi and Lao-tzu, Chuang-tzu*. Tokyo: Keio Institute of Cultural and Linguistic Studies, 1966–1967.

Jachimowicz, Edith. "Islamic Cosmology." In *Ancient Cosmologies*, edited by Carmen Blacker and Michael Loewe, 143–171. London: George Allen and Unwin, 1975.

Jackson, J.B. *Landscapes: Selected Writings of J.B. Jackson*. Edited by Ervin H. Zube. Amhurst, MA: University of Massachusetts Press, 1970.

Jacobs, Michael. *The Painted Voyage: Air, Travel and Exploration, 1564–1875*. London: British Museum Press 1995.

Jamaluddin, Syed. "Epistemology in the Sufi Discourse." *Islam and the Modern Age*, vol. 26 issue 2/3 (1995): 137–148.

Jamil-ur-Rehman, Mohammad, trans. *The Philosophy and Theology of Averroës*. Baroda, India: A.G. Widgery, 1921.

Jellicoe, Geoffrey A. *The Landscape of Man*. London: Thames and Hudson, 1987.

Jellicoe, Susan. "The Development of the Mughal Garden." In *The Islamic Garden*, edited by Elisabeth B. MacDougall and Richard Ettinghausen, 107–130. Washington, DC: Dumbarton Oaks Publications, 1976.

Johnston, R.J. *Geography and Geographers: Anglo American Human Geography since 1945*. London and New York: Arnold / Oxford University Press, 2000, c.1979.

Kafadar, Cemal. "Self and Others: The Diary of a Dervish in Seventeenth-Century Istanbul and First Person Narratives in Ottoman Literature." *Studia Islamica* 69 (1989): 95–120.

_____. *Between Two Worlds: The Construction of the Ottoman State*. Berkeley, CA: University of California Press, 1995.

Kafescioğlu, Çiğdem. "The Ottoman Capital in the Making: The Reconstruction of Constantinople in the Fifteenth Century." PhD diss., Harvard University, Cambridge, MA, 1996.

_____. "Heavenly and Unblessed, Splendid and Artless: Mehmed II's Mosque Complex in Istanbul in the Eyes of its Contemporaries." In *Aptullah Kuran için yazılar: Essays in Honour of Aptullah Kuran*, edited by Çigdem Kafescioglu and Lucienne Thys-Senocak, 211–212. Istanbul: Yapi Kredi Yayinlari, 1999.

_____. *Constantinopolis / Istanbul: Cultural Encounter, Imperial Vision and the Construction of the Ottoman Capital*. University Park, PA: The Pennyslvania State University Press, 2009.

Kafesoğlu, Ibrahim. *Selçuklu Tarihi*. Istanbul: MEB, 1972.

Kalender, Arzu. "'Taze can buldu cihan': Osmanli siirinde bahar." PhD diss., Bilkent University, Ankara, 2002.

Kalpaklı, Mehmet. *Osmanlı divan şiiri üzerine metinler*. Istanbul: YKY, 1999.

Kaplan, Mehmet."Nedim'in Şiirlerinde Mimari, Eşya ve Kıyafet." *İstanbul Enstitüsü Dergisi* 3 (1957): 43–55.

_____. *Şiir tahlilleri: Akif Paşa'dan Yahya Kemal'e kadar*. Istanbul: İstanbul Üniversitesi Basımevi, 1958.

Kaplan, Mahmut, ed. *Neşati Divanı*. Izmir: Akademi, 1996.

_____. *Türk Edebiyatı Üzerine Araştırmalar* 1. Istanbul: Dergah Yayınları, 1979.

Kara, Mustafa. *Din Hayat Sanat Açısından Tekkeler ve Zaviyeler*. Istanbul: 1977.

_____. *Tasavvuf ve Tarikatlar Tarihi*. Istanbul: Dergâh Yayınları, 1985.

Karaismailoğlu, Adnan. *Klasik dönem Türk şiiri incelemeleri*. Ankara: Akçağ, 2001.

Karamustafa, Ahmet. "Introduction to Ottoman Cartography." In *The History of Cartography Vol. 2 Book 1 Cartography in the Traditional Islamic and South Asian Societies*, edited by J.B. Harley and David Woodward. Chicago; London: University of Chicago Press, 1992. 206–208.

_____. "Cosmographical Diagrams," In *The History of Cartography Vol. 2 Book 1 Cartography in the Traditional Islamic and South Asian Societies*, edited by J.B. Harley and David Woodward, 71–89. Chicago; London: University of Chicago Press, 1992.

_____. "Military, Administrative, and Scholarly Maps and Plans." In *The History of Cartography Vol. 2 Book 1 Cartography in the Traditional Islamic and South Asian Societies*, edited by J.B. Harley and David Woodward, 209–227. Chicago; London: University of Chicago Press, 1992.

Kasır, Hasan Ali. "Türk Edebiyatında Fütüvvet-nâmeler ve Esrâr Dede Fütüvvet-nâmesi." *Atatürk Üniv. SBE Dergisi* 1 (1993): 107–130.

Katip, Çelebi. *The Balance of Truth*. Translated by Geoffrey Lewis. London: George Allen and Unwin, Ltd, 1957.

Katouzian, Shahab. "The Sense of Place in Persian Gardens." *Environmental Design* no. 4 (Rome, 1986): 42–47.

Kaya, İ. Güven. "Dükaginzade Taşlıcalı Yahya Beğ'in Şiirlerinde Cinsellik." *Journal of Turkish Studies* 14 (1990): 272–281.

Kayra, Cahit. *İstanbul Mekanlar ve Zamanlar*. Istanbul: Ak Yayınları, 1990.

Khansari, Mehdi, M.R. Moghtader and Minouch Yavari. *The Persian Garden: Echoes of Paradise*. Washington, DC: Mage Publishers, 1998.

King, David A. "Some Ottoman Schemes of Sacred Geography." Proceedings of the Second International Congress on the History of Turkish and Islamic Science and Technology in the 16th Century, 45–57. Istanbul: ITU Research Center of History of Science and Technology, 1986.

Kish, George. *The Suppressed Turkish Map of 1560*. Ann Arbor, MI: William L. Clements Library, 1957.

Koch, Ebba. "Mughal Palace Gardens from Babur to Shah Jahan (1526–1648)." *Muqarnas* 14 (Leiden: E.J. Brill, 1997): 143–165.

———. "The Mughal Waterfront Garden." In *Gardens in the Time of Great Muslim Empires*, edited by Attilio Petruccioli, 140–160. Leiden, New York; Cologne: E.J. Brill, 1997.

Koçu, Reşad Ekrem. *Tarihte İstanbul Esnafı*. 1970. Reprint, Istanbul: Doğan Yayınları, 2002.

Köprülü, Mehmed Fuad. *Milli Edebiyat Cereyanının İlk Mübeşşirleri ve Divan-ı Türk-i Basit*. Istanbul: Devlet Matbaası, 1928.

———. *Islam in Anatolia after the Turkish Invasion (Prolegomena)*, translated by Gary Lesier. Salt Lake City, UT: University of Utah Press, 1993.

Kortantamer, Tunca. "Nedim'in Şiirlerinde İstanbul Hayatından Sahneler." *Ege Üniversitesi Edebiyat Fakültesi Türk Dili ve Edebiyatı Araştırmaları Dergisi* IV (1985): 20–59.

———. "Nedim'in Manzum Küçük Hikayeleri." *Ege Üniversitesi Edebiyat Fakültesi Türk Dili ve Edebiyatı Araştırmaları Dergisi* V (1989): 13–27.

———. *Eski Türk edebiyatı: makaleler*. Ankara: Akçağ, 1993.

Kuban, Doğan. *Istanbul: An Urban History*. Istanbul: Türk Tarih Kurumu, 1996.

Kufralı, Kasım. *Türk Edebiyatında İlk Mutasavvıflar*, edited by Orhan Köprülü. Ankara: Diyanet İşleri Başkanlığı Yayınları, 1991.

Kügelgen, Anke von. *Averroës und die arabische Moderne: Ansätze zu einer Neubegründung des Rationalismus im Islam*. Leiden; New York: E.J. Brill, 1994.

Külekçi, Numan. *Mesnevi Edebiyatı Antolojisi*, 2 vols. Erzurum: Aktif Yayınevi, 1999.

Kuran, Aptullah "Interiority and Exteriority in Turkish Architecture." In *Islamic Art: Common Principles, Forms and Themes*. Proceedings of the International Symposium held in Istanbul in April 1983, edited by A.M. Issa and O. Tahaoglu, 84–88. Damascus: Dar al-Fikr, 1989.

Kutlar, Fatma S. "Mesnevi Nazım Şekline Genel Bir Bakış ve Türk edebiyatında Mesnevi Araştırmalarıyla İlgili Bir Kaynakça Denemesi." *Türkbilig* 1 (Nisan 2000): 102–157.

Kutlu, Şemsettin. *Divan Edebiyatı Antolojisi*. Istanbul: Remzi Kitabevi, 1983.

Lablaude, Pierre-Andre. *Les Jardins de Versailles*. Paris: Editions Scala, 1995.

Lamii, Çelebi. *Lami'is Guy u cevgan*. Stuttgart: Franz Steiner Verlag, 1994.

Landau, Rom. *The Philosophy of Ibn el-Arabi*. New York: Macmillan, 1959.

Latifi. *Evsaf-i Istanbul*. Istanbul: Fetih Cemiyeti, 1977.

———. *Latifi tezkiresi*. Ankara: Kültür Bakanlığı, 1990.

Laureano, P. "The Oasis: The Origin of Gardens." *Environmental Design*, no. 3 (Rome, 1986): 65–71.

Leaman, Oliver, ed. *An Introduction to Medieval Islamic Philosophy*. Cambridge; New York: Cambridge University Press, 1985.

———. *Averroës and his Philosophy*. London: Curzon Press, 1988.

———. *A Brief Introduction to Islamic Philosophy*. Cambridge: Polity Press, 1999.

———. *An Introduction to Classical Islamic Philosophy*, 2nd ed. Cambridge; New York: Cambridge University Press, 2002.

Le Brun, Cornelis. *A Voyage to the Levant*. London: 1702.

Leed, Erich J. *The Mind of the Traveler: From Gilgamesh to Global Tourism*. New York: Basic Books, 1991.

Lehrman, Jonas. *Earthly Paradise Garden and Courtyard in Islam*. London: Thames and Hudson, 1980.

Lentz, Thomas. "Memory and Ideology in the Timurid Garden." In *Mughal Gardens Sources, Places, Representations, and Prospects*, edited by James L. Wescoat and Joachim Wolschke-Bulmahn, 31–57. Washington, DC: Dumbarton Oaks Research Library and Collection, 1996.

Levend, Agah S. *Divan edebiyati: kelimeler ve remizler, mazmunlar ve mefhumlar.* Istanbul: Inkilap Kitapevi, 1943.

———. *Türk Edebiyatında Şehr-engizler ve Şehr-engizlerde Istanbul*. Istanbul: Baha Matbaası, 1958.

———. *Türk Edebiyatı Tarihi*. Ankara: Türk Tarih Kurumu, 1973.

Lifchez, R., ed. *The Dervish Lodge: Architecture, Art, and Sufism in Ottoman Turkey*. Berkeley, CA: University of California Press, 1992.

Löfgren, Orvar. "Landscapes of Mind." *Topos* 6 (1994): 6–14

Lybyer, Albert H. *The Government of the Ottoman Empire in the Time of Suleiman the Magnificent*. Cambridge, MA: Harvard University Press, 1913.

Macdonald, B. Duncan. "Emotional Religion in Islam Affected by Music and Singing." *Journal of the Royal Society* (1901): 195–252; 705–748.

Mackay, C. "Lale Deliliği," *TT* 72 (Aralık 1989): 35–39.

Mango, Cyril. "The Urbanism of Byzantium Constantinople." *Rassegna* 72 (1997): 16–23.

Mantran, Robert. *16. ve 17. Yüzyılda İstanbul'da Gündelik Hayat*. Translated by M. Ali Kılıçbay. Istanbul: Eren Yayıncılık, 1991.

Mardin, Şerif. *Türk Modernleşmesi: Makaleler*, vol. 4. Istanbul: İletişim Yayınları, 1991.

Marin, Louis. *Utopics: Spatial Play*. Translated by R.A. Wollrath. New Jersey: Humanities Press, 1984.

Matsumoto, Akira. *Consciousness and Reality: Studies in Memory of Toshihiko Izutsu,* edited by S.J. Ashtiyani, H. Matsubara and T. Iwami. Leiden: E.J. Brill, 2000.

Mazıoğlu, Hasibe. *Nedîm'in Divan Şiirine Getirdiği Yenilik.* Ankara: TTK, 1957.

———. *Nedîm.* Ankara: Başbakanlık Basımevi, 1988.

———. "Divan Edebiyatında Sadeleşme Akımı," *Dil Yazıları* 1 (Ankara: TKK Yayınları, 1998): 44–52.

Mehmed, Raşid. *Tarih-i Raşid* V. Istanbul: 1822

Meisami, Julie Scott. *Medieval Persian Court Poetry.* Princeton, NJ: Princeton University Press, 1987.

———. "The Theme of the Journey in Nizami's Haft Paykar," *Edebiyât* n.s. 4.2 (1993): 155–172.

———. "The Body as Garden: Nature and Sexuality in Persian Poetry." *Edebiyât* n.s. 6.2 (1995): 245–274.

Menage, Victor Lewis. "The Map of Hajji Ahmed and Its Makers," *Bulletin of the School of Oriental and African Studies* 21(1958): 291–314.

———. "Edirneli Ruhi'ye atfedilen osmanlı tarihinden iki parça." In *Ord. Prof. Ismail Hakkı Uzunçarşılı'ya Armağan,* 311–333. Ankara: 1976.

Mengi, Mine. *Divan Şiirinde Rindlik.* Ankara: Bizim Büro Basımevi, 1985.

Mesihi. *Mesihi Divani.* Ankara: Atatürk Kültür Merkezi Yayınları, 1995.

Milstein, R. "Sufi Elements in the Late Fifteenth-Century Painting of Heart." In *Studies in Memory of Gaston Wiet,* edited by Myriam Rosein-Ayalon, 357–369. Jerusalem: Hebrew University of Israel, 1977.

Montague, Lady Mary Wortley. *The Complete Letters of Lady Mary Wortley,* edited by R. Halsbard. London: 1965–1967.

Moore, Charles W., William J. Mitchell and J.R.W. Turnbull. *The Poetics of Garden.* Cambridge, MA: The MIT Press, 1989, c. 1988.

Mordtmann, J.H. "Runi Edrenewi." *Mitteilungen zur osmanischen Geschichte II* (1923–1926): 129–136.

Morewedge, Parviz, ed. *Neoplatonism and Islamic Thought.* Albany, NY: State University of New York Press, c. 1992.

Morris, James Winston. "Ibn-I Arabi and his Interpreters." *Journal of the American Oriental Society* 106 (1986): 539–551, 733–756; 107(1987): 101–119.

Morrison, Robert G. "The Portrayal of Nature in a Medieval Qur'an Commentary." *Studia Islamica* 94 (2002): 115–138.

Mostafa, Saleh C. "The Cairene Sabil: Form and Meaning." *Muqarnas* 6 (Leiden: E.J. Brill, 1990): 33–42.

Moynihan, Elizabeth. "The Lotus Garden Palace of Zahir al-Din Muhammad Babur," *Muqarnas* 5 (Leiden: E.J. Brill, 1988): 135–152.

Murata, Sachiko. *The Tao of Islam: A Sourcebook on Gender Relationships in Islamic Thought.* Albany, NY: State University of New York Press, 1992.

———. *Chinese Gleams of Sufi Light.* Albany, NY: State University of New York Press, c. 2000.

Murata, Sachiko and William C. Chittick, *Vision of Islam*. New York, NY: Paragon House, 1994.

Mustafa Sâfî. *Mustafa Sâfî'nin Zübdetü't-Tevârîh'i*, 2 vols. Edited by İbrahim H. Çuhadar. Ankara: TTK, 2003.

Nasr, Seyyed Hossein. *An Introduction to Islamic Cosmological Doctrines*. Cambridge, MA: Harvard University Press, 1964.

───── , ed. *Islamic studies: Essays on Law and Society, the Sciences, and Philosophy and Sufism*. Beirut: Librairie du Liban, 1967.

───── . *Three Muslim Sages: Avicenna, Suhrawardi, Ibn Arabi*. Cambridge, MA: Harvard University Press, 1964, c. 1969.

Nasr, Seyyed Hossein and Oliver Leaman, eds. *History of Islamic Philosophy*. London; New York: Routledge, 1996.

Necipoğlu, Gülru. "The Süleymaniye Complex in Istanbul." *Muqarnas* 3 (1985): 92–117.

───── . *The Topkapı Scroll—Geometry and Ornament in Islamic Architecture: Topkapı Palace Museum Library MS H1926* (Santa Monica, CA: The Getty Center for the History of Art and the Humanities, 1995): 197–216.

───── . "Plans and Models in 15th and 16th Century Ottoman Architectural Practice." *Journal of the Society of Architectural Historians* 45 (1986): 224–243.

───── . *Architecture, Ceremonial and Power: The Topkapı Palace in the Fifteenth and Sixteenth Centuries*. Cambridge, MA: The MIT Press, 1991.

───── . "The Suburban Landscape of Sixteenth-Century Istanbul as a Mirror of Classical Ottoman Garden Culture." In *Gardens in the Time of Great Muslim Empires*, edited by Attilio Petruccioli, 32–71. Leiden, New York; Cologne: E.J. Brill, 1997.

Nelson, Robert S., ed. *Visuality Before and Beyond the Renaissance: Seeing as Others Saw*. Cambridge, UK; New York, NY: Cambridge University Press, 2000.

Neşati, Ahmed Dede. *Neşati Divanı*. Edited by Mahmut Kaplan. Izmir: Akademi, 1996.

Netton, Ian Richard, ed. *Muslim Neoplatonists: An Introduction to the Thought of the Brethren of Purity (Ikhwan al-Safa')*. London; Boston: Allen & Unwin, 1982.

───── . *Allah Transcendent: Studies in the Structure and Semiotics of Islamic Philosophy, Theology, and Cosmology*. London; New York: Routledge, 1989.

Nicholson, Reynold A. *The Mystics of Islam*. Beirut: Khayats, 1966.

Nicolay, Nicolas de. *Navigations, peregrinations et voyages faicts en la Turquie*. Reprint, Paris: Presses du CNRS, 1989.

Nuti, Lucia. "The Perspective Plan in the Sixteenth Century: The Invention of a Representational Language." *The Art Bulletin* 76 (1994): 105–128.

Ocak, Ahmet Yaşar. *Islam-Türk İnançlarında Hızır yahut Hızır-Ilyas Kültü*. Ankara: Türk Kültürünü Araştırma Enstitüsü, 1985.

───── . "XV–XVI. Yüzyıllarda Osmanlı İmparatorluğunda 'Zendeka ve İlhad' meselesi." *Beşinci Milletlerarası Türkoloji Kongresi* (Istanbul: 1989): 465–472.

───── . "Kanuni Sultan Süleyman Devrinde Osmanlı resmi düşüncesine karşı bir tepki hareketi: Oğlan Şeyh Ismail-i Maşuki." *Osmanlı Araştırmaları* 10 (1990): 49–58.

———. "Kanuni Sultan Süleyman devrinde bir Osmanlı heretiği: Şeyh Muhyidin-i Karamani." In *Prof. Dr. Bekir Kütükoğlu'na Armağan*, 473–484. Istanbul: IÜ Edebiyat Fakültesi, Tarih Araştırma Merkezi, 1991.

———. *Osmanlı Toplumunda Zındıklar ve Mülhidler 15.–17. Yüzyıllar*. Istanbul: Tarih Vakfı, 1998.

Onan, Necmettin Halil. *Izahlı divan şiiri antolojisi*. Ankara: MEB, 1991.

Orbay, İffet. "Remarks on the Concept of Pictorial Space in Islamic Painting," *Journal of the Faculty of Architecture*, vol. 16 nos 1–2 (1996): 45–58.

———. "Istanbul Viewed: The Representation of the City in Ottoman Maps of the Sixteenth and Seventeenth Centuries." PhD diss., MIT, Cambridge, MA, 2001.

Pala, İskender. *Ansiklopedik Divan Şiiri Sözlüğü*. Ankara: Kültür Bakanlığı Yayınları, 1989.

———. "Şehrengiz." In *Dünden Bugüne İstanbul Ansiklopedisi*, vol. 7, 150–151 (1994).

Pincas, Stephane. *Versailles: The History of the Gardens and Their Sculpture*. Translated by Fiona Cowell. New York, NY: Thames and Hudson, 1996, c. 1995.

Pinder-Wilson, Ralph. "The Persian Garden: Bagh and Chaharbagh." In *The Islamic Garden*, edited by Elisabeth B. MacDougall and Richard Ettinghausen, 69–86. Washington, DC: Dumbarton Oaks Publications, 1976.

Pines, Shlomo. *Studies in Arabic Versions of Greek Texts and in Mediaeval Science*. Jerusalem: Magnes Press, Hebrew University / Leiden: E.J. Brill, 1986.

Pinto, John. "Origins and Development of the Iconographic City Plan." *Journal of the Society of Architectural Historians* 35 (1976): 35–50.

Quartet, Donald. *The Ottoman Empire, 1700–1922*. Cambridge, UK: Cambridge University Press, 2000.

Raby, Julian. "El Gran Turco: Mehmed the Conqueror as a Patron of the Arts of Christendom." PhD. diss., Oxford University, Oxford, 1980.

———. "Mehmed II Fatih and the Fatih Album," *Islamic Art* 1 (1981): 42–49.

———. "A Sultan of Paradox: Mehmed the Conqueror as a Patron of the Arts." *The Oxford Art Journal* 5, no. 1(1982): 3–8.

Rado, Şevket, ed. and trans. *Yirmisekiz Mehmet Çelebi'nin Fransa Seyahatnamesi*. Istanbul: Hayat Tarih Mecmuası Yayınları, Doğan Kardeş Yayınları, 1970.

Rasim, Ahmed. "Yetmiş Sene Evvelki Kağıthane Alemleri," *Resimli Tarih Mecmuası* 61 (Ocak 1955): 3,612–3,615.

Refik, Ahmed. *Hicri Onbirinci Asırda Istanbul Hayatı 1000–1100*. Istanbul: Devlet Matbaası, 1931.

Reighly, J. *Land and Life: Selections from the Writings of Carl Ortwin Sauer*. Berkeley and Los Angeles: University of California Press, 1963.

Reinhart, Kevin A. "The Here and Hereafter in Islamic Religious Thought." In Sheila S. Blair and Jonathan M. Bloom, eds., *Images of Paradise in Islamic Art*. New Haven: Trustees of Dartmouth College, 1991.

Relph, Edward. *Place and Placelessness*. London: Pion Ltd, 1976.

———. *Rational Landscapes and Humanistic Geography*. London: Croom Helm, 1981.

Rehman, Abdul. "Garden Types in Mughal Lahore According to Early Seventeenth-Century Written and Visual Sources," *Gardens in the Time of Great Muslim Empires*, edited by Attilio Petruccioli (Leiden, New York; Cologne: E.J. Brill, 1997): 161–172.

———. *Earthly Paradise: The Garden in the Times of the Great Muslim Empires.* Lahore: M. Shahid Adil for Dost Associates, 2001.

Renda, Günsel. "Zübdetü't Tevarih yazmalarının Minyatürleri." PhD diss., Hacettepe University, Ankara, 1968.

———. "Topkapı Sarayındaki H. 1321 no. lu Silsilename'nin Minyatürleri," *Sanat Tarihi Yıllığı* V (1973): 443–480.

———. "The Miniatures of Silsilename, H.1321 in the Topkapı Saray Museum Library." *Sanat Tarihi Yıllığı* V (1973): 481–496.

———. "İstanbul Türk ve İslam Eserleri Müzesi'ndeki Zübdetü't Tevarih'in Minyatürleri." *Sanat* 6 (1977): 58–67.

———. "The Miniatures of the Zubdat al Tawarikh." *Turkish Treasures* I (1978): 26–35.

———. "Wall Paintings in Turkish Houses." In Fifth International Congress of Turkish Art, Budapest 23–28 September 1975, 711–735. Budapest: Akademia Kiado, 1978.

———. "18. Yüzyıl Osmanlı Minyatüründe Yeni Konular: Topkapı Sarayı'ndaki Hamse-i Atayi'nin Minyatürleri." In *Bedrettin Cömert'e Armağan Kitabı Hacettepe Üniversitesi Sosyal Bilimler Fakültesi Beşeri Bilimler Dergisi Özel Sayı*, 481–496. Ankara: 1980.

———. "An Illustrated 18th Century Hamse in the Walters Art Gallery." *The Journal of the Walters Art Gallery Baltimore* 39 (1981): 15–32.

Riehle, Klaus. *Leben und Literarische Werke Mesîhîs = Mesîhî'nin hayati ve edebi eserleri.* Prizren: BAL-TAM, 2001.

Robillard, Valerie and Els Jongeneel, eds. *Pictures into Words: Theoretical and Descriptive Approaches to Ekphrasis.* Amsterdam: VU University Press, 1998.

Roger, Alain. "Life and Death of Landscapes." *Lotus* 101 (Milan: Elemond S.p.A. 1999): 83–91.

Rogers, J.M. "Itineraries and Town Views in Ottoman Histories." In *The History of Cartography Vol. 2 Book 1 Cartography in the Traditional Islamic and South Asian Societies*, edited by J.B. Harley and David Woodward, 228–255. Chicago; London: University of Chicago Press, 1992.

Ruggles, D. Fairchild. "A Mythology of an Agrarian Ideal." *Environmental Design*, no. 3 (Rome, 1986): 24–27.

———. "The Mirador in Abbasid and Hispano-Ummayad Garden Typology." *Muqarnas* 7 (Leiden: E.J. Brill, 1990): 73–82.

Rycaut, Sir Paul. *The History of the Turkish Empire from the Year 1623 to the Year 1677*, 2 vols. London: 1680.

Saad, M.T. "Traditional Urban Gardens in Identified Moslem Environments." *Environmental Design*, no. 3 (Rome, 1986): 28–31.

Sadettin, Nuzhet. *Nesati: hayati ve eserleri.* Istanbul: Kanaat Kutuphanesi, 1933.

Sahas, Daniel J. *John of Damascus on Islam. The "Heresy of the Ishmaelites."* Leiden: E.J. Brill, 1972.

Sâî Mustafa Çelebi. *Book of Buildings Tezkiretü'l-Bünyan and Tezkiretü'l-Ebniye. Memoirs of Sinan the Architect.* Translated by Hayati Develi. Istanbul: MAS Matbaacılık A.Ş., 2002.

Sakaoğlu, Necdet. "Lale." In *Dünden Bugüne Istanbul Ansiklopedisi*, vol. 5, 178–182. Istanbul: Türkiye Ekonomik ve Toplumsal Tarih Vakfı, Ana Basım, A.Ş., 1994.

Salim, Kemal. *The Philosophical Poetics of Alfarabi, Avicenna and Averroës: The Aristotelian Reception.* London; New York: Routledge Curzon, 2003.

Sandys, George, 1578–1644. *Sandys travels: containing an history of the original and present state of the Turkish Empire, their laws, government, policy, military force, courts of justice, and commerce, the Mahometan religion and ceremonies, a description of Constantinople, the Grand Signior's seraglio, and his manner of living. A Relation of a Journey begun An Dom: 1610 Fovre Books the sixt edition London: Printed for Philip Chetwin, 1610, 7th ed.* London: Printed for John Williams Junior, 1673.

Sardağ, Rüştü. *Klasik divan şiirimiz.* Istanbul: Inkılap ve Aka Kitabevleri, 1976.

Scarcia, G. "Lo `Sehrengiz-i maglup` di Mirza Shafi'." In *Studia Turcologica Memoriae Alexii Bombaci dicata*, edited by A. Gallotta and U. Marazzi, 481–485. I.U.O., Seminario di Studi Asiatici: Series Minor, XIX. Naples: Istituto Universitario Orientale, 1982.

Schimmel, Annemarie. *Mystical Dimensions of Islam* (Chapel Hill, NC: University of North Carolina Press, 1975).

———. "The Celestial Garden in Islam." In *The Islamic Garden*, edited by Elisabeth B. MacDougall and Richard Ettinghausen, 11–40. Washington, DC: Dumbarton Oaks Publications, 1976.

———. "The Water of Life." *Environmental Design*, no. 2 (Rome, 1985): 6–9.

Schmidt, Jan. "Sünbülzade Vehbi's Şevkengiz: An Ottoman Pornographic Poem." *Turcica: Revue d'Etudes turques* XXV (1993): 9–37.

Schmitt, Charles B. *Renaissance Averroism Studied Through the Venetian Editions of Aristotle–Averroës with Particular Reference to the Giunta Edition of 1550–2.* Rome: Accademia Nazionale dei Lincei, 1979.

Şentürk, Ahmet Atilla. *Klasik Osmanlı Edebiyatı Tiplerinden Sufi yahut Zahid Hakkında.* Istanbul: Enderun Kitabevi, 1996.

———. *Klasik Osmanlı Edebiyatı Tiplerinden Sufi yahut Zahit Hakkında.* Istanbul: Enderun Kitabevi, 1996.

———. *Osmanlı Şiiri Antolojisi.* Istanbul: YKY, 1999.

Sevengil, Refik Ahmet. *Istanbul Nasıl Eğleniyordu?* Istanbul: İletişim Yayınları, 1990.

Shah, Idries. *The Sufis.* New York, NY: Anchor Books, 1990, c. 1964: 158.

Shalem, Avinoam. "Fountains of Light: The Meaning of Medieval Islamic Rock Crystal Lamps." *Muqarnas* 11 (1994): 1–11.

———. "Fountains of Light: The Meaning of Medieval Islamic Rock Crystal Lamps" *Muqarnas* 11 (1999): 1–11.

Shaw, Stanford. *History of the Ottoman Empire and Modern Turkey Volume I: Empire of the Gazis: The Rise and Decline of the Ottoman Empire, 1280–1808.* Cambridge, UK: Cambridge University Press, 1976.

Shay, Mary Lucille. "The Ottoman Empire from 1720 to 1734 as Revealed in Despatches of the Venetian Balili." *Illinois Studies in the Social Sciences*, vol. 27, no. 3 (Urbana, IL: University of Illinois, 1944): 1–161.

Shoshan, Boaz. "High Culture and Popular Culture in Medieval Islam." *Studia Islamica* LXXIII (1991): 67–107.

Sieveking, Albert Forbes. *The Praise of Gardens; An Epitome of the Literature of the Garden-Art*. London: J.M. Dent and Co., 1899.

Sılay, Kemal. *Nedîm and the Poetics of the Ottoman Court: Medieval Inheritance and the Need for Change*. Bloomington, IN: Indiana University, 1994.

Simidchieva, Marta. "The River Runs Through It: A Persian Paradigm of Frustrated Desire." Edebiyât n.s. 6.2 (1995): 203–222.

Simpson, Marianna Shreve. *Persian Poetry, Painting and Patronage: Illustrations in a Sixteenth-Century Masterpiece*. New Haven, CT: Yale University Press / Freer Gallery of Art, Smithsonian Institution, Washington, DC, 1998.

Skander, S. "The Shalamar: A Typical Muslim Garden." *Environmental Design*, no. 4 (Rome, 1986): 24–29.

Soucek, Priscilla. "The Role of Landscape in Iranian Painting to the 15th Century." *Landscape Style in Asia*. A Colloquy held 25–27 June 1979 (London: University of London, 1980): 86–110.

Sözen, Metin and S. Saatçi. *Mimar Sinan ve Tezkiret-ül Bünyan*. Istanbul: Emlak Bankası, 1989.

Stelzer, Steffen. "Ibn Rushd, Ibn 'Arabî, and the Matter of Knowledge," *Alif* 16 (1996): 19–55.

Stewart-Robinson, J. "The Tezkere Genre in Islam," *Journal of Near Eastern Studies*, vol. 22 (1964): 57–65.

_____. "The Ottoman Biographies of Poets," *Journal of Near Eastern Studies*, vol. 24 (1965): 57–74.

Subtelny, Maria Eva. "Agriculture and the Timurid Chaharbagh: The Evidence from a Medieval Persian Agricultural Manual." In *Gardens in the Time of Great Muslim Empires*, edited by Attilio Petruccioli, 110–128. Leiden, New York; Cologne: E.J. Brill, 1997.

Sumi, Akiko Motoyoshi. *Description in Classical Arabic Poetry*. Leiden; Boston, MA: E.J. Brill, 2004.

Sunar, Cavit. *Melâmîlik ve Bektaşîlik*. Ankara: AÜ İlahiyat Fakültesi, 1975.

Şeyh Bedreddin. *Vâridât*. Translated by Abdülbaki Gölpınarlı. Istanbul: Elif, 1970.

Tabbaa, Yasser. "The 'Salsabil' and 'Shadirwan' in Medieval Islamic Courtyards." *Environmental Design*, no. 3 (Rome, 1986): 34–37.

Taeschner, Franz. "Djughrafiya: The Ottoman Geographers." In the *Encyclopedia of Islam*, vol. 2 (Leiden: E.J. Brill, 1965): 587–590.

Takeshita, Masataka. *Ibn Arabi's Theory of the Perfect Man and its Place in the History of Islamic Thought*. Tokyo: Institute for the Study of Languages and Cultures of Asia and Africa, 1987.

Tanındı, Zeren. "İslam Resminde Kutsal Kent ve Yöre Tasvirleri." *Journal of Turkish Studies* 7 (1983): 407–437.

_____. *Türk Minyatür Sanatı*. Istanbul: Türkiye İş Bankası Kültür Yayınları, 1996

Tarlan, Ali Nihad. *Şiir mecmualarinda XVI ve XVII. asir divan siiri*. Istanbul: Istanbul Universitesi Edebiyat Fakultesi, 1948.

Tavernier, Jean Baptiste. *The Six Voyages of Jean Baptiste Tavernier (1605–1689)*. London: Printed for R.L. and M.P., 1658.

Terzioğlu, Derin. "The Imperial Circumcision Festival of 1582: An Interpretation." *Muqarnas* 12 (1995): 84–100.

_____. "Sufi and Dissent in the Ottoman Empire: Niyazi-i Misri (1618–1694)." PhD diss., Harvard University, Cambridge, MA, 1999.

_____. "Man in the Image of God in the Image of Times: Sufi Self-narratives and the Diary of Niyazi-i Misri (1618–1694)." *Studia Islamica* 94 (2002): 139–166.

The Encylopedia of Islam New Edition. Volume 9. Leiden: E.J. Brill, 1995.

Thevenot, Jean. *Le Voyage du Levant*. Paris: La Decouverte / Maspero, 1980.

Thrower, N.J. *Maps and Man: An Examination of Cartography in Relation to Culture and Civilization*. London: Routledge, 1972.

Timurtaş, Faruk K. *Şeyhi'nin Hüsrev ü Şîrîn'i*. Istanbul: Istanbul Universitesi Yayınları, 1980.

Titley, Norah. *Persian Miniature Painting and its Influence on the Art of Turkey and India: The British Library Collections*. London: British Library, 1983.

_____. "Piante e giardini nell'arte persiana, moghul, e turca." *Il giardino islamico Architettura, natura, paesaggio*, edited by Attilio Petruccioli (Milan: Electa, 1994): 127–142.

Tobey, George B. *A History of Landscape Architecture: The Relationship of People to Environment*. New York, NY: Elsevier Publishing Company, 1973.

_____. *Plants and Gardens in Persian, Mughal, and Turkish Art*. London: British Library, 1979.

Tolasa, Harun. "15. yy Türk Edebiyatı Anadolu Sahası Mesnevileri." *Ege Universitesi Sosyal Bilimler Fakültesi Türk Dili ve Edebiyatı Araştırmaları Dergisi* 1 (1982): 1–13.

_____. *Sehi, Latifi, Aşık Çelebi tezkirelerine göre 16. y.y.'da edebiyat araştırmaları*. Izmir: Ege Üniversitesi Matbaası, 1983.

Tournefort, Joseph Pitton de, 1656–1708. *A Voyage into the Levant*. Translated by John Ozell: cf. Preface. London, 1743.

Trimingham, J. Spencer. *The Sufi Orders in Islam*. Oxford: Clarendon Press, 1971.

Tuan, Yi-Fu. *Topophilia: A Study of Environmental Perception, Attitudes and Values*. Engelwood Cliffs, NJ: Prentice Hall, 1974.

Tuncer, Hadiye and Hüner. *Osmanlı Diplomasisi ve Sefaretnameler*. Ankara: Ümit Yayıncılık, 1997.

Türkay, Cevdet. *Osmanlı Türklerinde Coğrafya*. Istanbul: Milli Eğitim Bakanlığı, 1999.

Turner, Victor Witter. *Dramas, Fields, and Metaphors: Symbolic Action in Human Society*. Ithaca, NY: Cornell University Press, 1974.

_____. *The Ritual Process: Structure and Anti-structure*. Ithaca, NY: Cornell University Press, 1977.

_____ . *From Ritual to Theatre: The Human Seriousness of Play*. New York, NY: Performing Arts Journal Publications, 1982.

_____ . *The Anthropology of Performance*. New York, NY: PAJ Publications, 1986.

_____ . "Are There Universals of Performance in Myth, Ritual, and Drama?" In *By Means of Performance: Intercultural Studies of Theatre and Ritual*, edited by Richard Schehner and Willa Appel, 8–18. Cambridge, UK: Cambridge University Press, 1990.

Turner, Victor W. and Edith Turner, *Image and Pilgrimage in Christian Culture: Anthropological Perspectives*. New York, NY: Columbia University Press, 1978.

Turner, Victor W. and Edward M. Bruner, eds. *The Anthropology of Experience*. Urbana, IL: University of Illinois Press, 1986.

Uçman, Abdullah. *Yirmisekiz Çelebi Mehmed Efendi Sefaretnâmesi*. Istanbul: Garanti Matbaacılık ve Neşriyat, 1975.

Ünver, Ismail. "Mesnevi." *Türk Dili* 415-6-7 (1986): 430–563.

_____ . *Nesati*. Ankara: Kultur ve Turizm Bakanligi, 1986.

Üsküplü, Ishak Çelebi. *Divan: Tenkidli Basım*. Istanbul: Istanbul Üniversitesi, 1982.

Usuli. *Usuli divani*. Ankara: Akcağ, 1990.

Uzunçarşılı, İsmail Hakkı. *Osmanlı Tarihi* I–IV. Ankara: Türk Tarih Kurumu, 1961.

_____ . *Osmanlı Devletinin İlmiye Teşkilatı*. Ankara: Türk Tarih Kurumu, 1965.

Vatin, Nicolas. "Bir Osmanlı Türkü Yaptığı Seyahati Niçin Anlatırdı?" *Cogito,* no. 19 (Istanbul: Yapı Kredi Yayınları, 1999): 161–178.

Veinstein, Gilles. *İlk osmanlı Sefiri 28 Mehmet Çelebi'nin Fransa Anıları* "Kafirlerin Cenneti." Translated by M.A. Erginöz. Istanbul: Ozgü Yayınları, 2002.

Vryonis, Junior, S. "Nomadization and Islamization in Asia Minor." *Dumbarton Oaks Papers* 29 (1975): 43–71.

Walbridge, John, ed. *The Wisdom of the Mystic East: Suhrawardi and Platonic Orientalism*. Albany, NY: State University of New York Press, c. 2001.

Warner, Jayne L. *Cultural Horizons: A Festschrift in Honor of Talat S. Halman*. Syracuse, NY: Syracuse University Press, 2001.

Watson, William. "Ibrahim Müteferrika and Turkish Incunabula." *Journal of the American Oriental Society* 88 (1968): 435–441.

_____ . "Landscape Elements in the Early Buddhist Art of China." *Landscape Style in Asia*. A Colloquy held 25–27 June 1979 (London: University of London, 1980): 1–29.

Wescoat, Junior, Jim. "The Islamic Garden: Issues for Landscape Research." *Environmental Design,* no. 3 (Rome, 1986): 10–19.

Wilber, Donald N. *Persian Gardens and Garden Pavilions*. Tokyo: Charles E. Tuttle Company, 1962.

Woodhouse, C.M. *George Gemistos Plethon: The Last of the Hellenes*. Oxford: Clarendon Press, 1986.

Yaltkaya, M. Şerafettin. *Simavne Kadısıoğlu Şeyh Bedreddin*. Edited by Hamit Er. Istanbul: 1994.

Yazıcı, Tahsin. "Gülşeni, Eserleri ve Fatih ve II. Beyazıd hakkındaki Kasideleri." *Fatih ve Istanbul* 2/ 7–12 (1954): 82–95.

———. "Fetihden Sonra Istanbul'da İlk Halveti Şeyhleri: Çelebi Muhammed Cemaleddin, Sünbül Sinan ve Merkez Efendi." *Istanbul Enstitüsü Dergisi* 2 (1956): 87–113.

Yazıcıoğlu, Ahmed Bîcân. *Envârü'l-âşıkîn*. 1451. Edited by H. Mahmud Serdaroğlu and A. Lütfi Aydın. Istanbul: Çelik Yayınları, 1977.

Yerasimos, Stefanos. *Türk Metinlerinde Konstantiniye ve Ayasofya Efsaneleri*. Translated by Şirin Tekeli. Istanbul: Iletişim Yayıncılık, 1993, c. 1990.

———. "Ottoman Istanbul." *Rassegna* 72 (1997): 24–36.

———. "Seyahatnamelerde Kültürel Algılama," In *Sanat ve Çevre, SANART Üçüncü Dönem Sempozyum ve Etkinliklerine Hazırlık Toplantıları, Metinler*, edited by Zeynep Aktüre, 1–12. Ankara: ODTÜ Mimarlık Fakültesi Basım İşliği, 1997.

———. *Istanbul İmparatorluklar Başkenti*. Translated by Ela Gültekin and Ayşe Sönmezay. Istanbul: Tarih Vakfı Yayınları, 2000.

Yesirgil, Nevzat. *Nedim: Hayatı, Sanatı, Şiirleri*. Istanbul: Varlık Yayınevi, 1982.

Yılmaz, Duralı. *Şeyh Bedrettin: Sufinin isyanı*. Istanbul: Bakış Kitaplığı, 2001.

Yöntem, Ali Canip. "Nedim'in Hayatı ve Çağdaşlarının Üzerindeki Tesirleri," In *III. Türk Tarih Kongresi: Kongreye Sunulan Tebliğler*, 108–121. Ankara: TTK Basımevi, 1948.

Yüksel, Aydın. *Osmanlı Mimarisinde II. Beyazıd ve Yavuz Selim Devri (886-926/ 1481– 1520)*. Istanbul: Istanbul Fetih Cemiyeti, 1983.

Yurdaydın, H.G. *Nasuhü's Silahi (Matrakçı) Beyan-ı menazil-i Sefer-i Irakeyn*. Ankara: 1976.

Zati. *Zati Divani*. Istanbul: Istanbul Üniversitesi, 1967.

Zolondek, L. *Book XX of Al-Ghazali's Ihya' 'Ulum al-Din*. Leiden: E.J. Brill, 1963.

Index

Ahmed-i Sârban 55, 117, 155, 165, 243
Amid 23 n15, 245
Ankara 41
Antakya 23 n15, 107, 137, 246
Aşık Çelebi viii, 65, 78, 100 n4, 102 n32, 102 n41, 147, 150–154, 182 n116

barzakh i, ix, 29, 35, 36, 37, 39, 53, 58 n32, 109, 110, 157, 158, 173, 229, 231, 232, 233
bath-house(s) x, 19, 133, 135, 159, 162, 165, 168, 170 (sea-bath), 173, 202, 206, 221, 226 n62, 229
bazaar(s) x, 19, 99, 108, 135, 170, 172, 212
bedesten 156, 172
Bektashi(s) 43, 52, 61 n77, 73, 165
Belgrad 21 n2, 23 n15, 107, 137, 192–193, 245
Beşiktaş 2, 3, 93, 130, 132, 165, 197, 204, 225 n62
Bursa 23 n15, 41, 43, 45, 60 n67, 107, 136–137, 181 n85, 243, 245–246

Câfer Çelebi 94, 146–148, 154, 183 n128, 183 n130, 184 n136, 185 n146

Davud b. Mahmud el-Rumi el-Kayseri 41, 44, 45, 46

Davudpaşa 132, 165
Defterdarzade Cemâli Efendi 188, 131, 133, 135, 162, 246

Edirne 11, 21 n2, 23 n15, 41, 43–45, 48–49, 55, 97, 107–109, 111, 113–114, 117–120, 122–123, 125–126, 134–137, 154–155, 157–162, 164–165, 169, 173, 175 n22, 182 n112, 191–192, 208, 230, 231, 233, 245–246
Efşancı Garden vii, 78–79
Evliya Çelebi 17, 22 n7, 24 n39, 25 n41, 91–93, 103 n65, 104 n76, 105 n95, 158, 167–172, 186 n172, 188 n209, 188 n211, 188 n215, 189 n221, 210, 233
Eyüp 125, 129–130, 132, 165, 168, 170–171, 203

Fakiri, Kalkandelenli 108, 126, 128, 135–136, 144, 158–159, 245
Fuzuli 145, 148

Galata 115, 125, 129, 132, 136, 149, 165, 167, 171–172
garden(s) vi–x, 1–14, 17, 21, 22 n7, 27, 29, 36–38, 46, 48, 63–75, 77–79, 84–100, 100 n1, 100 n5, 100 n7, 101 n10, 102 n37, 103 n68, 104 n71, 104 n72, 104 n81, 108, 111–117, 120, 124–130, 132–133,

135, 137–138, 145–149, 155–161, 164–165, 167–168, 170–173, 183 n134, 186 n173, 186 n174, 191, 193–198, 200–207, 209, 211–222, 223 n26, 226 n62, 226 n63, 227 n85, 228 n94, 228 n97, 228 n99, 229–233
gazel vii, x, 9–13, 19, 21, 63, 65, 69, 71–75, 77–83, 85–87, 89, 91, 93, 95, 97, 99–101, 108–109, 114, 116, 144, 155, 157, 159, 172, 173, 175 n13, 202, 204, 206, 209, 225, 232–233
Gelibolu 23 n15, 107, 137, 245–246
Gemistos Plethon 27–28, 56 n5
Ghazali 30, 56 n1
Göksu 132, 147, 165, 167, 206, 224 n55
guild(s) i, vii, 6, 9–13, 17, 23 n17, 52–55, 73–74, 108–109, 112, 134–136, 141–144, 154–155, 159, 165, 169, 171–172, 206, 208, 210, 230, 232–233
guild boy(s) 14, 107, 122, 126, 129, 126, 129, 132, 133, 136, 137, 141, 149, 155, 163, 173
Gülşeni(s) 42, 45, 51–52, 138, 154

Hacı Bayram Veli 23 n19, 41, 45–46, 49–50, 51–54, 60 n68, 108, 112, 114, 134, 136, 155, 164–165, 241
Hacı Bektaş Veli 158
Hagia Sophia 96–97, 114–115, 117, 129–130, 145, 156, 162–165, 167
Halvati(s) 19, 51, 52, 138, 181 n86
Hamza Bâlî 125, 165, 178 n53, 243
Hayreti viii, 69, 151, 245
Hippodrome (*Atmeydanı*) 99, 130, 141, 145, 156, 163, 165, 167, 208, 226 n62

Ibn al-'Arabî i, ix, 3, 8–10, 12, 21, 22–23 n12, 23 n13, 27–42, 44–47, 49–54, 56 n1, 56 n2, 56 n3, 56 n4, 57 n7, 57 n8, 57 n15, 57 n24, 58 n27, 58 n30, 58 n36, 58 n38, 58 n42, 58 n61, 59–60 n64, 60n66, 60n68, 81, 86, 88, 110, 103 n57, 112–113, 116, 121–122, 137, 140–141, 149, 158, 174 n5, 174 n10, 207, 221, 229, 231–233, 237–238, 238–239 n1, 239 n2, 239 n4, 241
Ibn Rushd (Averroës) 27, 29, 56 n1, 56 n3
imagination 4, 9, 11, 14, 32–40, 58 n33, 71, 78, 80, 81, 86, 87, 100, 103 n57, 109, 110, 112, 113, 119, 122, 123, 144, 146, 165, 173, 174 n10, 174 n12, 197, 203, 214, 215, 221, 229, 230, 231, 233
 creative imagination i, ix, 8, 9, 17, 27, 29, 32, 33, 57 n7, 57 n15, 57 n17, 57 n19, 57 n25, 58 n29, 113, 201, 174 n12, 238 n1, 239 n2, 239 n4
 market of the garden 39
 pool of imagination 39
 storehouse(s) (of imagination) 113, 140, 141, 155, 173, 215, 220, 229
Iram (Bag-ı Iram, Garden of Iram) (also see İrem Bağı) 6, 69, 92–93, 98, 127–128, 212, 217–221
İrem Bağı (*also see* Iram) 179 n59, 187 n178, 212
İshak Çelebi viii, 153–155, 208, 245
İsmail Maşuki 55, 62 n96, 165
Istanbul i, viii, x, 1–7, 11, 13–14, 18–19, 21, 21 n2, 22 n6, 22 n7, 22 n10, 23 n15, 23 n21, 25 n41, 28, 41–42, 45, 51–52, 55–56, 63, 86, 92–94, 99–100, 101 n28, 102 n41, 103 n68, 104 n81, 107–108, 114, 116–117, 122–124, 126–127, 129–131, 133, 135–137, 139, 141, 145, 147–148, 154–157, 159–162, 164–173, 174 n2, 175 n14, 175 n18, 181 n86, 182 n110, 182 n112, 185 n146, 186 n163, 186 n164, 186 n165, 188 n206, 188 n207, 189 n223, 191–193, 199–204, 206, 209–211, 222 n15, 222 n16, 222 n17, 223 n25, 223 n28, 224 n30,

224 n35, 224 n47, 224 n55, 225
n60, 225 n62, 226 n65, 227 n76,
230–231, 233, 243, 245–246

Kadıköy 132, 165
Kadiri(s) 28, 51, 138
Kağıthane viii, 3–4, 91–93, 130, 132,
145, 147, 165, 167–196, 171, 191,
194, 197, 199, 200, 202, 206–207,
209, 210–211, 214–215, 217–221,
226 n64, 226 n65, 226 n66, 226
n67, 233
Kashan 23 n15, 107, 137, 230
kaside 13, 20, 97–99, 201–204, 209,
224 n31, 224 n32, 224 n33, 224
n34, 224 n35
Kavak 132, 165
Khidr 32, 36, 60 n66, 124, 163–164,
178 n45
Konya 22 n12, 28–29, 41, 44, 60 n68,
237, 246

landscape i, x, 2, 11, 13, 29, 103 n68
144, 149, 157, 173, 174, 193–194,
197, 207, 215, 227 n85, 229–231,
233, 234 n1, 234 n2, 234 n3
Latifi 100 n1, 102 n32, 147, 182 n116
love 8–12, 16, 22 n9, 33–35, 40–42,
44, 46, 54, 62 n95, 63, 71–75, 77,
85–87, 93, 102 n38, 107, 109,
113–114, 117–118, 120–124, 127,
129, 131, 133, 144–149, 154, 157,
182 n121, 125 n49, 184 n140, 191,
202, 203, 205, 211, 229, 232

Manisa 23 n15, 107, 137, 246
meadow(s) x, 2, 4, 7, 10, 14, 51, 73,
108, 112, 119, 125–126, 129–130,
135, 138, 145, 147, 158–159, 165,
167–168, 172, 183 n134, 204–205,
207, 209–210, 233
Melâmî(s) i, ix–x, 12, 18–19, 23 n18,
23 n19, 23 n20, 25 n41, 28, 41–42,
49, 50–52, 54–56, 60 n68, 60 n74,
61 n79, 61 n88, 61 n90, 61 n92,
61 n93, 62 n96, 62 n97, 108, 112,
117, 121–122, 125, 134, 136, 155,
161, 164–165, 173, 175 n18, 175
n20, 177 n38, 181 n88, 185 n156,
187 n188, 188 n202, 207–208, 221,
231–233, 241, 243
Hamzavî(s) 18, 42, 243
Melâmî-Bayrami(s) 12, 41, 54, 108,
117, 125, 161, 165, 187 n188, 207
Mesîhî 11, 108–114, 131, 134–135,
144–145, 149, 154, 157, 159, 174
n1, 174 n5, 174 n9, 182 n112, 182
n113, 182 n115, 182 n116, 184
n142, 185 n143, 185 n146, 245
mesire 96, 98, 149, 167–171, 199, 206,
210–211, 220, 233
mesnevi 107, 119, 145–148, 154, 176,
201–202
Mevlevi(s) 51, 54, 134, 139, 194, 207
Molla Fenari 45, 47, 59 n61, 59 n65,
60 n67, 60 n68
multiplicity 32, 34, 38, 39, 41, 46, 47,
49, 60 n66, 88, 113, 117, 120, 123,
135, 140, 146, 148, 154, 165, 167,
173, 233
multiplicity of beloved ones 12, 46,
49, 113, 117, 124, 148

Nakşibendi(s) 138
Nedîm i, viii, x, 2, 4–5, 7, 10, 12–13,
21 n1, 54, 101 n26, 103 n50, 191,
200–209, 217, 220–221, 223 n25,
223 n26, 224 n31, 224 n32, 224
n48, 225 n55, 225 n58, 225 n59,
225 n60, 225 n61
Neşati Ahmed Dede 108, 134, 180
n80, 246
Nesimi 154
Nevşehirli Damad Ibrahim Pasha
3–4, 54–55, 191–194, 197, 199,
200–201, 204, 206–207, 221, 224
n31, 224 n35

paradise 1–2, 3, 5–7, 9–11, 13, 36–38,
40, 48–49, 69, 75, 77, 84, 86–87,

91–92, 94–100, 103 n56, 111–113,
115–116, 121, 124, 127–132, 134,
141, 147, 155, 157–159, 161, 164,
167, 171, 173, 191, 193, 200–201,
203–205, 212, 215, 217–221, 229,
232, 233, 183 n134, 186 n173, 186
n174, 228 n97, 228 n99
private garden(s) ix, 4, 6, 8–10,
12, 21, 63, 65, 68, 70, 73–74, 78,
85–87, 89, 93, 95, 99, 114, 155,
173, 193, 202, 206, 214, 220–221,
232

Revani 154
Rize 23 n15, 107, 137, 245
Rufai(s) 51, 138

Sa'd-âbâd Palace and gardens viii,
93, 194, 200, 202–206, 211–212,
214–215, 217–221, 224 n33, 224
n34, 224 n55
Sadreddin Konevi 29, 44, 59 n64, 60
n66
şarkı (song) 202, 204–206, 224 n37,
224 n38, 224 n39, 224 n40, 224
n41, 224 n42, 224 n43, 224 n44,
224 n45, 224 n46, 224 n47, 224
n48, 224 n49, 224 n50, 224 n51
şehrengiz i, iii, vii–x, 10–14, 16,
18, 20–21, 23 n15, 45, 107–141,
144–45, 149, 150–155, 157–159,
157–159, 161–165, 167, 170–173,
174 n1, 174 n5, 175 n13, 175 n22,
182 n110, 182 n112, 182 n114,
182 n116, 201–202, 204, 210–215,
221–222, 224, 230, 232–233,
245–246
Şeyh Bedreddin 41, 45–46, 48–49, 55,
59 n61, 60 n68, 60 n71, 61 n82,
165, 255
Şeyh Galip 77, 102 n38, 145, 183
n124
Sinan, Architect vii, 78–79, 91,
95–96, 104 n84, 104 n87, 104 n88,
104 n89, 105 n90, 105 n92

Sinop 23 n15, 107, 137, 246
Siroz 23 n15, 107, 133, 137, 246
Sohbetname 19, 25 n41
Sütlüce 129, 132, 171

Tab'î Ismail 108, 130, 246
Tanzîh 88–89, 157
Tashbîh 88
Taşlıcalı Yahya viii, 85, 89, 108,
117, 120–126, 129, 130, 135–137,
150, 155, 157–158, 175 n22, 177
n39, 178 n46, 178 n51, 178 n53,
185 n155, 186 n167, 186 n176,
245
Topkapı Palace 92–95, 101 n9, 104
n71, 145, 199, 213, 221
Türkmen 28, 43–45, 48, 50, 55

Üsküdar 4, 91, 92, 132, 155, 165, 197,
203
Usuli viii, 152, 154, 245

Vize 23 n15, 107–108, 114, 116–117,
135, 137, 165, 243, 245

Wahdat al-Mevcûd (Unity of Existent)
41–42
Wahdat al-Wujûd (Unity of Being)
8, 12, 29, 41, 42, 45–46, 48–49,
59–60, 120, 207

Yedikule 125, 165, 168
Yedikululeli Mustafa Azizi 108,
133–135, 246
Yenice 23 n15, 107, 137, 154, 245
Yenikapı 130, 165, 168
Yenişehir 107, 135, 137, 245
Yirmisekiz Mehmed Çelebi 3, 22n3,
25 n41, 192–194, 197, 212, 215,
222 n8, 227 n75, 227 n81, 227 n82,
227 n83, 227 n84, 227 n85, 228
n86, 228 n88, 228 n89, 228 n92,
228 n95

Zâtî 80, 89, 154, 245

Printed in Poland
by Amazon Fulfillment
Poland Sp. z o.o., Wrocław